educating
artistic
vision

ELLIOT W. EISNER
Stanford University

The Macmillan Company
New York

Collier-Macmillan Limited
London

The Macmillan Company
866 Third Avenue, New York,
New York 10022

Collier-Macmillan Canada, Ltd.,
Toronto, Ontario

Library of Congress
catalog card number:
76–155268

PRINTING 23456789 YEAR 3456789

preface

This book represents my effort to synthesize in as concise a statement as possible the ideas that have permeated my writing in the field of art education during the past decade. It represents an effort to put together the pieces of an intellectual puzzle, one that has intrigued me since my undergraduate days in Chicago. As one might suspect, the puzzle is not yet complete and probably never will be. The task of understanding how it is that people develop their ability to respond to and create visual form is one of the utmost complexity, but even if it were not, I suspect scholars would seek to generate problems around it for the sheer satisfaction that inquiry yields.

The sense of vital living that the perception and creation of art provide is one of the themes of this book. It is clear that such a sense is not now intentionally developed in the vast majority of schools that dot our land. The arts have not enjoyed a place of prominence in schools because of the way in which both art and education have been conceived. The dichotomies that have been established between the work of the head and the work of the hand are manifest in the role the arts are assigned in school. It has been my desire in this book to bridge these dichotomies by showing how experience in both the creation and appreciation of art can properly be conceived of as a product of intelligence. This is not to say that I have chosen to claim that artistic development is identical to development in the spheres of science or in the use of discursive tools of thought. It is to argue that an educational program that neglects the qualitative aspects of intelligence, one that side-steps the metaphorical and affective side of life, is only half an education at best. At worst it leads to the development of men callused to the insights of the visually poetic in life.

Many of the ideas in this book, especially those concerning the way in which curricula can be developed, have emanated from curriculum-development work that my students and I have been engaged in at Stanford University since 1967. This work represents an effort to translate theoretical ideas about artistic learning into a practical program that elementary school teachers can use in their classrooms. The general curriculum structure that the book describes, the types of instructional support media that are suggested, the various modes of evaluation outlined are, in part, products of that curriculum work. From it we have begun to catch a glimmer of the potential of art programs that provide children with an opportunity to work in depth in art and to develop the sense of competence that will enable them to convert material into a medium of artistic

expression. Much of what I say in this volume relates to the insights that work has provided.

I said earlier that the puzzle of understanding artistic learning is yet to be completed. This statement conveys a meaning that I hope is apparent throughout the pages to come. What I have offered on these pages contains a mix of the theoretical and the practical, the empirical and the speculative. The ideas put forth are not meant to be offered, or taken, as dogma. The last thing I hope for is blind obedience to unexamined belief. Instead, I hope the reader will treat my ideas as objects of critical attention, objects that invite and hopefully stimulate his own inquiries into the means and ends of art education.

Prefaces are places where an author can express his appreciation to those who have contributed to his development and work. My deep appreciation goes to my students at Stanford University who worked as colleagues with me in our mutual efforts to understand the processes of artistic learning and to apply such understanding to the development of an educational program in the visual arts. I wish to thank Edyth Covitt and Ray Shook for suffering through my handwriting on the initial typing of the manuscript and Eve Dimon for preparing portions of the final draft. I wish also to express my appreciation to the John Simon Guggenheim Foundation for its generosity in providing me with the time necessary for writing this book.

Finally, I wish to express my deepest appreciation to my wife, Ellie, and to my children, Steven and Linda, who had to put up with a grumpy fellow when the writing was going badly and an absent one when it was going well.

E. W. E.
Stanford, California

contents

educating artistic vision

1

why teach art?

The problems that are encountered by anyone attempting to understand and facilitate the educative process in any realm, but perhaps especially in the realm of art, are enormously difficult ones. After all, the scientific study of human experience and behavior is relatively new, only about a hundred years old, and the degree to which one can find scientifically confident answers to the problems of educating others is small. Because artistic learning and aesthetic experience are among the most sophisticated aspects of human action and feeling, we should not expect more than that which can be provided. The function of this book is to share with the reader some insights into those problems, to analyze and describe some of what is known, and to suggest courses of action for building programs in art that appear to be promising.

To provide these insights and to share these understandings at least four sources of knowledge will be examined. First, it will be important to understand some of the views that deal with the questions, Why teach art at all? What are the justifications for spending time, effort, and money in this particular area of human experience? Second, what have been the justifications for the teaching of art in the public schools of America? How have those who have gone before seen their mission? What have they attempted to accomplish and why? Ignorance of the past is no necessary virtue, and while knowledge of the past is no guarantee that it will not be repeated, such knowledge does provide one useful frame of reference for looking at the present.

Third, what do the social sciences have to say about the visual arts and the conditions that affect one's ability to produce and experience them? How, in fact, do people become sensitive to visual form? How do they acquire the insight, perceptivity, and skill needed to produce visual form that will have social or personal importance? Fourth, what can be gleaned from the practice of curriculum development, from the teaching of art, and from evaluating artistic learning that might be useful to those who are to teach art in the schools? Knowledge from the fields of philosophy, history, the social sciences, and the practical realms of teaching and curriculum making are those from which much of the content of this book is drawn.

The teaching of art in American schools has seldom been and is not now a central aspect of school programs. Most Americans view the arts as peripheral rather than central to the educational process as it occurs under the auspices of the school.[1] Those who value the arts and who have savored the quality of experience and insight they have provided need to think through the grounds on which their place in the school's program can be secured. Heartfelt testimony is often used to argue the importance

of art in educational programs, and unfortunately that testimony, while deeply felt, frequently lacks persuasiveness. How *does* one argue the case of art in the school? What claims can be made for its function? Why should a public support it as an important aspect of formal education?

There are, to my way of thinking, two major types of justifications for the teaching of art. The first type emphasizes the instrumental consequences of art in work and utilizes the particular needs of the students or the society as a major basis for forming its objectives. This type of justification is referred to as a *contextualist* justification.

Justifications for the Teaching of Art

The second type of justification emphasizes the kinds of contributions to human experience and understanding that only art can provide; it emphasizes what is indigenous and unique to art. This type of justification is referred to as an *essentialist* justification.

Let's look at the first type of justification at the outset, for it will be seen that this way of justifying the teaching of art has been widely used throughout art education's history in the public schools.

Using a contextual frame of reference we will argue that an educational program—both its means and its ends—can be properly determined only if one understands the context in which that program is to function. In that context both the characteristics of the students and the needs of the larger society must be considered. For example, let's assume the faculty of a school is working with economically deprived black children living in a ghetto. Let's assume further that among the things these students have been deprived of is an understanding of the high achievements in the arts their ancestors have made to world culture. Furthermore, these children need to be helped to develop a racial pride that American society has made it difficult for them to attain. Using the contextual frame of reference the art program in such a school would probably emphasize the art of the Benin, of the Ibo, and of other African peoples as well as the art of Black Americans. The art program in this school would use art to develop self-esteem. It would take as its starting point not art, but children, and would take from the arts what was appropriate for them, given some set of educational values. An example of this particular orientation to the arts in education is as follows.

What we need—and here I will speak only of the teaching of art—are new conceptions of modes of artistic behavior, new ideas of what might constitute the

curricula of the art class. These new curricula must be meaningful and relevant to pupils—to disadvantaged pupils and, by extension, to all pupils. These new ideas must engage the "guts and hopes" of youngsters and through these excitements provoke intellectual effort and growth. These new ideas must give the art class a share in the process of exploring social relationships and developing alternative models of human behavior in a quickly changing and, at this point in time, quickly worsening social environment.[2]

What we see here is a plea for the use of art in education that emanates only in part from the unique nature of art. The use of art in this context develops primarily from what are considered important human priorities. This orientation to the determination of the objectives and the content of the art curriculum is not a new one. In fact, it tends to be more characteristic than most of us realize. Not only is art education affected by the values held by those who control school programs, but education itself is so affected. A vivid and recent example is the effect of Sputnik on the content, aims, and importance of science programs in American secondary schools. When on October 7, 1957, the Russians sent Sputnik circling this planet, critics of American education gained a vehicle for pleading the case for the so-called academic subjects, especially mathematics and science.[3] Second best was not good enough it seems and, as in many other such situations, a perceived social need—catching up to Russian technology—gave impetus to the support and emphasis of science and mathematics in the high school curriculum.

Art education, too, has been affected by what people believed to be important social needs. During the late depression years the Owattona Project, about which more will be said later, was devoted to using art to improve community life and home interiors. During the Second World War art was often used in the public schools as a means of producing posters to help the war effort. Because American schools are social institutions they reflect the values and needs of the communities they serve. Needs that are acute or values that are threatened are often used to bring about or prevent change in educational programs.

What should be the goals and content of art education programs today? The answer depends, says the contextualist. It depends on who the child is, what type of needs the community has, what problems the larger society is facing. To those holding a contextualist position the goals of any particular educational program should be determined by assessing the situation, including students and faculty resources. This process, recently called "needs assessment,"[4] is often used as a first step in large-scale curriculum planning. Assessing the needs of students, or of a community,

or of a nation, gives the impression that these needs are somehow "out there" and that appropriate social analysis will reveal them. That is only part of the story. What a need is can be determined only in relation to a set of values. Thus, two individuals may examine the "same" community and arrive at opposite conclusions about what the needs of that community are. What, for example, do children need from art education: to develop their creative abilities, to learn to appreciate fine art, to become skilled at the production of art forms? The study of a group of children by individuals holding different values concerning art's role in education will yield different conclusions about what children need.

Two vivid examples of differing values about the function of art education are shown in the following. Viktor Lowenfeld, for a long time one of art education's most prominent theorists, writes:

If children developed without any interference from the outside world, no special stimulation for their creative work would be necessary. Every child would use his deeply rooted creative impulse without inhibition, confident in his own kind of expression. We find this creative confidence clearly demonstrated by those people who live in the remote sections of our country and who have not been inhibited by the influences of advertisements, funny books, and "education." Among these folk are found the most beautiful, natural, and clearest examples of children's art. What civilization has buried we must try to regain by recreating the natural base necessary for such free creation. Whenever we hear children say, "I can't draw that," we can be sure that some kind of interference has occurred in their lives.[5]

Yet Irving Kaufman pleads for a different set of values. He says,

Unlike other subject areas that are based upon the relatively stable structure of a particular discipline, the content of art education has been ambivalent and vague, frequently straying from the broad conditions that mold the nature of art. This may be due, in part, to the unstructured quality of art and the difficulty of designing an art curriculum. There is a stress on the inherent capacities of the individual teacher and trust in his knowledge of creative process. This trust is at once a blessing and a convenient blind for what may be trivial content. Art education has developed an all-encompassing and indiscriminate content. It frequently serves as a pipeline for the very surrounding culture that it purports to upgrade.[6]

For each of these scholars the needs that ought to be met by art in public school programs differ, and they differ primarily because the values in art education that each prizes differ. Thus, we find that what are considered needs of the child, of the community, and of the society are, in large measure, affected by the values that one holds.[7] When one argues that the goals of art education cannot be determined without reference to

the populations to be educated, one means that somebody or some group must apply a set of values to those populations to determine what the goals and content of the field ought to be.

The contextualist's position regarding the aims and content of art education is not without a lusty competitor. To answer those who argue that what art education should seek to achieve must depend upon who is to receive such education, essentialists provide another view. They reply that art is a unique aspect of human culture and experience, and that the most valuable contribution that art can make to human experience is that which is directly related to its particular characteristics. What art has to contribute to the education of the human is precisely what other fields cannot contribute.

Take, for example, the position that John Dewey argues regarding the nature of art. He writes that,

> Art is the living and concrete proof that man is capable of restoring consciously, and thus on the plane of meaning, the union of sense, need, and impulse and action characteristic of the live creature. The intervention of consciousness adds regulation, power of selection, and redisposition. Thus it varies the arts in ways without end. But its intervention also leads in time to the idea of art as a conscious idea—the greatest intellectual achievement in the history of humanity.[8]

Here we have a view that conceives of art as a form of experience having special and valuable characteristics. For Dewey, art is a form of experience that vivifies life; it helps the growing organism recognize that it is alive; it moves one to a height of feeling that makes it possible to identify that experience as a unique event in one's life. Such experience is for Dewey what we mean by art, it is intrinsically valuable, it is relatively rare, and it should not be subverted to serve other ends. To take objects and events that are capable of providing such experience and to distort them so that they are used exclusively as instruments for other ends is to violate the very characteristics that art, as experience, possesses.

The unique and valuable character of art is argued even more strongly by Suzanne Langer. She holds that there are two major modes of knowing through which an individual comes to understand the world. These are the discursive and the non-discursive modes.[9] The discursive mode of knowing is characterized by the scientific method, by logic, and by those fields of inquiry that proceed through verbal and written language. The knowledge such fields provide is systematic, rational, and propositional and makes enormous contributions to our understanding of the world. This mode,

however, is not the only way in which man achieves understanding; the arts provide the other major mode of knowing. Langer writes,

Whatever resists projection into the discursive form of language is, indeed, hard to hold in conception, and perhaps impossible to communicate, in the proper and strict sense of the word "communicate." But fortunately our logical intuition, or form-perception, is really much more powerful than we commonly believe, and our knoweldge—genuine knowledge, understanding—is considerably wider than our discourse.

and,

A work of art presents feeling (in the broad sense I mentioned before, as everything can be felt) for our contemplation, making it visible or audible or in some way perceivable through a symbol, not inferable from a symptom. Artistic form is congruent with the dynamic forms of our direct sensuous, mental, and emotional life; works of art are projections of "felt life," as Henry James called it, into spatial, temporal, and poetic structures. They are images of feeling, that formulate it for our cognition. What is artistically good is whatever articulates and presents feeling to our understanding.[10]

Here we have an eloquent statement regarding the nature of art and its function in human life as one aesthetician sees it. Langer points out that art is a constructed symbol that presents to our perception an artist's knowledge of the forms of feeling. Indeed, for her this is the core that all the arts share. The contribution the artist makes is an important one, a unique one; hence, it should be valued and not diluted by using art education for the host of other purposes for which it can be used.

Dewey and Langer are not alone in their analysis of the unique and significant character of art. The field of aesthetics within the larger field of philosophy has historically attempted to explicate the meaning, significance, and function of art. Although it is clear that art is an elusive concept and that works of art, indeed, all visual forms are difficult to describe, some very persuasive and eloquent attempts have been made to define and describe art. Leo Tolstoy, the famous Russian writer, believed art is the communication of emotion from one man or group to another.[11] When such emotion was sincere, deeply felt, and communicated to others so that they felt it too, such feeling achieved the status of art. And when it was good art, as compared to bad, it united men as brothers. Kinship and good feeling among men was felt and the fatherhood of God recognized. When art was bad, it alienated man from man and nation from nation. It tended to breed allegiances that were socially divisive.

Even today art, in Tolstoy's sense, is used to develop patriotic commitment, or allegiance to one's school, or communion with one's church. If art can perform such functions, if it can contribute to a feeling of brotherhood among men, if this is art's unique and powerful function, it would be easy to understand how such a function might be used in a school.[12]

Dewey, Langer, and Tolstoy are only a very few of the men and women who have attempted to illuminate the unique aspects of art. Each of the great aestheticians, Schiller, Read, Fry, Bell, Morris, Plato, Munro, has attempted to identify, as Morris Weitz [13] has pointed out, the true and essential character of art. Although no completely adequate conception has been formulated, each of their formulations attempts to highlight that which is both unique and valuable about art; each in its own way provides a case for the unique function of art in human life, and by implication, in the educational process. Thus, in opposition to the contextualist, the essentialist holds that the most important contributions of art are those that only art can provide, and that any art education program using art as an instrument to achieve other ends *primarily* is diluting the art experience, and in a sense, robbing the child of what art has to offer.

To those unfamiliar with the field of art education these two major orientations to the role of art in education might seem like academic quibbles. They are not. Each of these views have profound consequences for the teaching of art in American schools. For example, how does one conceive of pottery or weaving—as art or craft? What about the development of general creative ability in children through art—should this be a primary mission of the field? These questions are not mere academic disputes. The way one answers them affects the type of curriculum that one plans, the type of teachers one hires, the type of teacher education one provides. Take the question, Who should teach art? For years there have been debates in the field regarding the qualifications appropriate for teaching art. If one sees art education as a means of self-expression or of releasing emotions pent up because of overemphasis on academic study, then perhaps someone trained partly in art and partly in art therapy or psychology is the appropriate person to teach art. If one believes that the primary function of art education is to help the young learn to appreciate the great works of contemporary and historical art, then perhaps a person trained in art criticism or art history is most suited to teach. If one thinks that the major goal of art education is to prepare practicing artists, then perhaps practicing artists are best equipped to teach art.

The implications of different views about the goals and content of art go even further. If one starts with the premise that schools should concern

themselves with the development of intellect, and if one views art as a product of the emotions, it will be difficult to make a strong case for the arts in education. But if one embraces Langer's view, that art is a cognitive activity as well as one based on feeling, then the problem turns on the task of expanding the usually held conception of cognition, a conception that unduly restricts it to discursive mediation. The point here is that what looks at the outset like a set of abstract formulations about the nature of art affects the practical affairs of the classroom. Unfortunately, too few people who teach art have reflected upon what they are teaching. Hence, unexamined assumptions and beliefs permeate and guide the decisions they make in the classroom.

Thus far, I have tried to show that justifications for the place and function of art education in American schools can be divided into two types. Contextualist justifications argue the role of art education by first determining the needs of the child, the community, or the nation. Art education is seen as a means of meeting those needs, whether they be needs directly related to art or not. Essentialist justifications argue the place of art in the schools by analyzing the specific and unique character of art itself, and by pointing out that it has unique contributions to make and should not be subverted to other ends.

Let's look at the contextualist argument more specifically and identify the number of orientations that have and can be used to justify the place of art in education.

One type of justification deals with the avocational uses of art. For years it has been claimed that a well-rounded education prepares individuals to make good use of their leisure time. Art is sometimes justified on the grounds that it helps develop interests that can provide a sense of satisfaction after work in school ceases.

A second justification for the use of art in schools is therapeutic in nature. It is argued that children need opportunities to express themselves in media other than words and that art activities provide opportunities for the child to alleviate pent-up emotions that cannot be expressed in the so-called academic areas. Art, in this frame of reference, is used as a vehicle for self-expression. It is seen as something contributing to mental health.

A third justification argues that the development of creative thinking ought to be a primary goal of any good educational program. Art, it is claimed, has an especially important contribution to make to the development of creative thinking; therefore, art should be a part of the educational program because it develops the creative abilities of the individual.

A fourth justification argues that art activities develop the students' un-

derstanding of the academic subject areas, especially the social studies, and hence should be used as an important resource in teaching those subject areas. In such a view art is considered a handmaiden to concept formation.

A fifth type of justification used to make a place for art in education has a physiological base. For young children, especially, art is said to develop the finer muscles and hence improve the child's coordination. This justification is frequently used by nursery school and kindergarten teachers who see art as an instrument for the child's general development.

Although these various justifications are appropriate under certain circumstances, they do not, it seems to me, provide a sufficiently solid base for the field of art education. To argue that the justification for art education lies in the contributions it makes to the worthy use of leisure, that it contributes to the fine muscle development of the young child, that it provides release from pent-up emotions is something that can be claimed by a host of other fields as well. The prime value of the arts in education lies, from my point of view, in the unique contributions it makes to the individual's experience with and understanding of the world. The visual arts deal with an aspect of human consciousness that no other field touches on: the aesthetic contemplation of visual form. The other arts deal with other sensory modalities, whereas the sciences and the practical arts have still other ends. Scientific inquiry aims at producing knowledge couched in propositions about the world. The claims of science are generalizations and subject to the limits of language. The practical arts aim at the completion of a significant task; their end is to efficiently complete an action. The visual arts provide for our perception of form that vivifies life and that often makes an appraisal of it. In short, we can learn of the justification of art in education by examining the functions of art in human experience. We can ask, *What does art do?* To answer this question we need to turn directly to works of art themselves.

The Functions of Art as Sources of Justification for Its Teaching

One function of art is that of providing a sense of the visionary in human experience. This function is achieved in at least two ways: first, art, especially the visual arts, has been used to give expression to man's most sublime visions. Through the ages art has served as a means of making the spiritual, especially in religion, visual through the image. When the artist takes an idea such as the divine and transforms it into a visual metaphor, he creates not only a specific object worthy of attention in its own right, he

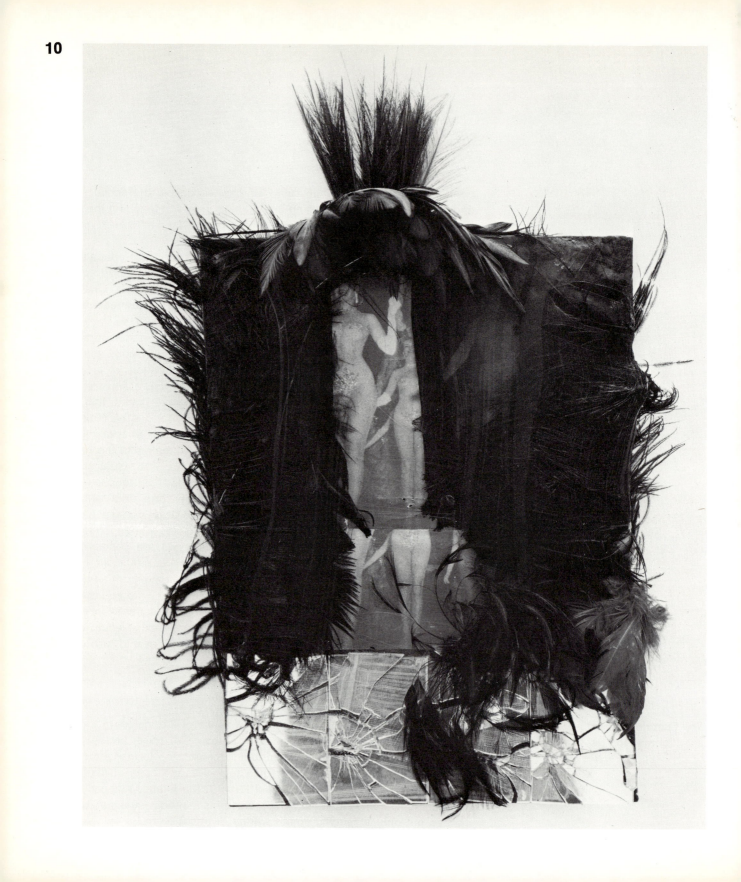

Bruce Conner, "St. Valentine's Day Massacre, Homage to Errol Flynn," 1960, collage. San Francisco Museum of Art.

also creates a form within which man's most cherished values can be embodied. When art performs this function it transforms the personal and ineffable into a public form in which others may participate, thus, the ideas of a culture can take on a corporate significance that they would not otherwise have.

Art not only functions as a vehicle for the articulation of sublime visions, it also takes those visions most characteristic of man, his fears, his dreams, his recollections, and provides these too with visual metaphors. Look, for example, at Bruce Conner's "St. Valentine Day's Massacre, Homage to Errol Flynn" and at Fred Reichman's "At the Edge of the Forest." The

Fred Reichman, "At the Edge of the Forest," oil. San Francisco Museum of Art.

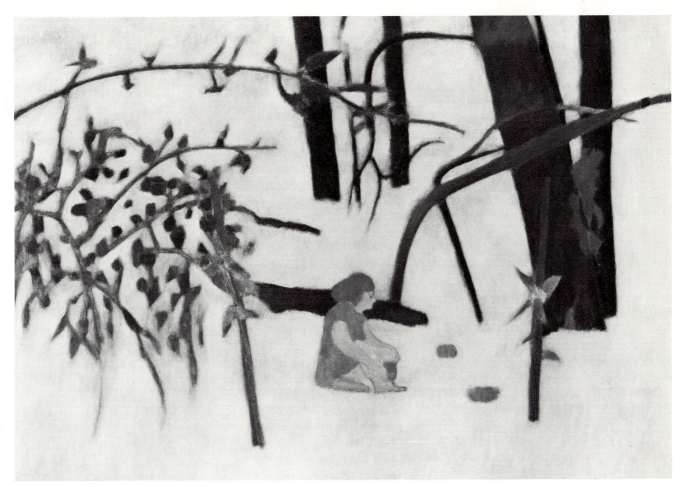

dreamlike quality of both works provides the sense of reality that only dreams can have. In the Conner, the vertical vagina-like aperture surrounded by feathers provides a glimpse as in a peep show. The cracked glass at the entry suggests the breaking of virginity's gateway, and at the same time, sets up a hard-soft relationship between it and the feathers surrounding the orifice.

Fred Reichman's work, tame, lovely, tender, fleeting, is a pastel image as though it were a recollection of a peaceful but brief moment in the past. The horizonless ground on which the girl sits provides a floating, almost magical quality to the work. In both cases—Conner's and Reichman's—the visual image aims not at the replication of the world "out there" but at that of the much more real world in the mind of man.

Art serves man not only by making the ineffable and visionary available, it also functions as a means of activating our sensibilities; art provides the subject matter through which our human potentialities can be exercised. Both Georges Braque and Corrado Marca Relli show us how our sensibilities can be moved by means of line, value, and composition. Each of these men has utilized long vertical rectangles to provide human sensibility with a qualitative journey. The pulsating rhythms of the Marca-Relli and the undulating waves of the Braque touch our fancy and capture our interest. Each artist is concerned with demonstrating what visual qualities can do to our experience. The contrast of soft edge to crisp edge in the Marca-Relli and the almost transparent, whimsical elegance of the Braque are made for our visual fascination. Through them our capacity to respond is increased.

A third function of art is its capacity to vivify the particular. Nature, it is said, imitates art. Having once seen a Constable landscape, the English countryside seems to imitate Constable. Often, what we overlook or disregard, the mundane, the ordinary, becomes a source of inspiration to the artist's eye. The atmospheric starkness of Richard Diebenkorn's "Landscape I" is an example of the artist's ability to heighten our awareness of vistas that many of us may have encountered before, but have not seen. Diebenkorn selects its essence, accentuates it, and holds it for our contemplation. Now we can see the patterns and sunny stillness of a summer day. Art frames our view and captures the moment.

The sources of artistic action emanate not only from the dream and the vision, nor from the desire to move the senses, nor from the effort to capture the moment and make it magical; artists are also moved by the social character of the society and world in which they live. José Clemente Orozco's "Bandera" is an effort to depict the burden of war. The hunch of

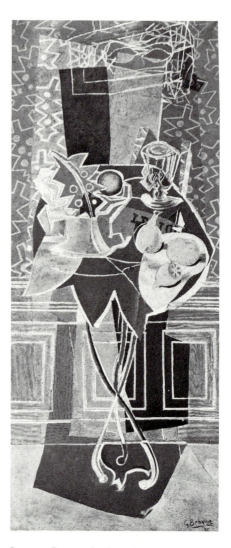

Georges Braque, *Le Gueridon* ("The Table"), oil. San Francisco Museum of Art.

Corrado Marca Relli, "December 27," oil and collage. San Francisco Museum of Art.

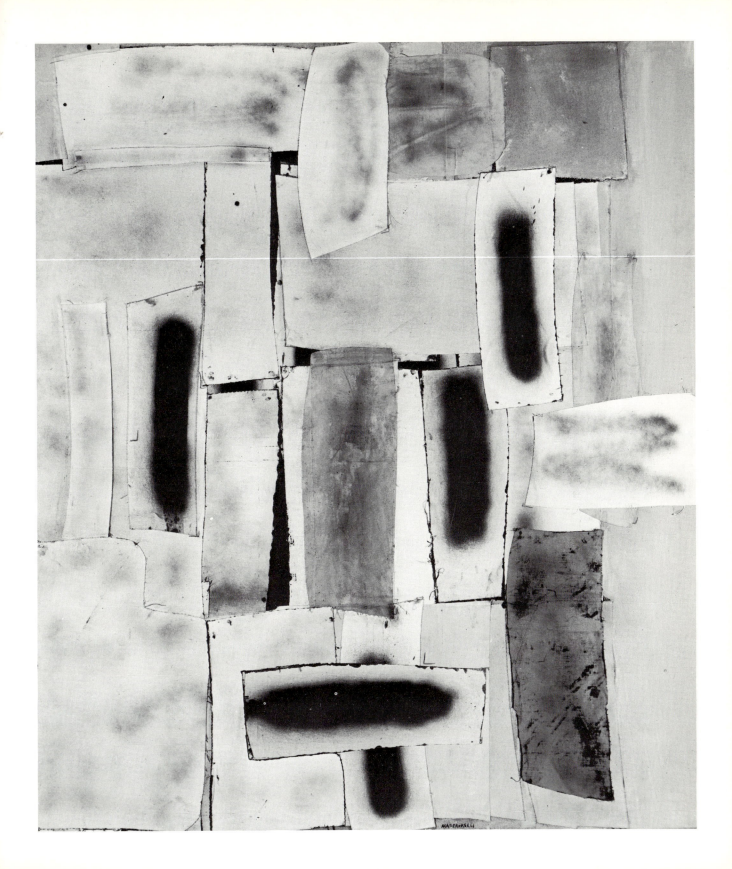

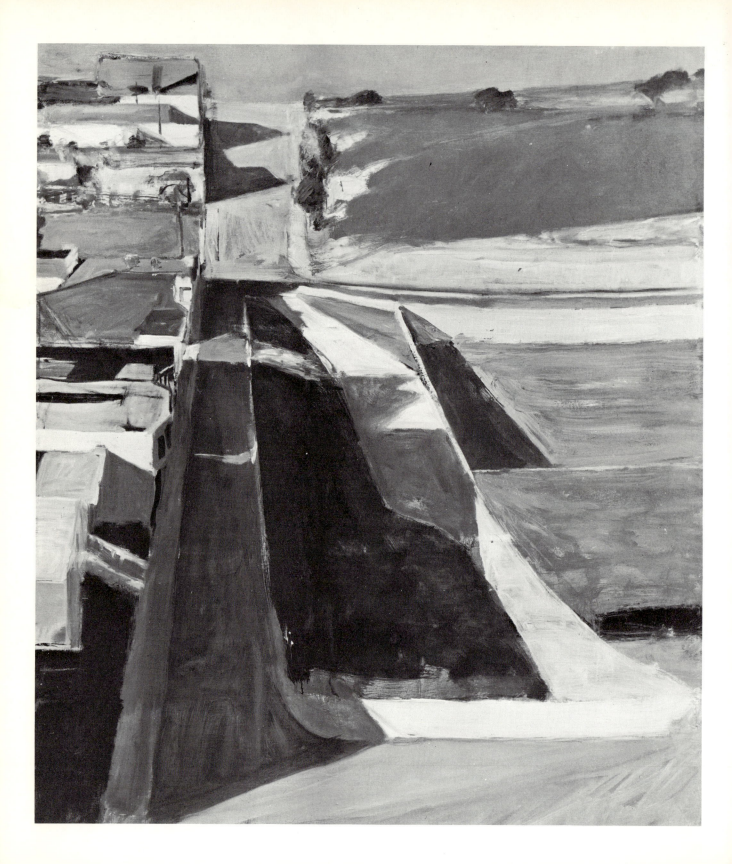

Richard Diebenkorn, ''Landscape I,'' 1963,
oil on canvas. San Francisco Museum of Art.

15

WHY TEACH ART?

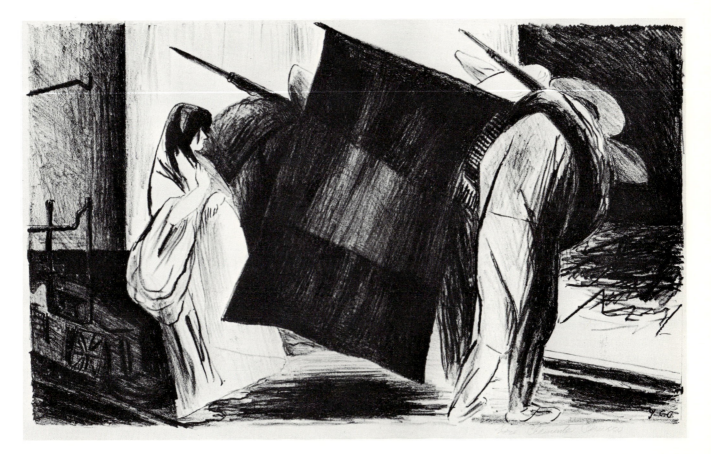

José Clemente Orozco, *Bandera* **(''The
Flag''), lithograph. San Francisco Museum
of Art.**

the shoulders, the barefoot and pregnant woman, the dark expanse of the
night into which the men go, and most of all, the weight of the flag centered
in the composition and dramatically set against the white of the back-
ground, make us feel this burden. Orozco, who has had a long-standing
love affair with the dignity of the common man, tells us what it feels like to
leave one's loved ones and to go to the field of battle. Artists through the
ages have used art to express the values they cherished and to provide
pungent statements about the condition of man, the nation, the world.

The foregoing works provide examples of functions that art performs.
What are these functions? Works of art serve to criticize the society in
which they were made and thus present to our attention visual metaphors
through which values are conveyed. The work of art frequently presents to

our senses a set of values, either positive or negative; the work praises or condemns, but it comments on the world and makes us feel toward the object it depicts—provided we have learned to "read" its message. In short, the artist frequently functions as a social critic and a visionary. His work enables those of us with less perceptivity to learn to see what was unseen, and having seen through art, we are the better for it.

Works of art also take us into the world of phantasy and dream. They revive old images and take us upon the wings of the visual image to the fantastic world of the dream. Such works help us participate once again in the magical moments of mind and disclose ideas and feelings hidden in its crevices.

The visual arts function not only in these ways, they also call to our attention the seemingly trivial aspects of our experience, thus enabling us to find new value in them. The artist's eye finds delight and significance in the suggestive subtlety of the reminiscences and places of our existence. The work of art displays these insights, makes them vivid, and reawakens our awareness to what we have learned not to see. Thus, art is the archenemy of the humdrum, the mundane.[14] It serves to help us rediscover meaning in the world of vision, it provides for the development of the life of sensibility, it serves as an image of what life might be.

Art also provides the bonds that strengthen ritual. It breeds affiliation through its power to move the emotions and to generate cohesiveness among men. It discloses the ineffable and enlarges our consciousness. Art's functions, in short, are manyfold. If it is a task of education to perform such functions, then the place of art in such a task can hardly be denied.

Why then, if art can serve such diversified functions should its place in American education be so tenuous? The next chapter will provide a description of the status of art in American schools and will trace some of the major intellectual currents regarding its aims and methods as it has evolved over the past hundred years.

2

art education today: its character, status, and goals

The previous chapter described two major frames of reference that can be used to justify programs of art education in American schools. In that chapter contextualist and essentialist positions were described, and aesthetic theories and works of art were used to demonstrate some of the functions art performs in human experience. Given the fact that, in one sense, the arts are considered important (our society builds special buildings to house and display them), it is puzzling to ponder why their place in American schools is so tenuous. The most comprehensive survey of the visual arts in American schools indicates that only one out of seven students—about 15 per cent of all high school students—study art for as little as a year.[1] In addition, slightly less than half the American high schools offer art in the curriculum.

At the elementary school level, competence in the teaching of art is required by less than half the school systems; less than half have a curriculum guide or systematic program for instruction in art. The survey also indicated that art specialists are available in only 10 per cent of the elementary schools.

Why is this the case? Why should a society that builds museums to house and display works of art not honor them in the classroom? Why do we compliment someone when we say he did something artfully or that he is an artist at some particular task and yet assign the arts only a peripheral place in the schools? I have an hypothesis I would like to share.

Covert Functions of Schooling

I believe that a large percentage of American parents tend to view the schools and their programs as agents contributing to their children's social and economic mobility. This is to say that education is frequently conceived as a process concerned primarily with helping children enter into higher levels of schooling and, hence, to be better able to earn a living. Now there is nothing wrong with learning how to earn a living but this process is not synonymous with being educated. Schooling may or may not be educational. Many things that occur in school are antithetical to the educational process. If my hypothesis is valid, if parents do place high priority upon the vocational and social uses of schooling, it is understandable that school studies that do not in their perception contribute directly to the attainment of such goals should not be highly valued.

Are there any data to support such an hypothesis? Why do I hold such a belief? The data sources for this belief are diverse. First, let's look at what some social critics and students of American education have to say about

the character of schools. Edgar Z. Friedenberg, a sociologist whose major interest is in the analysis of educational socialization, says that,

In a mass society, a principal function of the media of communication, and especially of the schools, is to forestall the development of real taste, to root out and wither both real elegance and real vulgarity and replace them with the banal, the generalized other. In discussing this process, critics of education—including myself —have generally spoken of it as imposing a middle-class way of life on public school students, whatever their own class-origin might be. This is true, insofar as what the school imposes is the pattern of life and values accepted by its own staff who are mostly lower middle class, and which is generally in practice throughout the country.[2]

Friedenberg is not alone. Paul Goodman, another student of American culture, writes,

This is a fundamental issue. Intellectually, humanly, and politically, our present universal high-schooling and vastly increasing college-going are a disaster. I will go over the crude facts still again! A youngster is compelled for twelve continuous years—if middle class, for sixteen years—to work on assigned lessons, during a lively period of life when one hopes he might invent enterprises of his own. Because of the school work, he cannot follow his nose in reading and browsing in the library, or concentrate on a hobby that fires him, or get a job, or carry on a responsible love-affair, or travel, or become involved in political action. The school system as a whole, with its increasingly set curriculum, stricter grading, incredible amounts of testing, is already a vast machine to shape acceptable responses. Programmed instruction closes the windows a little tighter and it rigidifies the present departmentalization and dogma. But worst of all, it tends to nullify the one lively virtue that any school does have, that it is a community of youth and of youth and adults.[3]

Newmann and Oliver reemphasize Goodman's appraisal and write,

Education, having developed into a concept of formal compulsory instruction publicly sponsored, could conceivably have taken many forms. Public schools might have become coordinating agencies which channeled the students into a variety of educational experiences provided by existing political, economic, cultural, and religious institutions. Schools might have become supplementary agencies, like libraries, appended to small neighborhood communities. In the long run, however, education adopted the prevailing institutional structure in the society at large; the factory served by an industrial development laboratory and managed according to production-line and bureaucratic principles. Architecturally, the schools came to resemble factories (instruction carried on first in rooms but more recently in large loft-like spaces, with different spaces reserved for different types of instruction) and office buildings (with corridors designed to handle traffic between compartments of uniform size). Conceivably, schools could have been built like private homes, cathedrals, artists' studios, or country villas.[4]

One could go on at length to provide similar opinions about the character of schooling in America. These are the views of sensitive and informed observers and social scientists. My own research provides support for what they have to say.[5] For example, in 1968 I conducted a study of the role and status of the arts in a school district that had for about a year been offering a federally-funded Title III program in the arts to the children in the elementary school district. My task was to evaluate the effects of the program and to determine whether the program for which the federal government was providing more than $100,000 per year was having any impact. To assess the attitudes of teachers and parents an instrument was constructed which asked these groups to respond to 24 questions dealing with five subject areas—mathematics, foreign languages, social studies, art, and music. For example, we would ask, "Some subject areas make a greater contribution to the good life than others. Please rate the following subject areas from 1 to 5 on the extent to which each contributes to the 'good life.'

Science _____, Art _____, Foreign Languages _____, Social Studies _____, Music _____.

"Children usually show more interest and enthusiasm for some subject areas than others. Please rate the following from 1 to 5 on the extent to which your child (or student in the case of teachers) shows interest and enthusiasm for them:

Social Studies _____, Music _____, Science _____, Foreign Languages _____, Art _____.

"If more school time could be spent on one subject area, which area should it be? Rate the subject areas from 1 to 5.

Science _____, Art _____, Social Studies _____, Foreign Languages _____, Music _____."

From this study several interesting findings emerged that are consonant with the hypotheses I advanced earlier. First, we found that the ratings of the various subject areas by teachers and parents were almost identical. Parents and teachers both rated science and the social studies highest, art and music third and fourth respectively, and foreign languages fifth. This was not surprising—we had expected general agreement between middle-class parents and teachers who themselves are middle class. The surprising aspect emerged when we examined responses to particular items.

When it came to questions dealing with the contributions of various subject areas to the good life, to questions dealing with children's enjoyment of various fields, to questions dealing with the avocational values of certain areas of study, art and music were consistently rated first or second. Science, social studies, and foreign languages were rated third, fourth, and fifth. Both parents and teachers appear to recognize the contribution that the arts make to a gratifying and personally meaningful life. Yet, when it came to questions such as "more instructional time should be devoted to some subject areas in school than to others. Please rate the following on the degree to which more attention should be devoted to them in school," science and social studies were rated highest, whereas art, music, and foreign languages were rated lowest.

What we have here, it seems, is a recognition on the part of both parents and teachers that the arts contribute to good living, enjoyment, and personal satisfaction, yet both groups still believe that in school more attention should be devoted to the "bread and butter" subjects than to others. This is, in some ways, a curious contradiction. We frequently say that education should help people learn how to live and not merely train them to earn a living. We often talk about the need for educational programs to cultivate those powers that help one lead the good life. Yet schooling, it seems in the eyes of at least one population of parents and teachers, appears to be thought of in somewhat different terms—even when they believe that the arts do contribute more to good living than other subject areas.

The conclusions from this study are supported by data from other studies. Lawrence Downey, for example, conducted a study of the task of American education in which he interviewed thousands of individuals and asked them to rate 16 subject areas in relation to their importance in elementary school programs.[6] The following 16 areas were listed:

A. Intellectual Dimensions
 1. Possession of Knowledge: A fund of information.
 2. Communication of Knowledge: Skill to acquire and transmit.
 3. Creation of Knowledge: Discrimination and imagination, a habit.
 4. Desire for Knowledge: A love for learning.
B. Social Dimensions
 5. Man to Man: Cooperation in day-to-day relations.
 6. Man to State: Civic rights and duties.
 7. Man to Country: Loyalty to one's own country.
 8. Man to World: Inter-relationships of peoples.

C. Personal Dimensions
 9. Physical: Bodily health and development.
 10. Emotional: Mental health and stability.
 11. Ethical: Moral integrity.
 12. Aesthetic: Cultural and leisure pursuits.
D. Productive Dimensions
 13. Vocation-Selective: Information and guidance.
 14. Vocation-Preparative: Training and placement.
 15. Home and Family: Housekeeping, do-it-yourself, family.
 16. Consumer: Personal buying, selling, and investment.

Then, people were asked to rate subject areas in relation to their importance in schooling. When his data were analyzed, Downey found that aesthetic education was, on the average, rated fourteenth by lay people and twelfth by educators. Although he found that the rank assigned to aesthetic education was related to the level of schooling people had attained —the higher the level of schooling the higher was aesthetic education rated—in no case did it break into the top half of the rank ordering.

In addition to the data coming from these studies there are other indicators of the status of the arts in American education. An example of these is the amount of support the arts have received from the federal government, compared to the support the Government has provided to other fields. It is estimated that over the past ten years the U. S. Office of Education and the National Science Foundation have allocated more than $100 million to support programs of curriculum development and teacher education in the sciences and in mathematics. In 1963–64, for example, the National Science Foundation provided 31,000 awards for work in the sciences. The NSF offered 39 summer institutes for elementary school science teachers and 420 institutes for secondary teachers. The dollar amount allocated to the arts and the number of summer institutes provided constitute only a very small fraction of what has been allocated to other areas of the curriculum.

One might wonder why I have attempted to describe this state of affairs in American schools. Why describe the academic values of the public or the support made available for art? The reason is simply this: schools are social institutions, and as social institutions, they tend to reflect the values of those who support them. Those of us concerned with enabling schools to provide programs that cultivate and develop the sensibilities, need to understand how our work has been and will be affected. Those preparing to teach should understand where we are today in the public schools, what

is emphasized, why, and where we might be headed. The fact that to the best of our knowledge only one out of seven students studies any visual art in high school indicates that at present the bulk of art teaching takes place at the elementary and junior high school levels. It is at these levels, and especially in the elementary school, that programs need development and to be made significant to children. It is at the elementary school level that the child begins the processes of educational socialization, a process that teaches him what is valued in school and what is rewarded, and that provides him with a set of norms and role expectations to carry him through school.[7] This process teaches him about the questions that are permissible to ask, the degree to which he is permitted to talk in the classroom, the rules he has to follow in conducting himself in the school at large. Children learn, for example, that they are not to talk without raising their hand. They learn that if they are to use the washroom they must first ask permission. They learn to sit in their seats for considerably longer periods of time than does the teacher, who developmentally needs less opportunity for movement. In short, they learn how to play the school game.

But children not only learn to cope with these aspects of the school's culture, they also learn to read the value code that is implicit in the decisions that teachers make about the curriculum. Children learn which subject areas are emphasized in school by noting the amount of time that each is allocated. They learn of the importance of certain areas in the school curriculum by the way in which teachers speak of them. If the teacher comments, "When you finish your work you can do art," children learn that art is a less important task than "work." If the teacher does not concern herself with helping children learn what is important in the arts, there is little reason for children to believe that the arts have something worth learning.

Thus, children learn to read the environment, whether at home, or at school, or in the neighborhood in which they live. They read the environment because they must. It is a survival skill. By the time the child reaches the end of the first grade he has begun to understand the culture of the school; educational socialization has begun to take place. Because the teaching of art is a part of that culture and because children are socialized in school to the place of various fields within a status hierarchy, those of us interested in understanding the factors that affect artistic learning need to understand the factors in the school context at large that bear upon our tasks. I am arguing that if art education is to increase its effectiveness, art educators—and this includes all of those who teach art—cannot afford to

neglect the general culture of the school because it is one of the most powerful aspects of schooling itself.[8]

Attention to the general culture of the school has not been a characteristic concern of art educators. Nor has it been a characteristic concern of specialists working in other fields such as social studies, science, or mathematics. Unfortunately, specialized groups whether they be in one field or another tend to define their interests in specialized ways. They too often see educational problems too narrowly and consequently fail to recognize the variety of factors which operate in the school that affect their ability to attain the goals they value. An example of this will make such influence apparent.

In recent years educators working in the field of social-studies education have been concerned with the development of the student's inquiry skills, with increasing his ability to ask penetrating questions, and with getting relevant data for answering those questions. In addition, they have been interested in developing a spirit of intellectual autonomy in students so that they will increasingly become responsible for their own education and less dependent upon direction and approval from teachers. Now these are, to my mind, worthwhile educational goals. Children should be helped to become increasingly independent of the school so that they can continue to develop their intellect and sensibilities after they leave it. Yet, the same school that employs inquiry-oriented programs in the social studies will require that students have a hall pass to go to the washroom and will require that they show that pass to student hall guards en route. Not to recognize the contradiction between what is being attempted in the classroom and what is being required of students in the halls is to court catastrophe.[9] We cannot afford to neglect the entire network of demands that schools place upon children. Single-minded attention to our own field is inadequate when the ecology of the school affects the likelihood that we will achieve the goals we value. In short, those of us concerned with art education must apply a principle that artists have always known: In a work of art everything counts. And in a school everything counts. We cannot afford the false luxury of tending to our own backyard.

Characteristics of Current Art Programs

When one looks at programs in art education that are offered in American schools, one is struck by some pervasive similarities. One of the most striking of these is the emphasis placed on providing students with a wide variety of materials with which to work. Elementary school teachers, es-

pecially those working with children at the primary level, frequently attempt to expose children to a wide variety of diversified material, so that the child's sensibilities and creativity will be cultivated. This often takes the form of having children work with, say, clay one week, tempera paint the next, printing the following week, papier mâché the next, and so on. Teachers frequently work on the assumption that the more material the better and often tend to equate a rich art program with one that provides the widest array of art material. Manuel Barkan, describing this belief in relation to art teachers, puts the situation well when he says:

> Any careful reading of the current literature in art education, both in books and in periodicals, would lead to the inescapable conclusion that virtually all art educators believe in using a variety of art media. Indeed, I don't think that I am overstating the case by saying that a great many art teachers judge the effectiveness of their teaching in terms of the number of different media they include. The more media they provide, the better they think they are teaching; the more varieties of media their children experience, the better they assume the learning to be. Talk to a great many art teachers, and by all means, talk to most undergraduate students who are preparing to become art teachers; and ask them to tell you something about a good art education program. Almost all will place experience with a wide variety of media uppermost on their list of values. Most of them are on a perpetual hunt not only for more media but also for new ones.[10]

The consequences of this practice are felt by the children who at first might be stimulated by the variety of material in such an approach, but who seldom develop the type of mastery that will enable them to use the materials aesthetically. Complex abilities, such as the production of art forms or the mastery of material, require the use of complex skills and complex skills take time to develop. By moving quickly from one project with one set of materials to another project with another set of materials, the rate at which students must learn is increased considerably, and because such rates are generally unrealistic, children do not gain the type of competencies that breed confidence in their own work. It is true that—in the short run—they might prefer such variety, for variety is generally stimulating. But after a while they begin to recognize the lack of competence they have and tend to turn away from art as a mode of perception and expression. Few of us like to participate in fields in which we feel inadequate.

A second characteristic of many art programs, in addition to their attention to a wide variety of material exploration and their general lack of sequence, is their diffuseness regarding the goals they seek to achieve. Unfortunately, too little attention in teacher education is devoted to an examination of the types of goals toward which education in and through

art might strive to achieve. Too often, the type of statements that are made about the objectives of programs in the arts are so broad and abstract that no one really knows what they signify. General, global statements about meeting needs, self-expression, and creativity are all too frequently slogans that are used to cover up muddle-headed thought about the very real functions the arts can perform in the educational process.

A third characteristic of art programs at the elementary level is the fact that only a small minority of classes are taught art by someone who has specialized in this field. This is not necessarily a vice. There are many arguments that could be made about the virtues of having a non-specialist teach this area in school. One could argue, for example, that a teacher who sees the child in a variety of fields obtains a more comprehensive picture of his abilities as a whole person and thus is in a better position to work with the child in art—or in other areas of the curriculum for that matter. Such an arrangement can be a virtue. Too often, however, the background and skill the teacher needs to be able to use the arts educationally is not available. The course or two he might have taken in art or art education at the college level is often inadequate, and the last formal work in art prior to college that the prospective teacher might have had was probably five to nine years earlier when he was a junior high school student. Thus, the teacher working in the self-contained classroom has the complicated task of coping with seven or more subject areas and trying to handle each of them well.

The result of this situation is that teachers who are not specialists are frequently in a quandary about what to teach in art and how to make educational capital out of the activities that they do introduce into the classroom. The problem of selecting content is often resolved in one of two ways. The first is an ad hoc approach in which teachers hunt for something new and "interesting" to introduce into the classroom. *New* materials, *new* techniques, *new* projects—these are seen as appropriate ingredients of an art program. As Barkan has indicated, the hunt for the new seems to be, for some teachers, a perpetual part of their task in the teaching of art.

A second way of resolving their difficulties in planning a curriculum in art is to rely upon the calendar. Although I say it with tongue in cheek, calendar-centered art programs are more common than most of us who value the arts would like to believe. The calendar-centered approach is one in which the art curriculum centers around the events of the calendar: on Thanksgiving the children make turkeys, during Christmas they make Christmas decorations and snowmen, and Valentine's Day brings you-know-what.

Now it is possible to build a first-rate educational program in the arts around the holidays. This can be done if one has a clear understanding how these events can be used to stimulate and focus activities that will develop the aesthetic sensibilities of children. Too often, however, the calendar is used simply as a vehicle to help teachers get through the school year.

A fourth characteristic of art programs at both the elementary and secondary level is their tendency to place almost exclusive curricular emphasis on the making of art. The vast majority of programs that are offered both children and teachers are aimed at helping them learn to create art forms, with making paintings, sculptures, and so forth. Now there is no good reason why the making of art forms should not be an exceedingly important part of every art program. Having children immerse themselves in the task of giving visible aesthetic form to their inner visions is clearly one of the goals that a large percentage of art educators would wholeheartedly endorse. But there is also no reason why the production of art forms must necessarily command exclusive attention in the art curriculum. Making art is important, to be sure, but there are other aspects of art education that are also important. Learning to see visual form, learning to understand how art functions in contemporary culture and how it has functioned in the cultures of the past are also important. To a very large degree, the historical and cultural aspects of the art curriculum have been neglected in schools. This has been due to a wide variety of reasons, but at least one of these reasons is that it has been assumed that if children were helped to make art projects they would, as a consequence of such activity, develop critical skills. By critical skills is meant the ability to see visual form, especially those forms we call works of art, on the plane of aesthetic meaning. It refers to an individual's ability to *aesthetically* encounter and experience visual form.

The assumption that making art projects will automatically yield high level critical abilities is questionable—given the quality of art instruction that is generally available. Learning to see visual forms aesthetically is not a simple task. It is one that demands the appropriate frame of reference and the use of complex perceptual skills. Attention to the use of such skills and to the utilization of aesthetic frames of reference surely deserves an important place in art programs. As for the historical or cultural aspect of the art curriculum, this aspect simply has not been considered of great importance. Why? The answer to that question will have to wait until we examine some of the beliefs that have guided the field of art education during the course of its historical development.

A fifth characteristic of art programs in American schools is the paucity of instructional resources that are used. If one goes into elementary school classrooms, for example, and examines the materials that are available, one might find paper, paint, crayons, paste, scissors, clay, and other forms of materials for art production. Indeed, when one thinks of material for art instruction one usually thinks of art supplies. This conception of instructional resources in art has become so pervasive that it is difficult to think of alternative types of resources. Yet if a science teacher wishes to illustrate, for example, how heat causes metal to expand, she has a device that is especially designed for this purpose.[11] If she wishes to illustrate Newton's second law of thermodynamics, she has a device that will illustrate that theoretical generalization. Art teachers could have similar instructional resources. For example, if one wants to demonstrate that "color is affected by the colors that surround it" or that "line can convey or elicit feeling," there are visual devices that can be created to illustrate such visual ideas. Teachers need and can have instructional resources to illustrate in visual terms the visual ideas they are interested in helping children learn to see and understand. Ironically, science, mathematics, and the social studies have a wider array of visual instructional resources to use in the classroom than do teachers working in the visual arts.

Why is there such a paucity of diversified instructional material in the teaching of art? Why have the historical and cultural aspects of art been generally neglected in the schools? Why are the arts given a relatively minor place in schools' programs? To answer these questions we need to know something about the way in which the teaching of art has evolved in American schools. In short, we must look at some of the dominant themes that historically have animated art education in American schools.

3

the roots of art in schools: an historical view from a contemporary perspective

The introduction of the teaching of art in the schools of America was one that was neither routinized nor systematic. This is not surprising: the formal organization of educational programs in American schools is a relatively recent phenomenon, developed in large measure out of the need to serve an increasingly large proportion of the school age population. Even as late as 1900 less than 5 per cent of the high school age population was attending such schools.[1] Prior to the turn of the last century, two features characterized American education: first, only a small percentage of the children of school age were being served by schools, and second, the most advanced programs were those located in schools in the Eastern-seaboard states.

Art and the Educational Pioneers

One of the first to provide for instruction in art was Benjamin Franklin, who in 1749 advocated its inclusion in the curriculum. To Franklin, as well as to other pioneers in American education, the arts had a utilitarian or materialistic value. Art instruction was not, in his view, to be used to teach children how to "paint the pretty picture," but rather to help to meet the needs of a growing nation. In 1749 he wrote concerning the education of youth,

As to their studies, it would be well if they could be taught everything that is useful, and everything that is ornamental. But art is long, and their time is short. It is, therefore, proposed that they learn those things that are likely to be most useful and most ornamental; regard being had to the several professions.[2]

To underscore the importance of meeting the nation's practical needs he wrote:

All things have their season, and with young countries as with young men, you must curb their fancy to strengthen their judgment . . . To America, one schoolmaster is worth a dozen poets, and the invention of a machine or the improvement of an implement is of more importance than a masterpiece of Raphael. . . .[3]

Franklin made no bones about it. The country, young and demanding, had needs that took priority over the simply ornamental. Art, in his view, was to be used as a tool for improving the skills of the professional and the quality of the crafts necessary for life.

The literature on education prior to 1830 does not provide a very vivid picture of the extent to which the arts were used in the schools that had

29

been established. However, it seems reasonable to assume that the practical and utilitarian conception of art was one that was characteristic of the period from 1642 to 1860. Indeed, the earliest laws passed on educational matters in this country viewed schooling itself in an instrumental light. The earliest of these laws established in 1642 and 1647 by the settlers of the Massachusetts Bay Colonies attempted to insure that children would be taught to read in order to understand the Scriptures and hence obtain salvation. The "Old Deluder Satan Act" proclaims,

It being one chief object of that old deluder, Satan, to keep men from the knowledge of the Scriptures, as in former times by keeping them in an unknown tongue, so in these latter times by persuading from the use of tongues, that so at least the true sense and meaning of the original might be clouded by false glosses of saint-seeming deceivers, that learning may not be buried in the grave of our fathers in the Church and Commonwealth, the Lord assisting our endeavors,

It is therefore ordered, That every township in this jurisdiction, after the Lord hath increased them to the number of fifty householders, shall then forthwith appoint one within their town to teach all such children as shall resort to him to write and read, whose wages shall be paid either by the parents or masters of such children, or by the inhabitants in general, by way of supply, as the major part of those that order the prudentials of the town shall appoint: Provided, Those that send their children be not oppressed by paying much more than they can have them taught for in other towns; and

It is further ordered, That where any town shall increase to the number of one hundred families or householders, they shall set up a grammar school, the master thereof being able to instruct youth so far as they may be fitted for the university: Provided, That if any town neglect the performance hereof above one year, that every such town shall pay five pounds to the next school till they shall perform this order.[4]

What we see here is a conception of the primary mission of the school, a mission that is practical and of the utmost importance to the salvation of the Puritan soul.

The Puritan orientation to life had still another effect on the teaching of the arts. When the arts were taught in schools they were not to be approached as "fine arts," that is, as activities unrelated to the practical needs of life but were, on the contrary, to meet the practical needs that people confronted in their daily tasks. Thus, the development of craft skills for making quilts, rugs, furniture, and other useful items became the major items of artistic attention during the period before and after the founding of this nation. The result of this orientation to art simply reinforced the breach that had already begun in the Renaissance: the distinc-

tion between the fine and the useful arts. Harry B. Green, writing of this distinction, says,

Such a bias resulted logically, however, from the development in America of an unhealthy split between the arts of expression and the arts of utility, a split rooted in the Renaissance—bequeathed disjunction between "fine" arts and "useful" arts. By denying to any applied, industrial, or utilitarian art any aesthetic importance, this dichotomy engendered in America a false attitude toward the so-called "fine arts" which differed from its European counterpart more in degree than in kind. The attitude thus created conceived of art as an activity removed from the main, serious business of life, as the product of only a gifted few, and as the prerogative of a wealthy leisure class.[5]

It is, I suppose, not unreasonable to expect that a nation that is expanding its frontiers, establishing trade, building new towns and cities should place highest priority upon those tasks and skills that contribute to the resolution of practical problems. When one is fighting for survival it is not likely that there will be time "for things ornamental." Even when viewed as instrumental skills useful in the larger society the arts, through the third decade of the nineteenth century, were assigned a marginal position in the schools.

The development of more systematic approaches to art teaching was to come with the work of William Bently Fowle, of Boston, and William Minifie, of Philadelphia.

William Bently Fowle, who was born in Boston on October 17, 1795, had a distinguished career in the field of general education in addition to the important contributions he made to American art education during the nineteenth century. As publisher of the *Common Schools Journal,* perhaps the most influential educational journal during its period of publication from 1842 to 1852, he provided enormous leadership in the field of education. Fowle not only introduced drawing into the school which he directed, he was one of the first to introduce the monitorial system into the schools of Boston. This system, developed independently by Joseph Lancaster and Andrew Bell, both of England, was one in which a teacher taught a group of student monitors, who in turn taught groups of fellow students the lessons that were to be learned.[6] Under this method it was believed that education could proceed with the utmost efficiency and effectiveness. Fowle advocated the use of monitorial methods in Boston schools and utilized a host of new inventions in his female monitorial school. Among these inventions were the use of maps to illustrate geographic terrain; the use of blackboards, which teachers could use for learning lessons in

**From the *Common Schools Journal*, Vol. VII
(Boston, December 15, 1845).**

drawing, grammar, and composition; the introduction of linear drawing in relation to geometrical exercises; and instruction in printing. In addition to these educational advances, Fowle eliminated corporal punishment from the school under his direction.

Fowle was an educator of vision, one who had a sense for the educational potential of new materials and new modes of instruction. And while, in the long run, the monitorial system that he introduced did not last, it did introduce an experimental spirit into the practice of education.

Fowle's influence as an educator concerned with the visual arts (which for all practical purposes were confined to drawing) did not terminate with the boundaries of the city of Boston or the state of Massachusetts. Fowle was not only a publisher, he was also an author who wrote more than fifty books on almost every branch of elementary education. He translated Benjamin Francoer's text on drawing that within three years after its publication in 1827 underwent three editions.[7]

Facilitating the introduction of drawing as a permissible subject into the Boston English High School in 1827 was not an unimpressive accomplishment, given the tendency of both the public and schoolmen to view art as more ornamental than useful. While this conception was not wholly rejected by Fowle, he was able to show how drawing could be taught in a

systematic way for ends that did not nurture the antagonisms or doubts of the pragmatic public of the first half of nineteenth-century Boston.

William Minifie was another who made important contributions to the teaching of art during the fourth and fifth decade of the nineteenth century. An architect whom the public commissioners of Baltimore hired to teach drawing in the Boys High School, Minifie was of the opinion that drawing can and should be taught as a science and not as picture making. To do this required systematic modes of instruction developed through exercises that were sequentially organized. To provide these methods, in 1849 Minifie published a textbook on geometrical drawing that was a standard resource in this field for many years. In addition to the systematic "scientific" approach he took to the teaching of drawing, Minifie also advocated, like Fowle, the belief that drawing should be useful, not merely ornamental. Thus, the uses to which drawing should be put, according to Minifie, were industrial. His vision was to use the skills of drawing to aid in the production and design of manufactured goods, a theme to be replayed twenty years later when Walter Smith came on the scene. And like Fowle, Minifie believed that everyone who could learn to write could learn to draw and that the learning of drawing would not only contribute to improved writing skills, it would also improve consumer taste and hence indirectly contribute to the prosperity of industry.

The means and ends of the teaching of art that was advocated by Franklin, Fowle, Minifie, and others such as Rembrandt Peale and William Bartholomew had a number of constant themes. First, and perhaps foremost, art (conceived primarily as drawing) was to be used to meet the practical needs of life. It was not—except in some girls' schools for the upper classes—to be used as a cultural nicety or for learning how to paint a pretty picture. For pragmatic America art was to have practical consequences, and it was the task of those advocating the introduction of art into the schools to demonstrate the uses to which it could be put.

A second theme that emerged during the first half of the nineteenth century was the belief that art can be used as a vehicle for increasing the skills of writing. After all, drawing, like writing, had an alphabet and a form, and the skills acquired in the former would, it was believed, contribute to the performance of the latter. Drawing was frequently considered as a means of developing coordination of the hand and eye, and thus, contributed to those skills that depended on such coordination.

A third theme began to emerge during the 1850's. It dealt with the industrial uses of art. This theme, already being played in Europe, saw art as a tool for increasing the visual quality of manufactured goods during

a period in which industrial America was beginning to grow. Minifie him-self had pointed out that in 1852 Americans had imported $36 million worth of textiles from Great Britain alone and $11 million worth from France. It was clear that if American industry was to compete with the nations of Europe designers and craftsmen would need to be trained. This was therefore considered one of the tasks of the school. The pressure for more salable goods and for the men capable of producing them was one of the factors that led to art becoming a required subject in the Bos-ton public schools in 1864. Indeed, in 1874 a U. S. Bureau of Education bulletin stated:

In addition to the increased competition arising from steam-carriage, new and cheaper methods of manufacture, and increased productiveness, another element of value has rapidly pervaded all manufacturers, an element in which the United States has been and is woefully deficient—the art element. The element of beauty is found to have pecuniary as well as aesthetic value. The training of the hand and of the eye which is given by drawing is found to be of the greatest advantage to the worker in many occupations and is rapidly becoming indispensable. This training is of value to all the children and offers to girls as well as boys opportunity for useful and remunerative occupations, for drawing in the public schools is not to be taught as a mere "accomplishment." The end sought is not to enable the scholar to draw a pretty picture, but to so train the hand and eye that he may be better fitted to become a bread-winner.[8]

Thus, we see during the early years in the nation the arts being used for practical or, as some might say, materialistic ends. The concept of art as a means of developing the imaginative powers of children, as a tool for developing the ability to perceive aesthetic quality, as a method for the facilitation of cultural understanding were not as yet on the drawing board. As we shall see, the industrial uses of art were to increase before they were to diminish as the practical justification for including art instruction in the curriculum of the common school.

Another of those who provided leadership in the teaching of drawing in American public schools was Horace Mann, first editor of the *Common Schools Journal* and first secretary of the Massachusetts State Board of Education. As secretary of the Massachusetts Board of Education, Mann decided to "fulfill" not only that provision of the law which required that

European Influences on the Teaching of Art

**From the *Common Schools Journal,* Vol. VII
(Boston, December 15, 1845).**

"the Secretary shall collect information, diffuse as widely as possible throughout every part of the commonwealth, information of the most approved and successful methods of arranging the studies and conducting the education of the young." He also applied for permission to travel at his own expense to visit European schools to assess their programs of instruction and to bring back to Massachusetts those that were most promising.

Among the schools with which he was impressed were those in Prussia, where children were taught not only to print well but to draw with much

facility. Mann believed that "a child will learn to draw and write sooner and with more sense than he will learn writing alone." But Mann not only believed drawing was useful for learning to write—a belief he shared with Fowle—he also believed that drawing was a beautiful and expressive language—a vehicle for communication. And that "there is no department of business or condition of life where the accomplishment (drawing) would not be of utility." [9]

These observations by the Secretary of the Board of Education of the most advanced state in the field of education were of no small import. As a leader in education his observations carried weight, and as editor of the *Common Schools Journal* he was in a position to make his ideas known. One of the ways in which he supported art in the schools was to publish the drawing lessons of a Prussian art teacher with whom he was particularly impressed, Peter Schmidt.

On August 15, 1843, Mann published a letter he received praising the methods Schmidt used in Prussia. The unidentified writer says, "The chief objections to the introduction of Drawing into the Common Schools are the want of instruction and want of problems; but both these objections would be done away, could Peter Schmidt's 'Guide to Drawing' be widely diffused in this Commonwealth." [10]

The diffusion that the writer speaks of was soon to follow when Mann published the Schmidt's drawing lessons. In Volumes 6 and 7 of the *Common Schools Journal* the lessons that Schmidt had developed in Germany were meticulously printed, with line engravings and the use of special paper for the illustrations that appeared. Of these lessons Mann wrote,

Those exercises, if introduced into our schools, will rescue children from disgust at the school; from aversion to the teacher, where otherwise that most unfortunate relation might arise; from habits of mischief; from the depraving effects of disobedience; and from an apprenticeship to dullness. In addition to all this, it will confer upon every child the rudiments of a most valuable art—a source of both pleasure and profit in later life. [11]

What we have in the views of Mann is a conception of the uses of art that has both a utilitarian and consummatory quality. We see a man who wanted to make American schooling humane and moral and yet who viewed art as a practical affair having broad beneficent consequences for both child and teacher. Through the use of prescribed drawing lessons the child would be able to achieve the benefits of both pleasure and productivity.

Walter Smith and the Industrial Uses of Art

While there is little doubt that men like Franklin, Minifie, Fowle, Peale, and Mann all helped to widen the scope of American public education, to expand its curriculum, to introduce innovation, and to support the importance of drawing, it was Walter Smith, an English art teacher, who provided the greatest impetus to the teaching of art in the Eastern seaboard states during the last thirty years of nineteenth-century America.

Smith was invited to Boston in 1871 from his position as art master in the South Kensington Art School at Leeds, England, to consider the opportunity to direct art education for the city of Boston and to serve as State Supervisor of Drawing. The Boston industrialists were beginning to feel the competition coming from England and France in the sale of manufactured goods. These countries provided for the training of artisans and craftsmen, and being sensitive to the potential loss of profit, the industrialists urged the State Legislature to provide free drawing instruction for all men, women, and children in all towns of more than 5,000 inhabitants. This was in 1869. By 1870 Massachusetts passed the first law making drawing a required subject in the schools of the state. By 1871 the Committee on Drawing, believing that drawing skills could be most effectively developed on a widespread basis, invited Smith to provide leadership to this program.

For Walter Smith the art of drawing and the art of writing had certain parallels—a theme already articulated by Franklin, Fowle, and Mann. As writing has its alphabet and grammar, so too does drawing have an alphabet—the straight line and the curved—and its form. As Smith saw it, the problem in the teaching of drawing was not one of providing special teachers but of preparing lessons that were so clear and precise that teachers—even those without training in art—could teach the student by using a series of graduated exercises.[12]

In many ways the lessons that Smith prepared are similar to the sequenced frames in programmed instruction. The initial lessons were aimed at the development of very simple skills such as locating the center of the paper or of connecting two points with a straight line. As the student proceeded, the skills became increasingly complex and finally enabled him to draw in perspective from nature. There appeared to be little doubt in Smith's mind that art could be taught. The problem was seen essentially as one of enabling teachers to use with scrupulous care the lessons that he had prepared. By using these lessons the necessary skills would develop, and the contribution of drawing to breadwinning would be made.

Walter Smith's work in the field of art education provided a systematic

THE

DRAWING BOOK

OF STANDARD REPRODUCTIONS AND ORIGINAL DESIGNS

FOR

PUBLIC SCHOOLS, DRAWING CLASSES, AND SCHOOLS OF ART IN AMERICA

Edited and Designed

BY

WALTER SMITH

STATE DIRECTOR OF ART EDUCATION, MASSACHUSETTS

" Having learned how to do a thing, we continue and extend our learning by persevering in doing it "

DRAWING IN PUBLIC SCHOOLS

BY THE USE OF

THE SMITH BOOKS

CONDEMNED.

The Inaccuracy of the Examples in these Books, the Lack of Systematic
Arrangement, the Exhibition of Inartistic Taste in the Grouping
of Examples and in the General Arrangement of the
Books, the Looseness in Forms of Expres-
sion, and Errors in Definition,
clearly shown.

THE MERITS

OF

THE BARTHOLOMEW BOOKS

PRESENTED.

————— ◆ —————

NEW YORK AND CHICAGO:
WOOLWORTH, AINSWORTH, & CO.
1874.

and rational spirit to the teaching of drawing. The Art Normal School which he directed was opened in 1873, and by the time of the Philadelphia Centennial Exposition in 1876, his reputation and the influence of his work had been well established. Despite the progress he made in the teaching of art, he was, on July 6, 1882, dismissed from his position as state director of art education and principal of the Art Normal School. Smith returned to England a year later and assumed a position as director of the art department of the newly established Art College at Bradford.[13]

The developments both social and intellectual that affect educational practice seldom proceed along a single line. At the same time that the teaching of drawing was being used for industrial purposes, a new view of the nature of man was being developed in England.

It was 1859 when Charles Darwin published the *Origin of Species,* the same year, incidentally, in which John Dewey was born. Darwin's ideas about the evolution of life, as well as the work of other European scientists, began to influence intellectual thought in this country. One source of influence was due to the fact that many of those who took American degrees in psychology went to Europe to apprentice themselves to men like Gustave Fechner and Wilhelm Wundt. Through advanced study, ideas developed in Europe and England began to cross the Atlantic.

One of those who affected art education with his conception of the nature of the child was a psychologist and the father of the Child Study Movement. G. Stanley Hall received the first doctorate in psychology from Harvard University in 1878.[14] Subsequently, he traveled to Europe to study with Helmholtz and Wundt in Germany. Upon his return he formulated the theory that the child's personal development was essentially a recapitulation of the development of the human race; hence, by studying the child one could obtain an understanding of how the race came to be what it is. This idea, in addition to his use of introspective methods for studying the mental life of the child, began to recast the pedagogue's conception of the child and the way in which teaching should occur. Perhaps the most profound conception that Hall advanced, a conception developed earlier by Rousseau and articulated by Pestalozzi and Froebel, was that of the evolutionary theory of child development and that the mind of the child was *qualitatively* different from that of an adult. Given these beliefs the responsibility of the teacher was not to be one primarily of molding the child into predetermined patterns of adult thought but rather of facilitating his natural development. If there was a genetic program built into the child at birth, and if that program set the limits of the

child's aptitudes, it was important for the teacher to study the child to determine the direction in which those aptitudes were developing and then to provide for that development through a nurturant environment.

The significance of such a view, especially as articulated by a man of position and influence (Hall was not only president of Clark University, he was also editor and founder of the important journal *Pedagogical Seminary*), should not be underestimated. How we conceive of the people with whom we work affects how we relate to them. Hall's work, his conception of the child's development, and his view of the child's mind were related to the emerging ideas of using the curriculum to meet the child's needs. Indeed, they were related to what many would say was a more humane view of the educational process.

John Dewey and the Age of the Child

The general theme that Hall orchestrated in America from the late 1880's through the turn of the century found even greater support from John Dewey, the man who more than any other provided the intellectual leadership to Progressivism in American education.

It should be emphasized that the period from 1860 to 1900 was a time of enormous vitality in both America and Europe. The work of Darwin, Spencer, Fechner, and Wundt was reaching our shores and in this country Charles Sanders Peirce in philosophy and William James in psychology were recasting both our conception of knowledge and the conditions under which it was obtained and warranted. Our conception of the child and the conditions that would educate him were being redefined by Hall and Dewey. In addition, the country was undergoing important industrial development. Railroads were reaching into the West, cities were expanding and immigration was increasing. The time was ripe for the testing of new ideas, not only in the factories and cities but in the schools as well. John Dewey was one of those who, like G. Stanley Hall, had an important effect on the teaching of art.

Dewey, perhaps the most influential American philosopher in American education, had a biological conception of man, a conception developed in large part from the work of Darwin in biology and Peirce in philosophy. For Dewey and for those who followed his lead, the child, like all men, was an organism that lived both in and through an environment. As the child encountered environmental conditions that were challenging, his equilibrium was upset and conditions were ripe for him to frame the situation

in which he found himself as problematic. These conditions were necessary in order for intelligent action to go forward and through which the problematic situation could be resolved. This meant that the teacher needed to understand the child, that he needed to know what conditions were likely to challenge him, and that he be able to arrange the environment so that an *educationally* problematic situation was likely to result.

The consequences of these views on the practices of American educators were profound. For one, they meant that the child needed to be viewed not as an object to be stuffed with information or skills but as a person with wants and needs. They meant that the teacher was to provide an environment that captured the interest of the child because interest was related to effort and to the meaningfulness of his learning. They meant that the child had to be an active agent and not a mere recipient of instruction, and that the curriculum of the school be problem centered. They meant even further that students should share responsibility with the teacher for determining the areas and problems they were to study. These and many other tenets flowed from Dewey's experimental orientation to education, tenets that were disseminated to the American public and to school men through the 34 books and more than 700 articles he published during his lifetime.

For art education the consequences of these views were also significant, not only during the first decade of the twentieth century but in those that were to follow. What were those consequences? First, Dewey's belief that the child's interests should be capitalized upon for educational purposes came to mean in the hands of some progressive educators that it was important to allow the child to do what he wanted to do in art. Second, Dewey's appreciation of the developing character of child art and of his more limited experience compared to that of an adult led to instructional practices in which it was assumed that the teacher should not intervene or provide instruction in art. Third, Dewey's desire to develop through schools the creative intelligence of children was transformed by art educators into a commitment to use art to foster the *general* creative abilities of the child. Dewey's understanding of the aesthetic aspect of experience in realms other than the formal arts led to glib slogans such as "art is everywhere" without the profound appreciation and understanding that Dewey had of the potentially aesthetic in all experience. Finally, his conception of the wholeness of experience, the fact that when a human being copes he feels as well as thinks, he learns values as well as facts, led to curriculum practices within which art was *supposedly* integrated with

From Henry T. Bailey and L. Walter
Sargent, *An Outline of Lessons in
Drawing for Rural Schools* (1896),
p. 51.

From Henry T. Bailey and L. Walter Sargent,
*An Outline of Lessons in Drawing for
Rural Schools* (1896), p. 52.

other fields of study. Thus, in many cases, "art" became a handmaiden to concept formation, a tool to be used primarily to teach ideas found in social study projects.[15]

That these ideas should find fertile ground in American education at about the turn of the century is not surprising considering the groundwork that had been laid. By the time William James had given his "talks to teachers," G. Stanley Hall's child study movement had been underway for more than a decade. By 1900 Freud, whom Hall invited to lecture at Clark University in 1909, had published his *On the Interpretation of Dreams*. In addition, Progressivism in American life generally had already made a solid start.[16] The age of the child heralded the shift from scholiocentric to pediocentric schools. Thus, what we have during this period is the birth of a new conception of child development and of the educational conditions that foster the child's growth. Whereas Walter Smith would emphasize the systematic organization of curriculum to prepare students to make vocational uses of art, those influenced by Progressive theory were more concerned with using art to provide children with opportunities for creative self-expression.

The fact that the ideas developed by Dewey and by his disciples were published in popular journals as well as in professional education periodicals should not be taken to mean that everywhere art was taught according to the principles that Dewey expounded. On the contrary, the use of his conceptions was a difficult task. One needed great pedagogical virtuosity as a teacher to employ them effectively in the teaching of art or in other fields. Indeed, when one looks at the publications that teachers did read in the early 1900's one is struck by the dichotomy between Progressive education theory and the prescriptions for practice that were provided in journals such as *The Applied Arts Book, The Voice of the Applied Arts Guild of Worcester, Massachusetts* (this journal later became *Schools Arts* magazine). The prefatory remarks in the frontispiece of the journal state, "The Applied Arts Guild aims to promote by every legitimate means the progress of Sound Art Instruction and the development of Public Taste in all matters relating to Applied Arts. It stands for beauty in American life." [17] To achieve taste and beauty the journal recommended the drawing of all flowers, "especially the dandelion and the aster," [18] from life and made recommendations for instruction for the Primary, Intermediate and Grammar grades. These lessons were organized sequentially through subsequent editions and governed by the principles of harmony, variety, rhythm, and balance. These principles were conceived of as the laws of design. The task of the art instructor was to

teach these laws to children and thus enable them to apply the laws to the creation of designs. The prescriptions that are found in the first volumes of *The Applied Arts Book* did not, in the main, reflect the ideas of the Progressives regarding the child's participation in the selection of learning activities; these lessons nevertheless were closer to children's interests than the prescriptions laid out by Walter Smith thirty years earlier.

By 1915 *The Applied Arts Book* began to expand considerably the types of art projects it was offering to its readers. The issues printed during this period included not only drawing, but also projects in bookbinding, leather tooling, lettering, blackboard drawing, and the design and construction of birdhouses. What is apparent is that the scope of the curriculum in art, at least as advocated by one of the leading art journals of its day, was widened considerably. No longer was the primary mission of the field one of preparing breadwinners, it was interested in the improvement of taste and the creation of beauty.

Concurrent with the widening conception of curriculum was the inclusion of art appreciation in the schools' art programs. Advertisements in *The Applied Arts Book* included The Perry Pictures at one cent for 25 or more, which included examples of great historical art, i.e., "Victory of Samothrace" as well as illustrations of the "Life of Christ." By 1927 art appreciation had become one of the important facets of good art programs. *Picture Study in the Grades,* wrote its author, Oscar Neale, "aims primarily to develop in children of our schools an appreciation of the great masterpieces of art so that their ideals may be influenced by the patriotism, the sympathy, the courage, the piety, and the beauty which the great artists of different ages have given to the world." [19] Thus, not only was there a growing interest among art educators with enabling children to develop good taste and hence to be able to respond to beauty, there was also a concern with enabling them to learn moral lessons through the stories that great art told.

It is interesting to compare the work illustrated in *School Arts* magazine with the art being produced in Europe during the same period. What one finds is a situation in which school art is taken from the work of Renaissance and realist painters and sculptors. There is next to nothing of the modern period of painting and sculpture, which by 1925 was already forty

The Moral Uses of Art Appreciation

Advertisement reproduced from *Notes and Suggestions on School Room Decoration* by the Boston Public School Art League (Cambridge: Riverside Press, 1898), p. 3.

years old. One does not find, for example, work by impressionists or by cubists. One looks in vain for expressionist art or for those of the Nabis. It should be remembered that the famous Armory Show was held in New York, Boston, and Chicago in 1913. Not only did it display the work of the foremost moderns of the day but thousands of people saw it. Yet the models of art to be found in art education journals were of the early and mid-nineteenth century at best. The very principles that Seurat, Cezanne, and Picasso were violating in their work were being taught as laws of design in the classroom.

The development of art education in the United States from the period of 1860 to 1915 was one in which the justification for the teaching of art shifted from a dominant concern with the development of industrial drawing skills to a desire to enable children to develop taste and to experience beauty. The curriculum of the schools expanded from one resembling a systematic program progressing in neat steps according to presumed levels of complexity in drawing to one that covered a wide range of crafts as well as painting and sculpture. To this productively oriented program

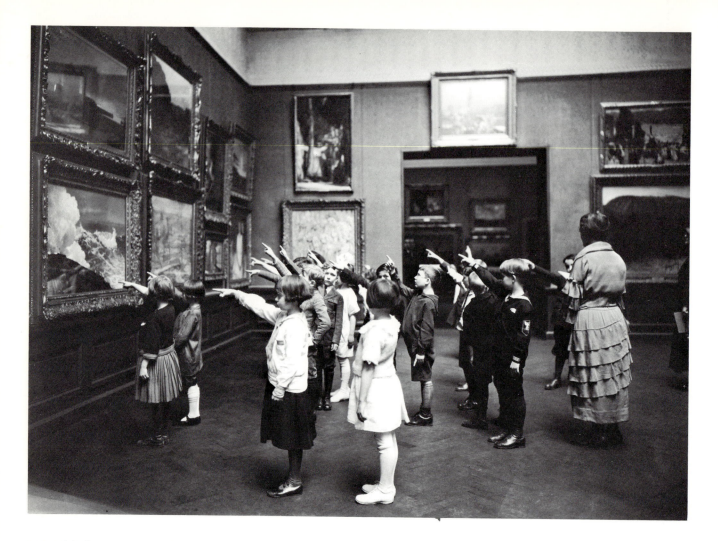

was added art appreciation—a study of the great masterpieces, not only for the beauty they radiated but for the moral lessons they provided. The expanding and liberalizing conception of the child, and of the processes appropriate for his education, was beginning to be felt in the way in which art was taught.

Art appreciation class circa 1900. Courtesy of the Metropolitan Museum of Art, New York.

The Teaching of Art in Progressive Schools

They say it takes a generation for an innovation in education to find its way into the average classroom. By the 1920's the ideas that had been developed by James, Hall, and especially by Dewey, were beginning to make themselves felt in educational literature. These ideas centered around teacher-pupil planning and the belief that children need to be actively engaged in tasks related to their interests and needs. At the forefront of Progressive practices in education were the great private schools of the 1920's—The Ethical Culture School in New York, The Walden

48

School, The Little Red School House, and The North Shore County Day School near Chicago. It was in these schools that Progressive ideas first took hold and it was the principals of these schools that provided much of the early leadership in the Progressive Education Association.[20]

Art education during the 1920's as reflected in *The Grade Teacher* and other journals still incorporated much of the work and ideas developed at the turn of the century. Projects using clay, leather, and wood were still being employed to produce objects that could be carried home and used. The principles of balance, harmony, repetition, and so forth were still being emphasized. It wasn't until the early thirties that attention to the child's creative impulse began to be reflected in articles published in the most widely read journals. When creative activities in art were suggested they frequently came in the form of correlated or integrated art projects. The teacher was often urged to use art in conjunction with her work in the social studies or to enhance creative dramatics. Because the basic curricular element that the Progressives frequently used was the unit—a project or problem that drew upon a variety of resources—it is not surprising that integrated art was considered a useful way of bringing it into the classroom. Integrated art made sense to teachers concerned with a host of subject matters to be taught. In addition, art projects could make vivid the abstract concepts teachers were attempting to help children learn. To describe a medieval fortress was one thing; to make one out of cardboard and clay was quite another. In many instances art in the elementary school classroom was used not only as a vehicle for creative self-expression, it was also put into the service of concept formation. Nevertheless, the Progressives were committed to the natural development of the child, and the arts were viewed as an exceedingly useful vehicle for facilitating this development. The arts were first of all directly related to play, a natural aspect of childhood; they were preverbal and nonverbal, hence made communication possible in ways other than through spoken and written language; they tapped the imaginative powers of children, hence they could develop the child's creativity.

The orientation that the Progressives developed to education and to children had profound consequences for the field of art education, not so much during the 1920's but during the thirty years following that decade. The Progressives were committed to the idea that the child should be free to develop naturally and that the teacher should function as a guide, not as a taskmaster. This meant that in practice the teacher was not to teach art but to unlock the creativity of the child by providing a stimulating environment and the necessary art media. Art was not so much taught as

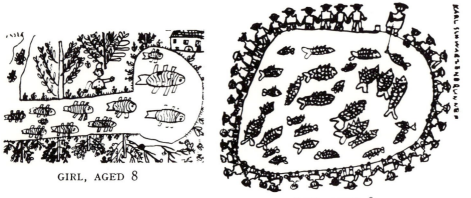

GIRL, AGED 8

BOY, AGED 8.

Drawings reproduced from *Child Art*,
2d ed., by Wilhelm Viola (Peoria,
Ill.: Chas. A. Bennett Co.), p. 196.

KARL SCHWARZENBRUNNER

BOY, AGED 8.

BOY, AGED 8.

BOY, AGED 10.

GIRL, AGED 8.

caught. This meant too that adult influence in the form of art reproductions—something that was advocated during the turn of the century and for two decades thereafter—was seen as a questionable activity for elementary school students. This questioning of the use of reproductions of works of art also spilled over into the use of illustrations in children's books. One writer in *Progressive Education,* the journal of the Progressive Education Association, stated,

It is because of my belief in the true creative vision of children that I disapprove of illustrated children's books . . . Such a situation cannot be but confusing to the child. If the words of a book are meant to evoke pictures, why the accompaniment of pictorial representation? [21]

The writer goes on:

Modern children are becoming increasingly less imaginative. There was a time when children's imaginations were nurtured by nature and life. Now they are overwhelmed by illustrated books, trips to Art Galleries and Museums, and the like. Art can be brought into the lives of our children not by sending them to museums but by bringing them closer to nature and life. Looking at pictures, if it teaches them anything, teaches them the art of imitation . . . Children should not be allowed to go to galleries and museums until they have learned to realize the emotional beauty of the lines of a factory or a locomotive . . .[22]

What we find some Progressives leading to is a type of neo-Rousseauianism in which the naivety of the child is to be maintained in the name of fresh vision. The task of the teacher is to sustain the vigor and spontaneity of the child by preventing his contact with the products of the human race.

The view of the child's development, and of the teacher's role with respect to it, is based on the assumption that the child develops best from the inside out, rather than from the outside in. In a sense it is reminiscent of Plato's belief that the task of education is to turn the individual's attention to the content of his soul: the educational problem for Plato was one of recollection.

The reason this view is significant for the field of art education is because it provided a major frame of reference for the training of teachers, especially those who were to work at the elementary school level. For a teacher who did not understand much about art and who felt incompetent in its production, the belief that her role was essentially one of stimulating but not one of teaching must have been reassuring. It relieved her of the

responsibility to teach that which she probably felt inadequate to teach. And since most of what passes for art education occurs at the elementary school level (remember that in the United States 85 per cent of all high school students study no art in high school), the significance of this view of the child and its implications for teachers became even greater.

If the view of art in education during the Progressive era of the 1920's and 1930's is contrasted with the view held by Horace Mann, William Minifie, and Walter Smith, several major differences emerge. First, the Progressives were concerned with using art to unlock the creative potential each child was believed to possess. This is in strict contrast to the use of art as a vehicle for developing marketable skills. Second, the Progressives were committed to the idea that art ability unfolded, as a flower did, when the proper environment was provided. For Minifie and especially for Smith artistic ability was a learned ability, one that could be taught. Third, the Progressives saw art as a tool for tapping the imagination and providing the child with nonverbal means of communication. Those in the industrial drawing movement saw art as culminating from the learning of a series of discrete steps. Relatively little emphasis was placed upon the use of imagination especially at the initial stages of instruction. Fourth, the Progressives viewed art as a field of activity to be integrated or correlated with the other fields of study in the curriculum. Minifie and Smith viewed art as an independent study that made its own particular demands upon those who would learn it. Fifth, during the industrial era the content of the art program was to be determined by the art specialist or curriculum maker: the teacher was to teach prescribed and systematically organized content. The Progressives wanted the art experience to flow from the needs and interests of the child. The teacher was not to prescribe but was to guide and facilitate.

These differences and a host of others can be found when comparing the Progressives' view of art education with the views prevalent fifty years earlier. Were the Progressives right and Walter Smith wrong? It is easy to conclude, I think, that the Progressive view of art education was more modern, more humane, and hence better than preceding views. This, I believe, would be a mistaken analysis. What we shall find as we proceed in our analysis of the dominant themes and goals of the field of art education is the realization that the themes encountered are context bound. Given the context of the industrial needs in the eastern seaboard states during the 1860's, 70's, and 80's, the goals and conception of the field as advocated by Minifie, Mann, and Smith could be said to be highly appropriate. As we shall see the goals that even the Progressives espoused dur-

ing the 1920's and early 30's were altered during the late 30's and during the Second World War.

Changes in the goals and methods of art education were not only influenced by social and economic changes in the larger society during the latter part of the 30's and the early 40's, they were also altered by criticisms leveled at some of the most hallowed ideas undergirding the Progressive movement itself. One of those ideas was the concept of "felt need" and the belief that much if not most of educational planning should emanate from the felt needs of children. By 1938 one of the leading educational philosophers of the day, who was an honorary vice president of the Progressive Education Association, wrote of this concept:

> The point at issue is far more than the verbal question of how the term "need" is to be employed. It concerns the question of what education should be primarily concerned to achieve. The failure to emancipate ourselves completely from Rousseauism and the instinct psychology is responsible for most, if not all, the weaknesses of the Progressive movement in education. The attitude of superstitious reverence for childhood is still with us. The insistence that we must stick like a leech at all times to the "needs" of childhood has bred a spirit of anti-intellectualism, which is reflected in the reliance on improvising instead of long-range organization, in the over-emphasis of the here and now, in the indiscriminate tirades against "subjects," in the absurdities of project planning, and in the lack of continuity in the educational program. It has frequently resulted in an unhealthy attitude towards children, an attitude which suggests that there is no such thing as a normal child, and that we must be everlastingly exploring his insides, like a Calvinist taking himself apart day after day to discover evidence of sin.[23]

Boyd Bode, like Dewey, did not hesitate to criticize what he believed to be a misinterpretation of experimental theory in education. What these philosophers saw was an excess of permissiveness in the name of freedom, a permissivness that left the teacher irresponsible with respect to instruction. These criticisms and those that followed, especially during the late 40's and 50's, contributed to the demise of the Progressive Education Association.

The 30's saw not only the strengthening of the child-centered orientation to art education, it also saw the expansion of the general conception of what the arts were. During the early part of the century, art was considered both a practical application of skills to create various crafts and a product of genius, created by those rare men we call artists. Their works in the forms of great paintings and sculpture were to be the objects of artistic attention. They were not only objects of beauty but objects with profound moral lessons to teach.

During the 30's the concept of art was expanded to include the world around us in general, the forms made by man as well as those made by nature. Perhaps the most striking examples of this approach is that taken in 1933 at Owattona, Minnesota, in what has since come to be known as the Owattona Project.

The Owattona Project in the words of its first director, Melvin Haggarty, dean of the College of Education of the University of Minnesota, was an experimental study that sought "to discover how the art needs of current American life can be picked up and made the basis of a school curriculum." [24] The thrust of the project was to take art out of the museum and to see it as a factor that pervades daily life, a factor that can be brought under intelligent control if the appropriate education is provided for. To demonstrate how pervasive art is, Haggarty asks the reader to imagine how one's home would be altered if all elements of art were removed. This image stands as a vivid reminder of the extent to which art, in Haggarty's terms, permeates and affects our lives. The problem as he and the Owattona staff saw it was to build an art program in the schools of Owattona, Minnesota, that would be relevant to the type of decisions that the average citizen might be called upon to make during the course of his life. Decisions about draperies, room layout, landscaping, furniture, dress, automobiles, and so forth were decisions that in part required aesthetic judgment. These were important decisions and ones that the school could help people make more effectively. Art, for Haggarty, was to become "a way of life," and not merely a cultural nicety that was to remain on the periphery of the educational program.

That this conception of art and its utility in life were developed during the Great Depression is not surprising. When budgets have to be cut, those competing for scarce funds are called upon to defend their claim to financial support. The Owattona Project was born during the depression and, in part, sought to provide a theoretical foundation of art education that would secure it against the vicissitudes of the depression years. Edwin Ziegfield, the resident director of the Project, wrote:

In the nineteen-thirties, such critical analysis [of school subjects] brought many people to the conclusion that art was one subject which could well be spared from the public school curriculum. All over the country art teachers were dismissed because art seemed to be one of education's frills, a pallid luxury-subject without sufficient vitality to be considered essential to the training of children. [25]

Under these circumstances the uses of art as a tool for enlivening not simply those rarefied moments in a museum but of daily life seemed a

Art Education During the Great Depression

Plate 1. This drawing, created by a fourth-grade child, resulted from a problem in which children were encouraged to attend carefully to the contours of a still life. The drawing provides evidence that the child's perceptual attention was indeed accorded to the contours of the still life and that a host of details that would normally be overlooked were seen and graphically described. Tasks such as this can develop the kind of qualitative intelligence concerning visual form that contributes to high level art as children continue to learn.

Plate 2. This drawing is an example of the way in which emphasis and meaning enter into children's drawings. The child was apparently so interested in guns and holsters that he was unable to attend to the placement of the figure on the paper. What results is a most interesting artistic accident. As Aristotle remarked, "Art loves chance."

Plate 3. "Girl with Ponytail," made by a seven-year-old girl, illustrates a number of conventional devices and psychological factors that affect the character of children's drawings. First, notice that rather typical and stereotyped conventional forms have been used in the treatment of the flowers. Similarly, the forms for representing the sun and the face indicate still other ways in which conventional forms are employed. The exaggeration of forms, for example, the length of the girl's ponytail, often occurs when emotional meaning or ideational significance enter the act of drawing. Also, note the way in which aspects of the form of the figure have been simplified, for example, in the elimination of shoulders and neck.

potent justification for the inclusion, if not the expansion, of art in the school curriculum. The approach developed at Owattona and the philosophical position upon which it was built was, when considered with other works such as Dewey's *Art as Experience,* instrumental in expanding the domain and responsibility of art education. No longer was it adequate to simply help children build pleasing objects, no longer were great works of art to be the sole objects of artistic contemplation, no longer was developing skills in drawing and painting sufficient, with the realization that art was a quality of experience to be had in any realm of human activity, the scope of art education and the responsibility of art educators expanded enormously.

As the depression years affected art education in one way, the years during the Second World War affected the field in another. When a nation is at war the concerns of people in and out of education turn to the development of ways in which schooling can contribute to the war's victorious culmination. Art education during the Second World War was not impervious to the need to use art for patriotic purposes, and in art programs, especially at the secondary levels, projects were initiated that "contributed to the war effort." High school students were encouraged to produce posters proclaiming the virtues of saving waste paper for the war effort, elementary school children made projects for use by service men, and art teachers were writing articles titled, "The Art Teacher's Call to Arms" [26] and emphasizing patriotic themes such as the making of victory pins in the classroom.

During the war years the justification for art in the schools shifted from the claims for economic and social utility advocated during the depression years to claims for the importance of art for national defense. Even Erwin Edman, a noted philosopher of culture, pointed to the arts as a fifth freedom to be added to the familiar four. The arts provided in Edman's terms "the freedom of being richly and fully one's self . . ." [27]

What is interesting to note is the way in which both justification and practice sway to meet the crucial needs of an era. During the depression art education was in the service of community betterment. During World War II it attempted to justify itself in relation to national defense.

To say that art education became concerned with the war effort during the Second World War is not to imply that the whole of art education was occupied with producing war posters. The bulk of the articles in *School Arts,* for example, was still devoted to descriptions of "clever" projects that teachers might employ in classrooms. In March 1944, during the middle of World War II, we find the following titles of articles listed in *School*

Arts: "A Department of Fine Arts Integrates with War Service," "Art Education in Wartime," "Ceramic Art Integrated with Radio in Making Visual Recordings of World-Wide Intercommunication," "The Swiss Alphorn in Legend and in Fact," "A Home Integrated with Creative Arts and Crafts," and so forth. The craft approach to art education was still very much alive, a mixture of the desire to provide opportunities for creative expression to children in the schools as well as to provide projects having practical value.

The Teaching of Art During the Age of the Heroes

The forties not only saw the emergence of the war theme as a major concern in art curricula, it also was the decade in which four very influential books were published in the field. Natalie Robinson Cole's *Art in the Classroom,*[28] Victor D'Amico's *Creative Teaching in Art,*[29] Viktor Lowenfeld's *Creative and Mental Growth,*[30] and Herbert Read's *Education Through Art* [31] were all published during this decade. Although each differs in many respects, there is a common theme that they share: the major mission of the field of art education is to facilitate the creative development of the child. Robinson's approach was to stimulate phantasy and feeling in the child and to allow him to express it through visual form. For D'Amico, the process was more complex. He saw the child as an artist who was to be immersed in the *process* of creation, a process more important than the product the child produced. Lowenfeld, who had emigrated to this country from Germany in 1939, applied his insights into the creative process to map out goals and methods in art education that had, perhaps more than any other, the most profound consequences for the field. And Read, the erudite philosopher from England, drew upon a great depth of scholarship to illustrate how the natural realization of the child's unique potential could contribute to a harmonious social order. Each writer saw art as a way of tapping into the creative wellspring of the child. Each was concerned with the *use* of art for personal development.

Although all four books were—and are—used in the field, it was Viktor Lowenfeld's *Creative and Mental Growth* that has had the most enduring and influential impact. Lowenfeld's influence in art education came not only through *Creative and Mental Growth* but from the fact that he became the chairman of one of the most influential graduate programs in art education in the country, the program at the Pennsylvania State University. Lowenfeld provided a scholarly model for the field, gave speeches in all parts of the country and wrote numerous articles for professional journals.

Last, and not least, the ideas he advocated regarding the teaching of art were compatible with the predispositions of those who taught in elementary schools as well as those who chose to teach art as specialists at the secondary level.

What were those ideas? While it is impossible to summarize the work of a man in a few sentences, Lowenfeld's major thesis seems clear. He was interested in the creative and mental growth of the child and viewed art as a vehicle for achieving this growth. Although art was important to him in his own life, and although he valued it for students, his primary concern was with the proper development of the child, with the use of art as a means for developing a seeing, thinking, and creative human being. To those trained in the precepts of Dewey and Kilpatrick these concerns were not strange. Indeed, they meshed nicely with an inclination to allow the child the freedom to come to fruition through art. During a period in which the allies were fighting to preserve freedom in the world, a philosophy that endorsed it for children was difficult to deny.

What can be learned from the evolution of art education in the United States? What insights can be secured about the factors that have affected its content, its goals, its methods? First, it must be apparent that the content, goals, and methods of art education change over time and that the aims to which the field is directed are related to the social, economic, and ideological situation in which it functions. As I have already indicated, the school is a social institution that derives its mission from the values and aspirations of those who support it. Art education is one component in the school program and adapts to the demands of the context. In this sense art education is a flexible enterprise that adjusts its own procedures to what the context has demanded. And while some of the leadership in that context has emanated from within the field of art education itself, more often than not, leadership for direction has been stimulated by forces from outside the field, whether it be from manufacturers seeking craftsmen, from a public concerned with the economic value of the arts, or from a society fighting for its survival.

At first blush, such flexibility might seem as though the field were fickle. Not so. Institutions in a changing social order must change to survive. A major problem that art educators must face is one of using art as a tool when necessary without sacrificing what art has to contribute to life in the long run.

A second observation that can be derived from an understanding of art education's development in the schools is that there is seldom a single unified approach to the teaching of art during any particular period. To be

sure, certain major theories or orientations are emphasized during certain eras in the history of the field, but at the same time that the dominant theme emphasized, say, a concern for developing the child's creativity through pupil-teacher planning, down the road a piece a program attempting to develop academic drawing skills is in full force. One gets a sense for the diversity of orientation during particular periods by comparing the contents of *Progressive Education* with those of *School Arts* during the 1920's. What is suggested in articles in each journal provides evidence of the wide variety of types of art programs operating during the decade.

A third observation that emerges from the examination of art education's past is the realization that the various orientations to the teaching of art can be located in a triadic relationship in whch one apex represents a child-centered view; a second, a society-centered view; and a third, a subject-centered view. See Figure 1. The child-centered view of the goals, content, and methods of the field starts with the premise that the content of educational programs in the arts or elsewhere is to be used primarily to unlock the potential that each child possesses, that educational content is instrumental to self-realization, and that the first responsibility of the teacher is to know the child well enough to help him develop his own interests and aptitudes. American education during the

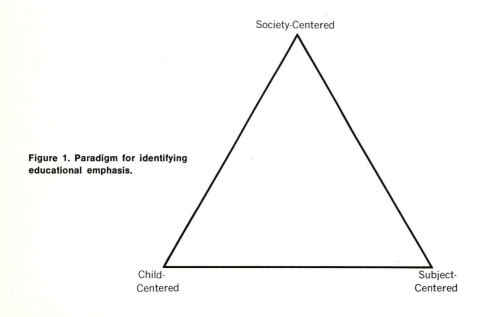

Figure 1. Paradigm for identifying educational emphasis.

Society-Centered

Child-Centered

Subject-Centered

twenties and thirties, and to some degree in the 1890's, tended to see the mission of art education in this light.

The society-centered view considers education as formalized through the public schools a social mechanism whereby the cultural heritage can be passed on to the younger generation. It sees the curriculum of the school as a vehicle for meeting social needs in the community; thus, if the society needs more scientists or engineers, the curriculum of the schools should emphasize the development of these skills. If the society in which the school functions has needs to be met with respect to air pollution or race relations, the curriculum of the school—including the curriculum in art—is to be used to meet these needs. Walter Smith's Massachusetts, and The Owattona Art Education Project are vivid examples of society-centered approaches to curriculum in art education.

The subject-centered approach to curriculum goals, content, and teaching method lays emphasis upon the integrity of the subject matter, its uses in human experience and understanding, and its intrinsic value. In this view of the goals of art education, the teacher is to emphasize the study of art per se; he is to help the student learn to see and appreciate the work of art not primarily because it will be socially useful for him to do so, but because great products of the human mind and spirit are the proper objects for educational attention. Surprisingly this orientation to art education in the United States has been emphasized the least during the course of its history. Some of the work of those in "picture study" during the first two decades of the twentieth century had this general orientation as well as during the forties, but as a general and pervasive theme in the field, among the three the subject-centered orientation has been the weakest.

Given the fact that art education has altered its goals over the years, that it is affected by social forces around it, and that its major orientations can be classified in relation to dominant concerns with the child, with the society, and with the subject matter, does this mean that no value position concerning the goals of the field is possible? Does one conclude from the fact that there has been change in the field that the problem of deciding what ought to be the aims of the field is superfluous or empty? I think not. As long as one chooses to choose, to attempt to determine the course of a state of affairs—and I believe every professional teacher and scholar not only has this right but has the responsibility to do so—some criteria and method for making value choices about means and ends are needed.

I have already indicated that I believe, in general, the most important contribution that art education can make to the growing child is directly

related to the nature of art. It is related to that which is distinctive about art; it is related to the functions art performs in human experience. This position is, in a sense, simple and straightforward, in fact too simple without appropriate qualification. It is to these qualifications that I wish now to address myself.

Although it is easy to say that, in general, the goals of art education should be based upon what it is that is unique and valuable about art, goals always function for people, and people live in contexts. Thus, any statement of goals without consideration for who and where can only be couched in the most general and abstract terms. I have thus far described the goals of art education at this level, a level both general and abstract. But because goals are for people and people live in contexts it is important to identify the characteristics of both people and contexts in order to determine whether or not the goals valued are valuable in that context.

Consider the following paradigm in Figure 2. The vertical axis of the paradigm is a developmental continuum. This continuum indicates that one dimension that needs to be considered in the formulation or applica-

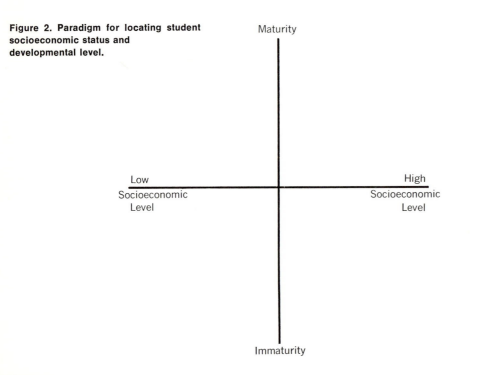

Figure 2. Paradigm for locating student socioeconomic status and developmental level.

Maturity

Low — High
Socioeconomic Socioeconomic
Level Level

Immaturity

tion of goals to people is their stage of development. Children obviously grow and change over time. A five-year old is developmentally capable of some types of learning and experience and not others, a nine-year old likewise. Thus, the appropriateness for emphasizing the making of useful art forms for five- or six-year olds will be different than for twelve-year olds. Each stage of development, so to speak, affects what we desire or aim to achieve. In addition, the particular personality needs of the child, if we know them, may affect how we choose to work with him.

Developmental psychologists such as Jean Piaget, Dale Harris, Heinz Werner, Jerome Bruner, and others have spent their professional lives attempting to find out how children change both cognitively and affectively during the course of their lives. Piaget,[32] for example, has indicated that children's cognitive development changes in a predictable pattern and that the type of cognitive operations a child is able to perform is related to his age and stage of development. Thus, work done on the study of cognition and on perception provide some clues as to what can be achieved for a particular age group.

Children differ not only with respect to developmental level, they differ with respect to the cultural background in which they live and which affects their view of the world. Hence, the horizontal axis is a continuum representing cultural differences. These differences deal with economic conditions, with social status, with geographic locale, in short, with all factors other than those that are developmental.

The recognition that cultural factors affect how a particular educational environment will be regarded by a child or group of children underscores the need to consider it not only with respect to the formulation of goals for the teaching of art but for deciding on content and method as well. Theoretically, but not as yet practically, one could view the paradigm as a type of Cartesian coordinate. A group or a child could be located on any point within the four sectors. Thus, a six-year-old child living in an urban ghetto might work in an art program with goals, content, and method quite different from a child of the same age but living in a well-to-do suburb. The goals formulated for children in each of these groups would in part depend upon their characteristics, characteristics that, if appropriate criteria were available, would locate them within one of the sectors of the paradigm. The goals of the art program, once having been "located" for a group, might or might not be related to the achievement of essentialist ends, that is, ends unique to art. They may be directed to the achievement of ends that *at the time* must take precedence over those that only art can achieve. For example, if one is working with rural chil-

dren who are suspicious of art and artists, one might decide to use the art program *at that time* to reduce their suspicion of art, to alter their attitudes toward artists, and so forth before moving toward aims more central to the nature and function of art. What we do in such cases is to recognize the type of characteristics that are likely to affect the realization of prized educational values and tactically alter goals in order to make strategic gains.

This procedure is not new. Teachers working in the classrooms use it regularly to maintain the educational ecology of the classroom. Sometimes it requires that they engage the class in highly active pursuits before moving into those that require a more sedentary style of behavior. Teachers sometimes refer to this process as pacing. Whatever name is used to describe it, it deals with the need to adapt the curriculum and the instruction to the situation and to alter the goals, even if only temporarily, in order to accommodate particular demands at that time.

When this general conception is used to guide thinking about the goals and content of art education one begins to see that the problem of formulating goals becomes considerably more complicated than heartfelt testimony regarding the values of art in education. What is good for whom depends at least in part on to whom the what is directed.

To complicate things even further, it should not be assumed that it is possible, once and for all to characterize children with respect to their location on either a developmental or cultural continuum, because both the developmental patterns and the cultural conditions change over time. Thus, the paradigm has a time dimension to it. As culture changes, what children learn and experience also changes—who would argue, for example, that attitudes toward sex have not altered over the past twenty years. Given these changes in culture, developmental patterns with respect to readiness also alter; thus, what might have been valid data on the status of a group five or ten years ago cannot necessarily be considered valid data today. The task, therefore, in responsible educational planning is, in part, one of securing valid current data on which to base educational decisions regarding the goals and content of a field. The advent of television, the expansion of the mass media, and the changes in film have exposed children to new and different sources of information and have shaped new attitudes and provided new heroes. The consequences of such material need to be taken into account in determining what will be educationally relevant and useful in the art curriculum.

Because I am arguing that the goals, content, and method of art education programs need to be determined in relation to a developmental and

cultural continuum, it should not be taken to mean that I believe any goals whatsoever are appropriate for the field or that the field has no distinctive contribution to make in the educational process. To the contrary. The contributions that are most valuable for art education are what art has to provide to human experience and understanding. If the field is justified in educational practice on other grounds, that is, if it is justified on grounds that are *not* unique to art, it has no more claim to educational support than any other field that claims to make the same contributions.

In short, art education, I believe, has unique contributions to make in education. Although it might be necessary at various times to use art for other purposes in education, those other purposes should be conceived of as short-term goals that are necessary for the achievement of those aims that only art can provide.

4

how artistic
learning occurs

In the previous chapters the functions of art in education were identified and discussed, and the evolution of major themes in the history of art education were described. Among the ideas that emerged in these chapters the following two seem to me to be especially important: to comprehend what art does to human experience requires some analysis of art itself. To understand why we believe and teach as we do about the role of art in education requires an understanding of the field in its historical-social-educational context.

But once these aspects of art education are understood one is still left with the problem of determining how the contributions of art can be made vivid to those in school. After all, the primary mission of art educators is not simply to understand something, it is to facilitate the artistic development of human beings. Thus, the problem that the teacher faces is one of deciding how to best do this. How does one learn to create, experience, and understand art? What is the teacher to do in the classroom? How can a curriculum in art be effectively planned?

This chapter will identify and discuss how learning in art occurs. Later chapters will deal with how it can be influenced through teaching and curriculum organization. The assumption here is that if we know something about how people learn in art we will be better able to effect such learning through teaching.

The Multiple Aspects of Artistic Learning

It is well to point out at the outset that artistic learning is not a single type of learning. Artistic learning deals with the development of abilities to create art forms; it deals with the development of powers of aesthetic perception, and it deals with the ability to understand art as a cultural phenomenon. Thus, an understanding of artistic learning requires us to attend to how people learn to create visual forms having aesthetic and expressive character, to how people learn to see visual forms in art and in nature, and to how understanding of art occurs. These three aspects of artistic learning we shall call the *productive,* the *critical,* and the *cultural.*

As I have indicated in the previous chapters, over the years there have been a host of different beliefs concerning the role of art in education and the responsibilities of the teacher with respect to that role. One that has been widely accepted in the past twenty years has tended to view the child as an unfolding organism whose talents in art come to fruition with sympathetic but unobtrusive teaching. The child was believed to develop primarily from the inside out.[1]

If artistic learning was in fact an automatic consequence of maturation, the task of the art teacher would be a relatively simple one. He merely would need to provide art supplies and encouragement, and watch the child unfold. Artistic development, however, is the product of complex forms of learning in each of the three realms previously identified. Even trained art teachers sometimes forget how much effort, practice, and study they underwent in order to achieve the abilities they possess in the field of art.

I, therefore, start with the premise that artistic learning is not an automatic consequence of maturation. And, second, that it can be facilitated through instruction. The question now turns to the problem of determining how learning in art occurs.

For the sake of convenience, we will start our discussion with the critical and productive aspects of such learning.

One of the most useful conceptions of artistic learning has been developed by Gestalt psychologists, especially by Rudolf Arnheim.[2] The Gestalt theory of perceptual development argues that as people mature their ability to discriminate among the qualities that constitute the environment increases. Thus, an adult, in this theory, is able to perceive qualities and relationships between qualities that are much more complex and subtle than those that most children perceive. This process of being able to perceive, compare, and contrast qualities is what Gestalt psychologists call perceptual differentiation.

An example of this process can be seen quite clearly in the abilities of experts or connoisseurs to distinguish among extremely subtle aspects of the world. In the gustatory area—the area of taste—one finds that wine gourmets are able to detect very subtle characteristics of wine, characteristics that escape most of us. Their experience with wine, their ability to attend to its aroma and color, as well as to its flavor, is manifested in the development of a highly refined palate. In the visual arts critics and artists also have developed highly refined powers of perception. Art critics are able to identify paintings produced by the same artist with respect to the time the works were created—even though the time period might be very short. The wide experience they have looking hard at visual form has increased their perceptual abilities. They have, by virtue of their work, become highly perceptually differentiated.

Children too develop in their ability to perceive qualities. They might not see, unless it is pointed out to them that a field of grass, for example, is not simply green but contains a wide variety of shades of green and other colors as well. They might not note that a particular form, a building, for

example, is slightly longer than it is tall. In short, their ability to perceive relationships develops as they learn, and this ability is affected by the type of experience they have.

It has been found that children coming from low income minority groups, especially the children of the poor living in ghettos, do not develop some types of perceptual abilities at the same rate as the children of more affluent parents [3] *in those areas* rewarded in the school. The experience they have—or do not have—in their homes or neighborhoods tends to hamper their ability to distinguish subtle aspects of *certain* parts of their environment. The fact that their measured perceptual ability is generally lower than that of middle-class children very often handicaps them in school tasks that require perceptual abilities beyond those they possess.

It should be noted that perceptual differentiation as well as general cognitive differentiation becomes increasingly more complex and refined as a person increases his expertise in an area. A skilled cabinetmaker, for example, can perceive aspects of furniture construction that most of us do not see. An expert in political science is able to think of ramifications of political decisions of which most of us are unaware. Indeed, one of the reasons that lay people get such long-winded answers to problems posed to experts in a field is precisely because lay people tend to oversimplify the question, whereas experts recognize the complexity of the answer. To the lay person, answers to questions or solutions to problems are often seen dichotomously. The expert, the person who is perceptually and cognitively differentiated in a particular field, sees continua. In each of the sensory modalities—the auditory, the kinesthetic, the visual, the olfactory, the gustatory—individuals can become increasingly perceptually differentiated. In art education we are primarily concerned with the development of the visual sensory modality.

The ability to see visual qualities in the environment does not simply develop in a linear fashion from the least differentiated to the most highly differentiated skills. The visual world is exceedingly complex and as we mature we learn to reduce the visual world to certain general visual and discursive symbols for those qualities. For example, if we were to look very carefully at the form and color of a tree, we would see a very complex three-dimensional form and a wide array of shapes, textures, color values, and intensities. Normally, we do not take the time to view a tree in this way. It is the essence of perception to be selective. The frame of reference we use at the time we view the tree affects our perception and, consequently, determines what we see. But, in addition, the general over-

all color and shape of the tree is generalized from the numerous particular trees we have seen. This visual generalization or visual concept in fact tends to interfere with a more qualitative and analytical perception of the particular qualities of a particular tree. Similarly, although a man standing in blue light actually appears blue, our knowledge of his "true" color interferes with our awareness of the visual qualities his figure now displays. These interferences that emanate from what we have learned to expect of certain phenomena are called visual constancies. These constancies replace what we see with what we know by substituting the visual generalizations or perceptual stereotypes we have developed through learning for the perception of the particular qualities we encounter at a particular time and place.

The acquisition of visual constancies is extremely useful in daily life. Normally, we see things instrumentally; that is, we normally se objects primarily to be able to recognize, label, or use them.[4] We use the qualities we perceive in the world as cues for doing the things we want to accomplish. In the contexts of practical life it would be inappropriate to spend a great deal of time and effort attending to the nuances of qualities. In most daily contexts such attention would be disfunctional. In short, visual constancies are in many settings functional skills that enable us to get on with our tasks.

In the field of the visual arts, however, these visual constancies need to be managed in order to see how the visual world is organized. They need to be managed because they often interfere with our aesthetic perception of the visual world. To help manage these visual constancies artists sometimes use devices such as extending the arm with a pencil in the hand, a device that they use to visually measure the forms they are looking at. Sometimes they look through cardboard apertures to frame an area they wish to see.

Visual constancies are not the only cognitive devices that affect visual perception. The dominance of certain cognitive structures, frames of reference, or sets also affects profoundly what we perceive in a visual field. What we make of a situation that we encounter depends in large measure not only on the objective characteristics of the situation but on what we bring to the situation in the form of our immediate needs and our general past life history. If, for example, we have an opportunity to cross a great bridge we could attend to it as a monument to man's engineering genius, as an example of man's conquest of nature, as a symbol of economic value, or as a visual form set against a background of sky and mountains. Each of these four frames of reference calls attention to differ-

ent aspects of the bridge and each provides the individual with a particular mode of meaning with respect to the bridge.

The impact of different frames of reference upon the "same" phenomenon is well illustrated by the comments made by a minister, a real estate broker, and a cowboy, each of whom stood on a cliff overlooking the Grand Canyon. After several moments of gazing, the minister pondered, "What a great gift of God!," the real estate broker mused, "What a fantastic place to build motels!," the cowboy exclaimed, "What a hell of a place to lose a cow!"

Each of these men saw the Grand Canyon differently, the experience that each of them had was affected by the frame of reference he brought to the situation. If we think of frames of reference as templates through which humans look at the world we will see that each template provides its own windows to the world, each admits some light and closes off perception in some areas. The aesthetic frame of reference is one of the templates that people can learn to use when having commerce with the world. With an aesthetic frame of reference the world is viewed in relation to its formal structure and its expressive content. What is attended to in viewing a form is not primarily its economic value, or its history, or its chemical makeup, but its visual qualities and their relations.

It has been argued by Philip Phenix [5] and other educational philosophers and psychologists that the process of schooling ought to consist of helping children learn to use the various frames of reference that men have developed in their attempt to understand, experience, and control nature. These frames of reference are most powerfully developed in those disciplines of human thought and feeling known as the arts and sciences. In Phenix's frame of reference concerning the curriculum of the school, children would be helped to acquire the tools of the various disciplines and learn how to use them to acquire meaning from experience.

The acquisition of these various disciplines, like the discipline of art, does not simply emerge automatically. Each must be learned. Like all disciplines, there is a technical dimension that is made up of both the language that constitutes the discipline, the particular terms or forms it uses, and a way in which it goes about its particular task, that is, its method of operation. In the visual arts children develop expectations for visual form, often from the illustrations in the books from which they learn to read as well as from the type of art they encounter at home and in their community. These forms of art influence the way the child conceives of art. Thus, they become his frame of reference for art. If, for example, he has never encountered abstract or nonobjective art, if his conception of art is

of forms that imitate nature, it will be difficult for him, in general, to en-
counter abstract or nonobjective art appreciatively. What he expects art to
be will tend to hamper his perception of objects that for him do not belong
to the category, "art." In short, what a child learns is, in part, due to what
he has had an opportunity to experience. These experiences contribute
to the development of frames of reference that in turn create expectancies
that admit or reject certain aspects of the environment. Part of the problem
that the art teacher faces is to help the child expand his frame of reference
so that his concept of art extends well beyond the often limited concep-
tion that has currency in many homes and communities.

Another characteristic of perceptual development is the fact that young
children often focus on one aspect of the visual world at a time and fre-
quently do not recognize the relationship that a particular form, or set of
forms, has to a larger visual field. Piaget calls this process centration—the
tendency to focus on particular forms or aspects of form without relating
that aspect to a larger field.[6] The opposite of this process Piaget calls
decentration.

Now the ability to perceive relationships of particular forms to complex
fields of form is crucial in the arts. The artist must be acutely aware of
the way in which change in one part of the painting or sculpture, for
example, affects the other parts. Not to be aware of the interaction among
forms is to impede the achievement of a total, unified form, one in which
the component qualities seem to hang together.

Thus, when a person develops competence as an artist he is able to
make decisions about the forms he uses within a visual field in relation to
other forms already developed or to be developed. His thinking and feel-
ing about qualities are relational and the qualities of the visual field as a
whole become the criterion against which decisions about particular
forms are made.

Individuals whose perceptual skills are undeveloped have a tendency to
focus on one form at a time. In decorating a room, for example, it mani-
fests itself in selecting individual items, each of which might be quite
handsome in its own right but which does not "work well" in relation to
the others. Perceptual development with respect to art and art-related
tasks is evidenced by the individual's ability to see complex visual rela-
tionships. Instead of focal vision, one develops contextual vision.

It is interesting to note that the ability to see and understand relation-
ships among phenomena is generally what we mean by having developed
a sense of maturity or perspective. It is the child who does not or will not
see or understand the long-range consequences of certain actions, whereas

it is the statesman who is presumably particularly able to do this. Indeed, this is what we expect of a statesman.

Thus far, I have described the concept of perceptual differentiation and have indicated that the ability to perceptually differentiate visual forms can be facilitated through experience. One of the major contributions of the field of art education can be said to be one of helping people learn to see qualities that normally escape attention. I have also indicated that not only do we learn to see through experience and through learning, but that some types of experience tend to hamper the ability to perceive the world in certain ways. The frame of reference, mental set, or expectation we bring to an encounter profoundly affects what we will make of the experience we have. Expectations function as perceptual constancies that often interfere with our perception of visual relationships. In such cases what we know displaces what we can see. Thus, some artists, especially students who are studying in art school, use visual "crutches" to help them overcome these constancies.[7] The use of a pencil or pen held in an extended arm is one such device, a frame made of paper or cardboard is another.

The Expressive Content of Visual Form

Perception of visual qualities in the service of aesthetic experience, however, is not merely achieved by noting visual relationships in a strictly formal sense. One also must attend to the expressive character of the visual form. By expressive character is meant the quality of life—the sense of feeling—that the visual object elicits. Take for example Gene Davis' "Cool Buzz Saw," and John Ferren's "Untitled." Each painting is nonobjective; that is, no representational forms can be found in either. Each is approximately the same proportion of height to width. But that is about where the similarity stops. Although each depends upon the use of line and color as major visual elements, the differences between the expressive content of each painting are enormous. In the Ferren we find an agitated, almost frenzied sense of movement. Like a nest of vibrating worms the painting seems to pulsate with life, the static background and the swift, broad, light-colored stroke serving as a foil for the wormlike forms that tangle together.

Davis' "Cool Buzz Saw" is indeed cool, the linear forms having a precision and rationality that Ferren's work lacks. Davis' work is mechanical, premeditated, precise. The patterns of light to dark areas establish for the

viewer a visual orchestration of value. Like a Bach opus it has order and variation.

The sense of depth between the two works also differs. In Ferren's work one experiences a thick cluster of tangled forms; in Davis' the surface is rather shallow, something one strums across, rather than something one goes into. Each work moves—but so differently. Each is tactile, yet remarkably distinct in kinesthetic quality. Each generates a special quality of life—each has its own expressive content.

What is important to remember about the analysis of the differences between these works is that *all* visual forms have some expressive character. Psychologists call such characteristics physiognomic qualities.

Gene Davis, "Cool Buzz Saw," 1964, acrylic.
San Francisco Museum of Art.

John Ferren, "Untitled," 1962, oil on canvas.
San Francisco Museum of Art.

Everything that we perceive can be attended to with respect to the quality of feeling the object or event elicits. The impact of an image is not simply its ability to attract attention, nor is it simply the fact that its qualitative relations may be vaguely pleasant. The impact and import of an image is the sense of feeling that it generates in those who encounter it.

73 Arnheim has pointed out,[8] and I believe to a degree accurately, that

expression is the primary content of perception. By that he means that before an individual perceives analytically he perceives the expressive character of visual form and, hence, experiences the feelingful nature of the object of his perception. His justification for such a belief is that the need to read the expressive character of objects is related to the organism's need to determine the expressive disposition of other organisms; that is, it is a skill necessary for survival. To take an example from daily life, most of us take our cues of another person's attitude toward us by how he behaves when he is with us. This behavior is not simply what he says but *how* he smiles or fails to smile, *how* he stands or sits when we are with him, the tone of his voice, and so forth.[9] These nonverbal physiognomic cues communicate a person's sense of comfort, confidence, hostility, anger, self-consciousness and so forth. As children we learn to respond to such cues well before we learn to understand formal language. We learn them in our mothers' arms.

Artists in all fields are concerned with the expressive content of form and often attempt to manage qualities so that their work expresses such content in particular ways. However, not all those who look at visual form are able to perceive its expressive content. When the expressive content of a work of art, for example, is subtle or where an individual's expectations or frame of reference is inappropriate, the expressiveness of the work will not be perceived; hence, affective experience with the work will be minimized. For example, if a person confronts a nonobjective painting with the expectation that art consists of the imitation of nature, it is likely that he will look at the painting to find representational forms. If he is unable to find such forms, it is likely that the encounter will be a disappointing experience. He will not know what to make of the work. The work will not live up to his expectations regarding what art is supposed to be. It is in this sense that Arnheim's claim that expression is the primary content of vision needs qualification. Only in some cases is this true.

The notion that the forms of art express feeling is an exceedingly important one in the field of aesthetics. One of the most prominent and persuasive advocates of this view of art is Suzanne Langer. She holds that "A work of art is an expressive form created for our perception through sense or imagination, and what it expresses is human feeling." [10] For Langer the artist knows in a nondiscursive way what the forms of feeling are and through this knowledge is able to bring them into existence. Once materialized they become public and provide for those able to perceive them a sense of feeling peculiar to the particular work of art encountered. Although this is not the place to go into a detailed examination of Langer's

theory of art, it is important to note at this point the prominence that expressiveness has held in aesthetic theory. The expressiveness that a form conveys is an important aspect of its total character but to experience it is, in part, the result of learning to attend to the form appropriately.

Why does visual form display not merely particular qualities, say red, blue, rough, or geometric; why does it express, convey, or elicit a particular feeling or emotional character such as strength, or tranquility, or tension, or melancholy? One theory argues that we respond to particular forms emotionally because we have learned to associate that form with other experiences that have particular emotional meaning to us. For example, in American society Lincoln cars are often associated with elegance and affluence. Many people who own these cars are wealthy and middle-aged. Our experience with the factors associated with Lincolns affects our perception of its expressive content. We feel the car has elegance because we have learned to associate that feeling with the car.

Similarly, the Jaguar XKE sports car provides a feeling of sleek swiftness. The manufacturer's ads also convey this character. Take our response to the Lincoln: the association theory holds that we learn to associate feeling with form but that there is nothing intrinsic in the form to generate certain feelings in us.

A competing theory argues that the character of the form itself—the relationship the figure or figures have to the ground on which they appear determines the quality of feeling we experience when we encounter them. This theory holds that figure-ground relationships are perceived because of the light that those relationships emit and that our visual sensory system responds to. These relationships elicit certain reactions in our nervous system. Thus, the fact that we feel a particular way in the presence of a painting by Motherwell, as compared to one by Ferren, is not simply a matter of association or learning, it is, the theory argues, because of the intrinsic character of the form itself.[11] The relationships among the forms within a visual field evokes a reaction because of the pattern of light they emit. The pattern itself, taken as a stimulus, is evocative.

The ramifications of these views of artistic response are, in my estimation, exceedingly great. If one believes that responses to visual forms are exclusively a function of association, then the problems of instruction in the critical aspects of art become primarily those of associative learning. That is, the teacher's task is to have the student associate the forms of the work with other experiences he has had. Or, it becomes the task of the teacher to provide particular experiences in the presence of the work,

so that the work becomes associated with those experiences. In psycho-
logical theory such a practice is called paired-associate learning.

If, however, one emphasizes the intrinsic character of visual form; that
is, if one believes that visual qualities, by virtue of their inherent rela-
tionships, elicit particular states of feeling—provided of course that they
are viewed with the appropriate frame of reference—then the task of the
teacher becomes one of helping those visually less sophisticated learn to
perceive and, hence, experience the qualities displayed by the work.

Take, for example, the question, "Is the expressive content of the 860–
880 Apartments, as compared to the expressive content of the Robie
House a function of association or a function of the relationships of forms
within each building?" The Gestalt theory would argue that the character
of the form of each of these buildings accounts for how we feel when we
perceive them and that the feelings we experience are not primarily a
matter of associating previously learned reactions to the buildings, but
rather a matter of reacting to the formal structure that each building

**Robert Motherwell, "Wall Painting No. 10,"
1964, acrylic. San Francisco Museum of Art.**

76

**Mies van der Rohe, 860–880 Apartments.
Photograph by Richard Nickel.**

displays. Thus, the feeling of precision, of lean and spare quality in the 860–880 Apartments as compared to the feeling of horizontal thrust to the Robie House, is because of the character of their respective forms. Precision and horizontality are objective features of the 860–880 Apartments and Robie House, respectively. This theory would argue that these features are as objective as their respective heights.

Theories of association would argue that the 860–880 Apartments gets its sense of precision from what we know about the use of metal and glass. Because these materials are manufactured and because they require small tolerances for adequate construction, especially in a building as tall as 860–880, we associate precision with this piece of architecture.

The Robie House's sense of horizontal thrust is achieved, this theory

77

Mies van der Rohe, detail, 860–880
Apartments. Photograph by Hedrich-
Blessing.

79

HOW ARTISTIC
LEARNING OCCURS

Frank Lloyd Wright, Robie House, 1909.

would hold, by the way in which the forms of the house imitate the mounds rising on a flat open plain. The feeling we experience on such plains and areas like it is associated with the cantilevered roof of the Robie House.

I believe that how we respond to a visual form depends on the characteristics found in both the forms and the viewer. Some of these characteristics are explained by association, some by Gestalt theory. In a later section of this book I will present a framework to identify how these components work and what it requires of the viewer. Now let's turn to the problems of the productive realm and to examine the demands that this mode of artistic activity make on the learner.

The Productive Aspects of Artistic Learning

How is it that one learns to draw, paint, or sculpt? What is it that a person must be able to do in order to produce forms—either representational or abstract—that have some aesthetic or expressive import? Although these questions are far from answered in the research literature, there are several factors that appear to be important in the productive realm of artistic learning. These four factors are

1. Skill in the management of material.

2. Skill in perceiving the qualitative relationships among those forms produced in the work itself, among forms seen in the environment, and among forms seen as mental images.
3. Skill in inventing forms that satisfy the producer within the limits of the material with which he is working.
4. Skill in creating spatial order, aesthetic order, and expressive power.

We will examine each of these factors or types of skill individually. The first skill identified as being important in the production of visual form is the ability to manage the material through which the form is to be realized. Every artistic form is a public object or event in the sense that someone, some artist, has to take what is a private image, idea, or feeling and transform it into some array of qualities that can be experienced by others. To do this the individual must work within and through the characteristics and potential qualities of some material. The material that an individual chooses to use is not an insignificant decision in the course of artistic production. The material profoundly affects the artist's work on at least two counts. First, the nature of the material, whether, for example, one is working with water color, oil paint, soft wood, or steel, contributes significantly to the character of the final product. Each material has its own visual and tactile character which will embody the form that one confers upon the material. This interdependence of material and form provides two of the most important parameters of the completed work.

Second, the material that an artist chooses to use makes particular demands upon his skill. The material, in this sense, is not merely a passive agent that awaits the insight and sensitivity of the maker; its particular characteristics set limits to what and how forms can be made. Some of the forms that are possible in glass or plastic are not possible in clay or wood. Each material sets different limits for the artist's work. But more, each material requires a somewhat different set of technical skills. How one holds a bristle brush as compared to one of red sable as one works with oil or water colors is different. The time one can wait before working back into paint depends upon whether one is working in casein or in oil. A person skilled in the handling of one material may be inept in another; thus, the material affects the final product in lending its peculiar character to the work and by placing a unique set of demands upon the one who chooses to use it.

The significance of material in the productive realm of artistic learning is considerable. Unless one has developed at least some control over the material which one hopes to use as a *medium* for artistic expression, it

is unlikely that the material will ever achieve the status of a medium. This means that an individual must have developed skill not only in the management of material, he also needs to have developed skill in the handling of tools necessary for working with the material.

The ability to manage material so that it acts as a medium or agent for artistic expression is a necessary condition for such expression. It is not, however, a sufficient condition. Artistic expression requires not only the ability to control the material with which one works, it also requires that the material be used to organize forms that will realize the artist's intention or satisfy his visual sensibilities once such forms are created or discovered in his work. For the major part of man's past in the visual arts this has meant some attention has been paid to the problem of representing the visual world. It has meant the attempt to create illusion through art. How is it that a person is able to create on a sheet of paper or on canvas an image that provides a viewer with a sense of the third dimension? How does one create an image that others are able to recognize as representing an object in the environment? In discursive language we do not expect the noises we make, which we call words, to imitate the forms we encounter. In the visual arts for centuries the attempt to provide some image that would represent the visual world has been characteristic. For children the desire to represent has been typical in drawing and painting. The problem that faces us now is one of determining how this feat is achieved. How does one create on a flat surface an illusion of a world known in quite another context?

The problem of explaining how a person, especially a child, learns to draw, has been one that has intrigued investigators for the past hundred years. During the course of this time certain theories and explanations have been advanced. We will focus first on those theories aimed primarily at accounting for the characteristics of children's drawings and then move to a more general level of explanation dealing with the problem of image making in art.

Theory and Speculation Concerning Changes in Children's Art

One of the most sophisticated theoretical concepts of the child's development in art has been advanced by Rudolf Arnheim in his book, *Art and Visual Perception*.[12] Working out of a Gestalt frame of reference Arnheim holds, as do other Gestalt psychologists, that perception develops from wholes to particulars by means of a process of perceptual differentiation. The processes of perception are given to the organism by nature, and

during the course of maturation, the perceptual abilities of the child become increasingly more differentiated. Thus, the child sees less than an adult and Arnheim argues that the simplified schemas the child draws are not a result primarily of limited motor skills but a reflection of his perceptual abilities. Thus, the child draws a circle before he draws a square because the latter is more highly differentiated. He draws what he sees, not what he knows, according to Arnheim. Calling attention to the "fallacy" of the intellectualistic theory of child art Arnheim writes:

The oldest—and even now most widespread—explanation of children's drawings is that since children are not drawing what they are assumed to see, some mental activity other than perception is responsible for the modification. It is evident that children limit themselves to representing the overall qualities of objects, such as the straightness of legs, the roundness of a head, the symmetry of the human body. These are facts of generalized knowledge; hence the famous theory according to which "the child draws what he knows rather than what he sees." In substituting intellectual knowledge for sensory perception, the theory follows the kind of thinking that Helmholtz popularized in the 1860's. Helmholtz explained the "constancy" phenomena in perception—that is, the fact that we see objects according to their objective size, shape, color—as the effect of unconscious acts of judgment. According to him, persons obtain a "correct idea" of an object's actual properties through frequent experience; since the actual properties are what interest them for practical purposes, they come to overlook their own visual sensations and to replace them unconsciously by what they know to be true. In a similar intellectualistic vein children's drawings have been described by hundreds of investigators as representations of abstract concepts.[13]

Arnheim counters this explanation with one of his own when he argues:

The intellectualistic theory would hardly have monopolized the writings on the subject for such long time if another theory had been available as an alternative. To work out a better explanation it was necessary: first, to revise the conventional psychology of perception; second, to become aware of the conditions imposed on artistic representation by the particular medium in which it occurs.

Children and primitives draw generalities and undistorted shape precisely because they draw what they see. But this is not the whole answer. Unquestionably children see more than they draw. At an age at which they easily tell one person from another and notice the smallest change in a familiar object, their pictures are still quite undifferentiated. The reasons must be sought in the process of representation.

In fact, as soon as we apply our revised notion of visual perception, a peculiar difficulty arises. I said that perception consists in the formation of perceptual concepts, in the grasping of integral features of structure. Thus, seeing the shape of a human head means seeing its roundness. Obviously roundness is not a tangible perceptual thing. It is not materialized in any one head or in any number of heads.

There are shapes that represent roundness to perfection, such as circles or spheres. Even these shapes stand for roundness rather than being it, and a head is neither a circle nor a sphere. In other words, if I want to represent the roundness of an object such as the head, I cannot use the shapes actually given in it but must find or invent a shape that will satisfactorily embody the visual generality "roundness" in the world of tangible things. If the child makes a circle stand for a head, that circle is not given to him in the object. It is a genuine invention, an impressive achievement, at which the child arrives only after laborious experimentation.[14]

Arnheim points out that when a child draws he confronts the difficult task of transforming objects perceived—which is itself an act of construction—onto a two-dimensional surface. To do this he must create the structural equivalent of the perceived object on the drawing paper. This is for Arnheim an act in which the ingenuity of the child must be exercised. That he is able to create such structural equivalents is no mean achievement.

While the child copes with the problem of creating structural equivalents for objectives perceived he tends to neglect the relationships existing among the objects drawn. Such neglect leads to what Arnheim aptly calls "local solutions," solutions to drawing problems that tend to neglect the wider contextual aspects of the drawing. Thus, a child of four or five might draw a number of objects well while at the same time neglecting the spatial or aesthetic relationships that they have with one another.

Although Arnheim discusses drawing as invention and implies the cognitive aspect of this type of human activity, he does not discuss cognition or the role of learning explicitly, nor does he mention how instruction might facilitate or hamper drawing development. The good Gestalt is, apparently in Arnheim's view, a given—it's in the nature of things as is the child's perceptual development.

The virtues of Arnheim's work are the fact that it is theoretically consistent, a variety of concepts are presented that are useful for thinking about the relationship between drawing and perception, and it relates a variety of theoretical work published in German to the views he presents in English in his own publication. The views that Arnheim advances are not, however, experimentally grounded, nor does he provide systematic quantitative descriptions of data to support his assertions. We do not know from Arnheim's work the extent to which the characteristics of children's drawings can be altered, nor do we know why individual differences emerge in drawing among children.

A second view that has had wide acceptance by lay individuals as well as by those in the field of art education has been advanced by Rose

Alschuler and LaBerta Hattwick [15] who began their study of the easel paintings made by preschool children. Working on the assumption that children's paintings, even those made by children of nursery school age, were not simply a matter of happenstance, Alschuler and Hattwick attempted to determine the relationship between the child's personality as manifested in his social behavior and the form and content of his paintings. Alschuler and Hattwick argue that as children mature they shift from a concern in their paintings with self-expression in directly emotional terms to a concern with literal representation. Following this belief they reason that by studying the characteristics of easel paintings made by nursery school children they would be able to identify relationships between the form and content of the paintings and the personality of the child as evidenced through his social behavior.

They reason further that the type of material a child uses affects the type of expression the child produces. Although crayons are appropriate for expressing ideas, paints with their flowing, dripping quality are more appropriate for the expression of feeling. And because feelings better reflect personality than do "ideas," which are under greater conscious control, they believe that easel paintings can be used effectively for the study of personality.

Alschuler and Hattwick distinguish between the function of materials this way:

Our data, both qualitative and quantitative, indicate that very young children choose and use crayons to express quite different needs, moods, and meanings from those expressed when they work with easel paints. Crayons tend to be associated with awareness of outside standards and with the desire to communicate with others. In contrast to when they paint, when children crayon they more often tend to name their work and show it to adults, are concerned about the finished product, and are perhaps critical of it themselves. Relatively soon they turn to representation with crayons. Even before they can make representative forms they will tease out their wavy scribbling and call it writing. They are seemingly conscious of crayons as a medium for communication, for expressing ideas.

With painting, on the other hand, children tend to express how they feel, regardless of what others think. The child who sits at the crayon table and makes a recognizable, detailed human being may on the same day go to the easel and produce only a colored mass. Our data reveal crayons as a medium for expressing ideas, whereas easel painting is more often a medium for expressing feelings. [16]

Using a case study approach in their analyses the researchers attempted to identify general tendencies in the child's painting that are associated with the psychological traits he displays in social situations.

According to Alschuler and Hattwick, the treatment of space in a painting may be considered *"as a sample of the child's usage of his environment. How he reacts to this part of his environment is likely to indicate his reaction to the larger environment."* [17] They go on further to analyze the import of various colors and various painting procedures such as overpainting and indicate that size, color, placement, and space usage are related to the personality characteristics the child possesses; but they caution readers that data secured from the analysis of easel paintings cannot be used confidently to predict behavior. It could be used, however, as one important data source. And they conclude that their findings have implications for "all adults who would impose patterns of work on children rather than encourage them to express themselves freely in creative media." [18]

This last observation is in keeping with the dominant view described earlier regarding the appropriate conditions for fostering the child's creative development. Alschuler and Hattwick's views were and are consonant with many of those working in the field of preschool education.

It is worth noting that the supposed relationship between art and personality is a belief that is both persistent and widespread. It is a rather widely held assumption that the artist expresses or projects his personality through his work. This assumption is manifested in several ways in the field of art. It is not unusual, for example, to find young art students anxious to discover their true style—as if they had a particular style of painting that lay latent within them. Recent research by Beittel [19] suggests that styles of work in drawing are much more flexible than had previously been supposed and that experimental methods can alter drawing styles significantly.

The assumption that drawings reflect the deeper levels of personality is held not only by many artists and art students but by those who work in the field of art therapy. Margaret Naumberg,[20] Emmanuel Hammer,[21] Ernst Kris,[22] and Karen Machover [23] are only a few who have used drawings as indicators of deep-seated personality dispositions. As a reflection of the unconscious and as a nonverbal and preverbal mode of expression, drawing and painting are supposed to provide a direct access to the unconscious and preconscious processes because they tend to by-pass many of the defense mechanisms employed in controlling more cognitive processes.

A third view of children's art has been advanced by Florence Goodenough [24] and Dale Harris.[25] This position, which was developed originally by Goodenough in her 1924 doctoral dissertation at Stanford Uni-

versity, views children's drawings as data useful for determining their intellectual maturity.[26] Intellectual maturity is conceived of by Goodenough and Harris as the level of concept formation that the child has attained. They argue that the ability to form concepts is an intellectual ability requiring that the child recognize similarities and differences among a group of particulars. If these distinctions can be made and if the child is able to recognize an instance of the class when he confronts a particular that shares its characteristics, the child can be said to have attained a concept of that class.

According to Goodenough and Harris, children's drawings reveal the extent to which such concepts have been formed. The amount of detail that appears in a child's drawing, especially in the drawing of a human figure, is an index of the intellectual maturity the child has attained.

Describing the rational underpinnings of their work Harris writes:

> The child's drawing of any object will reveal the discriminations he has made about that object as belonging to a class, i.e., as a *concept*. In particular, it is hypothesized that his concept of a frequently experienced object, such as a human being, becomes a useful index to the growing complexity of his concepts generally.[27]

Goodenough and Harris point out, however, that the identification of personality characteristics is not likely to be done as easily. Thus, their view of child art and the assumptions they make about its genesis and development appear to differ significantly from those of Alschuler and Hattwick, Machover, Hammer, and others concerned with the use of drawings as data for developing an understanding of personality. In his book Harris concludes his section on the clinical and projective uses of children's drawings by saying,

> A survey of the research and clinical literature is persuasive; the projective hypothesis as it applies to human figure drawings has never been adequately or consistently formulated, and systems for the evaluation of such drawings have, for the most part, been exceedingly loose. Consequently, the assessment of drawings by such methods very often shows modest reliability and low validity. The more rigorous the conditions of the experiment—control of variables, matching of control samples, and the like—the lower the validity of the human figure drawing as a measure of affect and personality.[28]

But if it is true that children's drawings cannot be used with validity as a data source for understanding personality, similar objections have been made by Medinnus, Bobitt, and Hullett [29] about the validity of the

Plate 4. This drawing is a good example of the way in which conventionalized forms are used in pictographic art. Each of the houses that were drawn by the eight-year-old girl who created this work follows a single pattern, and it is especially interesting to note that the community in which the child lives has almost no houses with the kind of roof line drawn in this picture.

Plate 5. This chalk still life painting made by a high school freshman resulted from a problem in which students were encouraged to focus on the color quality of a single piece of fruit. The student who created this work was able to achieve a luminosity of remarkable brilliance and, through his imaginative use of color, also created a background shape behind the table and pear that results in an extremely sensitive composition.

"Draw a Man Test." The assessment of an ability, especially a complex of abilities such as constitute intelligence, is supposed to be rather stable. According to Anastasi,[30] psychological traits are generally not amenable to rapid alteration. Yet in their research Medinnus, Bobitt, and Hullet demonstrated that children who had an opportunity to learn how to construct a puzzle figure of a person were able to significantly increase the scores they received on the Draw a Man Test after receiving the experimental treatment. The authors point out that if scores on the Draw a Man Test can be altered easily without changing performance on other tasks in which intelligence is exercised, the theoretical relationship between the test and intelligence can be brought into question.

Whether the Draw a Man Test *really* measures intelligence or something else depends, in part, on one's conception of intelligence. Construct validation of the test suggests that the claim the authors make about the role of concept formation in drawing appears plausible. Although the ability to form concepts is clearly not the whole story regarding the skills one needs to draw, Goodenough and Harris make no claim that it is. Indeed, they emphasize repeatedly that the Draw a Man Test is not suitable for measuring artistic aptitude, talent, or artistic creativity.[31] Its major type of validation is concurrent validity with correlations with other tests of intelligence yielding coefficients of .55 to .75.[32] Given the brevity of the test in terms of effort and time needed to take it, its concurrent validity is impressive.

The point to be emphasized here, however, is not the validity of the Draw a Man Test, but the theoretical position that its authors use to account for drawing performance. For Goodenough and Harris the child's level of concept attainment is reflected in the drawings he produces; hence, they argue a major aspect of drawing is cognitive in character.

A fourth view of child art has been advanced by Norman C. Meier.[33] It was at the University of Iowa during the 1930's that Meier established a laboratory for the study of artistic aptitude. During the period in which the laboratory was in operation a variety of studies of children with and without artistic talent, studies of artists and their life histories, and studies of creative abilities were undertaken. In a summary article published in the series *Psychological Monographs* [34] in 1939, Meier reports the major findings that culminated a decade of research. The most significant finding from Meiers' viewpoint is the identification of six factors that contribute most to artistic aptitude. These factors, half of which are a function of heredity and half a function of environment, are interactive although Meier does not describe how this interaction occurs. The first three fac-

tors, which are a consequence primarily of heredity, are manual skill, energy-perseverance, and intelligence. The last three factors, those primarily a consequence of nurture, are perceptual facility, creative imagination, and aesthetic judgment. Meier is quick to point out that the type of heredity he is referring to is not direct inheritance from parents but what he calls constitutional stock inheritance. This type of inheritance refers to the genetic contribution of relatives whose genetic endowment has apparently affected the genetic constitution of the individual. Meier found, for example, that children with artistic aptitude had a larger proportion of relatives who were craftsmen, artisans, or artists than children who apparently did not possess such an aptitude. Meier points out that factors emanating from constitutional stock inheritance *must* be present for an individual to display artistic aptitude. Whereas the genetic contribution is not a sufficient condition, it is a necessary one; thus, Meier emphasizes this aspect of aptitude more than those traits that are acquired.

It does not require much in the way of extrapolation to recognize that the view Meier has advanced is consonant with the widely accepted belief that artistic ability is a consequence of talent, and talent, it is believed, is a dichotomously distributed "gift" possessed by a precious few. Unlike the beliefs of the Progressives, who were committed to the idea that all children had the potentiality to think and act creatively, the generally prevailing lay view is that only a few individuals have artistic talent. It is not uncommon to hear people exclaim when asked about their ability or talent in art that "I can't draw a straight line with a ruler."

The implications of such a belief for educational practice are enormous. If it is true that only a few are gifted with artistic talent it could be argued cogently that the educational task should be one of identifying those who possess such gifts and of providing resources for their development. The vast majority without talent would be better advised to employ their energies elsewhere.

It is well to reemphasize the fact that Meier does not argue for *either* a nature *or* a nuture theory of artistic ability. He repeatedly points out the importance of interaction. But because certain factors must be present genetically for interaction to occur, their existence is a precondition for the development of artistic aptitude. Even with an interaction viewpoint the problem of selecting students who might profit from environmental conditions appropriate for developing artistic ability becomes crucial. A major aspect of educational planning for one who holds this view is one of selecting talented pupils and providing them with opportunities to work in art.

A fifth view of child art has been developed by one of the most influential art educators working in this country during the past thirty years. Viktor Lowenfeld arrived in the United States in 1939 after having worked extensively with blind children of the Vienna School for the Blind.

The Nature of Creative Activity,[35] his first major work translated into English, was followed in 1947 with the publication of *Creative and Mental Growth.*[36] In the latter work Lowenfeld argues a view of child development that emphasizes the relationship between mental health, self concept, and creativity. For Lowenfeld, whose work has been published in seven languages and who has had considerable influence on teacher education in art, each child possesses a capacity for creative development. The task of the teacher is to arrange the conditions whereby these potentialities are realized. When the teacher or the parent places pressure on the child, when either allows him to copy, trace, or use coloring books, the capacities the child has for creative work are stifled. The way creativity may be best realized is for the child to be exposed through all of his senses to the qualities of life. Through direct experiences with tactile, visual, and audial phenomena the child's imagination and perceptual powers are developed.

Lowenfeld argues further that the development of the child is holistic in character. Taking a leaf out of the Progressives' notion of the "whole child," Lowenfeld points out that the form and content of a child's drawing is affected by, for example, his particular stage of social development. The child's drawings of group activity reflect the sociability and the groupiness of the gang age.[37] In addition the child's drawing reflects the values he places upon experience. Children exaggerate the size of objects in their drawings when they take on special significance.[38]

The most systematic theme, however, which pervades *Creative and Mental Growth* is the conception of stages of development in child art. Lowenfeld lists these stages as

1. The scribbling stage (2 to 4 years of age)
2. The pre-schematic stage (4 to 7 years of age)
3. The schematic stage (7 to 9 years of age)
4. The gang age (9 to 11 years of age)
5. The stage of reasoning (11 to 13 years of age)
6. The crisis of adolescence.

The pervasive assumption in Lowenfeld's writings about these stages is that they are natural aspects of human development. In this view he is

in agreement with Gestalt psychologists. The development of a stage is like the unfolding of a genetic program, and although there are differences in rate of development among children as well as differences of an idiosyncratic variety, the over-all pattern and pace of development is remarkably similar. The general implication of Lowenfeld's writings is that the child must pass through one stage before he is ready or able to perform at the next level of development.

Lowenfeld departs from the Gestalt psychologists, however, by placing greater emphasis on the factors that militate against development of the child's perception and creativity, and by his concern with the contextual and social aspects of artistic behavior. Lowenfeld, as an educator, was profoundly concerned with the normative aspects of education; with the manner in which it could shape behavior in positive or negative ways. In *Creative and Mental Growth* Lowenfeld argues that art is an educational tool that could cultivate man's sensibilities, foster cooperation, reduce selfishness, and, above all, develop a general ability to function creatively.

Although Lowenfeld's work represents one of the most extensive efforts to classify and analyze children's art, it contains numerous assertions that lack adequate documentation. The stages that are described are not the result of empirical studies using scientific controls to insure objectivity, but insightful, even if at times dogmatic, conclusions drawn from years of experience working with children. Such an approach in the hands of a sensitive observer has much to recommend it, but it tends not to be easily corrected. Observation and insight give way to beliefs that are difficult to alter because the ground rules for alteration were not employed in the initial development of the observations. Furthermore, Lowenfeld's work does not benefit from the test that a rival hypothesis could provide. Whether creative ability is generic or specific is as yet undetermined; yet Lowenfeld implies strongly that it is generic and suggests that evidence for this has been found. Whether copying or tracing are in fact detrimental to the child's artistic growth is still not known; Lowenfeld writes, "Never let a child copy." [39] These and other conclusions are arrived at in *Creative and Mental Growth,* and yet such conclusions are problematic in character. Still, there is little question that Lowenfeld's views of child art were more comprehensive and systematic than the views of others working in the field at about the same time.

A set of concepts that has been given rather special attention by Lowenfeld in his effort to account for the character of children's art are those of haptic and visual modes of perception.[40] According to Lowenfeld as children mature, a proportion of them—about 70 per cent—orient

themselves to the world in one of two ways. Those whose perceptual orientation is visual tend to see the world as spectators who view phenomena in a literal sort of way, with little affective or kinesthetic regard for the phenomena being encountered. The objective qualities of visual phenomena are the qualities they tend to perceive and, hence, the drawings and paintings they produce tend to be representational in character.

The haptic individual interacts with the world as a participant rather than as a spectator. He undergoes experience in a highly affective and kinesthetic way; hence, his drawings and paintings are not literal but emotionally exaggerated. Haptically-minded individuals tend to produce drawings that represent the feelings they undergo as a result of perception rather than representations of their visual perception of the object's qualities.

Lowenfeld suggests that these perceptual traits are genetically determined; hence, art teachers should not require or expect visually minded individuals to produce haptic characteristics in their drawings, and vice versa. It should be noted that the published empirical evidence for the existence of these two types of individuals has not been validated on art tasks but on tasks requiring the production of words and the recognition of forms. Until validation occurs the existence of haptic and visual individuals should be considered interesting speculation deserving further study.

Still a sixth view of children's art has been advanced by Sir Herbert Read, one of the most widely published critics of the twentieth century. In his book *Education Through Art*,[41] Read develops a conception of art that has as its intellectual parent the ideas developed by Plato in *The Republic* and *The Laws*. Read considers art a general process through which man achieves harmony between his internal world and the social order in which he lives. Art, he writes in *The Redemption of the Robot*,[42] is based on two general principles; first, the growing human should come to understand the relationships and similarities existing in an *apparently* diversified world. This principle is based on the value of unity and the contribution art can make toward the achievement of unity. The second principle is that the child, to quote Rousseau, "should depend upon things only." [43] This is to say that the child should learn through the cultivation of his sensibilities. He should learn to know by coming into direct contact with objects through his senses, for it is only by means of such contact that a firm foundation can be built for intellectual abstraction.

In attempting to account for child art, Read uses Jung's conception of psychological types and his conception of the collective unconscious in a way similar, but not identical to, the theory of recollection that Plato

advanced in *The Republic*. According to Read, the characteristics of child art are a function of archetypes which have been left as traces in the mind during the evolution of the human race. Certain symbols, Read claims, such as the mandala, the circle, and the star reappear in children's drawings regardless of the culture in which they live. These recurrent symbols provide evidence of the common humanity of man and of the potency of art to reveal this commonality. Education through art, writes Read, is education for peace.

Regarding the psychological types that are revealed through children's drawings and paintings Read writes,

These parallelisms between types of ancient and modern art on the one hand, and types of temperament or personality on the other hand, may not be exact, and in any case we cannot too often repeat that *in their purity* all such types are hypothetical. But enough evidence has been brought forward to show that several distinctive types, both of art and of personality, do exist and are interdependent, and this is a factor of supreme importance in any consideration of the educational aspects of art. Art, we may say, has almost universally been taught according to one standard—the standard of the extraverted thinking type. In more progressive schools the standard of the introverted thinking type has been implicitly recognized. In a few others a complete freedom of expression has been allowed, though without any attempt at classification or integration. But obviously the teacher should be in a position to recognize the type-attitudes in all their variety, and to encourage and guide the child according to its inherited disposition. Education, at this stage, should imply the widest principle of tolerance.

To what extent art should be used as a key to pathological conditions will be considered in another chapter, but this would obviously be a task beyond the range of the normal teacher. The first aim of the art teacher should be to bring about the highest degree of correlation between the child's temperament and its modes of expression.[44]

One cannot help being impressed with the range of scholarship that permeates Read's writing. He freely draws upon ancient humanistic resources as well as modern scientific research to support the ideas he advances. Yet from this wealth of material emerges an unclear eclecticism that leaves the reader in a persistent state of wonder regarding the meaning Read intends. The hypotheses he formulates to account for child art are not hypotheses in a formal sense and are stated with such ambiguity and vagueness as to render them unsusceptible to scientific verification. The theory of types he supports and its relationship to the character of child art have yet to be demonstrated empirically. The evidence he provides is by analogy rather than through experiment. And aside from the laudable goals Read embraces for education and the important position he

assigns to art in achieving these goals, he offers little direction to those who would interpret children's drawings with the intention of facilitating the child's growth in this area of human activity. In short, Read's statements on art, children, and education are stimulating and scholarly but in their present form are outside the realm of empirical validation.

A seventh view of child art, and the last one to be examined here, has been advanced most recently by June McFee in her book *Preparation For Art.*[45] Having had the benefit of training in the behavioral sciences as well as in the practice of art, McFee has attempted to apply concepts and theories found in the former to explain what takes place in the latter. In this effort she has constructed what she calls a "perception-delineation theory." In this theory four factors come into play:

1. The readiness of the child. This includes factors such as the child's physical development, his intelligence, perceptual development, response sets, and the cultural dispositions he has acquired.
2. The psychological environment in which he is to work. This includes the degree of threat or support existing in this environment and the number and intensity of rewards or punishments.
3. Information handling. This factor is affected by the child's ability to handle detail, his intelligence, his ability to handle asymmetrical detail, and the categories he possesses for organizing perception.
4. Delineation skills. This includes the child's ability to manipulate media, his creative ability, and his ability to design qualities of form.

In differentiating these four factors McFee has established a broad base to her conception of factors affecting the child's development in art. There can be little question that the factors identified above can have an important effect on the quality of work in art that the child can produce—such factors would affect almost any human activity. If a comprehensive and useful theory of child art—indeed, artistic learning in general—is to be developed, it is reasonable to assume that these factors will need to be taken into account.

An important limitation in McFee's work is the fact that the concepts she identifies are not developed within a single theoretical frame of reference; the concepts are interdisciplinary. The virtue of such an approach is that it provides a broad view of the phenomena being studied, but at the same time it tends toward inconsistency and ambiguity, especially if terms are derived from theories whose assumptions are mutually exclusive.

In addition, the key concepts or points in the perception-delineation

theory are not operationally defined and between points one and three, for example, there appears to be considerable overlap. Yet the effort that McFee has made is valuable precisely because she called attention to the need for systematic and experimental studies of the various factors identified. If response sets, for example, affect the characteristics of delineation in drawing, it might be possible to alter response sets experimentally to determine their effects. If perception requires classification and categorization, language might be used to help the child acquire more elaborate forms of categorization. What types of measures, specific to the visual arts, would provide operational definitions of the factors identified in each of the four points that McFee identifies in her theory? The significance of her contribution lies not in its detailed description of the function of complex variables, their measurement and experimental manipulation, but in the broad schematic rendering of some of the factors that appear important to those who would understand the development of child art.

A Summary of Conceptions of Children's Art

Up to this point, seven views of child art have been described in brief and in somewhat oversimplified terms. None of the theories that have been presented are as neat as has been suggested. My purpose has not been to explicate and critique the nuances of theory but to point out the diversity of views that have been advanced. Categories are always simpler than the phenomena being categorized, and the adequacy of categorizing in any event depends upon the function the category is to serve. In this case the purpose is to make plain some of the major differences in several important views of child art.

By way of review we find that one conception of child art, one argued by Arnheim, is that which emphasizes the growth of perception through a process of perceptual differentiation. This process is accompanied by the increased differentiation of graphic forms produced by children as they create two-dimensional structural equivalents for the objects they perceive. Children, says Arnheim, draw what they see, not what they know.

A second view urges the importance of personality traits in affecting the painting characteristics of preschool children. Whereas the effect of personality is especially important when preschool children use fluid materials such as paints, it is never wholly absent from the work of any artist. The view of Alschuler and Hattwick present for preschool children is similar

to views advanced by those concerned with art therapy and with the use of art as data for psychological diagnosis. For such individuals art is manifestation of personality.

A third view sees child art as indicative of concept formation and thus an indication of general intelligence. Goodenough and Harris present this view in their work. Thus, the act in drawing is considered in large measure a cognitive activity and is affected by many of the abilities that affect performance on tasks not associated with drawing.

Norman Meier, in a fourth view of child art, emphasizes the importance of constitutional stock inheritance and considers art ability or art aptitude a result of an interaction between genetic traits and environmental conditions, identifying six factors that affect art aptitude.

A fifth view, this one developed by Viktor Lowenfeld, emphasizes the unfolding character of children's developmental stages and urges teachers to avoid intervening in the natural, hence, appropriate, course of the child's artistic development. According to Lowenfeld, this natural course yields people with two different visual orientations to the world. The haptic individual relies mainly upon affective, kinesthetic responses for contacting his environment, whereas the visually minded perceives the world in a more literally visual way. These types, Lowenfeld suggests are genetically determined.

Herbert Read theorizes that child art is affected by the particular personality type the child possesses and by an array of primordial images or archetypes "which have found their way from the unconscious levels of the mind." Art, says Read, "is a complete fusion of the two concepts (art and education) so that when I speak of art I mean an educational process, a process of upbringing; and when I speak of education I mean an artistic process of self-creation."

In a seventh and broad view of child art, McFee identifies four factors or points that affect the child's performance in art: his readiness, his ability to handle information, the particular situation in which he is to work, and the delineation skills he possesses. Although these points or factors are suggestive of needed research, they are not defined operationally in McFee's theory. They do remind the student of child art, however, of the fact that artistic behavior is due to several factors.

Each of the theories that has been described represents attempts to explain children's ability to produce visual forms. Each investigator has attempted to account for some or all of the factors that affect the character of the drawings, paintings, and sculpture that children produce. To some extent, each of the theories touches upon one important aspect of the

problem—each sheds some light on the problem of understanding the development of children's art.

You will recall that I identified four general factors that appear related to the production of visual art forms. These were

1. Skill in the management of materials.
2. Skill in perceiving qualitative relationships among those forms produced in the work itself, among forms seen in the environment, and among forms seen as mental images.
3. Skills in inventing forms that satisfy the producer within the limits of the material with which he is working.
4. Skill in creating spatial order, aesthetic order, and expressive power.

Because the first of those factors—skill in the management of material—has already been discussed, we will now examine the significance of other factors.

The management of material implies an ability to control the stuff with which one works. With such skill, material becomes an agent, a plastic vehicle for expression. But to produce personally satisfying visual forms also requires an ability to perceive the qualities that emerge as one works with a material, so that the skills acquired for management can be put to good use. For example, a child or an adult might have a good feel for clay and for what it can do. He might be able to handle it quite well but might not be able to appreciate the visual forms that emerge from his work with the material. Whereas his technical skills in material management might be refined, his ability to see sensitively what emerges from his work might be poorly developed. Such an individual's problem is one of reducing the gap between his technical skill and his perceptual skill. Though these are often related to one another, they are by no means identical.

Similarly, the ability to see and not merely look at the forms of art and nature is another factor that affects an individual's ability to produce visual forms. This ability makes it possible for individuals to experience the visual forms around him, forms that are in both art and nature. When the visual sensibilities are developed so that individuals are responsive to visual form, it becomes possible to use the "data" acquired through such perception as resources for one's own creative work.

The act of creation does not emanate from a vacuum. It is influenced by the experiences that have accumulated through the process of living. If that process did not include much nurture from the visual world, it is not

likely that that world will become a resource which the individual can draw upon for his own creative work. It is in this sense that heightened powers of aesthetic perception provide access to those phenomena that the individual uses in his work. It is also in this sense that seeing rather than looking becomes a sign of an achievement and not merely a task. To see is to acquire visual meaning through experience. To merely look is to engage in an act that hopefully terminates in seeing.[46]

The significance of the ability to see, and hence to construe meaning from visual experience cannot be overestimated in the production of visual art. Not only is such an ability critical with respect to decision making in one's own work, it is of fundamental importance for those who wish to create socially significant art. Artists who do more than repeat the solutions of the past are perceptive of social or natural conditions that most of us fail to see. Their perceptivity, their ability to come to grips with what is central to a state of affairs enables them to draw upon such perceptual insight when they embark upon the productive phase of their work.

The perceptual meanings acquired through refined sensibilities goes well beyond attention to the formal structure of visual form. Artists tend to see beneath the primary surface of a situation, to uncover the covert meanings or implications of the situation. Klee and Lachaise, though quite different in the forms they create, are both interested in reducing an image to heighten its visual and symbolic power. Throughout the history of art we find such reductions, the attempt by the artist to reach beneath the surface of personality or situation to uncover covert meanings. These meanings once perceived become a core around which artistic visual forms are constructed. This core of meaning is frequently the ideational base of significant art, and manifests itself in the artist's efforts to form matter in new ways.

The ability to manage material and the ability to perceive qualities, both primary and secondary, that flow from one's work are not sufficient conditions for the creation of visual form. Somehow, the child or the adult faces the problem of transforming some image, idea, or feeling into appropriate visual structures. The drawing of even the simplest shape requires an ability to invent in a material other than perception or imagination a form that will convey what the individual intends. Somehow, the child must invent or find a structure or code through which his ideas, images, or feelings can be expressed. It is this problem that takes us to the third factor affecting the creation of art form: Skill in inventing forms that satisfy the producer within the limits of the material with which he works.[47]

Paul Klee, "Nearly Hit," oil. San Francisco Museum of Art.

Two Modes of Artistic Action

Let us be clear at the outset that there are at least two dominant modes through which artistic production in the visual field can occur: one of these, the one used by children of two, three, or four years of age, and by some abstract expressionists and action painters, involves the discovery of forms that emerge from the activity of the hand and eye. The second mode, the one more historically prevalent, is the result of intention: it is the product of a will to transform a private idea, image, or feeling into a public material such as paint or clay.

The first mode of activity can be observed if one watches a very young child scribble with pen or brush. His efforts are not generally given to

98

Gaston Lachaise, "Floating Nude Figure," bronze. San Francisco Museum of Art.

articulating in visual form some preconceived image but rather one of being stimulated by the visual tracks his pencil or brush leaves as it moves across the surface of the paper. Frequently, the rate and pattern of this movement will be altered in order to provide a different array of visual tracking from those that have emerged before. The young child in this setting is concerned with the discovery of wholly formal arrays through a process of graphic exploration. It is often through such exploration that certain visual effects are noted and learned, and become, through that process, a part of the child's repertoire.

99 The second mode of artistic activity is and has been characteristic of

children and artists throughout the centuries. This mode requires the invention of a schema or structure that will stand for and therefore help realize the artist's or child's intention.

Now typically in the literature in the field of art education the characteristics found in children's drawings and paintings have been viewed as stages that are somehow considered a natural aspect of the internal evolution of the child's genetic make-up. The drawings that children make at various ages have been viewed as natural constructions that are predictable over the child's maturation period. Related to this conception of the character of children's art has been the belief that because children go through "natural" stages in their development in drawing and painting the teacher should not "interfere" or attempt to teach the child. The proper role of the teacher has been seen as that of a type of artistic midwife. His responsibility has been one of providing materials and stimulation, and of allowing the child to proceed at his own rate in his own way.

I will examine the strengths and weaknesses of this general conception in a later chapter, but let it suffice here for me to say that the premise underlying this conception of the development of artistic ability in children seems to me to be faulty. The ability to see, to conceive imaginatively, and to construct are abilities that are profoundly affected by the kind of experience children have. It is precisely in the provision of environmental conditions—through curriculum and teaching—that the teacher has an important contribution to make to the child's education in art.[48]

During the task of artistic creation in the second mode of activity previously identified, the child faces the problem of transforming some idea or image or feeling into a visual form in some material. When this is achieved, the material becomes a medium and the child—or adult—can be said to have expressed himself through visual form.

But what is required for such transformation? What must the child do to make the material function as a medium? The problem of drawing or painting for the child is one of inventing a form that will stand for what he intends. From the ages of about three or four to eight, under circumstances where relatively little practice or instruction is available, the child tends to create forms that, as Arnheim has indicated, function as the structural equivalent of the object seen or imagined.[49] The schema of the human figure, or the house, or the tree, to take common examples, is reduced to its simplest structural features and produced in the drawing or painting. As the child gets older and as he has increased opportunity to draw, his schemas become corrected through increased differentiation in the created image. The changes that emerge in the child's drawings are inven-

tions or refined schemas that have been facilitated through environmental conditions, and at times through instruction, although this is rare for primary grade children in American schools. Gombrich [50] has pointed out that the procedure of making and matching is a common practice in the production of art, and I believe his analysis to be correct in most cases. The exception is when the child employs a schema that functions as a pictograph or conventional sign. Conventionalized schemas, such as the drawing of the pitched roof house by children who live in areas where there are only flat-roofed houses, are learned schemas that become conventionalized and stand for, without attempting to imitate, the idea or image, house.

The major point to be emphasized here is that the child's activity in the act of creation is one of inventing forms that will carry his intention forward through some material. These forms are simplified approximations at the outset but become increasingly refined through more sophisticated inventions as the child learns to create illusion of the third dimension on a two-dimensional surface. These illusions take the forms of perspective drawing, value differentiation, the use of light and shadow, and so forth.

The creation of visual forms sufficiently powerful to create such illusions depends not only on graphic or painterly invention, it also requires that the child become more perceptually differentiated. For to create a sense of depth or roundness to a visual form requires that one see the angle of a line or the curvature of a sphere in ways that differ from those used in ordinary perception. To paint a curved surface upon which light is falling one needs to note the soft reflected light on the underside of the curved surface to render the image convincingly. This is not to say that we would not recognize such an image on paper if it were painted or drawn without such a detail. Indeed, one of the remarkable capacities of the human is to go beyond the information given. We can take merely the barest suggestion, and in the appropriate visual context, make the appropriate inference regarding its meaning. This ability to produce visual meaning through the invention and organization of visual form is akin to the development of a visual code. The schemas form the letters and words of that code and their composition, its syntax or grammar.

Pictographic and Representational Art

The development of a visual code for the expression of visual meaning can be constructed along three lines: forms can be used as pictographs, they can be used to imitate the visual environment in which we live, and

they can be used to express emotion. Although these distinctions are clearer on paper than in the reality of visual art itself, the distinctions will serve our purposes if we use them as tools for analysis.

Pictographic art is used by very young children as a way of schematizing certain images, ideas, or objects they wish to represent. For many children younger than six or seven, especially in American culture, this mode of representation is often adequate for their purposes. For children of these ages the pictographic form is used as a "stand in," a substitute for what is seen or imagined, and little concern is expressed about the relationship between these forms and what they were designed to represent. The child generally appears to be satisfied even if his forms share only the slightest structural relationship to the form he wishes to draw or paint.

Representational art is, in part, an effort to create the illusion of the visual world in some material. The intention in this mode of artistic activity is not simply to employ a pictographic or conventional sign to represent; here, mimesis is intended. And because the intention of the child is one of imitating the visual world or image his task is considerably more complex than the invention of pictographic forms. In this mode the child must cope with all of the problems of perspective, light, shade, and color identified earlier. The successful resolution of these problems yields for the child an array of visual devices that becomes a part of his artistic repertoire and that he can employ when dealing with subsequent problems.

It is well to appreciate the fact that the achievement of the illusion of the third dimension was a late development in Western art, occurring in the fifteenth century. The invention of the necessary visual devices for rendering a three-dimensional quality to a flat picture plane was, according to Gombrich, "not so much a general desire to imitate nature as a specific demand for the plausible narration of sacred events." [51] Nevertheless, once the techniques necessary for such rendering were invented their diffusion from artist to artist, area to area, was rapid. These methods of visual illusion and imitation were not easily won. In a similar manner the child begins to grapple with the problems that faced artists of pre-fifteenth century Europe. Yet their problem was even more severe because these artists did not have even the models that are available through painting and photograph to today's child.

A third mode of artistic activity that is available to the child is emotive or expressionistic in character. Here the intention is neither the depiction of an idea or image through a pictograph, nor is it the attempt to imitate nature. This mode of activity invents and organizes form for the sake of

expressing feeling. Art objects produced with this intention frequently alter imitative forms for the sake of eliciting feeling from the viewer. Children's drawings, painting, and sculpture are frequently altered this way when they are creating under emotional conditions to be described later. Adult artists, especially those whom we call expressionists—Edvard Munch and Alexei Jawlensky, for instance—exemplify through their work this mode of artistic activity.

Let me reemphasize that the distinctions I have made are not to be considered water-tight compartments. It is clear that *all* visual form has expressive character to it and that all pictographic art is in some sense representational. What I have tried to do is to make distinctions that relate to emphasis rather than to mutually exclusive categories.

Let's turn now to the fourth factor that must be treated in the creation of visual form, that of organizing the particular visual forms employed. The problem of creating a drawing or painting, for example, is not merely one

Edvard Munch, "Separation," 1896, lithograph. San Francisco Museum of Art.

Alexei Jawlensky, "Head," 1913, oil on canvas. San Francisco Museum of Art.

of dealing with particular forms; it is also one of organizing these forms so that some cohesive whole is achieved. To deal with this task requires attention to the relationships that are established among each of the "separate" forms. It demands attention to the composition of the work. For children and for adults who are untrained in this aspect of perceiving visual form, there is a tendency to focus on forms in isolation of one another. That is, the child will attend to one problem in drawing, and after having completed it, will move on to the next problem within the same drawing. This type of activity Arnheim has aptly called the local solution, a tendency for the child to focus upon one section of the drawing at a time. Yet if the work is to function as a whole rather than as a collection of separate parts the total set of relationships between forms needs attention. This type of seeing and construction for purposes of aesthetic order, expression, or the creation of the illusion of depth needs to be developed. The child needs to learn how to attend to the interrelationship of the qualities he has created and to make on-going decisions in light of these qualities and the purposes he wishes his work to serve.

When one considers the number of qualities that can be attended to in a set of visual interrelationships one can begin to appreciate how complex such perceptual tasks are for those involved in the creation of art. In the task of looking holistically at an emerging painting or drawing, attention to color, value, shape, space, texture, and intensity as well as a host of other visual factors is required. The individual with much experience and skill in seeing visual form is apparently able to note these relationships almost automatically and, furthermore, is able to make appropriate decisions about them. For those without such experience and skill one must gradually learn to see these qualities. It is in this task of learning to see that the teacher of art helps the child expand his perception of the emerging work. The child's ability to manage the material with which he is working, plus his ability to employ skills in the invention and use of schema, when combined with an ability to see the emerging forms, make possible the creation of an aesthetically satisfying and expressive visual whole.

Let me recapitulate the major points I have tried to make in this chapter because they form the foundation upon which many of the arguments in the book rest.

First, I have argued that artistic development is not an automatic consequence of maturation but rather a process that is affected by the type of experience children have. In large measure, a child's artistic ability is a function of that which he has learned. Second, I have argued that in the

productive realm, the realm dealing with the creation of art forms, a variety of factors comes into play. One of these is the ability to perceive the natural environment and to imagine visual possibilities in the mind's eye. A second of these factors is the management of material so that it functions as medium, a vehicle through which expression occurs. A third factor includes the ability to invent schemas that will transform an image, idea, or feeling into an appropriate form within a material. In this sense the child's creations, both early and late in his career, can be viewed as visual codes through which his ideas, images, and feelings are rendered. As the child works with material and as his experience grows, he invents or learns to employ an increasingly wide array of techniques for rendering these schema with greater versatility. Finally, the child needs to learn how to see the forms he creates as part of a total and emerging visual configuration and to make decisions in light of these relationships. This means he needs to decentrate his vision, as Piaget would say, or to avoid what Arnheim has called local solutions.

Perhaps the central point underlying these notions is the realization of the cognitive-perceptual complexity inherent in both the perception and creation of art. Learning to perceive what is subtle, learning to overcome visual constancies, learning to construct mental images of visual possibilities and learning to construct such images in another material are not simple tasks. It is the particular province of art education to assume responsibility for fostering these aspects of human ability.

Thus far, I have identified some of the major factors that come into play in the creation of visual art. But as I indicated earlier, the productive realm of the curriculum is only one of three general areas in which artistic learning can occur. In addition to this realm, art education programs can develop the abilities that enable the child to enjoy and experience these forms we call works of art. This realm of artistic activity is called the critical, and although some of the factors that affect perception have already been identified for visual form in general, the perception of visual art forms makes special demands upon the viewer. It is to an identification of these factors that we now turn to understand what meaningful experience with works of art requires.

One question that can be asked of those who view a work is one of determining how the work makes them feel, What is the quality of life that

The Critical Aspects of Artistic Learning

the work elicits? For those without well-developed skills, works that deviate from customary expectations for art often elicit little response. Yet even the first meager reaction to a work can function as a starting point for further analysis. We shall see that a dominant function of any work of art is to do something to our experience; to affect us. The more we bring to the work the more we are likely to construe meaning from it. One frame of reference for attending to visual art is called the experiential dimension. This experiential dimension or frame of reference is one in which the child reports how the work makes him feel. These feelings might result from responses to the forms of the work as such or to the ideas generated by the forms. In either case the first responses to a work can serve as a starting point for further analysis. Now it should be emphasized that the function of analysis is not to perform an intellectual exercise but to heighten one's perception of the work. The experiential dimension—that dimension which asks a viewer to attend to how a work makes him feel—is one of several frames of reference that can be used in viewing a visual form.

A second frame of reference is the formal dimension of the work. In this dimension the viewer attends to the formal structure of the work; that is, he attends to the relationships existing among the particular forms that constitute the work. To view visual form in this way requires that one look, for example, at one area of color in relation to another to see how they interplay and affect one another. This way of viewing the work also may involve seeing the general composition of the work as a whole, how the forms are arranged, where open simple areas are used, and how, for example, they complement closed complex areas. The child or adult who looks at works in this way focuses on the organization of the component forms as a total configuration. He is less concerned with how these forms make him feel—something of prime concern in the experiential dimension —than with unwrapping the structure of the work. The question that dominates visual inquiry in this dimension is, How is the work put together?

A third dimension that can be used in the perception of works of art is the symbolic dimension. Works of art, both historical and contemporary, often employ symbols having special meaning. The use of the lamb in religious paintings as a symbol of the crucifixion of Christ, the use of mythological figures to symbolize fertility and war, are examples of how artists have attempted to encode meaning in the work not only through abstract form but by the use of symbols as well. When works of art contain such symbols adequate experience with the work requires that they be recognized and decoded.

Kurt Schwitters, *Geprüft* ("Censored"), 1940, collage. San Francisco Museum of Art.

Take as an example the collage by Kurt Schwitters. Here we find an old shopping bag stamped with seals and stamps of various sorts. One of the seals bears the insignia of the Nazi Wehrmacht and another the German word "Geprüft," meaning censored. Stamps from the Third Reich are affixed on the paper bag, as is a paper seal from Oslo.

The Nazi insignia, the word censored, and the frayed and torn shopping bag, as it might be if carried by a refugee from the Nazi holocaust, all contribute to the visual impact of the work. Imagine how the significance of the work would be altered if one did not know of the Nazi regime during the late twenties, the thirties, and the forties. To develop a powerful visual image Schwitters uses icons and images associated with the tragedy of people fleeing an oppressor. Perception of works of art requires, therefore, the ability not only to perceive complex and subtle qualitative relationships among the forms used, it also requires an understanding of the meaning of the icons used in the work.

Pablo Picasso, "Guernica," 1937, oil on canvas. The Museum of Modern Art, New York.

Related to the symbolic dimension is the thematic. The thematic dimension is concerned with an appreciation of the underlying general meaning of the work. For example, Picasso's "Guernica" is a black, white, and gray painting depicting distorted images of humans and animals. The expres-

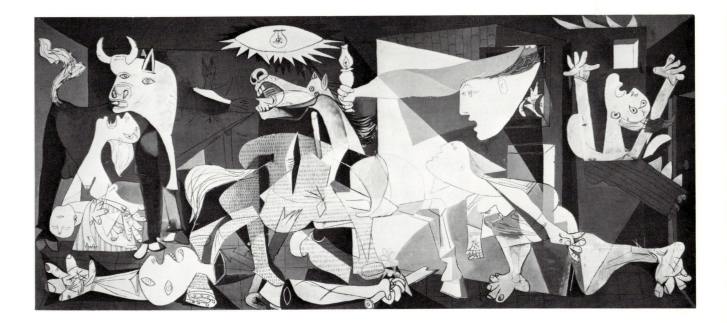

sive character of its forms tends to elicit sharp, active, almost painful experience. The theme of this work is not simply its formal structure or the fact that it contains animals and men. The painting's theme is war, men, pain, and cruelty. The idea or theme underlying the painting is what gave rise to the work. In this sense the idea or feeling underlies the image. The visual image articulates the idea and feeling of the tearing apart of life through war. Adequate perception of works of art demands some recognition of the underlying theme. Once understood, the theme then feeds back into the forms by providing a new matrix that confers new meaning to the forms.

The material dimension is another aspect of work that can be attended to. In contemporary art, especially, the selection of material is crucial, not only as indicated earlier because it makes particular demands upon the artist in the act of creation but because the choice of material—much wider a choice now than in previous generations—often is directly related to the type of visual meaning that the artist wishes to express. What is the contribution of the material to what the form conveys? How does the material affect the expressive content of the work? How would the work be altered if another material were used? These questions ask the child or adult to attend to the particular way in which the material sets limits, provides opportunities, and contributes to the nature of the visual experience. Jerold Ballaine's sculpture made of plastic that has been vacu-formed utilizes reflection and the peculiar quality of plastic for achieving its balloonlike effect.

The adequate perception of works of art requires attention not only to the five dimensions already identified, it also requires attention to the relationships of a work to other works of art. In the contextual dimension a work is seen as a part of the flow and tradition of the art that preceded it. Such perception demands an understanding of the tradition within which the work participates or from which it deviates. It is precisely this tradition that the naive viewer finds difficult to use. And it is this tradition, this understanding of context, that is so difficult to provide in a simple, short-answer manner. To understand the context of a work requires an understanding of the conditions that gave rise to the work as well as the way in which the work affected the times during which it was created. For example, contemporary hard-edge work is a part of a movement that emerged as a reaction to action painting, which was in full swing during the early and middle 1950's. The concern for precision, subtle color relationship, and presence, grew into an interest in optical illusion and hence into what is called "op art." To deal adequately with hard-edge and op art

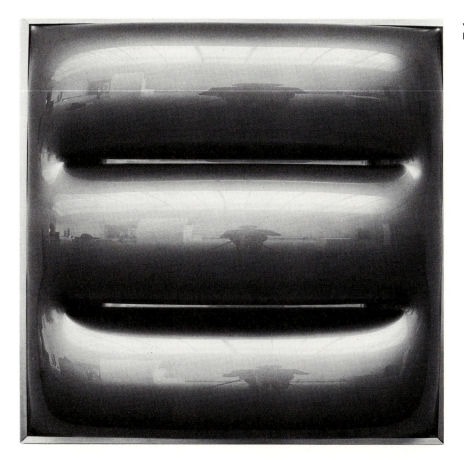

Jerold Ballaine, "Untitled," 1969, vac-form plastic. San Francisco Museum of Art.

requires an appreciation and understanding of the artistic context from which they grew. Experience with such works provides a background against which newly encountered works can be seen, compared, and contrasted. This background of visual experience with works of art makes it possible to note the ways in which the particular work deviates from those seen before. It also contributes to the funded visual experience that results from extensive viewing of works of art.

It should be noted that this aspect of the perception of works of art draws upon a comprehension of the history of art. Works of art are produced by men, these men live in cultures, and these cultures have available to them samples of previous artists' efforts. The tradition of the past,

therefore, serves as a base from which the artist works. His work reflects an effort to extend that tradition by working within its boundaries, yet pushing them forward, or by rejecting those boundaries and developing new ones. To appreciate the achievements of those in the arts at present therefore requires an understanding of its place in history.

5

empirical studies
of artistic learning

The previous chapter identified the areas in which artistic learning can take place, some of the theories that have been advanced to account for children's art, and the kinds of demands that work in the productive and critical realms makes. What is clear when one begins to analyze the factors that come into play in the production and appreciation of visual art is that its creation and appreciation is a complex cognitive-perceptual [1] activity that does not simply emerge full blown on its own. It is influenced by experience.

Indeed, the case I wish to make regarding the creation, appreciation, and understanding of visual form in general and visual art in particular is that this aspect of human ability can be considered a mode of intelligence. The case for considering artistic activity a mode of intelligence was advanced first by John Dewey [2] and later by writers such as Frances Villemain,[3] Nathaniel Champlin,[4] and especially David Ecker.[5] It is my task now to show why artistic ability should be seen in this light and to do this I will draw liberally upon ideas found in their work.

Artistic Action as a Mode of Intelligence

It was Dewey who first advanced the idea that intelligence was not the amount of "gray matter" in the cortex but the quality of an activity performed in behalf of inherently worthwhile ends. What this meant was that intelligence when properly conceived was a verb, a type of action, not a noun, not a quantity of something that someone possessed. For Dewey, intelligence was the way in which someone coped with a situation that was problematic.

Now if we use this general conception and apply it to art activity we will see that the child who paints, or draws, or sculpts is coping with a problem, one of finding ways to transform in some material an idea, image, or feeling he possesses. In this situation he encounters all of the problems identified in the last chapter. He faces, for example, a white sheet of paper and on this paper he must articulate a vision that conveys what he intends; he must be responsive to the consequences of his actions with material; and he must manage that material so that it functions as a medium, at the same time being aware of the happy (or unhappy) accidents that inevitably occur in the act of creation. While all of this is going on, he faces the problem of developing a sense of unity or cohesiveness in his work so that the work hangs together as a whole. In this situation he is coping with thousands of interactions among the visual qualities that emerge through his use of material and those he conceives as his artistic

purpose. This activity of his, because it deals with the visualization of qualities—that is, visual images—and because it is directed at the creation and control of qualities—color, line, shape, and so forth—is a mode of intelligence that operates in the domain of the qualitative. Hence, we can conceive of this type of activity as qualitative intelligence.

It was Dewey who said in *Art as Experience,*

> Any idea that ignores the necessary role of intelligence in production of works of art is based upon identification of thinking with use of one special kind of material, verbal signs and words. To think effectively in terms of relations of qualities is as severe a demand upon thought as to think in terms of symbols, verbal and mathematical. Indeed, since words are easily manipulated in mechanical ways, the production of a work of genuine art probably demands more intelligence than does most of the so-called thinking that goes on among those who pride themselves on being "intellectuals." [6]

What Dewey was suggesting here is that the problem of selecting qualities and organizing them so that they function expressively through a medium is a consequence of intelligent decision-making in the realm of the qualitative. What is mediated through thought are qualities, what is managed in process are qualities and what terminates at the end is a qualitative whole, an art form that expresses something by virtue of the way in which those qualities have been created and organized.[7]

Although schooling tends to lay primary emphasis on the use of verbal language for the mediation of thought, it should be clear that thinking is not limited to verbal operations. To organize sound as a composer does, to organize body movement as a dancer does, to organize visual qualities as a painter or sculptor does are also processes directed by thought, the difference being in the nature of the material used and in the character and appraisal of the product. For discursive language, logic is one of the criteria applied to appraise its meaning. For work in the arts, other criteria are applied. In each domain of human activity, however, humans make decisions and the products of their decisions are appraised.

What is also clear is that qualitative intelligence, as distinct from what might be called discursive intelligence, is employed in the widest spectrum of activities in living. Indeed, whenever we make decisions about the selection and organization of qualities, whatever they be, in the decisions about the furnishings of our home, the clothes we wear, the meals we serve, or how we choose to relate to people, we exercise this mode of intelligence.

When intelligence is considered in this way it becomes not simply a capacity given at birth and once and for all programmed into the genes; it becomes a mode of human action that can grow *through* experience. Intelligence in this sense is capable of expansion and through such expansion our consciousness of the world and the meanings that world can provide us also expand.

This conception of the process through which the perception and creation of form is achieved is in marked contrast to the concept of talent so pervasive in thinking about people with high-level ability in an area. Especially in the arts has this concept caused so much mischief. Whereas one would not want to deny that some people have great ability in an area of study or practice, the concept "talent" has all too often been conceived of as a dichotomously distributed ability, something that one either has or does not have. Yet there is hardly a human ability I can name that is so distributed. The overwhelming majority of man's abilities are developed in different degrees.

The major mischief, however, that the concept talent has caused in our thinking about artistic ability is that of being used as a cover-up, a way of explaining away feckless programs of art education. If a child displayed imagination, sensitivity, and skill in his work in art he was said to be talented; if he didn't he was said to be untalented. But if one conceives of artistic ability—whether it be in the productive or critical realms—as a consequence of qualitative intelligence, and if one views such ability as, in part, the product of educational experience, then the door is left open to ask how such intelligence can be developed.

The conceptualization of artistic ability as a product of qualitative intelligence has another important implication for education. It significantly broadens what we consider to be human thought. For many, the arts are seen as outlets for the release of affect. If one conceives of artistic activity as catharsis, the mere expression of emotion, and if one conceives of education as the process through which thinking is fostered, it is clear that the arts will, under such a conception, be considered peripheral to the major mission of education.

In short, the tendency to separate art from intellect and thought from feeling has been a source of difficulty for the field of art education. Such a conception does justice to neither art nor education. Artists are thoughtful people who feel deeply and who are able to transform their private thoughts, feelings, and images into some public form. Because the ability to do this depends on the visualization and control of qualities, it may be conceived as an act of qualitative thought. As a process of using qualita-

tive thought to solve qualitative problems, such a process can be conceived of as depending on the exercise of qualitative intelligence.

But what does such a conception imply for understanding children's art? What does it do to our beliefs regarding the development of, say, children's drawings?

As I have already indicated, the most widely held view of children's art is one which argues that children go through naturally ordered stages in their work in art and that these stages are the result of a natural unfolding of a genetically determined perceptual program. Some writers have held that children's art is a system of developing symbols that emanate from, and therefore are related to, the earliest visual symbols designed by primitive man.[8] In this theoretical view the existence in the child's mind of certain archetypical forms that are inherited from past generations affect and, in a significant measure, account for children's art.

The view I wish to argue is that the characteristics that children produce in their drawings and sculpture are products of both purpose and skill. When coping with a problem, the child, like the rest of us, brings to bear upon it those technologies of mind that seem to be relevant to its solution. When children have similar experiences the general character of these technologies and the characteristics of their products tend to be similar. These characteristics, when viewed as a group, have been called stages of development in children's art. But such "stages" are simply an indication of what children usually produce when left to their own devices. Indeed, Dale Harris has pointed out that,

The stages are merely convenient ways of describing perceptibly different orientations and organizations of the drawing act as the child moves from his first pencil strokes to quite elaborate productions. That different investigators have located similar stages, that these stages can be established against an age scale, and that the succession is notably similar for most children, has been sufficiently well validated to establish the usefulness of the concept of stages or phases in describing the course of development. Most investigators, certainly, have noted that the aspects which set off one phase from the next can be discerned only by looking at the "middle" of the period covered by the phase, or by constructing an artificial or idealized example that contains the several most common or characteristic features a child might include at this stage.[9]

What we have then when we talk about stages in children's art are midpoints or modal characteristics found in the art work of children at various ages. But what can be concluded from such typical patterns? Do we conclude that because there are typical types of characteristics associated with children's art at various age levels these therefore are natural, hence

good? I think such a conclusion is faulty. For it is precisely the responsibility of teachers in particular and of education in general not simply to observe development but to foster it. This is done, in part, by making available to children the ideas, skills, and products that are a part of their cultural heritage. These products become, through a process of learning, a part of the intellectual and aesthetic repertoire from which the child may select options for action. Thus, rather than assume that what the child is able to do without the benefit of sympathetic and effective teaching is sufficient, I assume that what we are interested in is just the opposite. One major educational problem in art education is to determine how far we can help the child develop. As this development takes place, his ability to cope with the creation and appreciation of visual form increases, and hence his qualitative intelligence grows. Problems once solved in the qualitative realm yield skills and ideas for the child which become part of the resources he can draw upon in coping with other problematic situations in the qualitative realm. In short, the child's ability in art grows as he learns to cope increasingly more effectively with the problems of art.

The most effective ways in which such intelligence can be fostered are not well understood. One of the ways in which investigators have tried to find out about the factors affecting learning in art is through research. This research has taken the form of descriptive studies—studies aimed at describing systematically and objectively the characteristics that are found in children's art, and experimental studies—studies that attempt to find causal relationships between curriculum and teaching, and what children learn as a consequence.

What have researchers learned about children's art? How can artistic learning be fostered? What practices appear useful for what students? First, we will examine some of the generalizations that have been made about children's art and then we will examine how it might be influenced in the classroom.

**Empirical Generalizations
Concerning Children's Artistic
Development**

1. *The characteristics found in children's art change in relation to the child's chronological age.*

This observation, one that has been noted for years and that is observed clearly by parents and teachers, simply indicates that the visual techniques children employ in their work changes in a more or less systematic fashion as a child gets older. As already indicated, this observation has

led to the belief that since these changes occurred "naturally" children should not be influenced by instruction. The natural development or evolution of the child's art work has been considered normal, hence good. Artistic development considered as a type of learning views these similarities as techniques that the child has learned, often on his own, in order to cope with the problem of formulating his images, ideas, and feelings in a material. When left to their own devices, most children at various age levels tend to employ similar techniques for dealing with such problems.

2. *The level of complexity in children's art increases as children mature.*

This observation like the previous one indicates that as children get older the array of techniques, both perceptual and productive, increase. This increase in technique allows the child to deal with a wider array of qualities and to treat them more comprehensively in his work in art.

It should also be emphasized that as a child gets older his purposes in art also begin to change. For preschool children art forms are often used to communicate or represent ideas. A drawing, for example, needs to be only as complex as necessary to communicate the idea the child intends. Children's work at this age tend to be pictographic. However, as a child matures, his purposes expand from not only wishing to represent an idea but of rendering the forms which carry these ideas in ways that adequately imitate the forms of the world. When this occurs, emphasis shifts from pictographic to representational painting and drawing.

3. *The sense of cohesiveness or Gestalt quality in drawing increases as children mature.*

One of the problems that anyone faces when using a material to achieve some artistic end is to produce a form that holds together visually as a unit. To do this requires, at minimum, attention to the emerging relationships that are established as forms are produced. Such perception is decentrated in character; the individual form is seen in context, in relation to the ground that it occupies. As children become more skilled perceptually and graphically the ability to decentrate their perception increases and their ability to think in terms of relationships among qualities increases. With such ability their work tends to be more unified, in general, than work produced by children who are younger.

It might be pointed out here that attention to the placement of forms within a field is an exceedingly important artistic skill. In portraiture or figure drawing, for example, art students learn to attend quite carefully

Plate 6. This watercolor of a seascape demonstrates high-level accomplishment in painting. The transparent potentiality of watercolor has been recognized and employed in this painting, especially in the water and the sky. In addition, the nine-year-old boy who painted this work understands how to employ dark values such as is used in the trees against lighter values to differentiate visual forms.

Plate 7. This is an example of line exercises
characteristic of one of the drawing tasks in the
Stanford Kettering Curriculum Development
Project. The activities represented by this task
are intended to enable children to acquire skill
in the handling of the felt-tip pen, to discover a
range of techniques that can be employed with
it, and to encourage them to think about the
design elements that can be created through
the variation of line. This exercise is considered
instrumental to other more expressive activities
which follow these exercises.

Figure 3. The effect of ground on the visual impact of the figure.

Figure 4. The effect of ground on the visual impact of the figure.

119

to the relationships they establish between the figure and its background. To observe the important function that such placement performs on our experience with visual art compare Figures 3 and 4.

4. *Children tend to exaggerate those aspects of a drawing, painting, or sculpture that are most meaningful to them.*

The analysis of children's art work indicates that quite frequently the shape or color of forms created are exaggerated in size or intensity when they are considered important to the child. This occurs, probably, because those ideas or objects that are considered important, those that are emotionally loaded, tend to be created first, and because interest in the relationships among forms and the expressive and aesthetic character of the whole work is learned relatively late in the child's artistic development.

5. *Children create works that emphasize pictographic purposes during late preschool and early primary years and later expand these purposes to problems of representation.*

This observation, already discussed in previous chapters, has, like some of the other generalizations, been observed by earlier investigators. The child of four or five years of age generally includes only as much detail in his drawings as he needs to communicate the ideas he holds. As his perception and skill develop, his intentions shift and he becomes interested in the creation of illusion or representation. Children of eight, nine, or ten are often dissatisfied with their lack of the skills necessary for rendering an image convincingly in a material. Such dissatisfaction is seldom displayed by preschool children, not because preschoolers don't see the difference between their drawings of a figure and how human beings look but because their purposes differ.

6. *The scribbles that preschool children make tend to be motivated by the kinesthetic and visual satisfaction emanating from their actions.*

Observations of young children between one and four years of age suggest that one of the primary motivations a child employs in the act of scribbling is one of receiving stimulation, both kinesthetic and visual, from the tracks his actions leave on paper or in clay. Children's activity with these media suggests that the pattern and tempo of movement shift in order to vary the stimuli. Such variation of movement proves stimulating since it eliminates redundancy and at the same time affects the quality of the line, for example, that results from this activity. At times the visual

character of a child's work will be neglected by the child—he will look elsewhere while working—and attend primarily to the experience of arm, wrist, and finger movement.

7. *The types of shapes that children are able to produce are related to their age.*

Read,[10] Kellogg,[11] and others [12] have found that the type of shapes that preschool children produce is associated with their age. For example, the drawing of circular forms precedes the drawing of a square. The drawing of a square precedes the drawing of a diamond. The reasons for this sequence of visual pattern has been explained in several ways. Kellogg argues that these patterns are a part of the inherited psychological constitution of the child, that the patterns created—the mandala, for example—are associated with the religious symbols that man has created and that these symbols may be found in children's drawings in all parts of the world. Kellogg and especially Read, interpret the commonalty of such forms as evidence of the common humanity of man and the emergence of those characteristics of mind that reside in the human's collective unconscious.

A more plausible interpretation of this phenomenon is simply that children tend to draw simple forms before those that are more complex because they need time and experience to acquire the skills necessary for creating complex graphic images. The drawing of a complex shape, a hexagon or three-dimensional square, for example, requires both perceptual and productive skills that young children have not as yet acquired. When these skills are acquired, either through discovery, invention, or instruction, they are able to produce those forms and a host of others as well. The similarity in pattern among the sequence of forms children can draw is a function, I believe, of similarity of experience in drawing and of the complexity of the forms that they can draw.

8. *The degree of differentiation created in children's drawings is related to their conceptual maturity.*

This observation, related to the previous generalization, has perhaps had the greatest degree of substantiation from the work of Florence Goodenough and Dale Harris in their effort to construct a test of intelligence. The Draw a Man Test, invented in 1926 by Goodenough and subsequently revised and improved by Dale Harris, is based on the premise that the number of details in a child's drawing of a human figure is an

indication of the extent to which he has been able to form concepts. Each detail is an instance of concept formation. The degree to which such concepts are formed and used in children's drawings of the human figure is, for Goodenough and Harris, an indication of the child's intelligence.

Validation of this assertion is made by correlating scores children receive on the Draw a Man Test and the scores they receive on standard tests of intelligence. The correlation coefficients between such tests indicate that the association between the scores is far higher than what would be expected to be found by chance association.

9. *Drawing and painting tend to serve different purposes for the young child; the former being used for the expression of ideas, the latter for the expression of feeling.*

According to Rose Alschuler and La Berta Hattwick,[13] the child's use of paints tends to be more affect-laden than his use, say, of pencil or crayon on drawing. According to these investigators, the characteristics of paint, their fluid, vivid qualities, elicit more emotional responses and uses than do pencil or crayon drawings, whose character lends itself to control and premeditation. Thus, they observe, if one wants to gain insights into the personality of the child, especially that aspect of personality that relates to how children feel, painting is a more appropriate mode than drawing.

10. *The use of form, color, and composition is related to the child's personality and social development.*

Alschuler and Hattwick also point out that the colors, forms, and composition that a child uses are not accidental but emanate from his feelings about himself and the world.[14] The research they have done, as well as work being done in the field of art therapy, rest upon the assumption that sound inferences about personality can be made from the content and form of children's painting.

It should also be pointed out that these observations need further substantiation through rigorous research. Some writers such as Goodenough and Harris claim that the more rigorous the study the less reliably personality can be assessed through the work that has been produced.[15]

11. *Children living in different cultures create visual forms having remarkable degrees of similarity, especially at the preschool level.*

It has been observed by individuals who have seen the art work of

children living in different cultures that the characteristics of their work are quite similar and that the similarity decreases as children get older. This observation is not surprising. As culture has increasing opportunity to affect the child, the character of his perception and skill will be changed. As culture differs, differences in the child's art also emerge with increased force. This observation, it seems to me, is evidence to support the impact of environment upon artistic learning. Infants are similar in all parts of the world precisely because the environment has had so little opportunity to affect them. As its effects are felt, the character of the individual's behavior, including his language, belief system, and aesthetic preferences, is also altered. In short, the more differing environments come into contact with individuals the more different they are likely to become.

12. *The human figure is the most common subject matter drawn by school-age children.*

Frequency distributions made of the subject matters used in the drawings of children have shown that among those subjects the human figure is the most popular. If we assume that children tend to draw what is most important to them it should not be surprising that people rank the highest. As children become visually sophisticated and begin finding meaning in the visually subtle, the content of their art is likely to change. Thus, children who find interest in the visual landscape and who have skills to work with, are likely to do more landscape painting and drawing than children who do not have interests in this area.

13. *When drawing, young children tend to neglect a model or still life even when it is placed before them.*

It has been pointed out by Earl Barnes [16] as early as 1893 that when drawing a still life children do not use visual cues in a still life set-up. This observation of the way in which children draw tends to support the thesis that for young children the desire to draw a symbol, a pictographic represenation of a form takes precedence over the need to construct a form that imitates a visual object. Indeed, even for art students of college age the need to learn how to see form is a skill which they slowly learn to acquire. For young children the image in the mind's eye—which is usually an image that is both simple and unambiguous—the drawing skill he possesses and the purpose he holds when drawing lead him to neglect attending carefully to an object before him, even when he is asked to draw it.

14. *Drawing skills tend to be arrested at about the period of adolescence.*

Goodenough,[17] Harris,[18] and Lowenfeld [19] have all pointed out that children's ability to draw or paint does not develop much after adolescence, except when teaching or self-instruction take place. If the drawings of college students or middle-aged adults are mixed together with those made by 14- or 15-year olds, it is extremely difficult to select those made by the high-school age group. This is not surprising. The ability to draw or to design well, as indicated earlier, is a complex skill and there is no good reason to assume that such skills develop on their own. Like most complex skills they are developed only so far under the natural course of ordinary experience. Development beyond that provided by such experience requires concerted effort or instruction. Thus, with respect to productive skills in the visual arts most adults' ability is equal to that of a 14- or 15-year old.

15. *During the preschool and early elementary ages children tend to focus on forms to be drawn exclusively with little regard to the larger context or visual field in which they are to function.*

The concepts "local solution" and "centration" developed by Rudolf Arnheim and Jean Piaget respectively refer to the tendency of the child not to focus on the way in which a form will influence or be influenced by other forms in his work. This tendency is not uncommon even among adults who have little experience in an area. It can be seen in misguided efforts by inexperienced interior decorators to buy the "wrong" sofa for the right room. It can be seen by the all too common experience of students in beginning lettering who find that they have run out of the space they need to complete the letters of a word on a sign. Decentrated vision is the ability to see the particular in relation to the whole. As such, it is a complex skill. Young children tend to focus on the particular and to make decisions in the qualitative realm with respect to it. Only later, when more experience is obtained and learning acquired, are these decisions made on a more contextual basis.

16. *No significant sex differences in skill in the productive realm has been found.*

Systematic studies of the drawing character of children's art have yielded no findings that indicates significant sex differences in skill. Research studies by Barnes,[20] Lewis,[21] and Eisner [22] found that in the drawings by boys and girls, on the average, performance was at about the same level during the elementary school years. Although there is some difference

between the subject matters that boys and girls draw, their ability to deal with those subject matters are comparable.

This finding of a lack of significant difference between boys' and girls' skills in the productive realm does not hold for their performance on measures of information or attitude toward art. In a series of studies conducted by Eisner [23] and by those who have used the Eisner Art Information and Art Attitude Inventories, girls from about the seventh-grade level and beyond consistently received higher scores than boys. The reasons for these findings and this aspect of development in art will be discussed more fully later.

17. *Children tend to prefer art forms which are visually unambiguous in character and which are related to their level of drawing ability and their age.*

Lewis [24] has found that elementary school children, when asked to select the drawing that they like best, tend to prefer drawings which are somewhat more realistic in character than those that they are able to create. Children do not tend to give greatest preference to those drawings that are the most realistic but rather to those that are only somewhat more realistic than those they are able to create themselves. The reasons for this are not clear although it suggests that young children especially prefer less visual information than they receive from a highly realistic picture. Because young children attend to pictures not primarily to appreciate their formal organization but as sources of ideas, they need, apparently, only as much detail as is necessary to secure such information. In short, illustrations may function as pictographs rather than as forms to be attended to aesthetically.

When one considers the extent to which the characteristics of children's art have been described by art educators and psychologists it is surprising to find so few efforts to objectively appraise its development under typical conditions. Two efforts to make such an appraisal have been undertaken by Lewis and Eisner. In terms of typical patterns of children's ability in the production of visual art a host of interesting questions can be asked. For example, one might want to know if sex differences exist in the rate and pattern of such development; one might wish to know if children from different socio-cultural groups display similar rates and patterns of development; one might wish to know if the range of ability or development at each age level increases or decreases as children get older. In the area of reading, for example, it has been found that as children proceed in school the range of reading ability in a typical classroom

tends to increase.[25] Thus, at the fourth grade there is a four-year range of reading ability (some children will be reading at the second-grade level, others at the sixth-grade level); at the fifth-grade level, there is a five-year range; at sixth grade a six-year range, and so forth. Do similar patterns emerge in children's drawing abilities? Until quite recently data necessary for answering this question and others were not available.

To answer the questions just posed, as well as others, I conducted a study of the developmental drawing characteristics of culturally advantaged and culturally disadvantaged children.[26] The major purposes of the study were to develop a scale that could be used to rate children's drawing with respect to their ability to create the illusion of space through the use of overlapping forms, and to determine, once such a scale was constructed, what differences in pattern or rate of development existed between children living in radically different environments.

To achieve these purposes about 1,300 students in grades one, three, five, and seven were selected. Half the group came from upper middle-class families living in well-manicured communities in suburbia. The other half came from low-income families (a substantial proportion were receiving aid to dependent children) living in a ghetto of a large midwestern city. Each of the children was asked to create a crayon drawing depicting what they do on the school yard either before school, after school, or during recess. To stimulate them the teachers made available to the children new boxes of crayons and papers and provided the task in a story setting.

The major motive for the study—aside from my desire to develop a scale that could be reliably applied to study the development of children's drawings—was the wish to test my belief that in the area of drawing, children who were disadvantaged in academic-discursive areas might not be disadvantaged. Indeed, I wanted to test my belief that their drawing ability might even be more advanced than that possessed by children coming from upper middle-class homes.

The reason for the belief was that my contact with children living in ghettos suggested to me that this environment was visually rich and that in many ways the visual complexity and pulse of such environments was more conducive to the development of visual sensibilities than what is available to children in neat, quiet suburbia.

**The Developmental Drawing
Characteristics of Advantaged and
Disadvantaged Children**

After the crayon drawings had been collected, two art teachers used a scale that I had developed to classify the drawings. This was done by mixing all the drawings randomly and having each judge, independently, rate the drawing on a scale of from 1 to 14, according to the characteristics it displayed. The ratings were then compared and the ones on which the judges disagreed were reviewed once again, this time jointly to determine if the difference was a matter of oversight, fatigue, or in fact was a genuine difference of opinion regarding the category in which it belonged.

This procedure made it possible to answer a variety of questions about the scale and about the development of children's art. First, I found that the independent agreement of the judges reached a level of 72 per cent. Judges using a fourteen-category scale assigned 72 per cent of the drawings to the same category independently. When one considers that a random assignment by two judges to fourteen categories would only bring agreement on 7.5 per cent of the drawings, the level of agreement achieved is significant. When judges had an opportunity to confer about the drawings on which they disagreed, about 95 per cent of the drawings were agreed upon. When the data from those agreed upon assignments were analyzed I found that the placement of the categories in the scale, in general, corresponded to the age levels of the children. For example, 21 per cent of the first-grade students produced drawings that were assigned to Category 1 by judges, whereas not one seventh-grade child's drawing was assigned to that category. At the end of the scale, 7 per cent of first graders' drawings were assigned to Category 13, compared to 37 per cent of those made by seventh graders. In short, the general placement of the categories was consonant with the empirical findings. See Figure 5 for a visual description of the categories of the scale.

When the drawings of boys and girls were compared at each grade level no significant sex differences were found, supporting the findings of previous investigations. One of the major goals of the study was to determine what differences, if any, existed between children from advantaged and disadvantaged backgrounds. To detect these differences, the drawing scores of each group at each of the four grade levels were compared. When this was done several interesting findings emerged. First, it was found that on the average children who came from advantaged communities tended at all grade levels to be more advanced in their ability to create visual depth through the use of overlapping forms than did children from ghetto areas. The finding was contrary to what I had thought—and hoped—might be true. You will remember that I conjectured that children

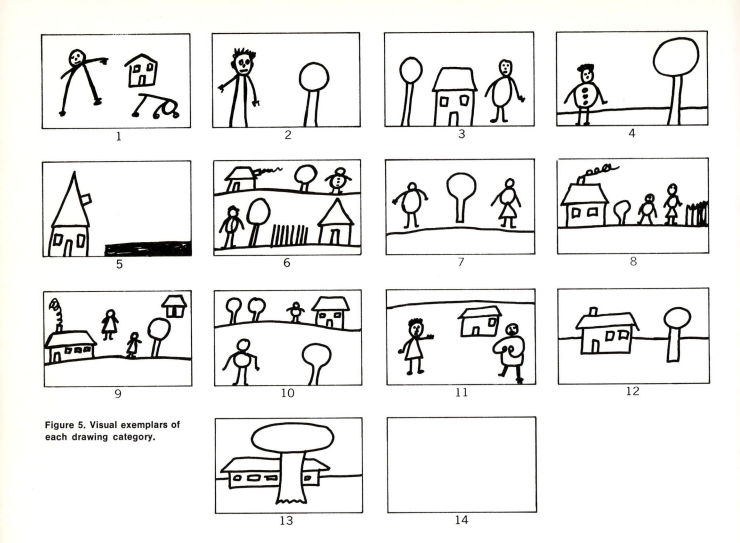

Figure 5. Visual exemplars of each drawing category.

living in ghetto areas have a richer, more diversified qualitative environment in which to live than do the children of suburbia. I reasoned that this might enable them to see more and, hence, be as able or more able in drawing than children from the so-called advantaged group. What was found was that on the variable measured, namely the treatment of space, children from disadvantaged backgrounds are so far behind their more advantaged counterparts at the first grade level that it takes, under present school conditions, until the fifth grade for their average achievement in drawing to rise to a level achieved at the first grade by the advantaged group. See Tables 1 and 2 for statistical data.

A second finding of interest is that the variability at each grade level for each group tends to decrease as children get older. This means that just the opposite of what occurs in reading performance occurred in this study. Children's abilities at the first-grade level in drawing were more heterogeneous than were those at the third-grade level; third graders were more heterogeneous than fifth graders, and fifth graders were more hetero-

Table 1. Means and Standard Deviations of Drawing Scores for Subjects Split by Socioeconomic Status for Total Population

	Lower Socioeconomic Status	Upper Socioeconomic Status	t	D.F.
Drawing Score	6.99	9.65	10.30*	1091
	Standard Deviation 4.27	Standard Deviation 3.70		

Source: Elliot W. Eisner, *The Development of Drawing Characteristics of Culturally Advantaged and Culturally Disadvantaged Children,* Project Number 3086, U.S. Department of Health, Education and Welfare, 1967.
* Significant at the .01 level of probability.

Table 2. Means and Standard Deviations of Drawing Scores by Grade and Socioeconomic Status

Grade	Lower Socioeconomic Status		Upper Socioeconomic Status		t	D.F.
	Mean	Standard Deviation	Mean	Standard Deviation		
1	5.56	4.23	7.69	4.16	4.03*	323
3	6.04	3.71	8.20	3.89	4.88*	342
5	8.93	3.94	11.07	2.65	4.78*	257
7	10.70	2.98	11.66	1.85	2.52*	163

Source: Elliot W. Eisner, *The Development of Drawing Characteristics of Culturally Advantaged and Culturally Disadvantaged Children,* Project Number 3086, U.S. Department of Health, Education and Welfare, 1967.
* Significant at the .01 level of probability.

geneous than seventh graders. In short, the older children become the less they differ in ability on the variable measured in this study.

A third finding of interest is that unlike other studies that have compared advantaged and disadvantaged performance in academic areas of study the differences between the two groups become smaller rather than larger, as is usually found. The largest difference in the performance of advantaged and disadvantaged children in this study was at the first-grade level and was about a two-category difference, at the third grade the difference was also two categories, at the fifth grade it was also about two categories, and at the seventh grade less than one category difference existed between the two groups.

What happened when the performance of the two groups was compared is that the advantaged group reached a plateau at the fifth-grade level and did not make much of a gain for two years, after which the disadvantaged group, although far behind at grade one, continued to make progress through grade seven and, hence, almost caught up.

Why this should happen is something about which it is interesting to

speculate. The teaching of drawing, especially the technical ability to create three-dimensional illusion on a two-dimensional surface, is not common in the elementary school. These techniques are difficult to acquire under self-instruction. What I believe accounts for the reduced gap between advantaged and disadvantaged students is that without the appropriate instruction, development in technique dealing with the illu-

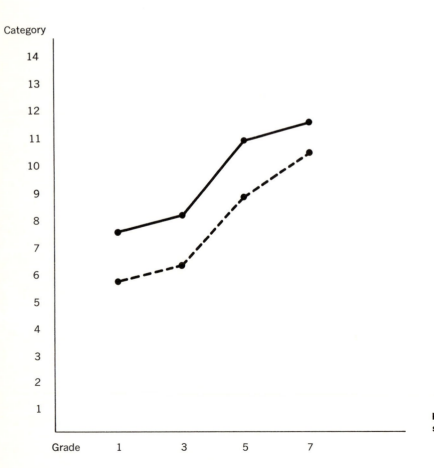

Figure 6. Drawing score means by grade and socioeconomic status.

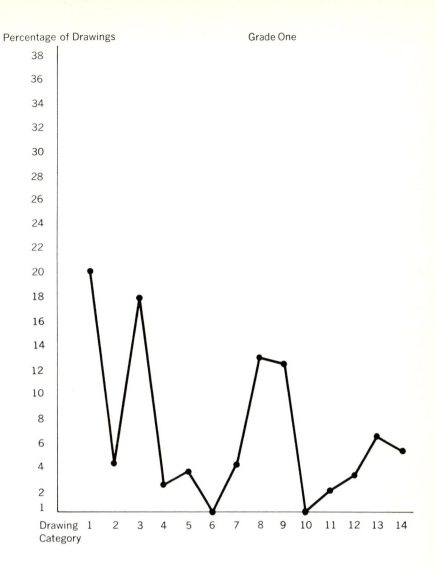

Percentage of Drawings — Grade One

Figure 7. Percentage of drawings assigned to each category, grade one.

sion of space in drawing did not occur markedly. But because the disadvantaged group had a longer way to go, so to speak, and because they had the time and practice to make gains in skill they did so, thus almost reaching the level of the advantaged group, which had a head start when they entered first grade.

This situation is in ways analogous to the task of learning to walk. At about eleven months of age there is considerable variance among children with respect to their ability to walk. At sixteen months there is little or no variance. Almost all physically and mentally able children can walk at this age. Furthermore, even those who had not begun to walk at one year are doing so at sixteen months. Thus, with more time and practice children who once were "behind" catch up to those who are "fast." With the acquisition of complex skills individuals will generally develop them to some normal or typical level, but will not develop them beyond this level unless there is a special need or desire to do so and unless the oppor-

131

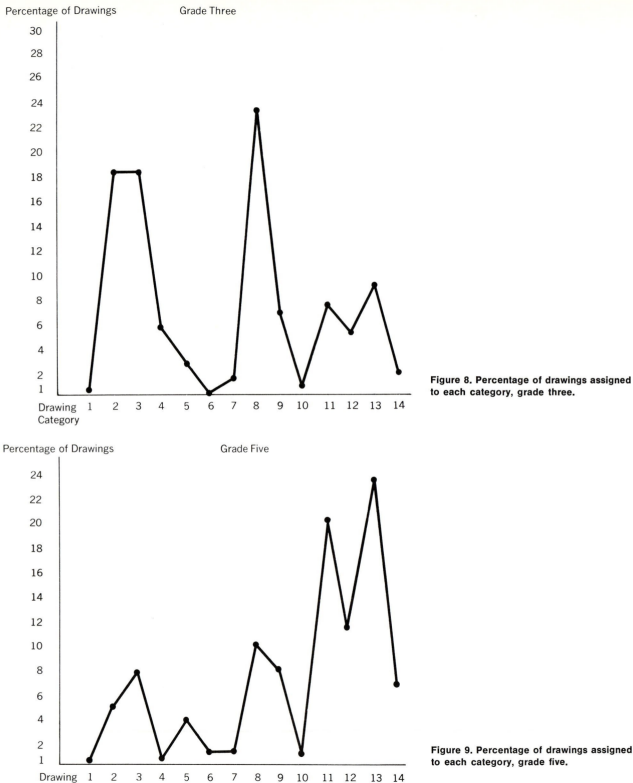

Figure 8. Percentage of drawings assigned to each category, grade three.

Figure 9. Percentage of drawings assigned to each category, grade five.

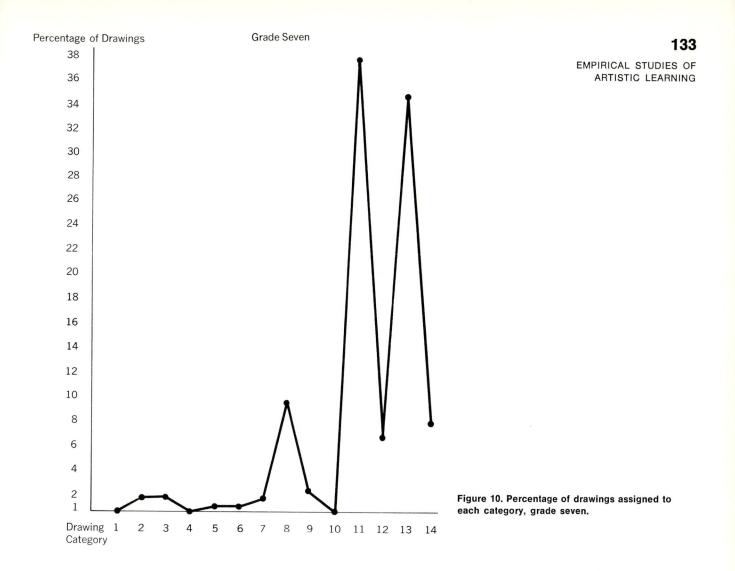

Figure 10. Percentage of drawings assigned to each category, grade seven.

tunity to learn to develop such skills is made available. I believe it is this phenomenon—the fact that drawing skills are developed up to a typical level—that accounts for the general reduction of difference between the groups studied. For a graphic presentation of the patterns of performance of these groups see Figures 6, 7, 8, 9, and 10.

In another study of the relationship between drawing and the environment in which children live, Lourenso, Greenberg, and Davidson [27] have attempted to analyze the drawings of the family made by 111 children from five fourth-grade classes in a severely depressed urban area. By asking the child to circle his "self" in the drawing and by analyzing the presence of hands, the proportion of the head to the body, the clothing drawn, and the facial expression, they were able to compare differences between students grouped by sex in relation to good, average, and poor Metropolitan Primary Reading Test scores. The striking finding of the study was that poor-

achieving boys, unlike poor-achieving girls, draw a "self" in which some major part of the body such as the head, trunk, limbs, hands with fingers, or feet are omitted. Ninety-three per cent of the boys omitted one or more of these parts as compared to 70 per cent of the poor-achieving girls. The authors explain this difference in relation to the research evidence, which indicates that Negro girls have better opportunities to develop a positive self-concept than do boys. And in general girls, for all groups, had higher scores indicating more positive personality development.

Research on the Critical Aspects of Artistic Learning

As I have already indicated, the development of qualitative intelligence with respect to the creation of visual form is one, but only one, aspect of artistic learning. This area, called the productive, is complemented by the critical and cultural realms of artistic learning. Because historically the productive realm has received the most attention by art education, it is not surprising that the bulk of empirical research in art education should deal with performance in that area. Nevertheless, the desire to expand the content and goals of the field has become extremely important since 1965 and research on learning in the critical realm is slowly beginning to develop. It will be useful now to examine some of the issues and research in the critical realm before moving to the cultural realm.

By learning in the critical realm of the curriculum two types of abilities are implied. First, it means that through programs in art education the visual sensibilities will be developed to the point where children are able to see qualities and their relations with respect to their aesthetic and expressive character. This means that children will be able to respond aesthetically to visual form—especially works of art—in ways that are aesthetically grounded. A second type of ability that learning in the critical realm implies is the ability to describe appropriately the qualities that constitute visual form. This ability is perhaps best exemplified by the art critic. His task is one of not only being responsive to the visual character of the works he confronts, but also of being able to aptly describe them. His task deals with the magic of rendering visual form into verbal language. This does not imply that what the critic does is to find linguistic equivalents to visual form. There are no equivalents. It means that he uses language—often poetically—to suggest qualities and to provide cues that will enable the more naive viewer to find meaning in the work. To do this

the critic often uses metaphors—terms that take one beyond the literal through suggestion. Max Kozloff, a contemporary art critic, writes of his work this way: "For this [art criticism] the most appropriate devices at my disposal have been innuendo, nuance, and hypothesis, because what is peripheral to direct statement in language is often central to a pictorial encounter or its memory." [28] As an example of such devices he offers the following statement, "about the surface of the late Bonnard landscape . . . overall, there emerges an unheard of miscegenation of touches—resembling peach bruises and handkerchief dabs—that characterizes the florescent, watery spectacle as some slightly polarized or overexposed color film." [29]

What we see here is suggestion and illusion through the use of words to help the viewer enter the work. For children the development of skills in the critical realm implies ability to see both the primary and secondary surface of the work—both its formal organization of qualities and the expressive character of those qualities, and the ability to describe those qualities appropriately.

One might ask how one knows when such description is appropriate? How can one evaluate the remarks that students or professional critics make about visual form? The answer to this question can be found by examining the extent to which such comments vivify the experience one has with the form to which those words are directed. The end of criticism is, as Dewey indicated in *Art as Experience,* the re-education of the perception of the work of art. The critical remarks that are made about works of art and about visual form in general are, therefore, to be evaluated by their effects: namely, the extent to which they open up the form for deepened experience.

It should also be noted that the critic's job is not so much one of passing approval or disapproval on a work, but rather of helping others see it more completely. All too often, premature judgments of good and bad are made about visual form without adequately attending to the qualities of the work.

Do the abilities in the critical realm fall under the general conception of qualitative intelligence described at the beginning of this chapter? The answer to that question is emphatically yes—and on two counts. First, the ability to experience the qualities that constitute a form is itself an act of qualitative intelligence. Seeing, as I have indicated earlier, is an achievement not a task. If the *aesthetic* perception of visual form occurred automatically, the need to try to develop it through educational programs would be superfluous. It is clear that without the appropriate set, cues,

and experience such an ability has a very low probability of development. To see qualities aesthetically is to have learned how to do so.

The second count on which the critical abilities identified earlier depend on—the exercise of qualitative intelligence—deals with the ability to use language artfully, poetically, and suggestively. You will recall that the critic does not provide merely a literal description of a visual form, he goes beyond that. He uses language—especially metaphor—as a vehicle for entry into the work. The ability to see the qualities that constitute the work, to appreciate its expressive character and then to "render" these qualities and expression into discursive forms that reflect back into the work, is an art form itself, one depending upon the qualitative use of discursive language.

Because this realm of art education is relatively new, the amount of research that deals with the study of critical skills is limited. There are, however, a few studies related to this area and it is to these that we now turn.

In preliminary studies to assess students' perception of visual art as reflected in the language they use to describe it, Brent Wilson [30] found practically no differences between children of the fifth-, seventh-, ninth-, and eleventh-grade levels. The language that students used to describe the works they encountered was literal in character when the work had representational forms in it. When the paintings were abstract or non-objective, students tended to use them as projective devices and respond as one might to ink blots.

This observation of the performance of children who differ in age by six years led Wilson to wonder about the efficacy of art programs that emphasized the productive realm of art activity regarding the development of students' ability to perceive and describe aesthetic qualities in works of art. To attempt to increase students' ability to respond to the formal aspects of visual art Wilson designed an experiment in which one group of fifth- and sixth-grade children was provided with a systematic program intended to help them learn to see and describe the formal aspects of a painting—in this case Picasso's "Guernica." The second group, also composed of fifth- and sixth-grade students, was provided with a typical art program for students at this age level, one that was exclusively studio-oriented.

Each group was administered a pre-test and post-test that Wilson had devised. This test, called the Wilson Aspective Perception Test, consists of thirty-four slides of well-known twentieth-century paintings. The slides are designed to elicit visual responses that indicate the student's method

of perceiving and evaluating the paintings. The responses, once secured, were then analyzed and coded through the use of a taxonomy that Wilson constructed. After the period of instruction, which lasted for twelve weeks, the performances of the groups were compared. Wilson found that the program of instruction that was provided proved effective in increasing the student's ability to describe a variety of aspects of visual works of art. The differences between the groups favored those who had received explicit instruction in the skills involved in looking at visual art and in the vocabulary they might use to describe what they see.

The findings of the Wilson study can, it seems to me, be explained in relation to some of the factors affecting perception that have been identified earlier. First, students apparently broadened the set they brought to the perception of art. That is, they learned that there was more to look at in a painting than simply attending to representational forms; they learned to attend to its qualities *qua* qualities. Second, students had sequential practice at looking for aspects of form in "Guernica" which tended to reinforce and develop both set and skill in discrimination. Third, the students acquired linguistic labels that enabled them to talk about the qualities they had seen. This itself is a form of practice and reinforcement. The perceptual data—so to speak—became socialized through discussion.

In a study of the relationship between personality and artistic preference, Pyron [31] studied the preferences of forty-eight college students with respect to popular, classical, and avant-garde art. Research by the investigator has indicated that the preferences individuals have for types of visual form are related to certain personality characteristics and to their general creativity. It has been found by Barron, for example, that highly creative scientists and artists have a preference for complex, asymmetrical visual configurations, as compared to those that are simple and symmetrical. Similarly, Pyron was interested in determining whether systematic differences in preference for types of art emerge that were related to personality factors such as rigidity, acceptance of change, authoritarianism, self-reliance, anxiety, and rejection of "types" of people.

The procedure that Pyron used was to ask subjects to evaluate four examples of art having three characteristics (popular, classical, and avant garde) in three art forms (painting, literature, and music). To evaluate works of art Pyron asked his subjects to rate them on what is known as a Semantic Differential, a scale consisting of twelve bipolar adjectives such as good–bad, honest–dishonest, nice–awful, sacred–profane, happy–unhappy, and so forth.

Once these works were evaluated through the use of the Semantic

Differential the scores that each person had assigned were then related to the scores they had received on the personality measures identified previously. Pyron found when these relationships had been determined that those subjects who were highest in attitudinal rigidity and highest in simplicity of perceptual organization rejected avant-garde art more than those who accepted change. They also tolerated a wider range of social stimuli and were more complex in their perceptual organization. In short, people who are rigid and who like what is neat and predictable in life prefer art whose forms or styles are related to a tradition with which they are familiar.

Pyron's findings appear to fit in nicely with those of Barron and Welch,[32] who also have found that flexible and creative people have a greater tolerance for ambiguity than those who are less flexible and creative. However, two points should be noted: first, preference for style in art requires no education or sophistication. As in taste, in matter of preference there can be no dispute. Anyone can have, and is entitled to, his own preference or taste. Judgment, on the other hand, is another matter. As David Ecker [33] has pointed out, judgment requires reasons or grounds for statements made about a work of art. To judge a work or to be critically informed with respect to it requires an ability to talk about the work critically and to provide reasons for the claims one makes about the work.

The second point I wish to make about research on the relationship between personality and aesthetic preference is that one's openness to an unfamiliar form might be a function of the level of skill one can bring to it. This is to say that the problem of seeing coherence and appreciating relationships among qualities depends on the various skills constituting qualitative intelligence. When these skills are absent a person will not be able to deal with the work on the plane of aesthetic meaning. Under such circumstances it would not be surprising if people would prefer what they can begin to make sense of rather than that which they cannot.

Some of the research on aesthetic preference as it relates to personality factors suggests that people who have succeeded in coping with complexity in their own work and who are imaginative in their approach to it prefer problems or stimuli which provide complexity and ambiguity. Now it is interesting to speculate about the possibility that the type of work that a person does daily develops particular modes of intellectual functioning. For example, as a part of the nature of his work an artist confronts problems of organizing form within the limits of a material. The demands he must meet are, in part, an aspect of the nature of the task. When the character of this task is similar from day to day, year to year, it seems

reasonable to expect that his ability to cope with such demands will increase. When an aspect of that element is the ability to seek out surprise, to cope with ambiguity, to provide order without being routine in one's solution, it seems likely that the skills, sensibility, and intellectual acuteness necessary for such tasks will be gradually developed. Thus, in a certain sense, it is the nature of the task that defines and refines the mode of intelligence that humans come to develop. And it is in this sense that we can refer to "the work of art" as having two distinct meanings. We refer to the work of art as an object produced, something that has certain valued characteristics. We can also speak of the work of art as the *work* of art; the act of arting, the task of art. When one is engaged in the *work* of art the task itself helps remake the maker. What people do when they work at the task of making an art form is not only to produce an object that is public and sharable, they also alter themselves. This alteration, when it emanates from the demands that creating art make, might develop the abilities and dispositions associated with certain personality traits or perceptual-cognitive abilities.

If such a notion has validity then what might it suggest for the content and character of curriculum activities in school generally? If people tend to become what they cope with, day after day, then it suggests we must examine with extreme care the nature of the tasks we ask children to engage in in school. It is those tasks that begin to define what abilities the child will develop—or let atrophy.

Another area of research related to the critical realm deals with the cross-cultural assessment of aesthetic preference. The most systematic work that has been done in this area in the United States is by Irvin Child.[34] Child has asked some questions that are both interesting and of fundamental importance in the appreciation of visual art. One such question is the extent to which "goodness of form" is culture free. That is, to what extent does work considered high in aesthetic quality in one culture receive the same judgment by people in other cultures? In order to answer this question individuals in radically different cultures have been asked to rate or to state their preferences for various types of visual art products. In a study of the aesthetic judgment of American art experts and Japanese potters,[35] Child and Iwao found that Japanese potters—even those living in remote villages having very little or no contact with Western art—agreed more with the aesthetic judgment of American art experts than did American high school students. This finding suggests that those who have continual contact with art, even though they have little contact with one another's culture, tend to develop greater similarities of preference for

types of visual art than those in the same culture who have relatively little contact with visual art.

In another study of aesthetic judgment, this one by Ford, Prothero, and Child,[36] the general findings of Child's previous study were supported; craftsmen and artisans in a remote Fijian village and in the Cycladic Islands of Greece generally agreed with the aesthetic judgments of American art experts.

The findings of these studies as well as that of Child and Siroto [37] indicate strongly that whereas cultural difference may have some effect on diversifying aesthetic judgments, individuals from different cultures who have an interest in art and who actively engage in art activities tend to agree more highly than do those within the same culture who are not engaged or interested in art.

The assessment of cross-cultural differences is a relatively new area of inquiry and through Child's efforts and those of his colleagues a solid foundation is beginning to be laid. Indeed, the entire critical realm of art education needs systematic investigation. The study by Wilson is a useful beginning. But it is only a beginning. We need a variety of experimental studies that will provide clues regarding the type of instructional and curricular activities that develop critical skills. It seems reasonable to expect, for example, that children from different socio-cultural backgrounds might need different approaches to develop high level perceptual skills regarding the analysis of visual art. To identify such differing approaches it might be useful to study some of the practices employed by highly effective teachers and to use their approaches as models from which theoretical understanding can be developed. In a coming chapter one approach, that used in Stanford's Kettering Project, and the materials to support that approach will be described.

Thus far in this chapter I have argued that the ability to create and experience art can be conceived of as a mode of human intelligence that can be called qualitative. I have also identified and discussed some of the research that has attempted to describe and account for children's art and some of the conditions that affect the critical judgment of works of art. It is clear from the material that is available that there is relatively little research on the development of those skills that enable people, especially children, to perceive aesthetically visual form. Similarly, the study of knowledge and attitudes toward art and artists has also been scarcely touched. We will now examine some of the research dealing with the assessment of these areas as well as the tests that have been developed to make this assessment possible.

Tests in the Visual Arts

If one consults the literature it does not take long to discover that few tests are available in published form in the field of the visual arts. Of the 2,126 tests listed in the comprehensive *Tests in Print*,[38] only 1.4 per cent or 29 are classified in the "fine arts." of these 29, only ten are devoted to the visual arts; the remainder are tests in the field of music. Of the ten that are devoted to the visual arts, six are designed to measure art ability or art aptitude. The Horn Art Aptitude Scale [39] and the Knauber Art Ability Tests [40] are examples of the latter type of tests. The published tests in print, at least as of June 1, 1960, which measure art knowledge or art preference specifically are the Knauber Art Vocabulary Test,[41] first published in 1935, the Meier Art Test,[42] published in 1937, the Graves Design Judgment Test,[43] published in 1948, and Tests in Fundamental Abilities in the Visual Arts,[44] published in 1927. The Selective Art Aptitude Test [45] and the McAdory Art Test,[46] both of which were published in the 30's are out of print.

There are several tests available such as the Cooperative General Culture Test [47] and the Cooperative Contemporary Affairs Test for College Students [48] which contain sections on art, music, and literature, but these tests do not provide sub-test scores for the visual arts. The National Teacher Examination [49] has a section on art education but this test is designed for prospective teachers and is not issued to secondary schools or colleges for general achievement testing.

With respect to published tests of art attitude the scarcity is even greater. I have been unable to locate a single published test specifically designed to assess the student's attitude toward the visual arts. The Purdue Master Attitude Scale [50] does provide a means for assessing attitudes toward any school subject but has some important limitations. The Kuder Preference Record [51] and the Allport-Vernon-Lindzay Study of Values [52] are both highly useful instruments with sections on "aesthetic values" but are intended for purposes other than measuring the student's attitude toward the visual arts.

The lack of instruments designed specifically to measure knowledge of and attitudes toward the visual arts become even more apparent when one compares the number of tests in the visual arts to those available in other subject matter fields. There are, for example, 106 science tests listed in *Tests in Print* and widely used tests such as the Stanford Achievement Tests,[53] the Sequential Test of Educational Progress [54] and the SRA Achievement Series [55] have no sections on the visual arts. Nor does the Every Pupil Scholastic Tests [56] with 47 subsections have a section on the visual arts.

Even the influential College Entrance Examination Board Admission Testing Programs [57] and the National Merit Scholarship Qualifying Test [58] have no sections devoted to achievement in art. Achievement tests in mathematics and in science are not only available in greater abundance but are constructed for specific subject matters such as algebra and chemistry. The few published tests that are available having sections on the fine arts measure achievement in the several arts and letters making it difficult to obtain reliable assessments of achievement in particular areas.

But what of the published tests that do purport to measure art knowledge and art appreciation? How adequate are they for the purposes they are designed to serve? The Knauber Art Vocabulary Test,[59] which is designed along lines similar to one of the instruments in the study reported in this book, was constructed more than thirty years ago and has not been revised. As a consequence, the Knauber Art Vocabulary Test [60] uses many items that are of little importance today. For example, in the test appear questions dealing with the meaning of terms such as lunette, Tanagra Figure, Isocephaly, and intercolumniation. In addition, by today's standards the test manual does not provide an adequate array of specifications regarding the reliability or validity of the instrument.

Both the Meier Art Tests [61] and the Tests in Fundamental Abilities in the Visual Arts [62] were, like the Knauber, constructed more than thirty years ago. The Meier first appeared in 1929 and was revised in 1942, and the test by Lewrenz was constructed in 1927 and has not been revised. The content of these tests, both visual and verbal, is out of date.

A more recently published test, the Graves Design Judgment Test,[63] appears to be a useful instrument, and, in general has received some positive reviews in the Mental Measurement Yearbook.[64] Although it has not been used extensively, the Graves Design Judgment Test has certain virtues that the Meier Art Tests lack such as presenting to the student designs of an abstract nature, rather than pictures that are dated in appearance and poor in quality.

Like the availability of published tests in art, research bearing upon art information and art attitudes is also scarce. If one consults *Studies in Art Education,* for example, one finds that since its inception in 1959, about 30 per cent of the research published in that journal has been devoted to the study of creativity. Questions dealing with the relationship between personality and creativity have been raised, problems concerning the effect various treatments have upon creativity have been posed,

and studies of types of creativity have been undertaken, but the assessment of the student's information about art has been neglected.

The reason for the dearth of research concerning student information about art is related to the values assigned to art education by art educators. These values have been conceived of primarily in relation to the development of creativity and aesthetic sensitivity. If one of the major contributions of art education is to develop the student's creativity, it is hardly likely that his information *about* art will be considered of great importance. Indeed, it is hardly likely that any standardized measure will be relevant, for tied to this conception of art education as education for creativity is a very personal, almost clinical view of the child. To understand the growth of the child requires that one know the child in a way that is personal, intimate, and in the last analysis, nondiscursive. In short, the lack of research on the "cognitive" outcomes of art instruction is due in large measure to the conceptions held by art educators about the purposes of art education.

As far as research on art appreciation is concerned, there are more studies available in this area. But the most widely used instrument, the Meier Art Tests, has not won the confidence of art educators on grounds related to both the quality of art provided in the test and the relevance of the test to objectives in art education.

A study of student attitudes toward art which has many similarities to the study to be reported here was undertaken by Bruno Bettelheim in 1943.[65] An instrument containing 170 items was administered to 246 college students attending two colleges, one in the East and the other in the South. The study, which attempted to determine what students thought about art, contained items such as, "All art is imitation," "The main task of the artist is to be the critic of his time," "The artist, much more than the scientist, is the person who promotes the development of human culture," and "Artists who defy tradition do not add anything to the mainstream of art." The student responded to such items by indicating that he either agreed, was uncertain, or disagreed. The test items dealt with the arts in general, not with the visual arts in particular, and responses were analyzed in relation to the importance of art, the over-evaluation of art, the prestige of art, why students study art, and how students approach art.

Perhaps the most significant finding in Bettelheim's study was the inconsistency of student responses. Students answered both affirmatively and negatively to sets of questions on the same issue. Bettelheim concluded from this that the students in his study had not matured in their

aesthetic attitudes and that rather than having an unreliable instrument, his subjects were in fact inconsistent.

The study also revealed that the students believed that art was a powerful means by which to influence people and that artists should receive more in the way of remuneration, even though they had no idea how much money artists made for a living. The study also indicated that, "Many students seemed confused about the most basic aspects of their own experiences. Only about half of the group had any opinion on the question of whether one's personality enters into the act of experiencing art, but most of those who did express an opinion thought that an art experience is sharply influenced by the personality of the subject." [66]

Bettelheim concluded that, "The students seemed to study art mainly for two reasons—because they wanted to gain knowledge of various kinds and because they enjoyed art courses." [67]

In a study attempting to construct a scale measuring art acceptance, which would distinguish between naive and sophisticated appreciation of art at the college level, Kenneth Beittel found that aesthetic attitude was part of a generalized set.[68] He found that a continuum existed between art acceptance and art rejection; the correlation between the Art Acceptance Scale and the Non-Art Acceptance Scale was $-.93$. Beittel concluded: "it has been found that by far the biggest component of the Art Acceptance Scale is a function of a generalized aesthetic attitude comparable to one's tolerance or openness to aesthetic materials and evaluations (as herein defined). It is not known just what brings about the restructuring of attitudes needed for growth in appreciative understanding or whether the Art Acceptance Scale, or some similarly derived instrument, could detect a change in all cases." [69] Going on to indicate what he thinks would be needed to change student attitudes toward art, he cited "self-confrontation of one's own evaluations as a beginning toward greater and greater self-involvement." [70]

Although Beittel's study did not measure attitudes toward art directly, he was able to obtain indices which are theoretically related to attitudes toward art, and like others, he found such "attitudes" to be stable.

In a study of relationships between attitudes about art experiences and behavior in art activity, Coretta Mitchell [71] found that no relationships existed between the elementary education students' verbal attitudes toward art as revealed in essay form and the quality of their art products. Using two classes of students majoring in elementary education, Mitchell asked students to prepare an essay that was structured to reveal their involvement in art, their flexibility in their approach to art problems, and their

abilities to plan and evaluate their experiences in terms of aesthetic criteria. Scores derived from rating verbal reports were then correlated with scores assigned to art products on criteria similar to those used grading the written essays. The largest correlation obtained was .28, not significant for the size of the population studied.

The scarcity of both tests and research in art education bearing upon art information and art attitudes is apparent from the few studies reported in this chapter. Other studies could have been presented, but these would have dealt with issues irrelevant to the ones with which this research is concerned. The reasons for the lack of research in art education have already been alluded to. To formulate scales, to construct tests, and to build inventories is to set standards for performance in a field where standards are considered an anathema. Art, it is claimed, cannot be—and should not be—graded. Art is, after all, incomparable.

Although it is true that art products are difficult to assess reliably, the task is not an impossible one. And if the teacher is really serious about the claim that art cannot and should not be evaluated, then he must assume the consequences of being reduced to little more than a motivator and distributor of materials in the classroom. If the teacher cannot or should not judge the quality of art produced in the classroom then who is to judge? And by what standards is artistic learning to be determined?

But there are still other reasons for the scarcity of research in the field of art education. Irving Kaufman, writing in 1959, in *Studies in Art Education* presents a case against research that is shared by many people in the field.

The findings in these studies are singularly divorced from any real relationship to creative behavior and relative understanding of art. This area of symbol endeavor, this range of imaginative involvement, this broad encompassing province of art is experienced and perceived as an immanent quality, as a thing-in-itself. The current findings in art education may add an iota of knowledge pertinent to educational statistics, but the quantitative analysis of art and its educational consequences do not really shed any meaningful light upon art. Nor does the supposed objective examination of the number of strokes Johnny places on a sheet of paper (is it 9 x 12 or 18 x 24) as he is emotionally stimulated by the proximity of Mary, the little blond (as measured by the encephalograph), while manipulating a significantly small, soft brush in preference to a large, hard one, have any real bearing on the condition of creative expression. True, all of these factors, conditions and aspects control and modify some of the individual avenues of visual structure; they are the properties of living which must develop and shape a student's attitude and awareness. But are they really the stuff of which art is made? Do these attributes or the lack of them, when properly catalogued, counted, collected and systematically

packaged for consumption really transform themselves into what Brewster Ghiselin so aptly calls, the realization of life in form? I think not.[72]

The import of Kaufman's view becomes even clearer when it is compared to a view expressed by Faulkner in 1941. Faulkner identifies three factors that have hindered the development of new art tests and of research generally in the field of art education.

First is the distrust, or downright antipathy, with which many art educators face scientific research in their field. Preferring to decide issues on the basis of opinion or emotion, they have hindered experimental investigations. Suspicious of statistics, they ignore or resist the contribution which can come through the use of statistical procedures. Second, the non-verbal nature of art increases the difficulties enormously. Whereas the symbols of expression in language and mathematics have been reduced to a science, well-adapted to experiment and measurement, the expressive vocabulary of art—form, color, space, line, and texture—is for most research people awkward to handle. This condition is aggravated by our educational procedures which, in the past at least, paid greatest attention to those concepts involving words and numbers, far less to those based on color and sound. Third, research in art education has been largely piece-meal. There have been few (if any) reports of comprehensive, organized investigations in which important problems and issues are clearly stated, in which existing evidence is brought together and organized, and in which plans for future programs are suggested.[73]

The situation Faulkner described over a quarter of a century ago, alas, has not changed much.

Although the issues that Kaufman and Faulkner raise are real and important, the need to understand what students know about the visual arts and how they feel about them is equally as real. To provide some evidence, on a national basis, of students' information and attitudes toward art I undertook a study in these areas. In that investigation students in secondary schools and in departments of education in colleges and universities in various parts of the country were tested on two instruments, the Eisner Art Information Inventory and Eisner Art Attitude Inventory.

Before describing the results of the study I will describe the nature of the instruments and questions that were asked.

Each of the Inventories contains sixty items that are divided into four sub-tests, each having fifteen items. The Eisner Art Information Inventory has one sub-test that deals with information about art terms, a second deals with information about art media and art processes, a third with in-

The Eisner Art Information and Art Attitude Inventories

formation about artists and their work, and a fourth with information about art history. Each of the items is in multiple-choice form having five possible answers. Thus, the students respond by selecting the one answer out of the five that they consider correct. And because each answer is worth one point the maximum score on this instrument is 60. Because there are five alternatives to each question, a chance score—one that could be gotten by guessing—is 12 (one out of five is 20 per cent, 20 per cent of 60 is 12).

The Eisner Art Attitude Inventory also has sixty items and four sub-tests. One sub-test deals with voluntary activity in art, a second with satisfaction in art, a third with self-estimate of art ability, and a fourth with attitude toward art and artists. This Inventory also has five alternatives from which the student can select, but these alternatives range from "strongly agree" to "strongly disagree." If a student selects "strongly agree" to an item he receives five points, if "strongly disagree," one point. Thus, a maximum score—one which indicates quite positive response to all items— would yield a score of 300 (5 × 60). A minimum score is 60, and a student who is "middle of the road" or "luke warm" in his attitude toward art would receive a score of 180 (3 × 60).

These instruments have been administered to thousands of students attending about forty schools located in ten states. Although the pattern of performance is similar in the several studies that have been conducted, the results I will describe now are for a study of 1,500 students attending fifteen schools in eight states.

First, what kinds of questions can be raised which data from the instruments can be used to answer? Among the more important questions are, "What happens to student performance on these instruments over time?" "To what extent do scores change?" "Are there differences between the performance of boys and girls?" "Do students who elect to study art score differently from those who do not?" "What are the relationships between information about art and attitude toward art?" "How do students respond to particular items on these inventories and does their response to particular items tell us anything about the role of art in their lives?"

Let's examine the data with respect to each of these questions. Table 3 presents art information scores for students in grades nine through the senior level in college. It should be remembered that the students in grades nine through twelve, the ones in high school, were all enrolled in art classes at the time they were tested, and because none of the high schools from which they came required that art be taken, their selection of it is an indication of at least some interest in the subject.

Grade	Mean	Standard Deviation	Number	Reliability
9	30.39	9.28	270	.871
10	33.32	9.41	159	.879
11	35.54	10.05	237	.899
12	35.93	10.86	183	.916
1	37.19	7.85	129	.835
2	40.38	6.90	137	.808
3	42.81	7.09	206	.832
4	43.23	6.21	167	.795

	Males	Females	Males	Females	Males	Females	Males	Females
9	28.06	31.50	8.54	9.44	87	183	.842	.878
10	30.39	34.83	9.98	8.77	58	101	.890	.864
11	34.53	36.16	11.15	9.32	89	148	.919	.884
12	34.45	36.88	11.95	10.06	71	112	.931	.902
1	32.23	37.74	8.48	7.62	13	116	.858	.827
2	34.08	41.04	3.66	6.84	13	124	.288	.808
3	35.38	43.44	7.85	6.67	16	190	.840	.815
4	39.47	43.65	6.07	6.10	17	150	.770	.791

Table 3. Art Information Test Scores by Grade for Total Population and by Sex and Grade

Source: Elliot W. Eisner, "The Development of Information and Attitudes Toward Art at the Secondary and College Levels," *Studies in Art Education,* Vol. 8, No. 1, Autumn, 1966.

The college group, students in grades one through four, were all elementary education majors at various colleges and universities.

When we look at Table 3 we can see that the scores have a steady increase over time and that the range from the highest to the lowest average score is about thirteen points. The average increase per year in scores of information about art is 2½ points. This indicates that as students get older their information about art grows but that the growth is small. Over the course of four years—for first-year high school to the last—for students enrolled in art classes the increase is only 5½ points. For students majoring in elementary education the increase over the four-year period is about 6 points.

This suggests that the high school art classes are not apparently effective in increasing information about art, at least of the type assessed by the Eisner Art Information Inventory. One should also consider that a chance score is 12, that is, 12 points at each grade level could have been received for just guessing; general cultural learning in out-of-school settings could explain much of the increase in score.

If we look further at Table 3 at the performance pattern of boys and girls, we find that girls consistently receive higher scores than boys for

the population as a whole and at each grade level. Furthermore, the differences between them are not likely to have happened by chance. What does this suggest? Why should girls consistently obtain higher scores of information about art than boys? Unless one chooses to explain these differences as a function of differences in average intelligence between the boys and girls in these grades—something which is highly unlikely—the explanation that seems most reasonable to me is related to cultural expectations for artistic learning. In American culture it is the female who is supposed to be responsive to visual aesthetic qualities. For many segments of the population interest in art for males is something less than masculine. Boys are supposed to be interested in more manly things. The woman of the house is the one who is to pick out the colors for the walls, the furniture, and so on. In selecting the family car, the television commercials show the woman admiring the interior fabric while the man kicks the tires and looks under the hood.

I believe these cultural expectations affect the inclination to learn in the visual arts and that the inclination and expectation accounts for the consistently higher scores received by girls.

If we examine the attitude scores received by the same students over the eight-year period we find a relatively constant profile. Table 4 presents

Table 4. Art Attitude Test Scores by Grade for Total Population and by Sex and Grade

Grade	Mean	Standard Deviation	Number	Reliability
9	197.13	30.16	270	.923
10	204.54	27.15	159	.908
11	207.17	27.63	237	.932
12	201.07	28.82	183	.933
1	180.88	30.26	129	.941
2	192.79	27.03	134	.946
3	194.84	31.01	206	.937
4	193.66	29.99	167	.952

	Males	Females	Males	Females	Males	Females	Males	Females
9	189.04	200.98	29.19	29.94	87	183	.910	.926
10	197.65	208.49	30.03	24.65	58	101	.926	.888
11	201.55	210.56	30.19	25.48	89	148	.953	.911
12	189.43	208.44	26.11	28.11	71	112	.928	.925
1	175.46	181.49	39.04	29.27	13	116	.963	.939
2	182.07	193.95	31.19	26.43	13	121	.956	.944
3	171.37	196.82	30.71	30.29	16	190	.906	.938
4	185.47	194.59	26.07	30.34	17	150	.930	.953

Source: Elliot W. Eisner, "The Development of Information and Attitudes Toward Art at the Secondary and College Levels," *Studies in Art Education,* Vol. 8, No. 1, Autumn, 1966.

these scores. Here we find that there is comparatively little change in score from grade nine to grade twelve. Remember that each answer on the sixty-item Attitude Inventory receives a score of from one to 5. Thus, a difference of 5 to 10 points in the Inventory is quite small. For students of the high school level the greatest difference is about 10 points (from 197 at the ninth grade to 207 at the eleventh grade). At the college level the largest difference is 14 points (from 180 at the first year of college to 194 at the third year). These scores suggest that attitudes toward art, at least as measured by these instruments, do not change much over time. Students apparently leave high school and college as they entered with respect to their attitude toward art.

It should also be noted that the high school students received higher scores at each grade level than did college students. This is wholly reasonable when we recall the differences in the population. The high school students were art interested; they had elected art in high school. The college students were elementary education majors. We do not know how interested in art they are, although it seems reasonable to assume that not all of them had elected art when they were in high school. Thu, we should expect higher attitude scores from the high school population and this is exactly what occurs.

Finally, we can ask what relationships exist between one's information about art and one's attitude toward it. Is one who knows much about art likely to feel positively about art as well, or vice versa? We find the answer to this question by systematically comparing the scores of students on the Information Inventory with those they received on the Attitude Inventory. This process, known as correlation, is reported in Table 5. This table provides the coefficients of the correlation for all of the four sub-tests on each Inventory as well as for the total scores for the Inventories. What we find here is that the coefficient of correlation for total attitude and total information scores is .278. This indicates that the relationship is statistically significant (something that could have happened by accident less than once out of a thousand times). It also indicates that although the relationship is statistically significant it is not very large. That is, there is only a small—even though statistically significant—relationship between one's information about art and one's attitude toward it.

The Eisner Art Information and Art Attitude Inventories have been used in dozens of studies by investigators throughout the country and, in general, the same findings reappear. These findings suggest that the development of student information about art and the shift of attitude toward it is not great. Art programs at the secondary level appear to be primarily

Plate 8 & 9. These
drawings are the results of
expressive activities
utilizing some of the skills
and understandings
developed in the line
exercises. In these works
the child is encouraged to
utilize skills expressively
and imaginatively. These
illustrations and the
previous ones were made
by children in fourth grade.

Plate 10. This watercolor, painted by a ten-year-old boy, demonstrates high-level technical competence in the use of art materials. He has been able to manage the liquid characteristics of watercolor in order to create subtle and sophisticated color variations. Furthermore, his ability to utilize value contrast has made it possible for him to develop a composition of more than modest interest.

Plate 11. About 700 individual instructional devices constitute a part of the Kettering Project materials. Here we see these materials displayed before a movable, metal cart in which they are housed.

Table 5. Coefficients of Correlation Between Art Attitude and Art Information Scores for Total Population

		Attitude					Information				
	Subtest	1	2	3	4	Total	Total	1	2	3	4
Satisfaction in Art	1	1.000									
Voluntary Activity in Art	2	.644	1.000								
Self-estimate in Art	3	.486	.594	1.000							
Attitude Toward Art	4	.480	.420	.376	1.000						
Total Attitude		.810	.855	.803	.689	1.000					
Total Info		.255	.200	.116	.347	.278	1.000				
Art Terms	1	.189	.157	.137	.303	.240	.773	1.000			
Art Media & Process	2	.213	.187	.133	.312	.258	.878	.645	1.000		
Artists & Their Work	3	.253	.183	.061	.296	.238	.828	.479	.626	1.000	
Art History	4	.203	.147	.066	.262	.204	.872	.535	.662	.676	1.000

N = 1485

Source: Elliot W. Eisner, "The Development of Information and Attitudes Toward Art at the Secondary and College Levels," *Studies in Art Education,* Vol. 8, No. 1, Autumn, 1966.

concerned with the productive realm of the art curriculum; little attention is devoted to the critical or cultural areas. As curriculum in art expands and as such curriculum becomes effective, it seems reasonable to assume that performance of the Eisner Inventories and test like them will show a remarkable rise of student performances. At present the areas which the inventories assess appear to receive little attention in school art programs.

The responses to individual items were especially informative. Performance on each of the items was obtained by calculating the percentage of the subject at each grade level that selected each of the five alternatives to each of the items on the Inventories. When these data are analyzed, the following emerges: one out of four college seniors, when asked to select the one out of five artists who painted the ceiling of the Sistine Chapel, selected Leonardo DaVinci. The same percentage indicated that the *medium* called pastels is a *technique* that gives a light airy quality to paintings. Thirty-eight per cent of approximately 1,500 students believed Picasso and Matisse worked in the seventeenth and eighteenth centuries. Less than three out of four students knew what the words "art medium" referred to and about two-thirds did not know what "hue" meant.

On the Attitude Inventory about 20 per cent of the students agreed that, "Artists should paint pictures the majority of the people can understand." To the statement, "A person either has talent for painting or he does not," 20 per cent agreed and 22 per cent were uncertain. Thirty-five

per cent were either uncertain or agreed that, "Advances in the field of art are important for a country's progress." To the statement, "An artist's contribution to society is not as important as that of a scientist," almost 30 per cent agreed. But the statement that received the highest percentage of argument was, "Good art is a matter of personal taste." To this statement 66⅔ per cent of the students agreed.

These data give one an interesting picture of the attitudes and information that student appear to have. Although knowledge of any particular item's correct answer on the Information Inventory is unimportant in itself, when a pattern emerges such performance can be used as an index of the absence or presence of other types of information about art and one's contact with it. When almost 40 per cent of the population believe that two of the most important visual artists of this century, Picasso and Matisse, lived two hundred or more years ago, one can only wonder how much in the way of understanding the cultural aspects of art and art history students are receiving in school or elsewhere.

6

building curricula in art education: some promising prospects

Although awareness of research conclusions are important in helping one understand factors affecting the perception and production of visual art, awareness of these conclusions is inadequate for effecting artistic learning. To do that an educational program—a curriculum—must be developed and brought in contact with students. What any educational institution must do is to develop a vehicle that will make the mission of the institution a reality. In American schools this has traditionally meant the development of curricula and the provision of instruction. Before we examine different orientations to curricla in art education it will be useful to be clear about what is meant by the term "curriculum" and the ways that it has been used in education.

The Meaning of "Curriculum"

By the term "curriculum" I mean a sequence of activities that is intentionally developed to provide educational experience for one or more students. In this conception the curriculum consists of activities in which the student is to engage and which are presumed to have educational consequences. Such a sequence of activities can be developed by the student without the assistance of the teacher, it can be developed jointly by teacher and student, it can be developed by the teacher alone, or it can be developed by groups outside the classroom and implemented by the classroom teacher. Furthermore, a curriculum can be developed for very brief periods of time or it can be developed for an entire school year or series of years. Thus, a teacher of art might, for example, plan an activity for a class or an individual student and decide after the students are engaged what to plan afterwards, or he can lay out a series of activities to be engaged in during an entire semester.

It should be pointed out that the term "activity" is central to the conception of curriculum used here. Activity implies that the curriculum is going to engage the student in some type of action—painting, discussion, reading, analyzing, exploring some object or idea. In this sense the identification by a teacher or a group of a series of topics does not constitute a curriculum any more than a book, by itself, or a single painting constitutes a curriculum. A curriculum is a series of activities designed to engage the student in some content that is intended to have educational consequences. An activity assumes some content; there is no activity that is without content. The hoped for consequences of curriculum activities are typically thought of as the objectives of the curriculum and in recent years there has been increasing interest—and controversy—in the

153

function and form that objectives should take in the development of curriculum.

Perhaps the most widely used rationale for curriculum planning has been developed by Ralph W. Tyler.[1] He believes that the curriculum planner should attend to four questions in the course of his work. He must ask 1. What educational ends should the school seek to attain? 2. What educational experiences are likely to attain those ends? 3. How can those experiences be most effectively organized? and 4. How can those experiences be evaluated? Using Tyler's rationale in planning a curriculum in art, one would need to describe what it is that students should be able to do after working through a curriculum. What types of behavior should they be able to display? The descriptions of such behavior constitute the instructional objectives of the curriculum.

The concept of instructional objectives has some important and useful functions to perform in the field of art education. One of the most important of these is that of encouraging curriculum makers to think with precision about what they are after. Since instructional objectives describe the ways in which students are to behave or the competencies they are to display after working through a curriculum, the careful statement of such objectives militates against the fuzzy thinking and language that too often makes goals in the field appear more like slogans than like statements having any real meaning. Statements such as "The goal of art education is to help each child develop his artistic potential and grow creatively through meaningful experience in art" are without much meaning. Such statements are sufficiently general and vague that hardly anyone could disagree. When a statement is made to which there is unanimous assent, there is reason to believe that the statement has little meaning. Similarly, statements of objectives which describe the teacher's task or behavior are also inadequate in curriculum planning. Statements, such as "The objective of this course is to provide students with opportunities to work with art material," refer to what will be provided, not what students are to experience or learn. Strictly speaking, with such a statement the objectives of the course are met when the opportunities are made available. Surely that is not what is wanted from a program in art. Statements of objectives in behavioral terms will help the curriculum planner think through what students will hopefully learn to do as a result of the curriculum provided. Such statements provide clues to teachers regarding what

The Use and Abuse of Instructional Objectives

to look for as indices of curriculum effectiveness and, in addition, they are more useful in formulating learning activities—the basic curriculum unit—than are vague statements having little meaning. In the field of art education the attempt to explicitly formulate some of the goals one hopes to achieve is salutory because objectives for the field have too often been little more than vagaries.

Yet the formulation of curriculum objectives in terms of the desired behavior of the student should not be embraced as an article of faith without proper sensitivity to the limitations of objectives stated in behavioral terms.

One should recognize that many of the most valued goals of the field are extremely difficult if not impossible to describe in terms of student behavior.[2] The development of students who are perceptive and insightful can be recognized by a sensitive teacher if students display perceptivity and insight, but the specific indices of such behavior are not easily described. Furthermore, it is dysfunctional to expect to have an instructional objective for each specific task a teacher provides or plans for students. Such a demand would create a curriculum quagmire of objectives that would appear more as an exercise to satisfy a supervisor or principal than a tool to facilitate one's work as a teacher.[3] The usefulness of instructional objectives is greatest when the objectives are treated with discretion rather than with passion, and when they are used with those activities that are intended to yield predictable consequences.

This last phrase—when they are used with those activities that are intended to yield predictable consequences—is especially important in the field of art education. In fields such as mathematics, spelling, and in some areas of science, the desired behavior of students can be clearly and unambiguously described. In spelling, for example, what a student must produce to spell a set of words correctly is known in advance: the last thing a teacher of spelling wants is creative spellers! The teacher's task in evaluating student performance is one of comparing the way the students spell to the way the words should be spelled. The evaluation task is one of matching; hopefully, the fit will be perfect.

In the teaching of art relatively seldom do teachers want a specific or highly predictable performance from the student. What is often hoped for is that the student will confer his private and imaginative interpretation upon some material. The character of his effort is judged on a wide range of criteria after it emerges. It is not simply a problem of catching the correct answer to the way in which the student solved the problem. In the creation of art forms, there is no single correct answer. To allow for

this type of behavior, indeed to encourage it, I have invented the concept, *expressive objective* [4] to complement, not to replace the concept, instructional objective.

An expressive objective does not describe the behavior or product a student is to display or construct; it describes an encounter the student is to have. From that encounter, hopefully positive consequences will flow. It is these consequences that the teacher attempts to discover and appraise. What the child has learned, experienced, or produced is determined after he has had an opportunity to work it through some material. Thus, what we have in this conception of objectives for the curriculum is a pair that deals with different types of outcomes. The instructional objective is one that describes a form of student behavior that is sufficiently specific so that it can be reliably described and recognized if it should be displayed. When performance is rule governed as it is in spelling or mathematics or where the standards for a product are strictly defined as they are in the application of quality control standards to manufactured goods the instructional objective is appropriate.

The Use of Expressive Objectives

When the teacher wants a student to use skills or ideas imaginatively, where he hopes the student will construct some form or idea that is uniquely his own, the expressive objective is appropriate. The specific relationships these types of objectives have for curriculum planning are extremely important and are based on beliefs about the need for skill in the act of expression.

You may recall that in previous chapters I argued that expression was not simply a matter of giving vent to feelings, but that it was the transformation of feeling, image, or idea into some material. Once transformed, the material becomes a medium of expression.

The need for skills in the transformation is crucial because without skills, transformation will not occur. Take as an example discoursive language. All of us would find it impossible to express our ideas in a language we did not speak, say, Swahili. This problem is not a function of not having ideas to express, it is a function of not being able to manage a material—Swahili—so that expression is possible. Under such circumstances, the ideas remain internal. For expression to take place we would need to become competent in the Swahili language. Once this would occur, we would be in a position to give our ideas form in that language. Similarly, in the creation of art forms, one needs skills with

which to express ideas, images, and feelings. Some of these skills can be developed in instructional contexts, contexts which aim not at the development of expressive art forms but at the exploration and mastery of material. Once such skills are developed, they can be used in expressive contexts, contexts in which those skills are used imaginatively. Thus, the distinction between the instructional objective and the expressive objective has as its counterpart instructional and expressive learning activities.

An instructional learning activity often takes the form of an exercise. It is designed to acquaint the student with the characteristics of a material and to help him develop skills necessary for its control. In painting, for example, the teacher might encourage children to experiment with paint. He might ask them to wet the paper and to make the paint flow, or to use a dry brush and to try to mix various shades of two or more colors. Such explorations develop skill and understanding of the management of material. They enable children to learn to cope with the peculiar characteristics and demands that the material makes upon them.

When such exploration has reached an appropriate level—and this is something a teacher must judge—the student will be better prepared to use the material imaginatively.

The major point here is that the instructional objective aims at the development of certain skills that are necessary for expression. These skills, once acquired, become used in expressive activities. A curriculum in art can have, therefore, a rhythm to it, one that oscillates between the instructional and the expressive. The instructional helps students acquire a repertoire of skills that make expression possible; the expressive intentionally encourages children to expand and explore their ideas, images, and feelings through the use of skills in that repertoire.

A word of caution should be entered with respect to the distinctions I have just drawn. It is possible that when these distinctions are used insensitively in curriculum planning, instructional objectives can be formulated that have a wooden, emotionally drained quality to them. Students can be required to do exercises in order to develop skills in which they see no meaning. Such insensitivity reduces art to a mechanical and lifeless enterprise for both teacher and student. Contrariwise, it is possible to expect children to express themselves in material over which they have no control. What results from such situations is an affair in which the material "controls" the child; he is so frustrated with trying to manage the technical demands that he has little energy or desire to attend to its use as a vehicle for expression. If a child has to spend most of his effort coping with dripping or bleeding tempera it is unlikely that he will be able

to exploit the material for his own purposes. Such situations are not rare in classrooms. In the name of free expression we have often failed to help children develop the skills needed in order to *achieve* expression through visual form. Too often self-disclosure, cathartic unloading, or just plain messing around in material has been mistaken for art activity. What I am urging therefore is an appreciation of the reciprocity between discipline and freedom. Freedom requires discipline—a sense of mastery in pursuit of style. If the student is to acquire such mastery the teacher, through the curriculum, will need to provide the student with opportunities to develop it. This can be done, at least in part, by providing some curriculum activities that are not intended to yield "hangable" objects, but rather are intended to develop those skills necessary for truly expressive and imaginative work in art. Such activities might take the form of exercises, and when used, should be recognized as such by the student. Once such exercises are explored, the student can then be helped to follow them up in projects in which they are utilized. The Kettering line exercise and the drawings of landscape and turtle are examples of how exercises in the use of line were subsequently used by elementary school children in their own imaginative work.

The use of instructional and expressive objectives and their counterparts, instructional and expressive curriculum activities, is related to two concepts in curriculum planning that are of central importance. These are the concepts of continuity and sequence.

Continuity and Sequence

The acquisition of complex skills in any field of activity is seldom achieved in a single session. To learn to write, to drive, to walk, or to draw or paint requires sustained opportunities to develop and practice certain skills so that they become internalized resources available when needed. Those of us who have learned to drive do not go through a groping, problem-solving experience when we are behind the wheel of a car. Whereas our first experiences driving were demanding, requiring a type of coordination that initially was difficult, now we can coordinate those actions almost mindlessly. To learn the skills and driving tactics necessary for surviving on urban freeways requires a series of sessions in which those skills can be taught and practiced. Most of us need time to learn to drive. Furthermore, few of us embark upon the task by attempting to learn all of the skills at once.

There is much in the example of driving that is useful for thinking about

learning to draw, to paint, to sculpt, or to artistically appraise visual art. First, it suggests that when children are moved abruptly from project to project in art they are not likely to learn to cope effectively with the demands that each of the projects make upon them. What often happens when this occurs is that although the child is stimulated by the novelty of a new material or project and although he may enjoy exploring it in a superficial way, the brevity of his experience with it does not permit him to learn to use the material with any real sense of craft. In short, lack of continuity hampers the development and refinement of the skills necessary for using the material as a medium of expression.

There are remedies to such situations in the art curriculum. First, it is important *not* to conceive of learning activities as merely a collection of independent events in which children are to work. A curriculum in art needs sufficient continuity so that skills can be developed, refined, and internalized and hence become a part of an expressive repertoire. Succumbing to the lure of novelty is no substitute for an analysis of the demands that a task makes upon children and using the results of such analysis in the selection of subsequent tasks.

Second, time intervals between art activities need to be short enough so that interest in the project does not wane. Long periods between projects increase the difficulty of developing and refining the insights and skills gained in previous work sessions. Children, like the rest of us, get rusty when the opportunity for practice is not available. Those who teach art as art specialists sometimes underestimate the importance of such continuity in programs for young children, yet the collegiate level art school provides daily contact with art tasks and such tasks extend over long periods of time. At the college level, painting or drawing, for example, are not simply engaged in for a week or two; they extend over a period of years. Furthermore, the amount of time spent during any one session may be as long as several hours. The point here is simply that those of us who have specialized in art or art education sometimes fail to appreciate how much time and effort have been spent in developing the skills we possess. If such time and effort are necessary for adults, why should we assume so much less is needed by children? Indeed, movement from one project to another on a week-by-week basis implies an extremely high rate of learning. Most of us, including children, need much more time than what is typically provided in the art curriculum to develop the competencies we desire.

The provision of adequate amounts of time is only one of the conditions necessary for developing ability and sensitivity in art. Although time

makes continuity possible, a sequence within projects is also desirable. Let me reiterate precisely what continuity refers to and then compare it with the meaning of sequence. *By continuity is meant the selection and organization of curriculum activities that make it possible for students to use, in each of the activities, the skills acquired in previous ones.* Thus, continuity refers to opportunities to practice and refine skills. This means, of course, that the curriculum planner should consider what demands are being made upon the child when he is asked or encouraged to work with a particular material. To the extent that the demands among projects are unique, to that extent is there likely to be a lack of continuity between them.

Sequence refers to the organization of curriculum activities which become increasingly complex as students proceed. Thus, a student might, for example, be encouraged to work with a limited palette when first starting to paint and to gradually increase the range of color he may work with. Such an arrangement of activities would be intentionally sequential and would build upon the skills previously acquired.[5]

It is significant, I believe, that the practice of providing a limited palette to children when they are first learning to paint has not been common in the classroom. Indeed, many teachers go to the other extreme: the child has available to him a wider range of color than he can cope with adequately. This range of color has apparently been provided in the name of free expression and is considered a vehicle for maximizing the child's creative freedom. When such a range of color is combined with the use of large, nonresilient brushes and an upright easel, on which is tacked a sheet of thin newsprint, one can only wonder how much freedom is in fact provided in such a context. The task of painting with fluid tempera paint on an upright surface using nonresilient brushes on newsprint is a task that would frighten most mature artists, yet nursery schools—in the name of creativity—are prone to make precisely these materials available to the young child.

If the curriculum in art is developed utilizing the concepts I have described, it would consist of a program of activities having both instructional and expressive objectives. Instructional objectives would be accompanied by instructional activities—activities designed to develop particular skills. In this curriculum would also be found expressive activities, activities that encouraged the child to use the skills acquired in instructional contexts for personally expressive and imaginative goals. These two types of activities and objectives would constitute the rhythm of the curriculum. The activities provided would be selected with an eye

to their continuity: the extent to which they would allow the child to practice the skills previously acquired. In addition, they would be selected with respect to sequence; subsequent activities would present more complex tasks, so that the skills acquired could be refined and expanded.

I hope it is clear from what I have just described that the curriculum that is provided to students or developed by them in art should not be a random array of novel explorations that simply lead to superficial dilettantism. Artistic learning is complex. It is not likely to develop a program saturated with fragmented excursions into novel material. This does not mean that a curriculum in art need be grim. An effective program need not be and should not be a no-smiles, hardheaded affair that is drained of emotion for the sake of rigor. On the contrary, when children capture a sense of control and use it in the pursuit of purpose, they tend to be charged up in a way that is quite different from a passing infatuation with novelty. Children who feel a sense of mastery seldom need to be motivated by a teacher. Their own delight in being able to achieve, in being able to give form to their thoughts, their images, and their feelings is tremendously gratifying to them. When this occurs, the problem the teacher has is usually one of keeping them away from paints, film, clay, and the like.

The development of such inclinations and competencies among children often creates an ambience in the classroom that gives artistic engagement with materials even more force. What often happens in such classrooms is that children's enthusiasm for working artistically with art materials becomes contagious. Children motivate one another as they work.[6] A spirit, or ethos, is established in the classroom in which working in the visual arts is valued. In such settings one might find children working on different types of art projects. Some children might be painting, others working on sculpture, still others working on other projects in, or related to art. When such activities occur, children have an opportunity to observe one another's work and to learn from it. But even more, they have an opportunity to observe people who are excited about their work in art. The students themselves serve as models for one another.

It is interesting to observe that copying, so long decried by educators, especially those in art education, can become in this setting a positive vehicle for facilitating learning. By creating their work in a public setting, the classroom, and by making it available to students who want to see how it develops, children actually provide cues to one another regarding the way in which technical and artistic problems can be resolved. These cues help students expand their artistic repertoire and facilitate their

understanding of how problems in the creation of visual form can be attacked. Rather than being a limitation on artistic development, copying (so-called) becomes an asset in art education.[7] The question of how close one child's work is to another—whether it is a so-called "direct copy" of another—is of no major concern as long as one realizes that some children may not be ready to venture off into personally original areas of work until they feel sufficiently comfortable with their ability to manage areas that have been or are being explored by someone else. This is neither unusual in life nor lamentable. The concern of the teacher should not rest so much with where or how students begin but rather with where they end up. If one student chooses to use the same stipple technique in painting a landscape as another, and even more, if his landscape looks like that of another in the room, it may simply reflect the student's need to deal with a territory that has already been charted before he goes off on his own. The problem that the teacher has, as already indicated, is not that the child is doing this but with determining where this type of activity is likely to lead.

Thus far in this chapter some of the more important aspects of curriculum planning have been identified. In many ways the curriculum and the type of teaching that goes on in the school is the core of the educational process. There can be no school without a program; that program is the curriculum. The curriculum is to the school what food is to a restaurant: it is a necessary condition for its existence. Just as the curriculum lies at the heart of the school, the learning activity lies at the heart of the curriculum. The learning activity, whether planned by student, teacher, or curriculum committee, is the imaginative invention of a vehicle designed to help children learn or experience something having educational value. The learning activity is the vehicle that carries the educational process forward. And because it is so important something should be said about the type of considerations that can be used in its formulation.

One criterion that can be applied to the learning activity is that of judging the extent to which it provides the child with educationally valuable experience. It's perfectly clear that teachers and children alike can be engaged in activities that have little educational significance. Although the determination of educational significance is a complicated affair—an *apparently* trivial activity in art might be of considerable significance to a particular group of children—what is being urged here is that curriculum

The Learning Activity: The Heart of the Curriculum

planners attend to the problem of judging the educational significance of the activities that are being planned. It is perfectly possible for a teacher to do a masterful job in teaching—his timing, rapport with students, clarity, and general style might be wonderful—and at the same time the content or problem with which students were coping might not be worth their time, considering alternatives.

In addition to making some judgment about the educational significance of the activities that are planned, it is also important to have a sense of how current activities build upon those that have gone before and how they might relate to those that are to come. What is the connection of the previous work to the task being planned? What can students use from the past to cope with the present? Towards what end is the activity leading? A teacher with wide experience and much skill can probably find numerous ways to help children re-establish relationships between past, present, and future. A teacher who knows the territory can help children "get home" from any number of starting points. Where teachers are experienced in art, *explicit* attention to sequence and continuity among learning activities is not, in my opinion, as important. Such a teacher can facilitate the child's realization of connectiveness among activities by creating the appropriate bridges in process. But for teachers without such expertise the need for building such relationships into the curriculum activities is crucial. Without them, too often the curriculum that is developed becomes a fragmented smorgasbord of unrelated events lacking direction.

Another important consideration in the formulation of learning activities deals with determining the appropriate level of complexity inherent in the activity in relation to the level of skill the students possess. For example, to encourage students to work in wood-block printing, without providing for the development of skills necessary for such work, is to court frustration in the classroom. To expect students to learn entirely new skills and at the same time cope effectively with the aesthetic and expressive aspect of their work is to expect a great deal. Whereas some students can handle such an array of problems, many cannot. It is important, therefore, when deciding upon a curriculum activity for the teacher to make a judgment about the degree of complexity children can handle. Note that I said the teacher must make a judgment. This word was used intentionally because at present there is no way of measuring these demands.

I believe that teachers tend to make such judgments in any case in the art of teaching as well as in curriculum planning. Determination of the appropriate level of difficulty might for some students center upon the teacher's judgment about the extent to which a child can work inde-

pendently without guidance. Such judgment depends upon the teacher's ability to estimate the amount of time a student can work alone on an independent basis. The analogue to this is the mother's awareness that it has been too quiet in the house for too long. Another such judgment might deal with the determination of the number of skills needed for a particular task, and the modification of that task so that frustration does not occur. For example, a teacher working with fifth-grade children, and interested in helping those children get a sense of what paint can do, might appropriately *not* encourage children to do a painting that emphasizes human figures, because such an emphasis might detract from their exploration of the qualities of paint. The teacher might, instead, talk with children about space exploration, life on other planets, or dreams or fantasies they have had, as potential subject matters for painting. Such topics tend to lend themselves to a freer treatment in painting than one that is likely to highlight the absence of drawing skills students often feel they should possess.

The point here is simply that the problem of curriculum planning includes consideration of the demands of the task in relation to the competencies the students possess. This consideration rests on judgment, and although there is some optimal distance between where a student is and what he can reach for and grasp, the judgment of that distance at present rests on the exercise of the teacher's intelligence rather than on the application of some mechanical measure.

One might add parenthetically that when teachers use examples, analogies, or similes to help children understand an idea, the teacher is inventing a device to create the appropriate optimal distance for the student. The example, analogue, or simile is simply a vehicle used by the teacher to facilitate student comprehension by providing a wider or more extensive platform for the student to use in achieving understanding. When curriculum activities are provided at an appropriate level of complexity the need for such explanations is reduced.

Still another consideration in the formulation of learning activities is the importance of either building such activities on the known interests of the students—if this can be done—or of selecting activities that are capable of generating interest among students. One mechanism for building such interest is to share with students the opportunity to plan the activities and/or to make available in the classroom a variety of curriculum options from which the student can select. These procedures will mean that in such classrooms there will be more than one project or activity underway. It will mean that the teacher will need to work with individual students in

Alexander Calder, "Four Big Dots," 1963, metal. San Francisco Museum of Art.

George Spaventa, "The Flowering," 1957,
bronze. San Francisco Museum of Art.

small groups rather than with the class as a whole. It will mean that the general character of the classroom, its pervasive quality, its sense of life, will be altered from one in which all students are working on the same type of project to one where several projects are undertaken. When providing such options the teacher will need to decide how much fluidity to have in class, how much structure, how much mobility he can best work with. In short, the teacher, like the student, has needs to be met. And just as there are individual differences among students, so too are there such differences among teachers. Different teachers prefer different settings in which to work with students.

Another consideration in selecting learning activities is that of determining the transfer value of the activity that is being planned. To what extent will the intended outcomes of this activity relate to events outside of the classroom? To what extent can that which is learned in art in school be used in the world at large? All too often, the events of schooling remained isolated from life outside of school. Learning in school and living well for many students have no apparent relationship. To make this relationship apparent to the student, curriculum activities should be developed with an eye toward their application outside of school. This may mean, for example, helping a child recognize the relationship between the structural problems he copes with in a repetitive sculpture problem and the type of problem architects have in the treatment and structure of architectural form. It may mean helping the child appreciate the fact that the qualities he might admire in a plant or a shell found at the beach are not unrelated to the qualities found in a Calder, in a Spaventa, or in an Arp sculpture. This means teaching for transfer by pointing out relationships where they exist and by having students find them by looking into their own experience. Learning to see these interrelationships, especially for the young adolescent student, tends to increase motivation by creating meaning. When such meanings are achieved, artistic learning has a better chance of being internalized by the student and thus made a valued part of his life.

Finally, and perhaps most important in the consideration of learning activities, is judging whether the learning activity allows students to develop and practice the skills they are supposed to acquire. It is my observation that the most highly practiced skill in most college classrooms is that of listening. More than anything else, students spend their time listening in class, yet in those same classes professors would be among the first to claim that listening skills were not the ones that they were interested in having students learn. What does this mean for the

Hans Arp, "Human Concretion Without Cup," 1933, brass cast. San Francisco Museum of Art.

teaching of art? It means simply this: if students are to acquire, say, the ability to critically appraise visual art they need an opportunity to do so. They need a chance to look at visual art, to compare art forms, and to talk about them. Incidentally, the same holds true in the preparation of the art teacher. If he is to be able to talk intelligently about art to children he needs opportunities to learn such skills; simply reading about how they can be done is inadequate, it's like reading about how to swim. Sometime soon after the first several pages it's important to get into the water!

To make some judgment about the extent to which the activity allows students to test out and practice desired skills or understandings requires

that some attention be devoted to the demands that the activities make upon students. This procedure is formally known as task analysis. It is an effort to analyze the nature of the task with which students are to cope in order to identify the skills that are required for its successful execution.

The principles that have been identified concerning curriculum planning have all been posed in somewhat abstract terms. The concepts of educational objectives, learning activity, continuity, and sequence are ideas that can be used to think about the organization of any educational program. And, in principle, these concepts can be used with almost any type of curriculum content. In that sense, the concepts are abstract—they are not content bound.

Types of Curricula in Art Education

There are differences in orientation to curricula that can be offered students in school. It is to these differences in orientation that we now turn. Before doing so, however, I would like to point out that the realms of artistic learning that have previously been identified—the productive, the critical, and the cultural—cover a broad range of objectives. Yet even when learning activities are planned in each of these areas it is possible to emphasize one type of program more than others. What are these types of emphasis? What is it that they attempt to do?

One type, the studio-oriented program, is the one most typically emphasized in school. In this type of program students primarily, if not exclusively, use art media for the creation of visual art. Children are encouraged to use their imagination and their fantasies to create expressive art products. Frequently, a theme or topic will be identified by the teacher, discussed with the students, and used as a focus for the students' work. In such a program, skills develop in the course of pursuing the work rather than as an independent activity which is later used in expressive work. A studio-oriented curriculum emphasizes the productive realm of the art curriculum; it is concerned with helping children externalize through visual form their internal feelings and ideas. It places high priority on the productive aspect of art.

A second type of program which also has a productive character to it is the type of program that is oriented to creative design. In a program having this type of emphasis students work with problems that generally must meet two criteria. First, the problem as posed must be capable of being resolved in relatively unambiguous ways. Second, the solution to the problem should have an aesthetic character to it. Examples of these

criteria will help in their clarification. Suppose a high school art teacher wants to help students understand the structural characteristics of clay. A problem that can be posed to students is to build a clay structure at least 18 inches tall in which no part of the clay structure should be fatter than the slender side of a nickel. The task here is clear. The achievement of the solution can be relatively easily determined, and in this sense, the project meets the first criterion. The *way* the problem is solved, the aesthetic character of the forms that are employed in such a structure, requires an aesthetic judgment meeting the second criterion.

Another example of the creative design approach in the art curriculum deals with the problem of using line to create a vibrating or waving surface to a flat sheet of paper. Like the previous example, determining whether or not this has been achieved is relatively straightforward. The problem is posed, the task of the student is to solve it. But at the same time the solution should be elegant, it should have visual appeal and, if possible, economy of means.

This type of approach to curricula has been common in schools of design such as the Bauhaus [8] in Germany and the Institute of Design [9] in Chicago. Designers are frequently faced with a problem given to them by others which they must solve as effectively and efficiently as possible. Problems of the sort I have described tend to develop skill in coping with relatively clearly defined art problems that are often posed by others.

Although it is true, of course, that studio-oriented programs also share some of the characteristics of creative design-oriented programs, the feel of these programs differs from one another in practice. The creative design orientation is not concerned with painting or sculpture per se. It is not as likely to encourage students to deal with problems of "self expression." Creative design-oriented programs lay heavier emphasis on the formal or design aspects of the visual arts and tend to relate problems of form to the practical and quasi-practical needs of the society. Thus, students in such programs are encouraged to see the relationship between abstract design solutions and the problems of graphic design, architecture, and product design. Furthermore, in such programs a high premium is placed on ingenuity of solution—probably higher than that emphasized in studio-oriented programs, where insight and feeling in artistic statement is valued.

A third type of orientation to curricula in art emphasizes a humanities or related arts approach. Programs having this orientation as their major emphasis focus the student's attention on the uses of art in society over time, on the statements artists make about the world—including them-

selves—through their work, and on the relationship between the society and the content and form of works of art. Such programs may involve the students in the production of visual art, but when they do it is generally instrumental to the understanding of art in culture. In such programs themes are often identified such as, "The Artist as Social Critic," or "The Good and the Evil in Art" and learning activities in the form of critical viewing, discussion, and reading are developed to help students deal with them. Through the use of such activities it is hoped that students will gain a deeper and more comprehensive understanding and appreciation of art as an individual and social event. As might be expected such programs tend to be more verbal and "intellectual" in character than studio-oriented programs. Indeed, such programs are often more attractive to some college-bound students than those that emphasize either of the two approaches described previously.

It should be clear that I am neither endorsing nor rejecting any one of these orientations, nor am I rating one as being better than the others. What I am attempting to do is to point out alternatives *in emphasis* in order to increase the array of options a teacher or an art faculty can consider. What program is best depends on what one values in art education and for whom. The essential matter in curriculum planning is to be able to consider a variety of possibilities, to understand the strengths and limitations of each, and then to exercise judgment regarding the approach that is likely to be most productive in a particular school context. When awareness of alternatives exists there is less likelihood, I believe, of becoming caught up in dogma about the best curriculum in art. When alternatives are recognized and considered, the teacher exercises a level of competence that distinguishes him from a blind disciple of a particular point of view.

Stanford's Kettering Project

Thus far in this chapter some important concepts have been identified that are useful in curriculum planning. Now we will examine the ways in which these concepts have been used in an actual curriculum development project. The project, called Stanford University's Kettering Project,[10] was designed to develop a curriculum and instructional material that could be used by elementary school teachers to teach significant art content to elementary school children. What we wanted was a curriculum that would provide teachers with resources they could use in the classroom, resources that would be useful for helping children learn to produce

art having aesthetic and expressive quality, that would help children learn to respond aesthetically to the visual world and that would help them understand the role and functions of the visual arts in culture.

The project, which was supported by the Charles F. Kettering Foundation, had as its first task the identification of the areas in which it was going to develop curriculum units, as well as establishing the general premises and goals toward which it would work.

The realms or domains of artistic learning, as they were called, that were used to build curriculum were the productive, the critical, and the historical. These domains correspond precisely to those aspects of artistic learning that have previously been identified. The reasons for selecting these areas for curriculum attention emanates from the belief that artistic learning is not an automatic consequence of maturation. Indeed, this is the first premise of the project staff. And because we held this premise, it was incumbent on us to ask ourselves, if artistic learning was not an automatic consequence of maturation, what in fact was teachable and learnable in art? The answer to this question was the skills and sensitivities necessary for producing visual art, the ability to respond sensitively to visual form made by man and nature, and the ability to appreciate—through understanding—the functions art performs in man's cultural experience.

There were a number of other premises we worked with as well. A second premise was that the most important contribution that art could make (for the children with whom we were going to work) was that which is indigenous to art. These contributions, we believe, are directly related to what learning in the three realms or domains of art provides. It means also that although the project staff recognized that art activities could be used as instrumentalities for the achievement of a variety of purposes—mental health, vocational training, the development of general creative ability, the provision of examples of ideas for social studies projects—those qualities which only the visual arts can provide are, in our opinion, their most prized contributions to the education of children.

Third, we assumed that to teach art well requires a curriculum that not only is well thought out with respect to aims, objectives, content, and learning activities but that also provides the teacher with materials useful for illuminating the visual qualities or skills he would like his students to see or acquire. To this end, the staff developed a wide range of instructional support materials in the form of reproductions, slides, transparent overlays, and specially prepared drawings and paintings that both teachers and students could use in their work in art.

Fourth, we assumed that although not all aspects of artistic learning could be evaluated, some aspects could be and that both informal and formal evaluation might prove useful for helping students and teachers understand the progress they had made. Indeed, without the ability to assess what has been accomplished one has little or no responsibility for what is done. We believed that assessment of consequences is a moral responsibility in teaching.

If one is building a curriculum exclusively for one's own use the need for systematizing and making explicit the assumptions, organization, and learning activities is not great, especially when one is experienced. Brief notes, for example, provided they are your own, are frequently sufficient to be able to work effectively. However, if the task is to develop a program that others are to use, especially those who have little background in art, the need for systematic organization and lucidity of expression is considerable. Thus, the staff had to decide how it would organize the curriculum once having formulated its premises and identified the areas in which it would attempt to facilitate learning. In short, the structure of the curriculum had to be built.

Before describing the structure that was used, I would like to identify the significance of the curriculum structure in curriculum building. First, the structure provides the basic plan that will be used by a staff to develop the particular units and activities that constitute the curriculum. Second, the components of the structure once identified are extremely difficult to change. After one decides, for example, that the curriculum will contain units, this decision commits the staff to a particular way of working. The analogue to the curriculum structure is an architectural plan. Once the number, size, and location of the rooms of a building are identified, they are difficult to change. How one fills those rooms, or the type of color treatment one chooses to use is quite flexible, but basic decisions about size, location, and so forth are considerably more stable. Similarly, the curriculum structure lays out the basic parameters that define the tasks to be undertaken and, hence, is a major influence on the character of the curriculum that is developed.

Let's turn now to the components of the curriculum that was used in Stanford's Kettering Project.

The categories that constitute the structure of the Kettering Project Curriculum are as follows:

1. Domain
2. Concept or Mode
3. Principle or Medium
4. Rationale

5. Objective
 a. Instructional Objective
 b. Expressive Objective
6. Motivating Activity

7. Learning Activity
8. Instructional Support Media
9. Evaluation Procedures

Three domains of artistic learning were identified in the Project: the Productive, the Critical, and the Historical. These domains were, as already identified, the areas in which we planned to develop curriculum materials and learning activities.

For the critical domain several concepts were identified. These were the concepts of color, line, and composition. These concepts served as focuses around which we identified generalizations, or as we called them, principles. Thus, the concept "color" would be used in a principle such as "Color can be used to communicate or evoke emotions." This principle or generalization was to be used by the teacher as a focus for subsequent work with students. That is, we were not interested in having children memorize such a generalization. We were interested in the teacher helping children recognize—through their own vision—the way in which color can in fact do this. Thus, the concept was the phenomenon to be attended to and the principle described what concerning that phenomenon was to be dealt with.

In the productive domain we identified not a concept but a mode, and instead of a principle a material. A mode is a technique or type of work in the visual arts. For example, drawing is a mode whereas charcoal is a material. Thus, drawing as a mode of productive activity could be done in any number of materials: charcoal, pen and ink, pencil, and so forth. Similarly, painting is a mode as is sculpture or printmaking. It is clear that in each of these modes a variety of materials could be used. Thus, the parallel to "concept" in the critical and historical domains is "mode" in the productive domain. The parallel to "principle" in critical and historical domains is "material" in the productive domain. A teacher working with the Kettering curriculum would know, therefore, what domain he was working in as well as the concept or mode he would use and the principle or material he would focus upon.

Because the Project staff wanted teachers to understand why what was prepared was considered important a rationale was provided for each lesson in the curriculum guide. The rationale attempted to explain to teachers what the significance of the ideas or skills were in the curriculum and for the development of artistic learning. We hoped through this rationale to avoid providing materials that would be used without a sense

Linoleum block print of extremely sensitive design by an eleven-year-old Japanese girl.

of comprehension. It is very difficult to explain in a couple of brief paragraphs what the meaning or significance of a learning activity is in art for those who have relatively little background in it, but we hoped that through the rationale as well as through the curriculum itself teachers would gradually increase their sophistication, comprehension, and sensibilities to the visual arts. In short, we hoped that the materials that were

provided would contribute to the art education not only of the student but to that of the teacher as well.

Following the rationale was an instructional or expressive objective. The instructional objective described what it was that the child should be able to do after having completed a lesson. The expressive objective described a situation in which he would be able to apply in personally expressive ways the skills acquired previously. We wanted the curriculum to have a rhythmic quality that moved back and forth between the instructional and expressive.

Following the objectives was a suggested motivating activity. This activity was simply a suggestion to the teacher regarding what might be done to interest children in a particular activity that was to be made available. Motivating activities might consist of a tour of the neighborhood to look for particular visual qualities, it might consist of a discussion about a set of reproductions of works of art, or it might consist of examining a special display board that was provided among the instructional materials. The motivating activity was designed to whet the appetite, to encourage children to think about aspects of art that they might not have reflected upon, or to encourage them to explore some aspect of art that was believed to be important in the development of the understanding or appreciation of art.

The suggested motivating activity was followed by providing the teacher with two or three learning activities, all of which were related to the objective of that lesson. The reason for providing two or three learning activities rather than one was to give teachers some options so that they could select the type of activity or activities that was best for their class or for particular students in it. Indeed, whenever teachers could identify activities that they thought more effective than those that we provided for the objectives of a lesson, they were encouraged to use them. What we wanted was to enable the teachers using the Kettering Curriculum to become so able as teachers in the visual arts that they would become independent agents who eventually would be able to develop their own programs for students in their class.

The concept of visual support media in art education does not have a long history. When most teachers think of materials for teaching art, the first and often the last thought is that of art supplies—paint, paper, crayons, scissors, and so forth. What we wanted to provide and what we did provide was not art supplies but visual devices in the form of transparencies, color slides, specially prepared drawings, texture and color boards, reproductions, and other types of visual materials that were designed to

be used with the units and lessons in the curriculum material. These materials—about 700 separate pieces—were contained in two large cardboard boxes and each was coded with a number that was cross-referenced in each of the lessons. Thus, if a teacher was working with his students on a lesson in the color unit, he would have at his disposal a variety of materials that were integrated into the curriculum materials that had been written. If a teacher wanted to help children recognize the fact that color is affected by the color that surrounds it, he would have at his disposal a set of reproductions of works of art whose various sections could be changed with respect to color, value, and intensity. What we tried to do is to provide visual resources for helping children perceive visual phenomena. Further, these resources were keyed into the lessons and units that constituted the curriculum.

Finally, at the end of most of the lessons were suggested evaluation procedures designed to help teachers assess the effectiveness of the materials we provided. The schema of the curriculum structure for Stanford's Kettering Project is found in Figure 11.

Figure 11. Curriculum structure used in Stanford's Kettering Project.

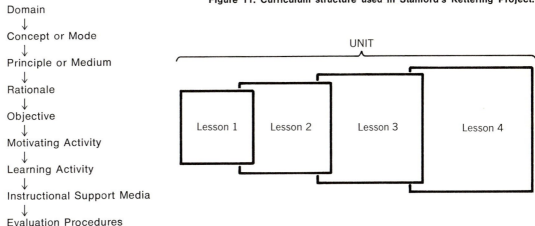

Domain
↓
Concept or Mode
↓
Principle or Medium
↓
Rationale
↓
Objective
↓
Motivating Activity
↓
Learning Activity
↓
Instructional Support Media
↓
Evaluation Procedures

The Kettering Project represented a pioneering effort in the field of art education to provide a sequentially organized curriculum in three areas of artistic learning for elementary school children. As you know from your understanding of earlier orientations to art education, one of

the most emphasized orientations has been concerned with the development of creativity through art. When such a conception dominates a field it is unlikely that curriculum content will be identified systematically, nor is it likely that the range of educational goals in art will include those dealing with the critical and historical aspects of art. It is precisely in this sense that leading ideas, theories, or notions about children's development, about the function of art in experience, about the mission of education affect teaching practice and curriculum development. Such practices are influenced in greater degree by the persuasiveness of leading ideas than they are by the conclusions developed by systematic research.

In many ways this is unfortunate. It tends to lead people to hold ideas without the benefit of evidence. It tends to lead to an advocate-adversary conception of educational practice. Although many, perhaps even most, significant issues in art education cannot now be resolved by appeals to empirical evidence, I believe such evidence should be employed wherever possible. Commitment to an unexamined or untested doctrine is not, in my opinion, the most productive way to improve educational practices in art education.

7

the metaphor and the mean: some observations on the art and science of teaching art

Thus far we have examined the background and dominant themes in the development of art education in America, we have discussed some important theoretical notions concerning the student's development in art, and we have reviewed some concepts and practices in curriculum development. The Stanford Kettering Project exemplified one effort to improve the quality of art education in schools by making certain ideas and materials available to teachers.

Dimensions of Teaching

Yet the most important aspect of art education from the standpoint of the student is what happens in the classroom or school. As long as schools remain the major social vehicle through which formal education is provided, the character of teaching will be a central consideration for those who wish to improve the quality of education.

There is some usefulness in distinguishing between curriculum and teaching—at least for purposes of analysis. By curriculum I mean that selection of learning activities provided by the staff of a school, a teacher or a student as the vehicle through which the students' experience will be educational. Instruction or teaching may be conceived of as the way in which a teacher implements curriculum plans. For example, it is possible to plan a curriculum that, from the standpoint of the significance and appropriateness of the learning activities, cannot be faulted. The learning activities, in this idealized case, are imaginative and the content important. However, the teaching or instruction might, even with such a curriculum, be inept. The teacher might be insensitive to his students, his understanding of the curriculum itself might be very limited, he might have little or no rapport with his students, and his pacing and tempo might be poor. In short, the curriculum in this case would be good and the teaching bad. Or the contrary case might exist; the curriculum might contain trivial content, but the skill of the teacher—in spite of such content—might be excellent. Now, for purposes of analysis, there is some virtue in distinguishing between these aspects of educational practice. In the ideal situation we would hope for both a superb curriculum and artful teaching.[1]

Regarding the scope of the curriculum in art education, I have already identified three realms in which curriculum can be developed; the productive, the critical and the cultural. In addition, I have argued that what constitutes an educationally significant curriculum in art depends, in part,

179

on the characteristics of the students to whom that curriculum is going to be made available. But what about the character of teaching in art education? How shall teaching proceed? What can teachers be aware of that will help them become more effective?

I believe one of the most important aspects of teaching—not only in art but in any field—is the type of relationship that is established between teacher and student. If the teacher is to understand how a student experiences a problem or task, the need for rapport, for honest relationships between pupil and teacher is crucial. All too often, the relationships that are established between teacher and student do not permit the student to make his feelings as well as his ideas known to the teacher. Indeed, the covering up of such feelings is so well developed by students that their ability to conceal becomes a mechanism through which many of them cope with the demands of schooling without being affected by it.[2] I believe these methods of coping are learned, early in the child's school career and take the form of institutionalized role playing. When this occurs it becomes difficult for the teacher to really understand how the student feels and thinks. A wall of formality separates teacher and student, who nevertheless are able to carry on the business of schooling. Such business, under these conditions, tends not to develop the type of internalized experiences that makes understandings and skill endure. Skills learned under such conditions are often viewed as short-term elements necessary for getting through the course.

What I am arguing here is that the development of a type of relationship that breeds trust and openness enhances the teacher's understanding of the student (and vice versa). Such a relationship puts the teacher in a better position, by virtue of the increased understanding that such a relationship affords, to provide those conditions that will make the student's experience in school educational.

The ways in which such relationships can be established with students are many and diverse. There are, alas, no formulas regarding the way in which they can be achieved. However, there are some procedures in teaching that can be used to establish the type of warm and supportive relationship I am suggesting. First, it is important to encourage students to participate in some of the curriculum decision-making procedures that go into educational planning. Students should have an opportunity to participate in the formation of the art program, where this is feasible. This means that the teacher should be ready to talk with students about the kinds of activities and goals that they value in art and to solicit their reactions and suggestions. How do students view curriculum activities that are being

181

THE METAPHOR
AND THE MEAN:
SOME OBSERVATIONS ON
THE ART AND
SCIENCE OF
TEACHING ART

considered? What ideas do students have about projects that they would like to undertake? What kind of classroom and time arrangements can they suggest regarding the planning of the art curriculum? These questions are not intended merely to be solicitous to the young, but rest upon three premises: first, students can provide really good ideas about possible learning activities in the art program. Second, by asking for students to participate in curriculum planning and by getting their approval of options to be considered, the teacher is in a better position to understand what students like and dislike in a program. Third, since one of the major objectives of American education is to help students acquire the skills and attitudes necessary for continuing their own education after they leave school, they should have an opportunity to acquire such skills and attitudes while they are in school.

The development of the type of relationship between students and teacher that I am describing—one of trust and warmth—takes time to cultivate. Students who have had a long history of working with teachers who established authoritarian relationships in class are sometimes suspicious of teachers who do not assume this role. Their previous experience hampers the development of new types of relationships. Yet without such relationships schooling is likely to continue to be a directed affair in which students obsequiously carry out the tasks assigned to them by teachers. Role playing takes over and neither teacher nor student understand one another.

I have indicated earlier that I believe the establishment of a trusting relationship and its concomitant consequence, an atmosphere in the classroom that is supportive, is crucial in the educational process. I want to reemphasize that point again yet, at the same time, I want to point out that although such an atmosphere is important, it is not adequate educationally. This is simply to say the establishment of warm, honest, and supportive relationships between student and teacher is a starting point in education—not an end. It provides the soil for the plant to take root. Decisions will still have to be made about the content and goals of the program. And these decisions need to be made with the expertise of the teacher utilizing the students' suggestions wherever and whenever appropriate and useful. In short, sound educational practice, in art education or in other fields, aims at establishing the type of relationships in classrooms that allow the feelings of the students as well as their ideas to be expressed. At the same time, it utilizes the maturity and professional skill of the teacher in making educational decisions. We must have it both ways. *If* authentic relationships are substituted for professional skill, the edu-

cational process will be the poorer. If professional skill stifles warm human relationships, instruction will be empty, short-termed in effect, and joyless. Both must be used in their proper measure. What this measure is, is precisely the type of question that no book can answer.

Another aspect of teaching that is too often neglected but which to my mind is potentially extremely influential is that which the teacher teaches through the muted cues he gives to his students.[3] Take, for example, a teacher's response to a painting in class. Say that the teacher has an opportunity to have a contemporary painting brought in to his class for a few weeks. How does he react to it? *How* does he talk about it? What does the work do to his feelings? Many students, perhaps most, have never seen a person really "turned on" before a painting. To see such an event can be an extremely potent educational experience for children: to realize, perhaps for the first time, that the cultivated eye has access to a special and rewarding visual world. Classrooms ought to provide opportunities for students to see teachers turn on to visual works, works made by students as well as by professional artists. Such opportunities provide instances of possibilities for students that they might not see at home. In short, seeing a teacher become ecstatic over a visual work of art is precisely one of the modes of human response that one hopes students will learn to acquire. The teacher as model can provide a vivid image of what such experience looks like when it is had.

The use of the model concept in teaching is a powerful one because much of what we learn from other people is by observing how they function and how they feel when they do so. Indeed, social learning theory would argue that imitation is one of the primary ways in which humans learn to behave.[4] What if we applied this theoretical notion to teaching art? What would be the implications of such a belief for practice? In art education it would seem that the teacher acts as a potentially powerful model for providing students with examples of what people do in the field of art. Take, for example, each of the three realms of artistic learning that have already been identified—the productive, the critical, and the cultural. In the productive realm the teacher functions as a model when he actually engages in the creation of art in the classroom. What would this mean in practice? It might mean that the teacher, too, would work on a creative art problem with the students—that he, as well as they, would engage in the making of art. This seldom happens anywhere in school at present.[5] Teachers seldom display the type of productive behavior that represents inquiry into the making of art, yet the opportunity to see a teacher take a painting problem seriously and become immersed in it could have ex-

183

THE METAPHOR
AND THE MEAN:
SOME OBSERVATIONS ON
THE ART AND
SCIENCE OF
TEACHING ART

tremely influential effects. One might be concerned that such an event would take the teacher away from the students. This is true in the sense that while painting or sculpting he would not be providing other types of instruction, but his activity while painting or sculpting is itself instructive. It provides an opportunity for students to see a teacher seriously engaged in the type of work he would like to help students learn to enjoy.

In many ways, American schools remove the student from the world of work and scholarship, and in this sense, while students are in school they do not have the opportunity to learn through observation how that world functions. The professional world that they do see while in school is that of teaching and in this particular area they have many insights regarding how this world functions. Students can role play a teacher by age eight because by that time they have already had 4000 hours to observe that role in action. I am suggesting that a part of what students can observe in school, a part with potentially important educational benefits, is that of seeing teachers *do* what they teach.

In the critical realm teachers provide educationally important models when they display to the class what criticism looks like, that is, when they function as critics. In practice, this means that teachers would use visual art—both student and professional work—as objects of critical attention: teachers would talk about these works, they would compare and contrast, they would analyze and appraise, and they would solicit reactions from students.

In the cultural realm the problem of providing a model is somewhat more difficult and complex. It is difficult because the resources for cultural inquiry into art are not readily available, and complex because the model of the cultural inquirer is not as well defined as that of the painter or critic. Yet students can have an image of what an individual does with art when they see and hear teachers relate the character of a particular work to its place in culture. They see such a model when they hear and see a teacher point out how particular pieces of architecture reflect, and apparently have been influenced by, a stream of architectural styles of the past. There is practically no man-made visual form that cannot be related to a stream of artistic development. There is no man-made visual form that does not relate to a culture's technology and values. For the student to see his teacher describe and analyze such relationships, to see him become excited about discovered insights in the process of analysis is to see a model of an active mind inquiring into the cultural dimensions of art. Such models as these, I maintain, are sorely lacking in American public schools.

Related to this concept of the model as a potentially powerful educational device is the diagram presented as Figure 12. This paradigm presents three sources that influence what students learn in the classroom. Segment A represents those outcomes that are a function of the subject matter of instruction. Thus, students who are in art classes or science classes learn some things about art or science. This is a truism and hardly needs stating. If a student is studying the Peloponnesian War, it is not likely that he will learn to invert fractions when he multiplies. But students learn other things as well in class. Segment B identifies those outcomes that are not simply a function of what is taught but a function of the particular intellectual characteristics of the student. This is to say that students in an art class—or any class—learn not only some things that are common to all students in that class but also learn ideas, skills, and attitudes that are specific to themselves. In short, each student, because of his own unique background and abilities, constructs meanings that are specific to such a background or set of abilities. We learn from a "com-

**A Model for Identifying
Instructional Outcomes**

Figure 12. Sources of educational outcomes.

185

THE METAPHOR
AND THE MEAN:
SOME OBSERVATIONS ON
THE ART AND
SCIENCE OF
TEACHING ART

mon" situation not only what is common, we also acquire personally unique meanings constructed from that situation.

Segment C identifies a third type of outcome in a class. That outcome is a function of what the teacher teaches as a model. Teachers teach themselves as well as their particular subject matters. How a teacher responds to a visual form, how he lights up or fails to light up a new idea, how he feels about precision, punctuality, and so forth are teachable, and learnable, through the type of person the teacher is.

Now it is curious in a way that the evaluation of students in American schools has focused almost exclusively on those outcomes identified in Section A of the paradigm. The question we typically ask when evaluating students is, "Did they learn what we intended to teach?" The personally idiosyncratic outcomes have been neglected in our effort to find out whether or not students are meeting standards or objectives. Yet what students take out of a class—in art or elsewhere—that is peculiarly their own, is surely as important as what they receive that is common to other students in the class. What students learn is both more and less than what teachers teach. An adequate understanding of the teaching of art needs to recognize and appraise both the common and unique outcomes of life in the classroom.

The third segment, the segment dealing with what the teacher teaches as a model, has, like what is learned in segment B, also been neglected in our efforts to understand and appraise teaching. If teachers do teach themselves as well as their subjects, then we would expect two different classes of outcomes in teaching. First, we would expect one set of outcomes to be common to all or most students. The subject matter being taught and the teacher as model would provide a basis for common learning. The second set of outcomes would be those that were unique to each student. If we are to understand teaching, we will need to understand both what is common and what is unique. In the field of art education a high priority has been placed, and in my opinion appropriately so, on encouraging student-specific learning. Unlike the teacher of spelling or mathematics who, if he is doing a good job achieves predictable and uniform behavior among students (all the students spell all of the words correctly, and hence the same way), the last thing the art teacher wants, at least in expressive activities, is thirty-five identical products. In the arts, perhaps more than in any other field of activity, student-specific outcomes are prized.

One of the characteristic techniques of teachers is that of introducing some conditions into an educational setting. These conditions can be as

These works represent solutions developed by high school students for building a structure using repetitive forms out of found objects.

187

THE METAPHOR
AND THE MEAN:
SOME OBSERVATIONS ON
THE ART AND
SCIENCE OF
TEACHING ART

open-ended as bringing into class a large contemporary painting and simply allowing students to respond to it as they will, or the condition can be as specific as prescribing a highly delimited problem with which students are to cope. The choices of the type and quantity of such conditions are at the option of the teacher. A paradigm that makes these conditions explicit in visual form is found in Figure 13.

Figure 13 represents a set of relationships between conditions introduced into the classroom and opportunities students have to make choices with respect to these conditions. In general, the greater number of conditions that an individual imposes *as restrictive conditions,* the fewer options the student has to choose. Conversely, the fewer the number of conditions one imposes, the larger the number of choices will be left to students to make. This can be seen quite clearly if we look at an example. Suppose a teacher at the elementary school level is interested in having his students explore animation in sculpture and suppose, further, that he chooses puppetry as his vehicle for such exploration. The teacher proceeds to show to his class a puppet that he has constructed; it's a light bulb puppet. He demonstrates the puppet to his class to generate their interest. Further, he demonstrates how light bulb puppets are made; he identifies the necessary materials and how they are to be used. In addition, he indicates to the class that they will have about two weeks to work on this project and, finally, he comments that good puppets often have bright colors or are like clowns in the circus.

Such a mode of teaching art at the elementary school level is not uncommon. The teacher identifies a project and introduces it to his class. But notice what else is being introduced. The teacher has not only introduced the project or problem, he has also identified the materials the students are to use, the method they are to employ in using these materials, the amount of time they will have to work on the project, and even the criteria for a "successful" puppet are identified: "It should have bright, happy colors like clowns at the circus."

Imposed Conditions

Opportunities for Choice

Figure 13. Paradigm for the analysis of visual problem-solving.

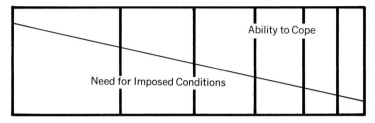

189

THE METAPHOR
AND THE MEAN:
SOME OBSERVATIONS ON
THE ART AND
SCIENCE OF
TEACHING ART

Figure 14. Paradigm for the analysis of visual problem-solving.

Each of these conditions, once introduced into the classroom, establishes parameters within which the student is to work. The student is no longer able to choose options or approaches other than those that were introduced by the teacher. He must learn to work within them.

Now it is possible that each of these conditions could be eliminated. For example, it is possible for a teacher to introduce the project, the materials, the method, and the time but leave the criteria to the students. Or the teacher could introduce the project, materials, and method but leave the decisions regarding time and criteria to students. A teacher might simply show students animated sculptures—puppets, marionettes, kinetic sculpture—and encourage them to develop their own form of animated sculpture, using any materials or methods they care to use. One can go even further as teacher and establish the type of classroom in which students define their own problems and proceed in their own way to solve them.

Figure 13 indicates that as the number of conditions introduced by the teacher decreases, the number of opportunities for choice by the student increases. Thus, in teaching there is a reciprocity between the conditions introduced and the type of choices available to the student.

One should not conclude from the foregoing that the fewer the number of conditions introduced, the better. There is no value connotation associated with these relationships. What the appropriate conditions are can be determined only with respect to the nature of the students and the goals of the program. Examine Figure 14. Here we find two other sets of relationships: ability to cope with problems and need for imposed conditions. These relationships indicate that as a student's ability to cope with problems in a field increases, his need for conditions to be introduced by others decreases. If such a hypothesis is valid we would, as teachers, introduce conditions to a class of students in relation to our assessment of their competencies to cope with the problem or project.

Thus, the introduction of conditions is determined in the ideal situation by our assessment of student capabilities. The relationship between the two figures is now seen in Figure 14. In a sense the type of ability that is to be developed through the process of education is not only an ability to define one's educational journey but the competencies to deal with the problems such a journey entails. In short, we would like to help students develop both the attitudes *and* skills that will facilitate their own artistic development well after they leave the confines of the school.

I said earlier that two criteria govern the problem of deciding on the appropriate type and number of individual conditions in teaching. These were the level of competence the students possessed with respect to the problem and the particular goals of the program. Only the former has been discussed thus far. The latter, the particular goals of the program, are also an important consideration. Take, for example, the problem of preparing a product design. At first, problems might be given to young design students with very expansive options. For example, a problem might be assigned to design a container to hold six milk cartons which can be handled easily by a housewife in a supermarket. Such a problem would leave the student with an array of options that included decisions about material, design, method of construction, and so forth. Now in the actual world of design such a range of options is seldom available. The product designer is usually given a set of rather specific requirements: the carton should be made of waxed cardboard, it must be no larger than such and such, it must require no metal brads for fastening sections, it must cost not more than such and such to produce. In addition, three prototypes must be ready by the end of the coming week. Within these requirements the designer works. The specifications are strict and the designer is faced with the problem of exercising his ingenuity in order to arrive at three potential solutions within the requirements provided.[6]

The point here is that with respect to the objectives of a design program the specification of a large number of conditions within which the student is to work is extremely appropriate. These are the conditions he will be confronted with when he leaves school. Ingenuity is to be developed within the limits established by the client. The visual artist within industry—product design, architecture, commercial graphic design, interior design, and so forth—must often work within such a frame. Competence in these fields in some sense means the ability to cope with the problematic successfully in the fact of severe limitations.

Painters, sculptors, and potters, because of their traditions and because they tend not, in general, to work for a client, have a much wider array of

191

THE METAPHOR
AND THE MEAN:
SOME OBSERVATIONS ON
THE ART AND
SCIENCE OF
TEACHING ART

options. Although a painter, for example, might elect a problem with severe limitations, such election is the artist's choice, not the client's. The painter typically defines his own problem, selects his own materials and methods of dealing with it, and determines when it is complete without heeding a fixed time schedule. The designer seldom has this range of choices. What then are appropriate conditions for the education of a designer are not necessarily the same for the education of a sculptor or painter. It is in this way that the goals of a program bear upon decisions about type and quantity of conditions to be introduced in the teaching situation.

Research on Teaching Art

When it comes to hard-headed empirical research on problems concerning the teaching of art one finds a paucity of really credible studies. Experimental studies, those studies in which intentional efforts are made to influence students' learning in art are much less available than are descriptive research studies. Descriptive research aims at describing conditions as they are—the national census is a prime example of descriptive research. Experimental research requires the time and means necessary to work with students so that the effects of experimental efforts can be detected through change in their ability to perform in any aspect of art that one designates.

Notwithstanding the paucity of experimental studies compared to those that are descriptive, there has been some work that is worth mentioning.

In the area concerned with the appreciation of art Wilson's study, already described in Chapter 5 stands out as a useful model.[7] Wilson found, you will recall, that when fifth- and sixth-grade children were provided with a program that intentionally gave them the opportunity to acquire linguistic concepts related to the formal aspects of art, they were able to use such concepts to describe works of art. Prior to Wilson's program, students tended to attend to and describe primarily the literal aspects of art, its subject matter, whatever representational forms it displayed and the ideas that it reminded them of. After having been helped to look for formal qualities and after learning the terms assigned to these qualities, the type and range of categories students employed in describing visual art expanded considerably.

What is significant about Wilson's study is not only its rarity as a type of experimental research in art education, but the fact that he realized

that linguistic categories concerning visual qualities can be taught and learned. Qualities such as hue, intensity, value, composition, and so forth do not wear their labels on their sleeves. There is no good reason to assume that students will generate such concepts themselves. Most college students are ignorant of the meaning of these concepts unless they have been immersed in art prior to college.[8]

Now what should be emphasized over and over again is that the verbal categories are not ends but means. Any teacher who merely helps children acquire words without helping them perceive the referents of those words is engaged in meaningless verbal teaching. The important point is that the verbal categories function as a starting point for reminding students of what can be attended to in a work of art. Verbal categories do not exhaust the work because they are considerably more gross than the amount of information that can be obtained through vision. They do function in much the same way that theories of art function. Morris Weitz described the function of theory in art this way.

Indeed, the great contribution of theories of works of art is precisely in their teachings, not in their definitions, of art: each of the theories represents a set of explorable criteria which serve to remind us of what we may have neglected or to make us see what we may not have seen. To do this, I should think, is the primary job of teaching. Here, then, is the relation between teaching and the nature of art or, to use the title of your conference, the nature of art and its implications for teaching: that the great theorists of the nature of art have served as the great teachers as well, in telling us, through their definitions of art, what we are to learn from them about the arts.[9]

It is interesting to note that although the type of research Wilson did is rare, a similar, although less sophisticated study was reported by Waymack and Henderson in 1933.[10] Working with fourth-, fifth- and sixth-grade students, Waymack and Henderson gave children a variety of reproductions and asked them to rank the pictures in order of preference. Following this the children were asked to keep the one they liked most, and to write why they liked it. With this information the researchers were able to determine what the children said they responded to about the work— its subject matter, its technique, its form, and so forth.

Following this, Waymack and Henderson provided a program through which they enabled the children to learn how to look at reproduction of works of art with respect to qualities such as color contrast, color repetition, and other formal aspects of the work. The experience they provided the students enabled them to expand the range of visual qualities students

193

THE METAPHOR
AND THE MEAN:
SOME OBSERVATIONS ON
THE ART AND
SCIENCE OF
TEACHING ART

were able to perceive. Like the Wilson study, the Waymack and Henderson study provides some evidence that instruction in the perception of art can increase what students are able to perceive in art—at least as evidenced in the way in which they talk about it.

In an effort to find out how paintings are judged, that is, the factors that influence judgment, James Doerter studied college instructors' influence on the painting styles of their students.[11] What Doerter did was to randomly select eight painting students from each of five painting classes in three colleges. Each instructor in each class furnished two personal paintings and each student furnished the first and last painting he did during the course of a semester's work with that instructor. After having constructed a scale by which to rate the student painting and after having selected judges to do so, Doerter was able to determine whether or not the instructor's style of painting "appeared" in his students' work. Doerter found that not only did this influence occur but that the vast proportion of students did in fact move toward their instructor's style during the course of the semester.

What is interesting about this study is not only the question itself, but the findings, especially since there has been such a great tendency among college teachers of art to espouse stylistic freedom in their teaching. The Doerter study suggests that the maintenance of stylistic independence on the part of the student might be more difficult than previously anticipated. It is not unlikely that art teachers use qualities related to their own work as criteria for judging and talking about student work. What the teacher likes in his own work he probably prefers in the work of others; what he dislikes in his own, he probably dislikes in others. If, in fact, such preferences are exercised in teaching, it is little wonder that the works of the student look like those of his teacher.

This condition, however, need not be seen as inevitable. It is possible for teachers to find out from students what they, the students, are after and to help them achieve it. This will require the teacher to use himself more consciously in the classroom, especially when he is engaged in talking with students about their work. It will require the teacher to enter the student's frame of reference, to understand the territory that he wants to travel, and to help him learn how to cope with the terrain.

Do the preferences people have for styles of art relate to the personality characteristics they possess? To answer this question Bernard Pyron studied the relationships between personality and the acceptance of popular, classical, and avant-garde styles in literature, painting, and music.[12] There has been some research to indicate that people who prefer com-

plex forms to simple ones are likely to be more flexible and more creative. The ability to tolerate, indeed to seek the ambiguous and the complex, has been considered a personality trait related to creative ability. Pyron hypothesized that people who have a high need for simple order would reject avant-garde art significantly more than those who have a high need for complexity.

To test the hypothesis, Pyron asked college students to evaluate four examples of avant-garde, popular, and classical art in each of three art forms: painting, literature, and music. Their evaluation of the work was made on a semantic differential, an instrument used to relate bipolar adjectives such as nice–awful, clear–dirty, and so forth, to each of the works. In addition, each of the subjects in the study was administered a variety of personality tests. Pyron found "that those people who are highest in attitudinal rigidity and highest in simplicity of perceptual organization reject avant-garde art more than those who accept change and tolerate a wider range of social stimuli." This suggests to me that art education might be able to perform a most important function in helping people, who tend to be rigid in their expectations, open up and become more receptive to change. Indeed, a desire to seek perceptual surprise might be an important consequence of effective art programs, especially if such an attitude developed within the realm of the visual arts extended to other human activities. Of course the need to eventually distinguish between the search for the merely bizarre from the search and recognition of the significant is crucial here. Yet without an inclination to search, it is hardly likely that much will be found. In principle and in practice teachers can encourage exploration, speculation, and inventiveness. The history of art is in an important sense a record of the products of such inclinations.

In the realm of the productive there are a variety of studies related to the problems of teaching art. One of the most influential of these is research on the effects of breadth and depth in curriculum on students' skills and attitudes toward art. As I have indicated a number of times in this book, elementary and junior high school programs in art have characteristically offered students a wide variety of materials and projects. This has been done in the name of richness, exposure, and curriculum diversity. I have argued that exposure, when provided in brief periods over projects that require the development of different skills, is not likely to develop those skills to a high degree. The research undertaken by Kenneth Beittel and Edward Mattil provides some empirical evidence for the arguments I have advanced.[13]

What Beittel and Mattil did was to develop a depth and breath cur-

195

THE METAPHOR
AND THE MEAN:
SOME OBSERVATIONS ON
THE ART AND
SCIENCE OF
TEACHING ART

riculum and to offer it to ninth-grade pupils over the course of an academic year. In the study the depth and breadth approach was defined as follows:

Depth approach:

A teaching program which allows a sustained long-term concentration in one specific area of study. There may be variety within this area but the different activities are such that they permit an easy transition from one problem to another. This approach stimulates both sequential and cumulative learning.

Breadth approach:

A teaching program in which a variety of well-chosen subjects and activities are dispersed in such a way as to accommodate differences in the interests and experiences of the pupils.[14]

The criteria for achievement were identified as spontaneity and aesthetic quality in students' paintings. Spontaneity is described as "freedom or ease in movement in the use of materials and rendering of forms." Deliberateness, its contrary, is defined as "stiffness of handling forms and materials in the total work."

Aesthetic quality was determined on a global or overall basis by judges using a five-point scale to rate the work produced. What did the study reveal about the effects of these different curriculum emphases? Did they have differential effects?

Beittel and Mattil found that the students who worked in the depth program produced paintings judged to have higher degrees of spontaneity and aesthetic quality than those students who worked in the breadth-oriented program. However, when the students were asked which type of program they preferred, it was the breadth rather than the depth program that came out on top.

What this study suggests is that spontaneity is a product of both control and confidence and that such abilities and attitudes are more likely to develop in programs that provide for intensive work in a limited range of media than in those that shift quickly from media to media. It is when skill is absent that confidence diminishes and tightness and rigidity enter. At the same time it reminds us that children develop expectations for art courses as a function of what they have experienced in the past.

If past courses emphasize variety they will come to expect it and may be disappointed if they do not find it. This should not be taken to mean that their desires should be catered to. Art educators should, I believe, understand what children want but should make judgments using such information as *part* of the data to be considered. If current practices dic-

This etching by a six-year-old Japanese girl provides a good example of a child drawing not only what she "sees" but also what she "knows." Notice that both the outside and the inside of the bus are represented simultaneously.

tate future practices, the future looks bleak indeed. Instead, I suggest that we let our visions of the desirable enter into our decisions for practice and that we scrutinize the consequences of those decisions to determine if that vision is being realized.

The problem of determining how children's drawing and painting skills can be improved has been of interest to a variety of investigators. What these investigators have in common is their desire to improve children's ability to draw or to paint and their belief that methods can be found that will have this effect. One of the earlier studies attempting to influence and improve children's art ability was carried out in 1944 by Elizabeth Dubin.[15] Working with children of nursery school age, Dubin identified from the literature describing stages of child art a series characteristic for children of nursery school age. Categories such as 1. Scribble-unnamed, 2. Scribble-named, 3. Diagram, 4. Design, and 5. Representation [16] were used to classify children's art and to determine whether or not artistic development had taken place. What Dubin did was to identify the particular stage at which children in her experimental group performed, and by use of discussion about their work and questions of various types, attempted to move them "one stage up" from where they were.

197

THE METAPHOR
AND THE MEAN:
SOME OBSERVATIONS ON
THE ART AND
SCIENCE OF
TEACHING ART

Dubin found that by talking with nursery school children about their work and by helping them begin to see more advanced possibilities she was able to significantly increase the group's development in art.

Although the Dubin study was completed in 1944 and although by present research standards it lacks some of the controls we now consider desirable, the study was a pioneering effort to facilitate growth in art. What is important about the study is not only the fact that it succeeded in facilitating artistic learning among nursery school children, but also that it represented an intentional and explicit rejection of a laissez-faire approach to art teaching.

Other attempts to develop drawing skills are represented by the more recent efforts of R. H. Salome.[17] The Salome study was based on theoretical ideas concerning the way in which humans secure visual information from the environment. One of the tenets of this theory argues that in any visual form there are certain contours that provide maximum information about it. For example, the points at which a form changes direction provides such information. One does not have to look at the total form to secure an understanding of its visual character; one can acquire such information by attending to areas of change.

Using this assumption Salome attempted to teach children how to attend to form, that is, to attend to points that theoretically provide the most visual information. Since perception of form is a necessary condition for drawing a form realistically, Salome hypothesized that the quality of children's drawing with respect to closure–clarity, proportion, and realism would increase.

Salome found that children in the fourth and fifth grades who received instruction in the perception of form achieved higher levels of drawing performance than a comparable control group. Salome also found that "Perceptual training relevant to the utilization of visual cues located along contour lines does increase the amount of visual information fifth-grade children include in drawings of visual objects . . ."[18]

The relationship between one's feelings and one's work in the visual arts has intrigued art educators for years. Do children express their feelings through art? If so, how? Do children display their frustrations in the art they produce? To answer some of these questions R. Murray Thomas conducted an experiment dealing with the effects of frustration on children's drawing.[19] In this experiment forty nursery school children from ages two to four were divided into control and experimental groups. In the experimental group the children were put into a potentially frustrating situation. This situation consisted of being shown toys and large

colored boxes that they were not allowed to open or play with. The control group, however, was shown the same items but was allowed to open and play with the toys and the contents of the boxes. After the experimental and control conditions the children were allowed to paint using tempera, brushes, and an easel.

Now according to one psychological theory frustration tends to breed regression. That is, people who become frustrated are likely to revert to forms of behavior characteristic of a period of development earlier than their own. Thus, a child of seven or eight when frightened might revert to sucking his thumb, an adolescent when frustrated might act out as a seven- or nine-year old, and so on. In the area of art it was hypothesized that the character of what children paint when frustrated would reflect an earlier stage of artistic development and would reveal qualities of frustration described in the work of Alschuler and Hattwick,[20] who provide some evidence on the relationship of art to personality at the nursery school level.

The paintings that were produced by children in the experimental and control groups were analyzed to determine whether regression had occurred. Alas, Thomas was able to find none of the differences he theoretically expected to find between the paintings made by children in the two groups. The children who were frustrated did not regress to an earlier stage of visual expression as he had anticipated they would.

Now it might be that the children in the experimental group were not sufficiently frustrated or, perhaps, not frustrated at all. If this was indeed the case, then the hypothesis that Thomas put forth was not really tested. If they were frustrated, the psychological theory which argues that frustration affects the level, type, and style of expression must be revised or qualified.

Frustrating children intentionally has an ominous ring to it. It does not sit well with those who care for the feelings of the young. One might hope that there would be less obnoxious ways of securing an understanding of the factors that affect artistic expression.

In another inquiry related to the effects of feelings and beliefs on artistic expression, an effort was made to find out how hypnotically induced change in a person's self-image affected his ability to draw.

In this study David Manzella hypothesized that drawing ability is influenced by a person's self-image and that reinforcement of an artist's belief in his talent and creativity would be reflected in his work.[21] Manzella theorized further that such reinforcement will tend to free the individual to use techniques and aesthetic insights that were only partly employed when working in normal conscious states. What Manzella did was

199

THE METAPHOR
AND THE MEAN:
SOME OBSERVATIONS ON
THE ART AND
SCIENCE OF
TEACHING ART

to select ten artists and to interview them concerning their own conceptions of their ability in art. These individuals were then asked to draw from a nude model in the normal waking state of consciousness. Following this they were put into an hypnotic state and were told such phrases as, "You are talented; you are very, very talented and creative; you are going to draw as the talented and creative artist you are; you are going to draw only to please yourself." Following these post-hypnotic suggestions they again drew from the model. Upon completion of both drawings their work was evaluated with respect to its inventiveness and aesthetic quality. Manzella found that the quality of the drawings the artists made under a hypnotic state did not differ significantly from those they made under normal circumstances:

There was general agreement among the judges that while one or more of each subject's drawings made under hypnosis was aesthetically more significant than those made in the waking state, they in no instance indicated an unexpected or unusual extension of the normal expressive range of the artist.[22]

The Thomas and Manzella studies share a common quality: both represent efforts to determine whether abnormal mental states affect the quality and character of expression. They also share a common conclusion: no significant differences due to such states were found.

To what extent do drawings provide an index to an individual's general intelligence? Since its publication in 1926 the Draw a Man Test has been used by psychologists and educators as a nonverbal measure of general intelligence. This test consists of asking a child to draw a man or a woman on a standard size sheet of paper using a pencil. The drawing that is made is then evaluated by applying a variety of visual criteria to the various parts of the human body. Validation of the Draw a Man Test has been made by comparing scores acquired on that test to those acquired on standard group and individual intelligence tests. Correlations between the Draw a Man Test scores and scores on the latter tests are far better than chance—ranging from +.50 to +.70.[22] Thus, the Draw a Man Test has been considered by many in psychometrics as a useful instrument, easy to administer, brief in time of administration, and not too difficult to score.

But can scores on the Draw a Man Test be experimentally manipulated? To answer this question Medinnus, Bobitt, and Hullett selected 14 kindergarten and 20 first-grade students and divided them into two groups.[24] The experimental and control groups were asked to make a drawing of

a man, using the standard procedures suggested by the test makers. The experimental group was then asked to assemble a jigsaw puzzle of a male figure made from plywood. The figure consisted of 14 separate pieces: hair, head, neck, trunk, shoulders, arms, hands, legs, and feet. During a two-week period the children had four sessions in which they had an opportunity to put the jigsaw puzzle together. Then, after the last experimental session, the Draw a Man Test was re-administered to both groups and comparisons of the scores received on pre- and post tests made. Medinnus, Bobitt and Hullett found upon analysis of the scores that the experimental group received a significantly higher score than did the control group. In other words, because of the experience of working on the jigsaw puzzle of the man the degree of complexity of their drawings was significantly increased.

What is theoretically interesting about this study is that the Draw a Man Test is designed to assess intelligence, yet practice in putting a puzzle of a man together was apparently responsible for increasing Draw a Man scores. The researchers rightfully point out that although they have no evidence that the children in the experimental group did not in fact increase their intelligence through the puzzle solving experience, it is unlikely that this would happen. Thus, they raise some questions about what it is that the Draw a Man Test actually measures—in light of the fact that its scores can be manipulated through brief training sessions with a puzzle.

What one finds when looking for experimental studies in the area of art teaching is a paucity of work that is easily applicable to classroom practice. One also finds a variety of studies that are only peripherally related to important problems of teaching art. Unfortunately, too many researchers in art education have cast their inquiries in terms that are perhaps more germane to the psychologist than to the art teacher. Studies capable of shedding light on key questions of practice are not, in my opinion, likely to be formulated without an intimate awareness of the nature of practice. This suggests to me the need to return to the phenomena of interest within the school itself to increase the probability that questions researchers ask will be useful to those who teach.

8

children's growth in art: can it be evaluated?

One of the most difficult problems in the field of education is that of determining how valid educational evaluation can occur. How does one assess and appraise educational outcomes? What indices are appropriate to use in making judgments? What, in fact, do our assessments of achievement predict? Indeed, the term "evaluation" itself has undergone a number of redefinitions in recent years by scholars attempting to develop more adequate theoretical conceptions of the means and ends of evaluation in educational practice. To the lay person evaluation connotes testing students. For many, "to evaluate" implies assigning grades to students in a class. Actually, the terms "evaluation," "testing," and "grading" have quite distinct meanings. It will help immeasurably if these distinctions are made clear at the outset.

1. *Evaluation* can be conceived of as a process through which value judgments are made about educationally relevant phenomena.
2. *Testing* is one procedure used to obtain data for purposes of forming descriptions or judgments about one or more human behaviors.
3. *Grading* is a process of assigning a symbol standing for some judgment of quality relative to some criterion.

Let's examine each of these definitions in some detail. Evaluation has been defined as a process, something that one does, in order to make value judgments about educationally relevant phenomena. This definition is a broad one that underscores two major characteristics: first, value judgments are inherent in the process of evaluation; that is, evaluation is not simply a description of a phenomenon but an appraisal of its worth, import, or significance; second, evaluation in the context of education can be made, in principle, on any educationally relevant phenomenon.

What are such phenomena? One model, developed by Daniel Stuffelbeam,[1] identifies four educationally significant aspects of curriculum planning. These aspects have the acronym CIPP, letters which stand for Context, Input, Process, and Product. It is Stuffelbeam's contention, one which I share, that educational decision-making can utilize evaluation procedures in each of these four areas. In the area of context, evaluation is an appraisal of aspects of the context, such as the characteristics of the students, the community, the resources both material and personnel of the educational institution, and so forth. Adequate planning of educational programs requires some evaluation of these and other aspects of the context in which that program is to function. In the field of art education it would require some attention to who is to be served by the art curriculum.

What are the characteristics of the students? Do the students have any special qualities that should be considered in curriculum planning? What are the competencies of the staff in art? It might be that an idea or program that looks good on paper might be justifiably abandoned after one takes a careful look at students, the faculty, or the resources that these groups would have to work with if the program were to be put into effect.

Each of these phenomena is educationally relevant, demanding an appraisal or judgment regarding its significance in light of the goals of the art program; hence, each is a candidate for educational evaluation.

The second aspect of the Stuffelbeam model deals with input evaluation, an appraisal of the potential learning activities that can be used in a particular context. Let's assume for a moment that some goals have been formulated for an educational program in art. Let's assume, further, that the relevant aspects of the context have also been evaluated. Under such circumstances it is possible to evaluate a variety of ways in which the goals of the program might be realized, given the nature of the context. Such evaluation—the evaluation of input—assumes the possibility that more than one possible curriculum "route" can be conceived of, that each of these is feasible, and that one is in a position to judge the instrumental relationship between these "routes" and the goals of the curriculum.

One of the virtues of the CIPP model, as it is called, is the fact that it draws to our attention the possibility of evaluating the vehicles that might carry students toward the goals of the curriculum. The content and activities relevant to those goals are also candidates of careful evaluation. In this way the components of the model serve as analytic devices for isolating various dimensions for evaluative attention.

The third aspect of the model, process, is directed toward an evaluation of the effects of the curriculum while it is being employed.[2] Most frequently in the world of schooling, evaluation procedures are used at the end of a semester or unit of study. Data is secured and appraised, so to speak, after the game is over. What Stuffelbeam is reminding us of is the need to secure data on which judgments can be made *during* the course of the program and not simply at its conclusion. Process evaluation might take the form of evaluating the quality of student work at intervals during the course of the semester or school year, it might be directed toward the assessment of their understanding of the ideas or processes being taught or it might deal with their sense of satisfaction toward the art program. In each case process evaluation is aimed at securing evidence about the effects of a program which is in progress and while something can still be done to improve it. For the teacher of art such evaluation

```
NAME          _____

DATE          _____

NAME OF PROJECT  _____

DATE COMPLETED   _____

1. I thought this project was:  Boring  ____ ____ ____ ____ ____  Exciting

2. I found the work on it:       Easy    ____ ____ ____ ____ ____  Difficult

3. I think I learned:            A lot   ____ ____ ____ ____ ____  A little
   from this project

4. This project was my:     Worst piece                           Best piece
                            of work ____ ____ ____ ____ ____ of work

5. The most important things I got out of this project were:  _____

   _____

   _____

   _____
```

Figure 15. Student self-evaluation form.

could take the form of using a simple student self-report sheet on which he rates his satisfaction with his work. He might be asked to rank it with respect to other projects he has done in class; he might indicate what he thinks he "got out of" the project, and so forth. If such sheets were to be filled out by students at the completion of each project and placed in a notebook that the student would keep, both he and the teacher would have interesting and useful material concerning the student's assessment of his ongoing work. Figure 15 provides an example of one such form. Teachers can of course develop their own forms in any manner that suits their purposes.

The fourth aspect of the Stuffelbeam model deals with evaluation of the product. This type of evaluation is an appraisal of the outcomes of an instructional unit. In some aspects of educational literature it is referred to as the terminal behavior of the student.[3]

Curricula that have instructional objectives generally frame such ob-

jectives as terminal outcomes. That is, they specify what the intended outcomes of the course are. Product evaluation is that mode of evaluation aimed at determining the extent to which such objectives have been attained.

The categories that constitute the CIPP model, then, identify a wide range of educationally relevant phenomena which are objects of evaluative study. Each dimension of study provides information that is to be used subsequently for educational planning. Thus, the primary mission of evaluation in the model presented is to secure information that will allow the teacher or curriculum planner to improve the educational process. Evaluation, in this light, is an educational tool through which professional intelligence can be exercised in behalf of the students whom the program is designed to serve.

This point cannot be too strongly emphasized—that evaluation can be seen as an educational device. For too long it has been used as a means for distributing rewards and punishments to students. It has been viewed as a mechanism for approving or disapproving what students do; it has too seldom been seen as a diagnostic procedure to improve what is done in schools. If students are not succeeding in school programs, if their experience is not satisfactory, the program that is offered and the instruction that is provided should at least be two of the conditions that are examined. If students drop out of school or if they turn away from art as a means of personal expression and satisfaction, perhaps the cause lies more in the curriculum than in the student.

Evaluation and Testing Are Not Identical

Not only has there been a very limited conception of evaluation employed in educational practice—one limited to assessment of student terminal behavior—there has also been some confusion between evaluation and testing. Evaluation has already been defined as a process of making value judgments about educationally relevant phenomena. Testing is simply one of several possible vehicles for gathering information for making such judgments. Consider the typical test; it generally consists of a set of questions to which a student responds. These questions might be posed within an essay format or a short answer format. In either case the items on the test simply represent a sample of a population of possible test items representing a range of skills in a particular area. In this sense a test is a type of shorthand device that samples the students' abilities. Performance on that sample then becomes a part of the data or evidence

that is considered when we engage in evaluation. Tests, therefore, are simply mechanisms for securing information. To administer a test is not the same as to evaluate.

Data for evaluation purposes are not only secured through the use of tests; data are also secured through unobtrusive modes of data collection.[4] Perhaps the most commonly used of these is teacher observation. During the course of teaching, teachers collect data for making judgments —watching children paint or sculpt, listening to what they say in class, noting the level of enthusiasm they display, and observing the way in which they use tools and materials, are all ways in which data are secured by teachers. Typically, judgments are made almost concurrently with the observation of such conditions. The data that such conditions provide and the judgments teachers make with respect to them hopefully guide the teacher's actions in the classroom. Such data-gathering procedures are unobtrusive because the teacher does not ask the student to display his competencies in a formally structured test situation.

Classroom observation is only one important data collection procedure. Other unobtrusive methods of collecting data for purposes of evaluation include such things as finding out if students increase or decrease their interest in art by noting the number of books on art that are checked out of the school library, "by counting nose prints on the glass in front of the painting near the principal's office" and so forth. To use unobtrusive modes of observation is simply to look for evidence wherever it might be found. Although such methods are not infallible—no method is—such methods when developed imaginatively and interpreted judiciously can provide information having high degrees of educational validity.

The typical testing situation puts students in an artificial situation in the sense that students know that they are being asked to perform and that their performance will be appraised and rewarded accordingly. In this sense test situations provide information as to how students *can* perform; they do not provide information as to how they in fact *do* behave outside of test situations. If we want that type of information we must demonstrate that test scores do in fact predict student behavior outside of the classroom, a type of demonstration that few educational tests have, or we must use students' actual out-of-class behavior as data for making judgments about the efficacy of the programs we have provided. Tests that do predict student behavior outside of the test situation are said to have predictive validity.[5] The latter type of data can be secured through the use of unobtrusive methods of data collection.

Unlike those in the fields of mathematics, social studies, and reading,

art educators have not used tests to any great degree. Indeed, in *Tests in Print,*[6] the most comprehensive catalogue of published tests available in the world, only 10 of the 2,100 tests listed are for the visual arts. The reasons for this stem from at least two sources. First, the general philosophical orientation of art educators over the past thirty years has not lent itself to the use of tests in the field. As long as the major mission of the field was to unlock creative self-expression through the use of art media, it was not likely that tests would be seen as educationally relevant to the goals of the field. Second, the difficulty of testing the types of responses art eductaors have been concerned with is extreme. The problem of testing creative thinking and self expression is considerably more difficult than testing for achievement in mathematics or spelling, or of comprehension in reading. These factors, plus others, have not provided fertile soil for test development in the field.

Some in the field would say to such barren soil, "Thank heavens!" And it is true that testing has caused much mischief in educational practice. It has, all too often, motivated children to seek rewards extrinsic to the joys of inquiry. In many children it has caused strong feelings of anxiety. Yet any tool, even the most useful, can be misused. Our problem, it seems to me, is not to throw away tools but to learn how to use them with sensitivity and discretion.

Testing and Grading Are Not Identical

Testing has not only been confused with evaluation; it has also been confused with grading. What is grading? Should students be graded in art? Should they be graded in any area of the curriculum?

From a strictly logical point of view, to assign a grade to a student is to assign a symbol representing the quality of the student's work or effort based on some criterion or criteria. In this sense a grade is a shorthand report that conveys something of the quality of the student's performance; it is a summative "statement" and not synonymous with evaluation or testing.

There has been much concern about the appropriateness of using grades—usually in the form of assigning some letter, A, B, C, D, and so forth—not only in art education but in other curriculum areas as well. There are several reasons for those concerns. First, it has been recognized that the meaning of a grade to both the students and his parents is not likely to be very clear. Just what an "A" denotes, aside from high quality work (and perhaps not even that), is not at all clear. Single grades in a particu-

lar field are, in effect, used to encompass the total range of a student's efforts and to reduce those efforts to a single symbol. Many people in education believe that at best such a practice provides extremely limited information; at worst it is misleading and harmful.[7]

A second criticism leveled against the practice of assigning grades is that they tend to establish goals that are essentially extrinsic to the goals of education. It is claimed that grades tend to motivate students neither to the joys of inquiry nor to its products but to extrinsic pay-offs. One of my students, an instructor of art education at a large state university, recalls an incident in which one of his students brought to class a project that she had just completed. When asked by one of her classmates what the project was, she replied, "It's a B+."

Such stories highlight the type of mental set and attitude that some students develop when grades are used as summary statements of their work. Working for a grade is not an unheard of idea in American colleges. Critics of grading claim such attitudes are developed quite early in a student's school career, probably by the time the child leaves the first grade.

Those supporting the use of grading argue that each of these two criticisms is really not inherent in grading. They argue that teachers have a responsibility to evaluate and to communicate their evaluations in the form of grades to a variety of interested people—parents, teachers, administrators, and students. Grading practices can rest on clearly defined criteria; if they do not, it is not because something is inherently wrong with grading, but because teachers have not thought through the criteria and communicated it to students.

They argue further that men in society are in fact rewarded in relation to the value that others place on their work. A competitive society rewards most highly those who "come in first." Since schooling should help children learn how to cope with the problems and characteristics of the society in which they live, the assignment of grades is considered appropriate; it is simply one of the reward systems that students will be dealing with throughout their lives. To avoid such a system in school is to increase the irrelevance of schooling in life.

Like most important educational questions there are no simple answers that are adequate. It's clear that teachers and school administrators have some responsibility to report to parents and other relevant adults about the achievement of the young and the effectiveness of the curriculum. Schoolmen have a responsibility to the public as well as to the child. Yet at the same time practices that interfere with the development of affection

by the young for the objects of their study ought to be removed. On the whole, given the character of grading practices in American schools and the effects I have observed, I would argue for the curtailment of letter grades and the substitution of brief evaluative statements by the teacher regarding the characteristics, strengths, and limitations of the student's development in art and other areas. When useful and feasible I would like to see teacher-parent conferences, at which time such written statements could be discussed and elaborated upon.

Again, this should not be interpreted to mean that I disfavor evaluation. On the contrary, I believe the teacher has a moral responsibility to evaluate.[8] I am arguing for the use of expanded written evaluation practices with teacher-parent conferences to supplement and explicate the meaning of such statements.

Contexts for Evaluation

Discussions of grading inevitably give rise to considerations of the criteria that should be used in making judgments about student work. There are three major contexts within which such judgments can be made: student with self, student with class, and student with criterion.

Judgments made within the first context—student with self—are aimed at ascertaining the extent to which the student's competencies, his sensibilities, and his understanding have grown from a previous point in time. For example, a teacher might make systematic note of where each of his students is in his work in art at the beginning of a semester or year. Then later in the semester or year he might encourage students to compare, say, the quality of their later work with what they produced earlier. Such an analysis and comparison would probably reveal a wide range of differences in the learning rates of students. Some students might have barely moved, others might have developed enormously. In any case the criteria in such an evaluation would be developed for each student individually. Once such criteria were developed, the problem of application would be treated by using individual student work as the data to be compared. To use such an approach to evaluation requires that either students or teachers keep student work or some record of it. It is not at all uncommon to find that students do not really appreciate how much progress they have made over the course of a semester. Comparisons of earlier to later work can make progress vivid and increase both the student's motivation and his self-confidence in art.

A second context that can be used for evaluation is that of comparing a student's performance with those of his classmates. "Who is the most technically proficient painter in the class?" "Who is most creative?" are questions that harbor implicit assumptions about how answers are to be determined. In each case it is through comparison not with one's own past performance but with the performance of others. Such assumptions run so deeply in our grading and evaluation practices that we hardly ever make them explicit. They are most vividly revealed in the use of the normal curve in educational practice. Benjamin Bloom, an educational scholar long concerned with problems of evaluation, writes:

> Each teacher begins a new term (or course) with the expectation that about a third of his students will adequately learn what he has to teach. He expects about a third of his students to fail or to just "get by." Finally, he expects another third to learn a good deal of what he has to teach, but not enough to be regarded as "good students." This set of expectations, supported by school policies and practices in grading, becomes transmitted to the students through the grading procedures and through the methods and materials of instruction. The system creates a self-fulfilling prophecy such that the final sorting of students through the grading process becomes approximately equivalent to the original expectations.
>
> This set of expectations, which fixes the academic goals of teachers and students, is the most wasteful and destructive aspect of the present educational system. It reduces the aspirations of both teachers and students; it reduces motivation for learning in students; and it systematically destroys the ego and self-concept of a sizable group of students who are legally required to attend school for 10 to 12 years under conditions which are frustrating and humiliating year after year. The cost of this system in reducing opportunities for further learning and in alienating youth from both school and society is so great that no society can tolerate it for long.[9]

What Bloom is pointing out is the way in which our tradition-based expectations often negatively affect our educational practices. A teacher who assigned all "A's" to a class or who evaluated all students negatively would most likely run into great difficulty in school. Somehow not all students are supposed to get "A's," yet the explicit rationale for that expectation is seldom revealed.

The use of student-class comparisons is also embedded in our conception of normal developmental levels. A student who exceeds or who falls below expected levels of performance for his age level is considered abnormal—indeed, those who lag below expectation have often been referred to as sub-normal. The use of such a mode of comparison for educational purposes has important shortcomings. First, it tends to lead educators to commit the naturalistic fallacy: namely, to assume that be-

cause *most* children perform a particular way at a particular age it is "good" for them to do so, thus moving illogically from description to prescription. This fallacy has been committed with great frequency in art education. It is quite often assumed that the way most children draw at age seven is the way they ought to draw. Yet the way children draw without the benefit of sensitive teaching is no indication that all children should draw that way. If most children of a particular age were to have ten cavities in their teeth, would we be justified in assuming that a child who had five should develop five more? I think not.

In short, expectations developed by looking at group averages have often deleteriously affected our educational practices. Although there are some useful understandings that can be gained by comparing a student to those of his age level, such a practice, in my view, should be only *one* context that can be used for purposes of evaluation. In American schools it is too often the only or dominant one.

A third context for evaluation is that of comparing student performance with a criterion. This practice rests on the assumption that the course or program has a set of instructional objectives, and that curriculum activities are designed to help students attain those objectives. Students are evaluated by comparing their performance with the expectations for that performance as stated in the objectives for the course. If, for example, a course in art had objectives dealing with enabling students to learn how to stack a kiln, stretch a canvas, throw a pot on a wheel, or other such specifiable skills or information, it would be possible to evaluate student behavior in light of those objectives. Ideally for all students in the class all of the stated instructional objectives would be realized. Some fields especially lend themselves to student-criterion context evaluation. In teaching swimming or high jump, for example, it is possible to specify that "Students will be able to swim 10 laps of the pool," or "Students will be able to jump 5'6"." The evaluation problem is simply one of applying those criteria to student behavior to determine whether the objectives have been attained. The problem is essentially one of matching desired student behavior with observed behavior.

One virtue of such an approach—not only to evaluation but to educational practice—is that it allows students to demonstrate competency whenever they are ready to do so. If a program of study has instructional objectives, there is no reason why students should not know what they are and, further, be permitted to demonstrate competence with respect to these objectives when they feel they are able to do so. Under such a policy we might find that a substantial proportion of students would attain course

objectives in only a fraction of the time now allocated for an entire group of students. We might find that some students would require considerably more time than what is now provided. In either case the central focus, that of developing pre-specified competencies, would become the criterion against which the students' abilities would be assessed.

As I have indicated in Chapter 6, the use of instructional objectives is appropriate for only a portion of the problems in curriculum planning and evaluation. Many of the most highly prized outcomes of art education are not capable of being stated in advance in the form of instructional objectives. To foster such outcomes expressive objectives are appropriate. Evaluation occurs not by the application of a pre-specified criterion against which the student's work or behavior is matched but by the attempt to discover valuable qualities in the work or behavior after it is displayed. It's one thing to ask, "Did the student learn what (he or I) intended?" It is another to ask, "What did the student learn?"

In the area of evaluation theory there are two terms that are applied to student-class and student-criterion contexts of evaluation. The former is referred to as "norm referenced evaluation" and the latter, "criterion referenced evaluation." The most common example of norm referenced evaluation is found in the use of tests of intelligence. Intelligence test scores, for example, are determined by comparing the position of a child on a set of test items to those of his age group. Standardized achievement tests operate on the same principle.

Examples of criterion referenced evaluation are found in learning to swim. Here the student must be able to swim a certain number of laps of a pool in order to go into the deep end. Increasingly in education criterion referenced testing and evaluation is being used to determine what aspects of the program will be provided next to students.

It is important to note that the mode of evaluation procedure that one employs is implicitly related to the conception of education that one holds. Where education is conceived of as a process of discovery for both student and teacher and where curriculum planning is an on the spot affair, the use of post facto evaluation procedures dominates. Because little specific is anticipated in the way of outcomes, it is not likely that criterion referenced evaluation will be used. When education is conceived of as the development in the young of certain *specific* skills or understandings then criterion referenced evaluation is more likely to be employed. This is simply to say that policies regarding modes of evaluation and criteria for grading are part of a larger fabric; that fabric constitutes the general view one holds about the means and ends of education.

Thus far, several important distinctions have been drawn among evaluation, testing, and grading. In addition four focuses for evaluation practices have been discussed. These were context, input, process, and product evaluation. Finally, three contexts for evaluation have been identified: student with self, student with class, and student with criterion. Given these distinctions, how do they apply to the various realms of curriculum that have been discussed in earlier chapters? What do they mean for the evaluation in the productive and critical realms? First, we will examine the productive and then the critical realms of artistic learning.

What Can Be Evaluated?

In the productive realm of the art curriculum the focus of student attention is on the creation of a visual form having artistically prized qualities. In the productive realm the child is engaged in the act of making. He is attempting to bring into existence a visual form that in some way satisfies an insight, feeling, image, or idea he has or has discovered in the act of creation itself. But as was pointed out in earlier chapters the realization of such insights, feelings, images, or ideas demands that a material be converted to a medium, a vehicle that will carry or embody them. Because the conversion of material into medium requires an ability to work with and to control various aspects of the emerging form, these aspects can be the subject matter for evaluation.

One of these subject matters is the technical skill displayed in the work. To what extent has the student displayed ability to handle with skill the technical characteristics of the material with which he is working? If that material is tempera paint or water color, attention can be focused on the way these materials are used. Does the student have control over these materials? Are the colors managed so that they function as media, or do they appear to be out of control? For example, if a student's painting paper displays holes from overworking paint into its surface, or if it contains large puddles of paint that were not intended, one can infer that the student is having difficulty with the technical demands of the material; he is still attempting to learn how to cope with material. If the clay sculpture he is working on continues to separate at various sections and if he does not know how to score clay surface or to use slip, he is lacking technical skills. Those skills are necessary but not sufficient conditions for artistic creation. Without the necessary skills expression is doomed to be stifled because of the lack of discipline necessary for its realization.

Henri Matisse, "Girl with a Shawl," 1949, crayon drawing. San Francisco Museum of Art.

Yves Tanguy, "Second Thoughts," 1939, oil.
San Francisco Museum of Art.

Jackson Pollock, "Guardians of the Secret,"
1943, oil on canvas. San Francisco
Museum of Art.

Every visual art object requires the use of technical skills, and in vary-
ing degrees artists have displayed ability to utilize such skills in their
work. Some artists like Matisse, Tanguy, and Pollock display remarkable
technical competencies in the materials with which they choose to work.
Although some artists are less technically competent than others, no
artist can afford to neglect the technical aspect of the work he produces.
Thus, one aspect of student work that can be appraised is its technical
adequacy. To what extent does the work provide evidence that the stu-
dent is developing increased control over the material with which he is
working?

A second aspect of visual art that can be evaluated deals with the aes-

thetic and expressive aspects of the work. To what extent has the student attended to the organization of form in the work? How do the forms function? What type of expressive character does the work display? These questions and others call to the attention of both student and teacher the formal aspects of the work that is being or has been produced. The questions provide a focus for appraisal and discussion. Although it is clear that there is an important interaction between the technical aspects of the work and its aesthetic-expressive aspects, it is useful for purposes of analysis to treat them separately. Such treatment tends to provide a focus for a more perceptually detailed examination and reminds the student of what to appraise during the course of his work.

One of the skills of teaching art rests on the teacher's ability to know when to help the student attend to the technical aspects of his work and when the aesthetic-expressive aspects need attention. If a teacher chooses to confront the student with all aspects of visual form that may need attention, it is likely that such a demand would be cognitively overwhelming, especially since for most students skills in these areas are in the process of development. How much support? How much direction? What type of focus? How to relate to a particular student? These are some of the questions and implied skills that constitute the teaching of art. Because the context is fluid in most classrooms, the demands made on the teacher with respect to the exercise of such skills require an active intelligence to be adequately satisfied. Yet it is, in my view, better in the long run to recognize these demands in all their glorious complexity than to give young teachers the corrupting notion that teaching is a simple affair to be handled by use of recipes.

A third focus for evaluation in the productive realm deals with assessing the extent to which creative imagination has been used in the work. It is quite clear that students can produce visual forms that are technically sophisticated and aesthetically pleasing and yet display little imagination. To what extent does the work display ingenuity? Has the student used the materials in a fresh way? Does the work provide a sense of insight? Does it illuminate some aspect of the world or of the self that previously was obscure or opaque? These questions are aimed at helping students attend to the imaginative aspects of visual art. Students might produce highly imaginative works that are technically crude and vice versa. In the ideal state of affairs the student would be not only technically competent but would utilize his imagination and give it aesthetic-expressive form as well. Although this is not typically achieved, it is, it seems to me, a star worth reaching for.

Evaluating Types of Creativity

The identification of the creative aspects of a work is not itself a simple matter, for creative thinking can be exercised on various levels in various ways. In an effort to identify the ways in which creativity can be displayed, I have formulated a typology of creativity in the visual arts. In this typology there are four general types of creativity identified. These types are described as follows:

Boundary Pushing

In every culture, objects are embedded in various mental fields. These fields are bounded in such a way as to enable members of the culture to place an object in some meaningful context, usually that in which the object is normally found. These fields also provide a sort of psychic economy, a slicing up of the world so that objects within it can be meaningfully and efficiently classified. In addition, they provide the culture with a common set of object-field expectations that act to discourage bizarre actions by individuals in that culture. The fields specify and encourage acceptable, stereotyped, and restricted behavior on the part of individuals who act within the limits of the fields. Some individuals, however, are able to extend these limits. The process of extending or redefining the limits of common objectives is called Boundary Pushing.

In the area of technology, Boundary Pushing was demonstrated by the individual who first thought of installing electric shaver outlets in automobiles, thus extending the usual limits of both the automobile and the shaver. It was also demonstrated by the person who first thought of using rubber for the blades of electric fans and by the individual who first used nylon for the wheels on roller skates. In the classroom, Boundary Pushing is displayed by the child who uses numerals to create designs or pictures or who uses an inked eraser as a rubber stamp. Boundary Pushing is displayed in the recognition that plywood can be molded into a chair, that a cellophane strip can be used to open a package of cigarettes, and that a key can open a can of coffee. Thus, Boundary Pushing is the ability to attain the possible by extending the given.

Inventing

Inventing is the process of employing the known to create an essentially new object or class of objects. The inventor does not merely extend the usual limits of the conventional; he creates a new object by restructuring the known. Edison, to use a classic case, exemplifies the inventor, for his

activities were directed not merely toward the novel implementation of known materials or objects but rather toward their combination and reconstruction. His contributions differ markedly from those produced by Boundary Pushing. The terminus of Inventing is the creation of a new product that may itself be creatively employed, thus being the subject of Boundary Pushing. Gutenberg, Bell, and Marconi are only a few of those who have displayed inventive behavior; and our recognition of their contributions combined with our general reluctance to call them scientists is indicative of the distinctions we make at the common-sense level of the ways in which creativity is displayed.

In *Insight and Outlook* Arthur Koestler discusses the creative process and his analysis of this process is similar to the description of Inventing. Koestler claims that creativity is primarily a bi-sociative process in which the creator finds that two fields usually considered separate could be made to dovetail to establish a new productive relationship. He believes that the ability to find this relationship emanates from motives resulting from aggression and that these motives are also exercised in the production of witticisms and humor. Specifically, in describing bi-sociation Koestler writes:

. . . the creative originality of this matchmaking bi-sociation is not apparent in the smooth syllogistic scheme. The scheme gives the impression that the mental achievement consisted in drawing the conclusions. In fact the achievement was to bring two premises under one roof, as it were. The conclusion is merely the off-spring of the marriage, arrived at by routine actions. In other words, syllogism and deductive reasoning are not the method of creative thought, they merely serve as its formal justification after the act (and as a scheme for repeating the process by analogy after the original-bisociation of the two fields in which the premises are representatively located). The solutions of problems are not "invented" or "deducted"—they are "found"; they "occur." [10]

He goes on further to give examples of such occurrences, among which is Darwin's "find."

In Darwin's case the stick was Malthus's "An Essay on the Principle of Population," published in 1797—more than forty years earlier. In it Darwin saw in a flash the "natural selector," the functional concept he was looking for:

This is the doctrine of Malthus, applied to the whole animal and vegetable kingdoms. As many more individuals of each species are born than can possibly survive; and as consequently there is a frequently recurring struggle for existence, it follows that any being, if it vary ever so slightly in manner profitable to itself, under the complex and sometimes varying condition of life will have a better chance of surviving and thus being *naturally selected*. [Emphasis is Darwin's] [11]

The conception of Inventing used here holds that although the impetus for Inventing may lie in the discovery or the "find" of the congruence of two fields, this find is not enough. From this find the individual must deduce ideas, structure, and conclusions. It is from this process that the invention develops—discovery must be succeeded by purposeful ordered activity, for it is in this activity that the invention becomes manifest.

Boundary Breaking

Boundary Breaking is defined as the rejection or reversal of accepted assumptions and the making of the "given" problematic. This type of behavior is probably characterized by the highest level of cognition. In Boundary Breaking the individual sees gaps and limitations in present theories and proceeds to develop new premises which contain their own limits. Copernicus, for example, displayed Boundary Breaking behavior in his conceptual, if not theological, rejection of the theory that the earth was the center of the universe. His hypothesis that it was the earth that moved around the sun, and not vice versa, led him to develop a theory that, as far as we know, validly describes the astronomical system. His rejection of the knowledge available at the time—knowledge and theories that were limiting—allowed him to make a significant contribution toward helping man understand the universe. In the present era, Einstein's notion of simultaneity allowed him, through his theory of relativity, to develop new concepts useful for understanding nature. His questioning of previous theories of relationships in time and space allowed him to develop a theory from which better predictions of natural phenomena can be made.

Still another example of Boundary Breaking can be found in the work of Binet. "Binet's approach was the direct opposite of that of his predecessors. Instead of trying to find a single index of intelligence, he went to the other extreme and deliberately searched for a multiplicity of indexes." [12] By making the "given" problematic and by reversing the approach taken by others, Binet set the pattern for over fifty years of intelligence testing.

Two kinds of behavior characteristically displayed by Boundary Breakers—insight and imagination—may function in the following ways. Insight may help the Boundary Breaker grasp relationships among seemingly discrete events. It may also enable him to recognize incongruities or gaps in accepted explanations or descriptions. As he recognizes these gaps, his imagination may come into play and enable him to generate images or ideas (or both) useful for closing the gaps. Through the production of

these images and ideas, he is able to reorganize or even reject the accepted in order to formulate a more comprehensive view of the relationships among the elements that gave impetus to the initial insight. Insight into gaps in contemporary theory or actions and visions of the possible are probably insufficient to satisfy the Boundary Breaker; he must be able to establish an order and structure between the gaps he has "seen" and the ideas he has generated.

Aesthetic Organizing

Aesthetic Organizing is characterized by the presence in objects of a high degree of coherence and harmony. The individual who displays this type of creativity confers order and unity upon matters; his overriding concern is in the aesthetic organization of qualitative components. Decisions about the placements of objects are made through what may be called a qualitative creativity.

Individuals who are able to organize components aesthetically probably obtain a great deal of pleasure from so doing. This inclination towards aesthetic order also seems to be displayed in the way in which forms are perceived. Barron [13] has reported that both creative artists and creative scientists show more preference for designs that are highly complex, asymmetrical, and seemingly disorganized than do less creative individuals. In this sense, the Aesthetic Organizer may be an aesthetic "see-er" as well; that is, he may obtain his aesthetic pleasures by seeing through disorder to identify orderly elements. Some artists and writers report that they are controlled by these urges and drives and admit to following their lead consciously, rather than having and adhering to carefully preconceived plans of execution.

It should be noted that a major difference exists between Aesthetic Organizing and the other three types of creativity. In Boundary Breaking, Inventing, and Boundary Pushing, novelty is a defining characteristic. Either a new use for an object or a new object itself is created. In Aesthetic Organizing, this is not necessarily the case; neither a new use nor a new object may have been created. The object upon which creativity was exercised, however, displays a high degree of coherence. Its parts hang together harmoniously. For most artists the aesthetic organization of form is a prime concern, but in children high aesthetic organizing ability is relatively rare. The preadolescent who is able to organize form to a high degree of coherence and harmony is often said to be gifted; in this

typology this particular kind of giftedness is considered one type of creativity.

Each of these types of creativity might be displayed in a student's work, although it is likely that only one or two types will be displayed in any single work. The virtue of the distinctions is to call to the teacher's attention that students may function creatively in different ways, thus putting the teacher in the position to recognize different "creativities" when they are present. In a study of children's drawings and sculpture I found that children who were highly creative in one mode—say, sculpture—were not necessarily highly creative in another mode.[14] I found, further, only a small relationship among the four types of creativity; that is, some children were able to push boundaries whereas others engaged in invention. The least often displayed type of creativity in the 160 art products that were evaluated was boundary breaking, the most common type was boundary pushing. Like most of us, it seems children are more apt to work within or to extend the given than to question it in order to establish their own rules. Indeed, this has not only been characteristic of most artists, it has been typical of men of science as well. Thomas Kuhn,[15] an historian and philosopher of science, distinguishes between "normal scientists," those who work within given theories attempting to fill in the gaps with empirical evidence within the boundaries of such theories, and "revolutionary scientists," those who reject the existing theories and establish new ones within which they and other "normal scientists" work. Even with children it seems there appear to be more "normal" artists than "revolutionary" ones.

The major point, however, of the typology is not the empirical evidence, although that is useful, but rather its function as a reminder to those who teach the young to look in various places for various types of creativity. One of the educational responsibilities of the teacher is to help students appreciate the character of their work. Conceptual schemes like the typology just described are tools that make such appreciation more likely.

By way of review, thus far I have tried to indicate that the evaluation of an art product can focus on at least three aspects of the work: its technical aspect, its aesthetic-expressive aspect, and its creative aspect. I have indicated, further, that the creative behavior in art can be differentiated into four types: Boundary Pushing, Inventing, Boundary Breaking, and Aesthetic Organizing. The major functions of these distinctions is to provide a conceptual screen for the teacher and the student, so that their perception of the emerging or completed work is more comprehensive. It is apparent that attention to the various aspects of the work that have been

identified is an aspect of art criticism. Because the goal of criticism is the reeducation of perception, tools which point out, which sharpen perception are, in a sense, tools of criticism. The distinguishing feature of evaluation in the productive realm, as distinct from the critical and cultural realms, is that in the productive realm the goal of evaluation is to enable the student to improve the quality of his work as well as to recognize and appreciate what he has produced. In the critical realm evaluation aims not primarily at improving the work, because in most situations the work under scrutiny is not the student's, but rather to see the work more completely. In this sense evaluation in the realm of the productive has the added burden of being instrumental to improved production. In the strictly critical area such a consequence is ancillary rather than direct.

Evaluation in the critical realm requires attention to the character and content of the statements students make about visual form. Evaluation in this realm may also consist of the appraisal of nonverbal responses to visual form—but more of that later.

Critical appreciation of visual form is most frequently a covert act. How one *feels* when encountering an art object is, by definition, not physically apparent. The type of experience one has, the way in which such experience plucks the heart strings, what the object does to the imagination of the beholder are private affairs. To understand such private affairs the teacher makes inferences about them from those actions of the student that are public—his speech, his gestures, his eagerness to seek out and encounter other visual forms. In short, the assessment of experience or appreciation of a work of art requires the making of inferences, of moving from what one can observe to what one can infer.

One major source of information about a student's critical abilities is the type of statements he makes about visual art. What is it that the student notices about a particular work? What type of statements does he make about what he observes? How penetrating are those statements? Is he able to relate his observations of the work to the context in which it was created?

Many people, especially those who are visually naive, often spend very little time looking at art. It has been estimated that the average viewer spends less than seven seconds looking at a work of art in a museum. Art works are most often viewed "on the fly." In spite of the brevity of

Art Criticism as a Type of Evaluation

such encounters naive viewers are often quick to judge, to exclaim their likes or dislikes regarding the particular works they so briefly encountered.

In an effort to help students avoid impulsive judgments of works of visual art, David Ecker suggests the following procedures:

First, get the students to report freely their feelings, attitudes, and immediate responses to a given artwork (their own or a masterpiece). *Second,* point out to students that there are differences in how people (including their teacher) respond to what is apparently the same stimulus, and that this is a consequence of different experiences and learnings. *Third,* get them to distinguish psychological reports which are true by virtue of their correspondence with physiological and psychological states, with value judgments which are true—or better, justified—by virtue of arguments and supporting evidence. *Fourth,* broaden their experiences with contemporary and historical works of art and develop their ability to justify their independent judgments or the merit of art objects, whether or not they initially happen to like or dislike them.[16]

Such statements—those of like and dislike—are referred to as statements of preference. And in matters of preference, as in matters of taste there can be no dispute. If a student says he likes or dislikes a painting he can never be wrong. The statement, as David Ecker [17] has pointed out, is incorrigible; on logical grounds it cannot be challenged. In this sense a statement of preference is a psychological report, it describes the student's reaction and as a psychological report it is not subject to refutation.

But whereas there can be no dispute in matters of preference or taste, there certainly can be in matters of judgment. Judgment consists of making statements about visual form which can be supported or refuted by evidence. For example, a student might say, "I think this is a great sculpture." Here the teacher can ask why, and the student (it is hoped) will then be able to point out qualities and provide reasons to support his judgment of the work. If he says, "I think the sculpture is great because I like it," liking it and greatness can be considered tautological, they mean the same thing. He has stated a preference disguised as a judgment. Thus, we can distinguish among the things students say about art. The first two distinctions that I wish to make clear are those between statements of preference, "I like it," and statements of judgment, "This is a good (or bad) painting."

Given these distinctions it should be clear that what art education is after is to help children acquire those sensibilities and understandings that will enable them to experience visual form on the plane of aesthetic meaning. This implies a willingness to suspend preferences until a visual

analysis has been made. Quick statements of preference often provide premature closure; the student fails to see the work in any depth. What students say with respect to preference or judgment provides an initial set of clues that can be used to evaluate their ability to recover meaning from the work of art. What type of statements do students make about a given work? Are they statements of preference or statements of judgment? And if the latter, do they offer reasons to justify the judgments they make?

Not only can a teacher attend to the type of statements students make about art in evaluating their development in the critical realm, he can also help students understand the types of statements that can be made about art. Morris Weitz, among others, has distinguished among statements of description, statements of interpretation, and statements of evaluation. For instructional purposes a teacher can help children learn how to attend to and describe the strictly factual aspects of a work. Statements such as, "The painting is asymmetrical in composition having a horizon line above the center of the picture plane," is an example of a descriptive statement. Statements such as, "The dominant colors are orange on a yellow field," "Three figures sit huddled together forming a circle near the lower half of the canvas" are other examples of descriptive statements. As an instructional device this procedure simply encourages students to attend to the subject matter and form of the work in a matter of fact way. Such a procedure is intended to increase the amount of visual information the student can extract. Statements of this sort made voluntarily by the student first, suggest that he understands the procedure of looking at a work with respect to its descriptive qualities and second, provide evidence of the qualities he is able to see.

But attention to the "literal" aspects of a visual form is only a first step. Surely one hopes for more than mere description. The second type of statement that can be made about a visual form represents going beyond the descriptive. The second type of statement is called an interpretive statement. Interpretive statements are those like the following made by an eminent American critic about the work of the French impressionist Pierre Bonnard:

Challenged to start at any definite point, one might begin to detect, say in *View from the Studio, Le Cannet,* shreds and patches of porous color—blond pinks sieved by lavender blues, surrounding greens freckled by spots of orange—which only gradually reconstitute themselves into delicate lineaments of furrowed fields, truck gardens, trees, and maroon groves, at a moment of burnt-gold sunset. The

substance of these images is open-stitched and knit at apparently careless angles so that they boggle, molest, and yet dissolve into one another.[18]

An analysis of these remarks indicates that the critic makes a creative use of simile and metaphor to suggest poetically the feeling and imaginative qualities of Bonnard's *View from the Studio, Le Cannet,* "shreds and patches of porous color—blond pinks sieved by lavender blues," and so forth. These are verbal efforts to carry the reader beyond the literal visual qualities that constitute Bonnard's work and to help the reader experience their expressive meaning. The vehicle for such experience is words that carry associative or poetic meaning. Kozloff goes on to say of Bonnard's work, "And over all there emerges an unheard of miscegenation of touches—resembling peach bruises and handkerchief dabs—that characterize the fluorescent, watery spectacle as some slightly polarized or overexposed film." [19]

We see in such statements not literal description but interpretation, analogue, suggestion. Such statements represent a creative interpretation based on the critic's ability to see such qualities in the first place, to find their poetic analogue, and to string such analogues together syntactically so that by reading his words one can experience the qualitative meaning of Bonnard's *View from the Studio, Le Cannet* more deeply. In this sense the test of criticism is empirical.

What we must do with critical statements is to determine the extent to which that which they suggest can be found in the work itself. The end of criticism, as Dewey pointed out in *Art as Experience,* is the reeducation of the perception of the work of art. What we ask of interpretive statements is that they carry us along that road—a road which is to lead into, not away from, the work.

What does this mean for the evaluation in the critical realm? It means a teacher can take note of the statements students make about art to determine not only their type, i.e., descriptive or interpretive, but their quality. Do they lead one into the work being described? How revealing are the metaphors and similes that are used? Do the statements students make suggest that they are experiencing the feel of the work? Do they seem to experience what the work communicates emotionally?

It should be reemphasized here that it is possible for students to have deep and meaningful encounters with a visual form and not be able to articulate its qualities in discursive language. Children can feel without being able to say, and to the extent that this is true, verbal evidence will not be a valid indicator of such experience. Other types of evidence need

to be sought. Yet when verbal evidence is provided the teacher is in a position to appraise its type and its quality to infer how far into the work students were able to go.

Finally, statements of an evaluative type can be made about a visual form. Such statements are judgments of its value or significance. "This is one of the finest examples of Frank Lloyd Wright's architecture," "This sculpture is better than that one," are evaluative statements for which a teacher can ask for evidence. "Why do you think so?" "What leads you to that conclusion?" are questions that can legitimately be put to anyone making judgmental statements about a visual art form. If a student's judgment is not simply preference in disguise and if he has some verbal facility, he will be able to provide some reasons to support it.

Now the assertion is often made by some art educators that verbalizing about art is deleterious, that it reduces visual experience to verbal experience. I see no validity in such an assertion as a necessary consequence of talking about art. The problem is not whether one talks about art, but one of determining the quality and utility of the talk. There is no reason why man should not use one of his unique intellectual tools, spoken language, as a tool for experiencing visual art. There is to my mind no necessary virtue in standing in mute silence before an art form or in uttering grunts. Where criticism is responsible, it helps those less able to see more clearly. Although verbal language is not now and can never be a substitute for the visual, it can function as a midwife to aesthetic experience, and when used by students, it can provide evidence of the extent to which they are able to see and feel the work in question.

Within the interpretive realm various types of statements can be made about various aspects of a visual form. These types and aspects are the experiential, the formal, the material, the thematic, and the contextual.

Statements of an experiential character describe how the work makes one feel. "The work has a sense of surprise to it, it jumps and pops in unexpected places," is an example of such a statement. The statement describes the individual's reaction to its qualities.

Formal statements are those describing relationships among the visual forms constituting the whole. Statements such as, "The arrangement of figures in painting takes the form of an S curve," or "The red patch in the lower right hand tends to advance because it's the most intense of all the colors used," are examples of formal statements.

Statements about the material, especially as it interacts with form and subject matter, constitute material statements. "The material used in Michelangelo's 'David' is white marble, a soft stone capable of being

treated with much detail, which lends itself well to the subject and theme Michelangelo wanted to create,'' is an example of a material statement embedded in an interpretive-evaluation context.

Thematic statements deal with the idea or ideas embedded within the particular work encountered. In many, perhaps most, works of art there is an idea or theme that provides direction to the artist's work. In Picasso's "Guernica" the theme is man's inhumanity to man. A mother holding her dead child, the screaming of injured horses, the sharp, jagged shapes, and the stark black and white color of the painting are all instrumental to the artistic realization of this theme. Although it would of course be possible for someone to attend only to the formal and material aspects of the work, lack of realization of the underlying theme would leave such a viewer with less than he needs to have for a full appreciation of what Picasso has achieved in this work.

An example of the way in which theme is identified and described can be found in the following remarks by H. W. Janson concerning "Guernica":

The mural, executed for the Pavilion of the Spanish Republic at the Paris International Exposition, was inspired by the terror-bombing of Guernica, the ancient capital of the Basques in northern Spain. It does not represent the event itself; rather, with a series of powerful images, it evokes the agony of total war.[20]

Identification of the thematic aspects of the visual work of art requires our ability to go beyond the visual information given. It requires an ability to understand what the visual work is attempting to illuminate. Henri Daumier's lithographs of nineteenth-century French lawyers and their clients are not merely about them but also about the administration of justice in France during that period, and about the types of relationships that existed between advocate and accused. Mark Tobey's "Written over the Plains" (1950) is not simply about relationships between form and color but represents the idea that paintings can have no recognizable subject matter and yet deal with ideas. What we have, then, in the thematic analysis of works of art is attention to the idea or principle underlying the work.

It should be pointed out that some critics and aestheticians object to using art—a particular—to illuminate a universal. It has been argued that the proper office for the latter is science. It is through scientific rather than artistic inquiry that generalizations can be most securely known. Yet I believe that such a doctrine places too narrow a limit on what art can do. Not only visual art but literature as well has used the concrete and particular to speak to a higher principle than the immediate. After all

War and Peace, The Old Man and the Sea, One Day in the Life of Ivan Denisovich, are not simply about the main characters in those works. Similarly, the men of Goya, Giacometti, Picasso, and Bacon are not simply about shape and color. When one develops a high level of sensibility and insight into visual art, when one's qualitative intelligence is highly developed, the thematic aspect of the work becomes apparent.

The adequacy of one's understanding of the theme of a work is determined, like one's assertions about its form, by its relationship to the referent itself—the work of art—and by knowledge coming from an understanding of the context in which the work developed. The contextual aspect of critical evaluation brings us to the fifth and final (for our purposes) type of statement that can be made in the interpretive aspect of art.

Although for purposes of analysis I have made clear-cut distinctions between the experiential, the formal, the material, the thematic, and the contextual aspects of the interpretation of art, all of these aspects are

Mark Tobey, "Written over the Plains," 1950, oil and tempera. San Francisco Museum of Art.

228

Marc Chagall, "Anniversary Flowers," 1946–1947, oil on canvas. Norton Gallery and School of Art.

used in various degrees by critics. The fabric of art criticism is inter-woven with these strands; only analysis separates them. The contextual aspect of art interpretation is the bringing to bear on the art work a wide variety of information, including historical information concerning not only the work but the era in which it was created. Thus, an understanding of the character of fifteenth-century Venice helps shed light on the character of Titian's work. The values held by the members of the French Academy in early nineteenth-century France illuminate the work of Jacques Louis David and to understand that at an early age Georges Rouault was apprenticed to a maker of stained glass windows contributes to a richer appreciation of the form and content of his work.

The contextual aspect of criticism is the ability to put a work into its context, a context which includes its place in time, its relationship to other works, and something of the character and intent of the man or woman who created it.

Works of art, like artists, are seldom, if ever, developed *de novo.* By virtue of their training and their experience with art, artists come out of a tradition. The character of their work, its function, its subject matter, its form, are in some way influenced by that tradition, even if the influence takes the form of rejecting it. What we see, therefore, when we confront a work of art is not an isolated product developed by someone blind and ignorant of the artistic past, but more likely a work whose creation stands in some way on the shoulders of those who have preceded him. In short, we see in art a part of a picture of a changing civilization.

A student who can when discussing a work of art deal with the era in which it was made and show how that work participates in that era, a student who knows something about the artist who created the work and who can illuminate the work with such knowledge, a student who can see a work as a part of the fabric of changing artistic styles and objectives is, when discussing these aspects, engaged in the contextual aspects of art criticism.

For evaluating learning in the third realm of the curriculum, the cultural realm, little will be said. This aspect of learning is essentially verbal in nature, and of the three realms, teachers usually have the most expertise in assessing this type of learning. In evaluating this aspect of learning what we are after is an assessment of the student's ability to understand, in discursive terms, the characteristics of the time and place in which art was created, the influence time and place had upon the form and content of art, and the character of major social practices and beliefs and their effects upon art. In many ways the contextual aspect of art criticism is

Georges Rouault, "Lonely Sojourner in This Life of Pitfalls and Malice," plate 5 from *Miserere* (1922). The Museum of Modern Art, New York.

much like performance in the cultural realm, the major difference being that in the contextual aspect of criticism the discourse is to be instrumental to a more profound appreciation of a particular work of art. In the cultural realm we might use works of art but they are generally instrumental to an understanding of the period—rather than the reverse.

For assessing such ability classroom discourse is one source of evidence. Students can also write, in the manner of art historians, critics, or cultural anthropologists, to provide a written source of data. Indeed, one worthwhile learning activity is to provide students with an opportunity to read and discuss the work of such individuals in order to understand not only what they say, but what they do. Once having read such works they will be better able to use them as models for their own.

In any case, what concerns us in this realm of artistic learning is to help students understand the sweep of a period in human history and the role art played within it. We want students to understand that the men who create art are part of a human culture and therefore reflect that culture in their art. Furthermore, we would like them to understand that although the culture in which artists work affects their work, it is not a one-way street. Artists, through their work, comment on that culture, provide models of value for it, and the great ones profoundly influence it. Art is more than a mirror; it also provides visions towards which men reach.

Figure 16 presents a grid that might help you see both the three types of artistic learning that have been identified and discussed and the three types of criteria that can be applied in appraising student growth in art. On the vertical axis are the three realms: productive, critical, and cultural. These are the modes of behavior which we are interested in facilitating. On the horizontal axis are three types of criteria that can be used to appraise student development. One can compare student performance with a pre-specified standard (in which case one has a criterion referenced measure), one can compare student performance to the performance of a group (in which case one has a norm referenced measure), or one can compare student performance with his own past performance. Each of these criteria can, and usually does provide different types of information. In addition, students who, for example, might progress exceedingly well in the productive realm might not progress as well in other areas. Remembering that the dominant function of evaluation is the improvement of curriculum and teaching, the information received from such a grid would then be used to determine how the program and what the teacher does can be made more effective. Such a grid also makes it possible to provide a more comprehensive description of student performance to the student or

	Student with Standard	Student with Group	Student with Self
Productive			
Critical			
Cultural			

Figure 16. Student evaluation grid.

to his parents. The general global systems that are now used in school do not make clear what it is that is being evaluated and graded and what the criteria are that are being employed. Through analysis such vagaries can be eliminated.

As already indicated, one simple device that can be used by students in class is the self-report scale. Such a scale can be constructed by a teacher and completed by the student after he finishes a project in class. By completing the form and keeping it in a notebook the teacher can accrue information about how the student thinks and feels about his own work in a particular class. What do students think of the work they produce? What is it that they believe they learned from doing it? What did they like least about a particular project? What would they like to work on next? These questions and others that can be raised give both teacher and student an opportunity to review what the student has done. Often the teacher's perception of the student's satisfaction with a particular project does not

match the student's own perception. By providing a vehicle for recording student evaluations the teacher can better recognize such differences. In addition, a collection of such report forms turned in for each project completed provides a useful running assessment of the student's appraisal of his own development and satisfaction over the course of a semester or academic year.

Self-report forms are only one of the underused procedures for securing data for evaluation; another such procedure is that of using unobtrusive modes of data collection. As already indicated unobtrusive modes of data collection are those that attempt to secure information in non-test like situations, situations which provide evidence of interest and participation in the activity or field being assessed. Test situations are highly artificial. Both student and teacher know what the test situation is for and what type of information it is to provide. But how do students behave in non-test like situations? What types of interest in the visual arts do they display when not under the stress of testing? To answer such questions requires ingenious and subtle modes of observation, not as a spy but as a person interested in finding out what effects the art program is having in situations outside the classroom or school. Indeed, the power of educational programs should be assessed by their effects not only within the school but outside as well if their educational significance is to be determined. Whereas some of the effects of school programs will not be detectable immediately, some will. It behooves educators, when evaluating the effectiveness of school programs, to look to these out-of-classroom and school behaviors as well as those within the classroom.

Another useful technique for revaluation in art education is the group critique. This method consists of having students display one or more pieces of their work, describing the work and then soliciting reactions from their classmates. In such a situation students will walk around the room from table to table looking at and reacting to—hopefully utilizing developing critical skills—the work produced by their classmates. Because each student's work is "up for critique" the likelihood of being unfair, or worse, unkind in one's criticism is reduced, but not necessarily absent. In any case such a procedure has several potential benefits. First, it allows each student to discuss what he did and, thus, to have some practice in the critical realm of the art curriculum. Second, it allows students to systematically learn how other students have fared with the problems they undertook. The critique makes public not only their successes but their failures as well and provides students with the invaluable realization that art demands risk and risk, by definition, yields some results

that fail to meet the mark. Third, it provides the teacher with an opportunity to use student comments diagnostically. To what do students respond in the work of their peers: its technical quality, its ingenuity, its aesthetic character, its subject matter? By noticing what students see and react to first the teacher is in a better position to understand what students *miss* seeing. Obviously such information has implications for curriculum and instruction.

Regarding the use of formalized testing for purposes of evaluation I have already indicated that there is a paucity of such instruments available. This makes it necessary for those teachers or curriculum specialists who want to use formal testing procedures to create their own instruments. The limitation of such an approach is the time and effort that it takes to develop reliable and valid instruments. The asset, however, is that instruments can be developed to suit the specific purposes for which they are to be used. Too often I have found curriculum directors seeking "scientific" tests to demonstrate effectiveness of a particular program whether or not the tests measured skills or understandings that the program was aimed at developing. Teacher-made instruments need not suffer from that affliction.

If tests are to be developed for evaluation in art education it is useful to remember that the format of the items—if it is not an essay test—need not be exclusively verbal. For example, one can provide a verbal stimulus, say, directions to select out of five samples of modern painting the one that is an example of cubism, and elicit a visual response—selection of a visual exemplar. Similarly, one can provide a visual stimulus, say, a particular reproduction and ask for a verbal response—an essay or an analysis in class. It is also, of course, possible to provide a verbal stimulus and seek a verbal response or to provide a visual stimulus and seek a visual response. In short, the format test items come in and the type of response that can be elicited need not be restricted to the conventions that have characterized so much achievement testing in American schools. Indeed, it would be excellent for American schools to provide a much wider scope of response possibilities to students, not only in the visual arts but in other fields as well. I believe the spoken word has for too long had far too much emphasis in public schools. Other modes of expression—the visual, the dramatic, the musical, and the poetic—have distinctive and equally important contributions to make to human experience. Their neglect in our schools is only symptomatic of an aborted conception of education.

9

research in art education: what can be expected?

Attitudes toward research in the field of art education tend to cluster around two poles. At one end are those who squarely condemn research on the basis that it is alien to the nature of art and that nothing less than the subversion of creativity in art can come from it. At the other end are those who embrace it warmly and who believe that through research art educators have the most promising means of increasing the effectiveness of art education. The members of these camps have been warring for some time and frequently, as is often the case when parties contend for power or influence, overstate their respective cases. What are the claims that each makes to support its views? What is the debate about? And what can we reasonably expect research to provide the field?

First, it should be remembered that art education as a field of educational practice has not had a history of research, scientific or otherwise, comparable to that of psychology, sociology, or any of the "hard" sciences. Art educators "grew up" within the fields of education and art. Their background most often consists of training in art gained by attending art schools or majoring in art in colleges and universities. Such training did not then, and, in general, does not now, tend to develop much understanding of scholarship. Further, it does not tend to develop analytic skills in the use of language or theory. It is no wonder, then, that those trained in such a tradition would see research in art education as an uncomfortable intruder, somehow not belonging to the family of art.

The suspicion of the intruder is not all that is objected to by those who see research, especially the type aimed at studying human creativity, as basically antagonistic to the very process those who use it seek to understand. Creativity, it is maintained, develops best when protected by the cloak of mystery. To throw a spotlight on, to illuminate each crack and cranny is to rob creativity of its power. In short, creativity—a major object of interest to art educators for years—is believed by some to be incapable of being understood.

Arguments against research in art education proceed further to claim that scientific research (the type most frequently thought about and rejected) employs tools that miss the mark when it comes to art. Art, it is claimed, operates precisely in that realm of human experience and understanding where scientific tools—tests, measurements, statistics, and the like—are feckless. If one wants to understand artistic development or art itself one must use art or artistically relevant modes of inquiry. To attempt to bring to bear on art tools appropriate for the physics laboratory is to misconceive art, and what is worse, to miseducate children. In short, perhaps the basic objection to research in art education rests on

epistemological grounds, grounds dealing with how men secure knowledge. For some in the field, artistic modes of knowing cannot be revealed through those modes of knowing that we call the sciences. Each field operates in its own sphere and each, for the mutual health and development, needs to be kept separate.

Thus tradition, training, and belief systems undergird much of the objection to research in art education. How are these charges answered? What does one reply to such assertions?

For those who embrace research in art education the arguments just made do not carry much weight. First, it is argued that no area of human activity should, in principle, be forbidden territory as far as human inquiry is concerned. No artistic community would permit restrictions regarding what artists can create; such restrictions have no place in a free society. When one enters a wedge saying, "This you can study, and this you can't," where that wedge stops no one can tell. The freedom to inquire and create should be available to all free men.

Second, it is argued that research is one of the best ways of testing beliefs and that members of the field have for too long endorsed beliefs and practices based on the flimsiest of evidence or no evidence at all. Children deserve our best and most careful efforts to understand and appraise what we do to and for them in schools that they have no other choice but to attend. Not to seek evidence, not to go beyond mere opinion, not to subject one's private beliefs to public scrutiny and test is all too often to sanction superstition as a guide to action.

Regarding the appropriateness of research in art, a question dealing with the ability of one mode of inquiry to penetrate another, advocates of research point out that research does not attempt to produce visual art but to understand some of the conditions that give rise to it, some of the ways in which art affects people, and other such questions.

The argument proceeds that such questions can function as the stimulus to inquiry, and inquiry, when handled well, provides that which should be the cornerstone to action: knowledge. Because knowledge is desired, it is only reasonable that the methods of science should be used as an important tool in making knowledge. Indeed, according to some philosophers of science,[1] it is the only way in which knowledge can be produced, for it is the only way in which warrant can be obtained for belief. All claims to knowledge that are untestable (in principle) are unwarrantable and, therefore, inadmissible as knowledge. Furthermore, since scientific knowledge is theoretical, that is propositional and predictive, it is not difficult to understand why such knowledge should be con-

sidered useful in art education. Propositions are easily communicable, and when predictive, powerful. Thus, one of the most potent tools for improved practice, it is argued, is good theory. To the extent that research contributes to better theory it contributes to the improvement of practice in art education.

What we see in the debates between those who praise and those who condemn research are different views of what art education should be and how it should proceed. What we see reflected in argument are differences in tradition, training, and belief. It is no surprise that most of those who engage in research in art education are at the younger end of the age-continuum as far as membership in the field is concerned.

Yet despite the debates that have appeared in the literature and at conventions, there is still much confusion over what research means. In order to determine whether research is an appropriate activity in the field, it seems reasonable to have some idea about what it is. It is to that problem that we now turn.

The Functions of Research in Art Education

Research in art education is the systematic attempt to utilize the tools of scholarship in answering questions germane to the field. This statement, taken as a definition, is sufficiently broad to include a wide range of activities in the domain of research. Note that research is defined as a systematic effort to utilize scholarly tools to answer questions; thus, by implication, research activity is an act of inquiry, an effort to find out. It is not an effort to preach a doctrine, to proselytize, to convert members of the field into a sect of true believers. It is an effort to understand.

Note too that the definition does not limit systematic inquiry to one or two fields. In no sense is research restricted to psychological inquiry, nor is it limited to inquiry utilizing the tools of the other behavioral sciences. *Any* systematic inquiry including those in ethics, politics, history, and philosophy can be appropriate for research in art education. The important point to note is that the distinctive traits of research are those of being problem or question *seeking* and *solving* and those in which the search is marked by care and system. What distinguishes educational research in art education is not the difference between the scientific and the non-scientific but the differences among the hortatary, the casual, the analytic and the careful.

Scientific inquiry is aimed at describing, explaining, predicting, and when possible, controlling empirical phenomena. The term "empirical,"

coming from the Greek *empeiria,* simply means experience. Scientific inquiry is aimed at those phenomena that are subject to our experience, those phenomena available to our senses.

In the world of scientific study the two major types of research can be undertaken: descriptive and experimental research. Descriptive research is intended to provide a clarification and explanation of conditions as they are. Studies of population, of the characteristics of art teachers, and of the characteristics of children's art are examples of descriptive research. In such studies no attempt is made at intervention; there is no effort made to alter the existing state of affairs but rather to describe it carefully and with precision. When one does that, one is engaged in a status study, a study of the status of a particular set of characteristics or variables as they are called.

But one can do descriptive research other than that of status studies. One can ask what characteristics are related to what other characteristics. For example, are personal traits of femininity associated with masculine or feminine characteristics in art productions? To answer such a question one might do a correlational study, one in which test scores of femininity would be secured from a population of artists or art students and a set of ratings secured on the feminine-masculine characteristics of their art. Once having secured such ratings on both the people and their art, coefficients of correlation could be computed to determine the degree of association between the two.

What is important to note is that descriptive research does not in any way attempt to alter a state of affairs but rather to find out what it is. My own studies, reported in Chapters 2 and 5, are examples of descriptive research in art education.

Experimental research, in contrast to descriptive research, attempts to determine the effects of a treatment on a group of people. Do art contests affect the quality of art children produce in class? Do contests affect children's satisfaction with art and their self-concepts as young artists? Such questions require that one provide an experimental treatment, in this case art contests, and compare their effects on children with a group of children having no contests in which to participate during a similar period. All other things being equal between the two groups (age, intelligence, socio-economic level, and other variables that could affect student performance), it would be possible, in principle, to experimentally secure answers to such questions. At present, we have only the flimsiest empirical data to support *or* reject the belief that contests are harmful (or helpful) to the child's artistic development.

Thus, in experimental research an effort is made to identify causal relationships by bringing to bear on the situation what is known as an experimental treatment—a new form of motivation, a new teaching method, a set of rewards, and so on. A systematic logic of experimental research has been established to enable both producers and consumers of research to avoid the traps of faulty research design, such as overgeneralization and other errors of inquiry.[2] The problem of design in all research, descriptive or experimental, is to inquire in such a way as to reduce rival explanations for the results that are secured. One wants to design a research study carefully enough to have confidence in its conclusions. More will be said about scientific research in art education, but for now it will suffice to note the two major types of scientific research, descriptive and experimental, and the differences between them.

Research in the humanistic tradition such as in philosophy and history is extremely diverse in character. Philosophical inquiry in art education can deal with questions such as "What is art's place in education?" to "What does Herbert Read's conception of art include that John Dewey's does not and how do their respective conceptions of art bear upon its teaching?" Philosophical inquiry in art education aims at providing and arguing for certain values in art education and at clarifying the language used by others as they talk about art in education. The former type of philosophical activity is normative in character; it argues matters of value. The latter is analytic; it attempts to clarify meaning. Although these categories are by no means separate, they are sufficiently distinguishable in emphasis to warrant differentiation.

Normative philosophical work in art education can be found in the writings of John Dewey,[3] Herbert Read,[4] Harry Broudy,[5] and Frances Villemain.[6] Analytic philosophical work can be found in the writings of Nathaniel Champlin,[7] David Ecker,[8] and Ralph Smith.[9] Again, the goal of these scholars is to attend seriously to problems in art education in order to gain new understanding. Their efforts are creative ventures designed to provide new meanings to the field.

Historical scholarship, although relatively rare in art education, is generally intended to help us avoid losing our memory. A field without a memory of its past is in continual danger of rediscovering the wheel. An understanding of the past develops a sense of gratitude and respect. It is the historian's task to illuminate that past and to make it resonate with the present. Harry Beck Green,[10] Robert Saunders,[11] John Keel,[12] and Fred Logan[13] are some of those who have helped us keep the past alive. Indeed, what characterizes the work of all of these men, whether they do

scientific or humanistic work is the care, creativity, and skill they bring to their task. Their major goal is to know, to *create* dependable knowledge about the subject matter of their inquiry. Unlike some in the field they do not believe that they have a priori truths about solutions to problems in art education.

Another characteristic of scholarly work in art education is the use of technical skills and terms in the doing and reporting of such work. To some, the use of technical language is just so much jargon. And for some pseudo research, this assessment is accurate. It is not uncommon to find published material that has the trappings of scholarship but that upon closer inspection is merely an imposter. Technical terms have a place, a necessary place in research because they bring a degree of precision that ordinary language does not possess. Ordinary terms of daily language are frequently imprecise. They are often loaded with an extremely wide range of meanings. What does creativity mean, for example? What is the meaning of aesthetic development? What is meant by self-expression? Such terms can be used in ordinary discourse but lose much utility when one wants precision. For precision, special terms having clearly defined meanings must be introduced. Exactly because of their technicality such terms will be difficult to understand by a person without the background appropriate to them. It is for this reason, among others, that some in the field decry their use and attempt to reduce it to jargon. It is paradoxical that for those who cannot "read" the language of modern art, it too is jargon. Now it appears the shoe is on the other foot.

Perhaps one of the most misunderstood aspects of scientific research in art education is the meaning and function of theory within the research problem. It is possible, of course, to engage in research without invoking theory. One can ask questions such as, "How many art teachers are there in the United States and has the number changed each year over the past ten years?" Such a question by itself entails no theoretical concerns. The problem has to do simply with the generation of fact. In this sense such an inquiry yields no principles, it merely states fact as an historical event.

The Uses of Theory

If one wants principles, ideas with durable meaning that can explain or predict and can be used as reasonable guides to action, then one needs to begin with a set of ideas that appear plausible but that need to be tested in order to secure warrant. Scientific theory is a set of beliefs, couched as a set of statements that purportedly describe and explain some set of em-

pirical phenomena and which, in principle, is subject to verification or refutation through empirical test. Theoretical statements thus provide a general intellectual network out of which useful empirical research proceeds. Blind empiricism, that is, the simple hunt for facts, will not by itself yield one good idea. One must have some leading ideas which bind facts together and give them meaning. In the most useful of empirical research studies there is a theoretical set of beliefs from which interesting problems are posed. The problem of the researcher is to identify a situation that will in some way provide a test for the theoretical belief. The hypothesis, a logical deduction from a theory, provides that function. The hypothesis is simply a statement predicting a consequence in a particular situation. The researcher is not just interested in the truth or falsity of a particular hypothesis but rather in the theory which confirmation of the hypothesis will yield. In short, confirmation of the truth of an hypothesis is simply one step along the way in affirming the truth (usefulness) of the theory from which it was derived.

An example here might help make this point clear. Let's assume that we believe that anxiety tends to restrict the child's ability to engage in imaginative exploration, that when children are anxious they are afraid of exploring the world, even their own mental world, and therefore stay with ideas that are safe, the ones they know best. Let's assume, further, that encouragement of phantasy by the teacher and support for it by the child's peers will facilitate the child's use of phantasy and that the results of such use will show up in his art. Now given these assumptions, one about the effects of anxiety, the other about the effects of phantasy, it would be possible to create experimental situations in which, say, one class of students would be in an environment that would tend to be restrictive and anxiety-producing and another in which children would be encouraged to engage in role playing, socio-drama, and other forms of imaginative activity. One would hypothesize that the drawings made by children in the role playing group would be rated higher in imaginative quality by judges than the drawings made by children in the anxiety-producing environment.

To carry out such an experiment one would need to do several things to make sure the results would be reliable and valid. For example, one would need to be sure that the characteristics of the two groups were comparable. One would need to judge the drawings in a randomly mixed single pile without the judges knowing which children made which drawings. The type of materials used and amount of time the children worked would need to be the same, and the judges would need to make their ratings of the drawings independently, that is, as individuals, not as a

single group. In this way it would be possible to determine the extent to which the drawings could be reliably judged. Finally, it would be useful to repeat the experiment by reversing the treatment for the groups to determine if the results secured in the first experiment held up in the second. The scores assigned to drawings by the judges would need to be treated statistically in order to find out if the treatment made a difference other than one that could be expected by chance.

Now the important point to remember in all of this is that the researcher is not simply interested in the effects of anxiety and role playing on the imaginative life of the children in the two particular groups described. He is interested in their effects in general, that is, for children of similar characteristics. The hypothesis is simply a prediction of what he expects to happen in a *particular* situation, but he uses the evidence in that particular situation as a means of confirming or refuting his general theory.

Now that I have provided this example, I would like to point out that I would not condone any educational experiment that would attempt to generate anxiety in children for experimental purposes. The example used was for effect. Similar results could be obtained by having only one experimental treatment—a role playing treatment. Although the results would probably not be as dramatic, one of the considerations in all research involving human beings is an ethical one. Neither in the name of science nor of art should such a consideration be sacrificed.

Research in art education, like research in education, can be generated from two different contexts. One of these contexts is called field-generated research, the other, discipline-generated research. Before describing them I would like to emphasize that there is no hard and fast line between the distinctions I am about to draw; they are simply a matter of emphasis.

In field-generated research studies problems are formulated out of the particular needs of practice. Questions are raised that, in general, bear closely on the type of questions or problems that teachers of art or, for example, curriculum developers face when dealing with their respective responsibilities. Questions such as, "Do contests increase the artistic quality of student art work?" "Does grouping classes for artistic ability affect artistic learning?" "Does the use of demonstration in art teaching affect the type of products children produce?" "Does grading art affect students' attitudes towards art?" are examples of questions that are likely to be field-generated questions. To be able to raise such questions for research, in the first place, suggests that the researcher has had some contact with schools and the problems of teaching. The research that is undertaken is aimed at resolving these problems.

Discipline-generated research is research whose primary goal is not to resolve problems of practice but to resolve problems generated within the parent discipline. A psychologically oriented art educator might raise questions about the effects of variable reinforcement on artistic learning. Such a question might have no special or direct relationship to the teaching of art but might be of special merit to a person interested in the refinement of reinforcement theory and its application to behaviors in nonverbal fields. A discipline-generated question in history might deal with the role of the visual arts in programs designed to Americanize the large number of immigrant children who entered the schools from 1895 to 1910. Again, such a question might have no direct bearing on a particular problem of current practice in the field but might be extremely useful in helping historians of American education obtain a more complete picture of how the various fields of study were used to cope with the problems of acculturation.

To distinguish between field-generated and discipline-generated questions is not to imply that the former are useful and the latter are not. Questions investigated on purely scholarly grounds can yield important ideas for practice. In addition, art education in my view should be broad enough to encourage a wide range of research activity under its wing. The distinction between field-generated research and discipline-generated research is mainly one of intent and of history: intent, because the motives of the researcher affect the character of the conclusion and the style of investigation; history, because the source of the problem, whether from familiarity with the field or with the problems of a particular discipline, affects which of the two types of inquiry will dominate.

The distinctions that have been drawn between field- and discipline-generated research are related to differences between decision-oriented research and conclusion-oriented research. Describing these differences Cronbach and Suppes say:

We propose to distinguish decision-oriented from conclusion-oriented investigations. In a decision-oriented study the investigator is asked to provide information wanted by a decision-maker: a school administrator, a governmental policy-maker, the manager of a project to develop a new biology textbook, or the like. . . . The conclusion-oriented study, on the other hand, takes its direction from the investigator's commitments and hunches. The educational decision-maker can, at most, arouse the investigator's interest in a problem. The latter formulates his own question, usually a general one rather than a question about a particular institution.[14]

In all fairness it should be pointed out that those who emphasize discipline-generated research in education—not only in art education but in other fields as well—tend to see as their major reference group those scholars within the discipline in which the problem is posed. Quite often the results of such research will be published not in journals directed to practitioners in education but in journals directed to other scholars usually working in universities. Thus, the style of the reporting, the character of the language, the use of examples are selected not with an eye towards illuminating problems of practice but with the intention of contributing to theory in a field of scholarship. Consequently, both the utility and relevance of such reportage are not the same for members of the two fields.

I have already alluded to some of the problems encountered in relating research to practice; let me speak to these problems more directly.

Some Limitations of Scientific Research

First, with respect to scientific research in art education there is far more research available that is descriptive than is experimental. This is curious in many ways because the type of knowledge most useful for guiding educational practice is not simply a description of a state of affairs but an identification of causal relationships. As educators we are interested primarily not in understanding children but in helping them develop. The most useful research for bringing such change about is the type that will indicate the probable consequences of a particular educational action. Such knowledge is most likely to be secured from experimental studies. Experimental studies in education are not as common as descriptive studies, in part because they are more complex ventures. To do an experimental study requires students on whom the experimental situation can be brought to bear. In addition, experimental research demands a set of research controls that are complex and generally more difficult to achieve than those needed for descriptive work.

A second set of problems concerning scientific research in education deals with the fact that almost all of it is statistical in nature. Although statistical conclusions are useful, they are relevant to groups, not to individuals. What is true at some level of probability for a group of sixty children nine years of age, living in an upper-middle-class suburb, might or might not be true for nine-year old Susie Riggs living in a similar suburb. And it is the particular Susie Riggs of the fourth grade that Miss Sharington, fourth-grade teacher at the Beechwood School, must work with. The

teacher, in the final analysis, must decide. This decision—if decision it is —requires that the findings of research be artfully transformed to fit the concrete reality of life in the particular classroom. Let us not underestimate the magnitude of this task. The teacher is faced with a fluid situation: children change, their interests alter, the teacher himself shifts in attitude and needs through time. Within this kaleidoscopic array the teacher, if the findings of research are to be applied, must be able to recognize the instance in which the research findings or the ideas behind them are applicable and must then be able to invent a situation so that the research findings or ideas can be applied effectively, not at all an easy task.

A third limitation of scientific research concerned with questions of education deals with the fact that much research is fact-, not value-oriented. By this I mean that scientific inquiry, whether descriptive or experimental, provides conclusions about the world as it is. Such inquiries do not provide conclusions about what ought to be. Thus, science can help us understand what is desired but it cannot tell us what is desirable. For that we must turn to research in the humanistic fields.

Let's assume for a moment that a researcher in art education has conducted a series of experiments through which he has found out how to increase the creative abilities of students by five-fold. Such findings would have no implication for art education unless one believed that the development of creativity was a worthwhile educational goal. This is simply to say that logically one cannot deduce a value conclusion without first establishing a value premise, a set of ideas that one cherishes and toward which one works.

This apparently obvious truism would not be worth mentioning except for the numerous times I have read research reports that conclude with a section titled, "Implications for Art Education." Somehow the researcher pulls out of the hat, post facto, a set of values that attempt to give his conclusions some educational significance. Values should precede the inquiry; indeed, the inquiry itself provides facts that take on *educational* significance by virtue of their instrumental relationship to educational values: no values, no significance.

A fourth problem that surrounds research in education, including of course research in art education, is not a problem of principle but one of practice. As I have alluded earlier, most researchers work in university contexts. Art education as a field of practice operates in elementary and secondary schools. The separation between the university and the lower schools has a number of consequences for research and for its dissemination. For one, because many who engage in research have little contact

with the schools, there is a tendency for researchers to miss the most significant problems of the field, even when their questions are field generated. Universities and the lower schools are both concerned with education, but they play ball in different fields and secure their rewards from different audiences. The physical and intellectual isolation of the university from the schools makes rapport difficult. Too often the researcher enters the school as a stranger, someone who comes there to secure data and to get out as fast as possible. Such a relationship does not lead to the type of understanding that makes for either the identification of significant problems of schooling or for insightful interpretation of the data once collected and analyzed. Researchers who have little contact with schools except as a visiting data collector are likely to be naive about the educational meaning of research conclusions.

Perhaps one of the most mischievous consequences of the intellectual separation of the university from the school is the fact that such separation is reinforced by specialized professional associations and journals. Associations of university researchers provide a professional public to which research results are reported. Schoolmen and practitioners have another public. Such professional associations develop their own status systems and their own rewards and form a professional network for advancement within a field. In the research community seldom is the criterion for the conferring of reward the extent to which a particular study or set of studies improves practice. Most often it is honored for other reasons; its contribution to theory, its design sophistication, and so on. In short, the social mechanisms surrounding the research community serve as a buffer between it and the problems and practices of schools.

Now there is some important virtue in separation—when done in moderation. Total immersion in the problems of the classroom can have the deleterious effect of continual coping with the immediate; one might not be able to step back in order to gain perspective on what is occurring within the school. Too strict a concern with the immediate problems of practice reduces research to a type of service function that can rob it of its imagination. As Alfred North Whitehead remarked, "To set limits to speculation is treason to the future." The university, after all, should not only attend to the pressing problems of the present, it should also provide both students and the society in general with a demonstration of the reach of man's mind. What I am cautioning against with respect to research in art education is seduction into interests, problems, and affiliations that lead one away from the questions that animate art education as a field of practice. I am not calling for less discipline-generated re-

search in art education; I am asking that discipline-generated researchers keep one eye, at least part of the time, on the field of practice which their work will ultimately serve. I am also calling for the development of meaningful contact and communication with members of the field of practice so that research will meet the mark.

There are other difficulties which surround research in education that are worth brief mention. One of these is the fact that whereas we have in research developed some relatively refined instruments for measuring educational outcomes, we have paid relatively little attention to the problem of measuring or even describing with accuracy the environment in which educational practice occurs. Shulman [15] describes the situation accurately when he says, "The language of education and the behavioral sciences is in great need of a set of terms for describing environments that is as articulate and functional as those already possessed for characterizing individuals." [16] He proceeds:

An example that is familiar to all educators is the continued use of such gross terms as "deprived" or "disadvantaged" to characterize the environments of many minority-group children. Labeling the setting as "disadvantaged," of course, communicates little that is meaningful about the characteristics of that environment. Educators seem unable to progress beyond such a simple dichotomy as "advantaged-disadvantaged." Reviewers and critics of research have long realized that even those few categories which attempt to describe environments such as social class, have been remarkably ineffectual in pinpointing the educationally relevant differences in the backgrounds of individuals. [17]

What Shulman identifies is the need to develop a precise way of characterizing the educational setting. What is the art classroom like? How do various classrooms differ? What are the roles of the students and the teacher in such classrooms? How are such settings structured? Can classrooms be characterized with respect to their emotional tone? Their competitiveness? Their sense of affiliation among students? Their commitment to serious work? We have not yet learned how to make such descriptions, probably because we have been preoccupied with developing adequate measures of outcomes. Indeed, even descriptions of educational treatments get scant attention in the research literature. In a review of the experimental research studies reported in two years' volumes of the *American Educational Research Journal* I found that about four times as much space was devoted to describing the findings of a study as was devoted to describing the experimental treatment. It is obvious that the likelihood of replicating studies to test the validity of their conclusions is

slim as long as such a paucity of information exists regarding what was done in the first place.

Still another limitation of current experimental research is the brevity of the treatment that is used. In the same review of experimental research I found that the modal amount of time devoted to the experimental treatment was forty-five minutes. In other words, most experimental studies reported in two years' volumes of one of the most influential research journals in American education allocated less than an hour's time to the experimental conditions. To bring about significant educational change in such a brief period requires that the treatment be extremely powerful, something of a peak experience or a traumatic event. Neither of these conditions is characteristic of educational experimentation. When such conditions do not exist, the need for highly refined tools for measuring outcomes is great. Where effects are small, one needs highly sensitive measures for detecting them. This too is rare in educational research. Is it no wonder then that most educational experiments yield no significant differences? And where differences are found significance refers to statistical significance; that is, non-chance occurrence at some level of probability. It does not refer to educational significance; that cannot be determined through the use of statistical probabilities but through the application of educational values.

Given these limitations and general problems surrounding research and the research community is one not justified in rejecting research in art education as a useful source for the improvement of practice? I think not. That there are limitations to research, especially scientific research, in art education there is no question. But no single field of inquiry, practical or theoretical, can provide all the answers to the problems of art education. What I believe we must avoid is fuzzy thinking and shallow feeling. I believe it is just as faulty to underestimate the contributions of research to art education as it is to overestimate them.

The Contributions of Scientific Research

What are the potential contributions? Where do they come from? What relationship do they have to practice? One obvious contribution of research, especially descriptive research, is its ability to provide the field with statements of fact. How many secondary schools offer art programs to students? What percentage of students study art in high school? Has this percentage changed over time? What are the characteristics of those who choose to become art educators? Do they differ from those who

enter other art fields? What do students know about art history or about methods of art production?

These questions are best answered, and have been, by careful empirical descriptive studies. Determining what the facts are is an appropriate task for empirical research. With accurate information better educational decisions are likely to be made. There is no virtue in relying on opinion, when one can rely on fact. Clearly then, one important contribution of empirical research to practice in art education is that of making the facts known to those who practice so that decision-making in practice can be based on ideas that are accurate.

A second type of contribution of research, especially philosophical research having an analytic character, is that of helping practitioners as well as scholars more closely examine the meaning of statements made by writers in the field. The major responsibility of analytically oriented philosophy is that of clarifying meaning. The literature of art education is sorely in need of such clarification. Because many of those who write in the field have not had the benefit of rigorous theoretical training, there is much in the literature that suffers from faulty logic, overgeneralization, slogan making, and vague and ambiguous use of language. What does good art teaching mean? What do we mean by the phrase ''developing the child's creativity through art?'' What do we mean by the term ''art?'' Is it a descriptive term or a value term? Do we mean by art what children produce when they paint or sculpt? Or do we mean a very special type of human achievement? The answers to these questions are by no means clear. What is clear is that different writers use these terms and phrases in different ways. As long as such terms go unexamined the meanings secured from them will be unclear. One of the important contributions that philosophic research can provide is the clarification of language in art education, the unwrapping of language so that the thought it contains shines through.

Perhaps the most significant contribution that research in art education can make to practice in art education resides not primarily in the findings such research produces but in the theoretical models that are generated by researchers in their efforts to understand. As I have argued in previous chapters the frame of reference one uses to confront the world functions as a template or a screen through which that world is viewed. Templates and screens not only admit, they also restrict certain aspects of the world. Furthermore, they serve to organize experience so that it takes on meaning. But what do templates and screens, which are after all metaphorical terms, have to do with the contributions of research to practice? Simply

this: the major contribution that research provides practice is not in the particular results of particular inquiries but in the leading ideas that generate such inquiry in the first place. It is the theories that provide the basis for research that have the greatest effect on practice. These theories provide the major frames of reference for our interpretation of experience as well as for the having of that experience itself. In that sense theory functions as a template, admitting and rejecting certain types of data according to the terms and conceptions of the theory. Indeed, the very questions that researchers choose to ask are profoundly affected by the theories they embrace.

There is perhaps no more brilliant explication of that phenomenon than that provided by the work of Thomas Kuhn. He argues that the paradigms that scientists use determine the nature of their work. Normal scientists, as I have indicated in my discussion of creativity, work *within* accepted paradigms. They see their scientific problem as *filling* in the gaps of knowledge within the theoretical structure that has already been provided. Kuhn writes

Normal science, the activity in which most scientists inevitably spend almost all their time, is predicated on the assumption that the scientific community knows what the world is like. Much of the success of the enterprise derives from the community's willingness to defend that assumption, if necessary at considerable cost. Normal science, for example, often suppresses fundamental novelties because they are necessarily subversive of its basic commitments. Nevertheless, so long as those commitments retain an element of the arbitrary, the very nature of normal research ensures that novelty shall not be suppressed for very long. Sometimes a normal problem, one that ought to be solvable by known rules and procedures, resists the reiterated onslaught of the ablest members of the group within whose competence it falls. On other occasions a piece of equipment designed and constructed for the purpose of normal research fails to perform in the anticipated manner, revealing an anomaly that cannot, despite repeated effort, be aligned with professional expectation. In these and other ways, besides, normal science repeatedly goes astray. And when it does—when, that is, the profession can no longer evade anomalies that subvert the existing tradition of scientific practice—then begin the extraordinary investigations that lead the profession at least to a new set of commitments, a new basis for the practice of science.[18]

Some scientists, those whom Kuhn refers to as revolutionary scientists, do not simply attempt to fill in gaps in the limits set by previous theories but construct new theories, or paradigms as Kuhn calls them, in which new and hopefully more productive questions can be raised. Kuhn argues, therefore, that scientific progress proceeds not like a stack of bricks built upon one another but by the replacement of old structures by new

ones. These new structures, to carry the metaphor further, provide new and different vistas through which reality can be *made.* But let Kuhn speak for himself:

Each of them necessitated the community's rejection of one time-honored scientific theory in favor of another incompatible with it. Each produced a consequent shift in the problems available for scientific scrutiny and in the standards by which the profession determined what should count as an admissible problem or as a legitimate problem-solution. And each transformed the scientific imagination in ways that we shall ultimately need to describe as a transformation of the world within which scientific work was done. Such changes, together with the controversies that almost always accompany them, are the defining characteristics of scientific revolutions.[19]

What is profound and powerful in Kuhn's observations is his insight into the impact ideas have on experience. To common sense, we say we learn *from* experience. The emphasis is on what the environment does to shape us. Kuhn reminds us of what we do to the environment. Our conception of it is profoundly affected by the ideas we bring to it. Our conception of man and his motives for action have never been the same since Freud invented the terms ego, superego, and id. Concepts such as defense mechanism, sublimation, and transference have altered our view of man, have affected our literature and our theater, and have influenced our visual art. Edward L. Thorndike's conception of reinforcement and his "Law of Effect" have become extremely important concepts affecting how research in the empirical behavioral sciences is pursued. What we sometimes fail to see are the values embedded in the theoretical conceptions that researchers utilize. How shall the child be viewed: as a stimulus-seeking organism or a stimulus-reducing organism? Shall he be viewed as an organism or a person; or is the correct term "a subject"?

It might seem at first glance that the terms used in research are simply neutral and that my attention to them is just "nit-picking." The terms one chooses to use are not trivial; they are emotionally loaded, they provide a point of emphasis, and they disclose a covert set of assumptions.

Compare for example the following statements.

It is in producing such skills in the child that the complexity of the repertoire may be seen as well as the particular stimulus-response elements that must be acquired. I have presented training based upon this analysis to children, utilizing the stimulus-response materials. Three- and four-year-old children have been used in studies extending over long periods of time during which each stimulus presented and each response made was recorded. These records show the progressive acqui-

sition of skill that takes place through the instrumental conditioning procedures—and systematic samples of the records indicate the characteristics of the process.[20]

The unconscious meanings of the spontaneous art productions created during art therapy are frequently obtained by encouraging the patient's free associations to the images he creates. Such pictures are often a direct form of communication that functions as symbolic speech. It is sometimes difficult to convey to psychoanalysts accustomed only to communication through words that a primary nonverbal technique such as art therapy can effectively release many repressed feelings of a patient more directly and more swiftly than words. Furthermore, a patient who projects his conflicts and the stages of ego development into images frequently becomes able to interpret their symbolic meaning correctly himself, without assistance from the art therapist.[21]

What we find in these statements are radically different views concerning human activity. The very language that the writers use reveals something of the orientation they bring to the problem of understanding such behavior. To talk about "spontaneous art" is one thing, to talk about "behavioral repertory" and "stimulus-response materials" is something else. To refer to "ego development" and "images" provides one frame of reference; to refer to "instrumental conditioning procedures," again, is to speak a different language having different implicit as well as explicit meaning. The terms "ego" and "image" have meanings that suggest and disclose rather than specify in measurable terms. The terms "instrumental conditioning procedures" come out of a different scientific tradition and tend to have a specificity that the former lack.

I am not attempting here to make judgments about the statements I have quoted above. I am trying to demonstrate how the words and syntax one uses affect the way in which the problem is viewed. Those of us who grew up professionally in a single scientific tradition may not be able to appreciate such effects. In verbal language as in visual art the material for comparison must be available if the distinctive features of form—linguistic or visual—are to be recognized and appreciated.

What then does all of this mean for appraising the contributions of research to art education? For me it means that it is a mistake to reject research as being irrelevant to practice. However, it is just as much a mistake to assume that it can provide specific directions for practice. The major contribution of research resides not in its ability to provide directives but in its ability to provide perspectives, ways of looking at educational phenomena, and ways of asking new questions. The most dramatic examples of such contributions are found in the work of a Freud and a Dewey, but they are also found in the work of lesser men. What these

men were able to do is to see problems from a new angle, to open up new questions, to ponder new possibilities. The ideas that Dewey developed concerning education have had enormous effects on school practices; it is almost impossible to buy screwed down desks for elementary school classrooms. But this is only a small indicator. The way in which children are viewed, their relationships to their classmates, the roles that teachers are to take have been touched by Dewey's ideas. The profound ideas about art, children, and learning have the capacity to capture the imagination of men and to live on.

But this is not to imply that with new ideas and theories the problems of teaching becomes less complex. On the contrary, the teacher who sees a child's difficulty in learning in school as evidence of laziness has a much simpler explanation than a teacher who has the tools and is willing to probe more deeply. Ignorance breeds simple solutions. But in the long run more adequate conceptions of human thought, feeling, and action are likely to provide for more effective educational programs in the visual arts. Thus, I see our problem in art education as one of developing through thoughtful inquiry of all kinds a more comprehensive and insightful understanding of what we do in the schools with respect to art education. Research, I believe, has a major contribution to make toward the realization of that end.

10

from an age of
science to an age
of art

Throughout this book several ideas of major importance have been presented and discussed. Because these ideas form the cornerstone on which the volume rests it might be helpful to reidentify them before proceeding to the major focus of this chapter, the contribution of art education to society through schooling.

A Summary of Major Ideas

One of these ideas deals with the recognition of the unique contribution of art to human experience and understanding. I have argued in the opening chapter that although it is possible to use art for the attainment of non-artistic ends, indeed, that in some educational situations it would be most appropriate to do so, the major justification for the teaching of art lies precisely in its unique contributions. If a field puts itself in a position of justifying its claim to time in schools on bases that other fields can also claim, it has no more right to that time than those other fields. But the argument for recognizing art as a unique type of experience making special contributions to human experience need not rest upon political arguments. It can rest upon a factual appreciation that art education is the only field that has the special mission of *educating artistic vision.* In art education we are concerned with educating human vision so that the world man encounters can be seen as art. No field other than art education can make such a claim.

The argument rests further on the recognition that those objects called works of art are a special category of human invention. This is not to say that art as experience cannot be had in principle in a wide variety of human encounters; it is to say that some of those products produced by artists have the capacity not only to move the emotions of man but to enlighten him. Art educates because of the qualitative insights works of art provide. The works of de Kooning, Carroll, Diebenkorn, and Ramos exemplify such insight. Each of these works, created by an important American artist within the past thirty years, represents an effort to convey the artist's conception of woman. Each communicates his conception differently with respect to method and each conveys differences with respect to the content of the conception. Willem de Kooning's "Woman," 1950 conveys a sharp, slashing starkness that is altogether different in character from the almost feline quality of John Carroll's pencil drawing of a woman's head. The differences between the two are not merely a function of material but a function of the expressive intent of the artist.

257 Similarly, Richard Diebenkorn's untitled ink drawing portrays the las-

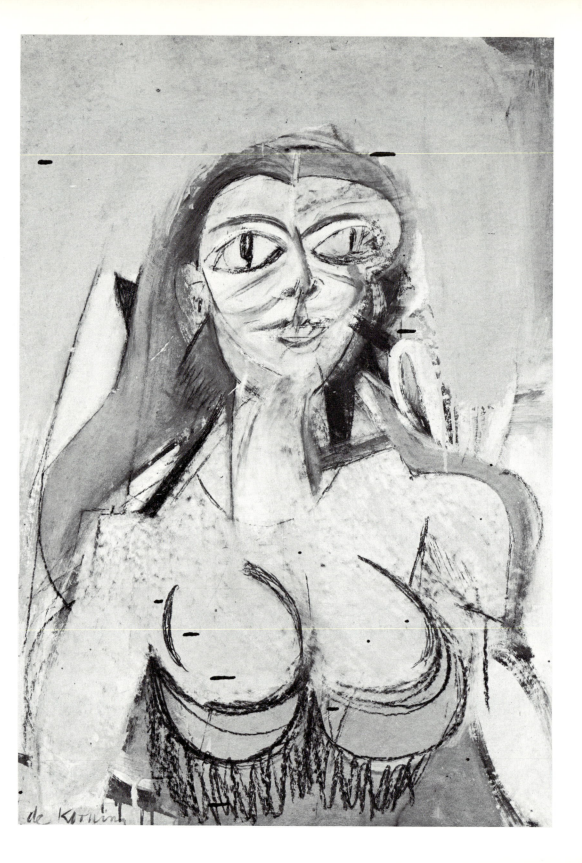

Willem de Kooning,
"Woman," 1950, oil on
paper. San Francisco
Museum of Art.

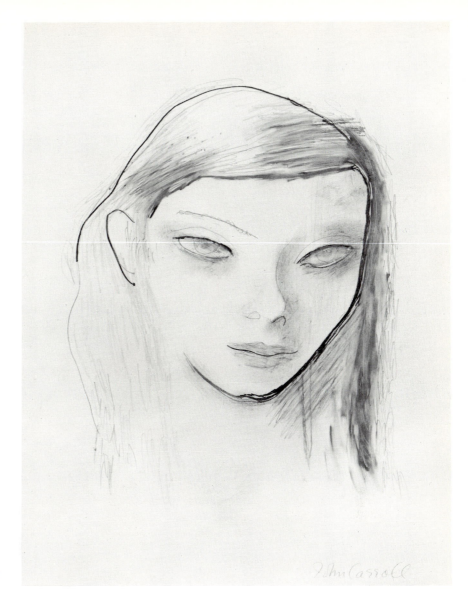

John Carroll, "Untitled" (head), pencil. San Francisco Museum of Art.

civious quality of a brothel, whereas Mel Ramos' *"Miss Grapefruit Festival"* has the character of a Playboy centerfold; sexually attractive yet collegiate and all American.

These works demonstrate vividly the way in which the "same" subject matter can be used for vastly different expressive purposes, and demonstrate how visual form can convey a kind of meaning that is extremely difficult to replicate in verbal discourse.

I have also tried to show that art education as a field of practice has not been isolated from the mainstream of American society. Instead, I have argued that a study of its history shows how practitioners in the field have in fact been responsive to the various pressures, demands, and expectations that society has brought to bear on the schools. This is not

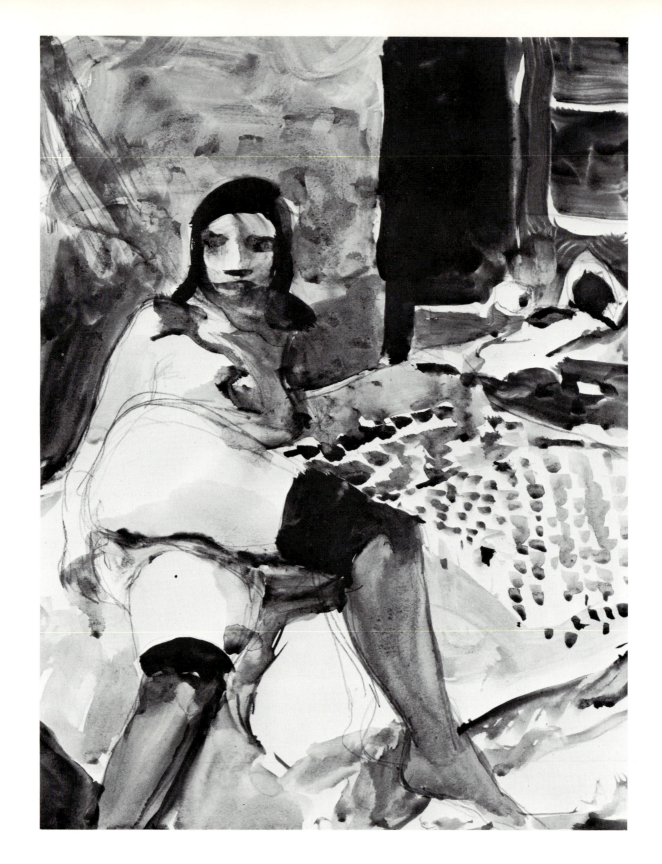

Richard Diebenkorn, "Untitled," India ink. San Francisco Museum of Art.

Mel Ramos, "Miss Grapefruit Festival," oil on canvas. San Francisco Museum of Art.

surprising. American schools are social institutions, political structures provided for by the state. Their existence, their regulation, and their accreditation are legally in the hands of those in state government. But even more than this formal political relationship they are informally political as well. The communities in which schools function provide a controlling mechanism regarding what schools will permit, prohibit, and emphasize. As these communities have been affected by large scale social or economic change, change often beyond their control, they have in turn transferred such changes into demands for various types of school emphases.

What we may learn from an understanding of history is that there is an organic connection between school practice and the society in which schooling occurs. We may anticipate, therefore, that the goals of art education are likely to alter in the future as they have in the past. If the past is any indication at all, it is not likely that we will have universal commitment to unalterable ends for the field.

A third idea that I have attempted to underscore deals with the current status of the visual arts in American schools. It would be much more pleasant for me to be able to paint a rosy picture of the current situation. This is not possible. Although I think I see the beginnings of change, the visual arts at present are considered by most adults, including teachers and school administrators, as marginal in school curricula. Empirical evidence for this claim is provided in several studies cited earlier.

The reasons for the present status of art in American schools are not as clear as the fact that they are considered by most as marginal. Nevertheless, there are certain explanations that I consider plausible. First, the intellectual heritage that we have regarding the central mission of the school does not place art in a central position. Ever since Plato distinguished between the work of the head and the work of the hand, assigning the former to higher levels of goodness than the latter, there has been little question about which realm the arts occupied. As long as schooling was to be concerned with developing the child's ability to think and as long as the arts were concerned with feeling, the arts must take, with this conception, a second place to the central goal of schooling.

That experience and creativity in the arts, visual or otherwise, required thought, that work in the arts developed the qualitative aspects of intelligence was not and is not now widely recognized. After all, distinctions between the mental and the manual, between thought and feeling, between working with one's head as contrasted to working with one's hands, are a part of the "common sense" language of daily life.

Philosophical reasons for the status of art in the schools provide only a part of the explanation. In American society a substantial proportion of citizens view the schools as important instruments for social and economic mobility. Schooling at the elementary and secondary level is seen as preparatory. Preparatory to what? To access to the right college, a better job, a place in the community. I do not decry these objectives: access to a good college is a laudable goal, doing productive work and being paid well for it is not to be demeaned, having a place in one's community and the amenities that go with it are not to be condemned. Yet when the achievement of such objectives is wholly or primarily dependent or results in the development of a limited range of human capacity, there is, to my mind, sufficient reason to question it. Parents have accurately assessed the sanction system of schools and colleges. And in spite of their apparent realization of the arts' contribution to the joys of life, they want schools to attend to the serious business of developing those skills necessary for meeting the demands of the system. Parents are merely assigning educational priorities to sanctioned skills.

A fourth idea that I have tried to emphasize deals with the nature of learning in art. For years in the field of art education the dominant conception of artistic development was one that saw the child as an unfolding organism whose potentialities would come to fruition if left to develop in a permissive and nurturant environment. Whereas permissiveness and nurturance are words that strike a resonant chord in most of us who hear them used in sentences concerning the young, such a view is theoretically naive and underestimates the positive contributions teaching can have. Artistic development, I have argued, is not a simple unfolding of a pre-programmed genetic constitution. It is not like the genetic determination of height which with minimal nutrition will come to fruition. Artistic learning is complex and is strongly influenced by the environmental conditions in which it occurs. The ability to perceive the qualitatively subtle, to understand the context in which works of art have been produced and understand the relationship between the two, to be able to utilize highly refined skills in the creation of a visual art form are not easy or simple achievements. When left to their own devices children show great ingenuity in devising forms to convey certain ideas. But these achievements, as real as they are, fall short of what is possible to achieve when learning is facilitated. For many youngsters the lack of such skills has bred a sense of impotence in art, a conviction that they are inherently unable—or as they say "untalented," in this area of human activity.

One of the major problems facing art educators is that of inventing ef-

fective ways of working with students so that the joy of discovery is kept alive while the skills necessary for expression in art are being developed.

A fifth idea of significance deals with the scope and conditions of curricula in art education. To be sure children coming from different backgrounds will ideally work in programs that are especially designed for their particular situations. Yet at the level of principle I have argued that the range of curriculum content that should be made available, in general, ought to include not only the productive aspects of art, but the critical and cultural aspects of art as well. The assumption that a productive curriculum emphasis yields critical abilities and cultural understandings has not as yet been demonstrated. On the contrary the evidence that is available suggests that such abilities are not being developed. If students are to be able to aesthetically encounter visual form, if they are to understand art as a social and cultural phenomenon, attention will need to be paid to their development in the curriculum. In short, we must not only teach for transfer, we should not expect the transfer of skills or ideas that were not developed in the first place.

I have also argued that curricula that do not enable students to develop degrees of mastery over the material with which they are working are unlikely to enable students to use that material as a medium of expression. The provision of programs that provide for continuity and that build sequentially are needed if work with art material is to be more than a superficial excursion into novelty. Because the skills needed for using materials for artistic expression are complex, time is required for their development. The forty-minute art period once per week on projects that last only one period and that change each week is not likely to develop the type of skill, appreciation, or understanding that are valued in this volume. They can, in fact, have a deleterious effect; they can corrupt children's conception of art by reconfirming the beliefs of adults with whom they come in contact that art is trivial and unimportant, not really on a par with the serious business of schooling.

A sixth idea worth reemphasizing deals with the problems and possibilities of evaluation in art education. I have tried to identify the meanings of evaluation and to distinguish between it and grading and testing. Evaluation, in one form or another, is necessary for making decisions in teaching and in curriculum planning. Unfortunately it has taken on an onerous connotation among some art educators and others in the field of education. But as long as we desire to understand the consequences of our activities as educators, some effort to evaluate those consequences is a necessity. Through *some* means—classroom observation, analysis of the

work students produce, testing of one kind or another—we will have to secure some evidence on which we can make some appraisal.

Unfortunately, the vast majority of formal evaluation data in American schools has been secured in written form. This emphasis on the written and the verbal militates against those whose preferences and abilities lie in nonverbal areas. In addition, the data-collection mechanism, often in the form of formal tests, has lacked the kind of validity that leads to confident predictions about student interests or attitudes out of the classroom. Whereas evaluation practices in art education need to be made more sophisticated and need to deal with wider range of outcomes consonant with an expanded conception of curriculum content, such practices need to look beyond the confines of the classroom. I would hope that evaluation procedures could be developed through which it would be possible to know not only what a student can do but what he will do. As long as schooling aims to have effects that extend beyond the school, some evaluation of those effects—beyond the school—needs to be undertaken. The use of unobtrusive measures and other imaginative vehicles for evaluation provides promising leads regarding the ways in which such data can be secured.

Finally, I have tried to identify the kinds of contributions that research, properly conceived, is capable of making to practitioners in the field. If one looks to research to provide categorical statements regarding the effects of specific educational practices, one is likely to be disappointed. At present, research in the social sciences has not developed to the point where such statements are possible. But if one looks to research to provide overriding conceptions, theories, or frames of reference through which a phenomenon can be viewed and interpreted, then one can secure from research ideas useful for guiding practice. General conceptions such as those embodied in terms such as perceptual differentiation, visual constancies, perceptual stereotype, functional fixedness, local solution, and so forth, all are useful in thinking about the conditions of seeing and creating. Theoretical views of children's development as found in the work of Piaget, Erickson, and Arnheim provide even more generalized maps for guiding curriculum development and teaching in art. Thus, what I have tried to show is that the most useful aspects of research in art education are not primarily the specific findings of particular studies, but rather the theoretical network the investigator brought to bear on the phenomena he studied. It is through a persuasive view of the world that practice in schools beings to alter.

Thus far in this chapter I have discussed some of the more important

ideas treated in this book. What I intend to do now is to show the ways in which the American school reflects the society in which it functions. But first we must examine some of the characteristics of that society.

What is American society like? Is it possible to characterize a society as complex and multifaceted as this one? The fact that we tend to think of American society as complex and multifaceted is already an indication that at least some of its salient features can be identified. For one, we know that during the past hundred years the country has become increasingly more urbanized. A nation that once was primarily rural and agricultural in character has begun to develop into a nation of large cities. Phillip Hauser and Leo Schnore, noted population sociologists write of this shift.

Some Characteristics of American Society

In the United States both total population growth and urban concentration far exceeded the world rates. During the three centuries of the modern era the population of the United States increased from perhaps a million Indians and a few shiploads of Europeans to about 180 million persons as reported in the eighteenth decennial census in 1960. When the first census of the United States was taken in 1790, 95 per cent of the population lived in rural places of fewer than 2,500 persons. There were only twenty-four urban places in the nation, only two of which had populations in excess of 25,000. By 1960, however, there were about 5,400 urban places containing 70 per cent of the entire population. For the first sixty years of the present century the population of the United States increased from about 75 million to 180 million. The increase in urban population over the same period absorbed 92 per cent of the total increase of the nation. In the last decade of that period, 1950–1960, increase in the urban population accounted for more than 100 per cent of the total population growth of the country. That is, for the first time in the history of the nation, rural population actually declined during the intercensal decade. The extent to which the population of the country is becoming concentrated is even more dramatically indicated by growth of metropolitan and large metropolitan area populations. Over the first sixty years of the century, the increase in metropolitan population absorbed 85 per cent of the total growth of the nation. Although the increase in population of the metropolitan areas between 1950 and 1960 (using 1960 boundaries) absorbed about the same proportion of total national growth during the decade, the increase in population classified as metropolitan (boundaries as in 1950 and 1960, respectively) absorbed 97 per cent of the total growth of the nation during the decade.

In 1900 there were only five metropolitan areas having a million or more persons in the United States. They contained about 16 per cent of the total population. By 1960 there were twenty-four such places in which over a third of the nation's population resided (34 per cent). Over the first sixty years of the century, the increase

in large metropolitan area population absorbed 48 per cent of total national growth. In the decade between 1950 and 1960, population increase in large metropolitan areas accounted for 60 per cent of total national growth. Over the first sixty years of the century, then, total population increased about two and a half times, urban population increased almost fourfold, metropolitan area population increased more than fourfold, and large metropolitan area population increased fivefold.

During this same period the United States changed from a predominantly rural to a predominantly urban nation. At the turn of the century, about two-fifths of the population was urban. It was not until 1920 that more than half of the inhabitants were urban (51.2 per cent). In 1960, 70 per cent of the population was urban. It will not be until the end of this decade, 1970, that the United States will have completed its first half century as an urban nation—which is why there is still evidence that it is in transition from a preindustrial and preurban order to "urbanism as a way of life." [1]

If we inquire further we find that in the past fifteen years the great cities of the country lost population. In spite of the rise in population people who once moved to the cities to find work and to enjoy the cultural amenities that city life afforded have begun to move out of the large cities into the suburbs. Further analysis indicates that the majority of the movement consists of middle-class whites while the influx into the cities consists of lower- and middle-class racial minority groups.

Now the development of urban life in America, as in most large cities of the world, brings with it certain changes in the style of living characteristic of the small community. With high population density comes needs to manage and control human action. Large clusters of population centers require an increasingly complex form of social management through what has come to be known as "big government." In addition, the growth of cities and the industrial centers within them have fostered high levels of specialization within the cities themselves. Technological advancement breeds specialization as jobs to be performed become more complex and division of labor is used as one device for efficiently dealing with this complexity.[2] Thus, the work of the artist, the craftsman, or indeed the generalist becomes increasingly difficult to sustain. Specialization tends, by definition, to reduce one's scope of professional concern or expertise. Specialists begin to look intensely at smaller and smaller slices of their professional life. The physician who specializes in orthopedics tends to focus on problems in that area, the surgeon on other areas; indeed, even a workman in the plant might never have the experience of beginning and finishing the completed product produced by the company for which he works. In short, the professional aspect of work is fragmented in order to maximize the efficiency and effectiveness of the plant or busi-

ness in which one works. The one-time satisfaction of the farmer or arti-san of planting and reaping; of initiating and concluding; of seeing a proc-ess begin, run its course, and culminate, is becoming increasingly less possible with the increase of specialization in work.

The development of technology and urbanization has not only affected our ways of working; it has also affected our style of family life. With specialization of work and the availability of rapid modes of transporta-tion has come a breakdown of the extended family, a family composed of three or more generations living within the same household or in close proximity to each other. Young families tend to move frequently. In search of better job opportunities and the desire to open new vistas, young fam-ilies pull up roots and leave. With such movement often comes a sense of dislocation, a lack of the type of family relationships that once character-ized small community life. Grandparents, aunts, uncles, and cousins are not visited often. Hundreds, sometimes thousands of miles must be trav-eled if they are to be seen at all. A man works in an office and is trans-ferred to another city. The family must then reconstitute the type of social relationships that might have begun to form in their previous community. When marriages are strong such movement can bring nuclear families (families of two generations) closer together, but often such movement has the opposite effect.

Frequent movement, lack of rootedness, difficulty in establishing en-during intimate relationships, fragmented work tend to militate against the development of sentiment and emotion as a basis for decision-making. Increasingly, relationships between people tend to become secondary group contacts rather than primary relationships, utilitarian or instru-mental in quality rather than consummatory or sentimental. Rational, and at times mechanical, controls come to replace those controls that in smaller communities in earlier years evolved out of tradition, affiliation, and an organic sense of belonging.

The shift from an agricultural mode of life to one that is predominantly urban has had special consequences for the young. While living on the farm children had an opportunity to make a real and valued contribution to the economic prosperity of the family. Like the other members of these families, children could work the fields, planting and reaping were a part of their normal chores. In this way the child felt a part of an organic en-terprise, one in which he played an important part.

With the growth of urbanization and the passing of child labor laws op-portunities for meaningful work were severely curtailed. Children were kept off the job market and spent their childhood and adolescence under

the guidance of the school. These laws, passed to protect the child from exploitation, also had the ancillary consequence of wrenching from him a role of contributor that he once possessed. Learning through apprenticeship, direct observation of the world of work, the availability of adult models gradually became less available. Today such opportunities and models are virtually absent. In suburbia, especially, fathers are simply not around during the major portion of the child's day. No longer can children or adolescents participate in the economic life of the families. Indeed, many children have very little idea of what their fathers do for a living—some might have a name for their father's occupation but few actually know what the work is like. Urbanization, centralization, and specialization have tended to separate the young from the meaningful occupational life of the community.

Now it might be argued that although such phenomena might be characteristic of urban life where population is high, it does not accurately characterize life in the suburbs. I think this argument is fallacious. For one, the vast majority of breadwinners in suburbia earn their livelihood in the city or in plants having the segmented character I described. But what is even worse, suburban life itself, by virtue of its social structure, economic status, and physical architecture militates against the type of organic relationships characterizing small community life in years past.

Look, for example, at the way houses are built. On the typical suburban street one finds rows of houses, many of which look alike in size and cost and which have small front yards and large back yards into which the house opens. Because of this physical arrangement family life outside the house is likely to occur in the backyard. And children are encouraged to stay in their own backyard and use the sometimes elaborate playground equipment installed there. This arrangement means, further, that the likelihood for socialization among families is reduced. Fences beyond or through which one cannot see surround these yards; thus, visual contact with neighbors is often impossible. Such contact can occur in the front of the house, but presence in this area is generally limited to mowing the lawn or cutting the hedges. The physical setup, therefore, tends to reduce contact or socialization among neighbors. Common community areas adjacent to a set of homes, if and when available, often go unused.

Because of the relatively low population density in suburbia, the geographic areas that businesses must serve in order to remain economically viable is quite large. In the city 5,000 people might live on an average four square block area. Many complete suburbs have less. Thus, the shopping center was developed to provide services for such large geographic areas.

And because the area is large the possibility of walking to a neighborhood store for such services is out of the question for most people; the size of parking lots alone would discourage such an enterprise! Because walking through the neighborhood is not done (except if one walks one's dog), one's contact with people of the community is further restricted. The informal encounters of neighborhood strolls are limited because there are few places to which one can walk and because few people are "in front of the house."

Once at the shopping center one cannot help but be impressed with its size; scale is one of its most striking features. Suppose, further, that one goes into the center's food store; here you enter a vast panorama filled with foods of all kinds, baskets on wheels are at your right at you enter, and should you get lost or want to find the current specials, some stores have intercoms that will answer your questions. Once having filled your cart you proceed to the check-out area. The express line is for those customers in a hurry who have six items or less; the other lines are filled with people with more than six items. No time to talk with people in line: for one thing you don't know them, for another each is intent on getting through with the ordeal as quickly as possible. A conversation with the cashier is equally as unlikely; people are in a metal-lined groove behind you waiting to be processed and besides the store has eight cashiers; you take the shortest line rather than the same cashier as on your previous trip, and anything more than facial recognition is hardly likely with those odds.

Once having paid the cashier, back to the car and back to home, pulling into the driveway or garage, which is only steps from the kitchen.

Is this a caricature of an aspect of suburban life? Certainly. Is it accurate? To a great degree I believe it is. What we have done in the name of better living is to create suburbs which militate against a sense of community and affiliation. We have built superhighways and freeways that make it possible for people to work dozens of miles away from their homes and to fight traffic doing so. In spite of the lack of density the move to suburbia has spawned other problems, lack of affiliation, impersonality, a sense of isolation.

The growth of population, the development of urban centers and urbanization, the emergence of suburbia have created in America a need for complex communication and recording systems. With the development of mass media and the computer, information dissemination, processing, storage, and retrieval have attained new heights. Face-to-face relationships have increased with respect to the number of people with whom

one comes in contact, but the depth of such relationships tends to be shallow and instrumental in character. Becoming a number is not an empty phrase. Where organizations are larger and complex, numbers are efficient. The move from the person to the number—as a reality—is not difficult to make, especially when no firsthand contact is possible.

Concern with the effects of such conditions in human life has been insightfully revealed in books such as *The Man in the Gray Flannel Suit,*[3] *The Organization Man,*[4] *The Making of a Counter-Culture,*[5] and a host of others. In the visual arts one finds such themes in the work of Francis Bacon, Alberto Giacometti, and George Tooker. The young, especially, have sensed the growing lack of meaningful and satisfying work and have responded to such awareness in their efforts to make themselves heard on important social issues. Indeed, the very lyrics of the songs they sing —from folk to rock—reveal an image of life that flies in the face of American society's dominant character. In many ways the young have provided the moral leadership for a generation or two older than themselves.

Some Characteristics of American Schools

In what sense are the conditions that are prevalent in American society also characteristic of its public school system? Do schools reflect the values of the society in which they function? If so, how? Can schools lead the social order? Is such a goal legitimate in the first place? What can the arts in general and the visual arts in particular contribute to ameliorate the kind of social conditions I have attempted to vignette? It is to these questions that we now turn.

I have already indicated that as society has become technologized, the need for specialization has grown. This is also true for the schools. Increasingly, elementary schools, like secondary schools, are becoming fragmented with respect to program and organization. The most obvious form this has taken is in the areas of departmentalization. Elementary schools, especially at the upper grade levels, have tended to develop programs of study handled by specialists who see the student only in that setting. The model employed has been one taken from secondary schools in which, for all practical purposes, the entire program is departmentalized.

Now the departmentalization of elementary schools has potential virtues as well as potential vices. Elementary school teachers are frequently expected to possess the wisdom of Solomon and the teaching skill of Socrates. It is not likely that such expectations will be realized. Hence, the

use of specialists at the elementary school level, in art as well as in other areas, can in principle provide students with a kind of expertise that the teacher working in a self-contained classroom is not likely to possess. When such specialists are available, it is argued, learning is facilitated and the student's progress in school is enhanced. The argument proceeds that when this occurs, when the student succeeds in school, his success contributes to his mental health. Hence, departmentalization contributes to the child's psychological development.

Yet those who argue against departmentalization point out that in such a mode of school organization programs become fragmented and intellectual or aesthetic cohesion is lost. Further, they argue that a teacher who sees a child in only one area of work gets a distorted picture of his capabilities. The child's progress and adequacy are seen in terms of performance in one particular area.

I believe the differences between advocates of each system generally emanate from differences in philosophical starting points. Those who advocate self-contained classrooms, in general, tend to begin with the child and place emphasis on process. Those emphasizing departmentalization generally start with the subject matter and see departmentalization as a way providing expertise in the content of educational programs. From the standpoint of empirical evidence, there is little to indicate what the benefits or liabilities are for these alternatives. Like much in education, decisions have to be made by reflecting carefully on one's experience.

There is no doubt in my mind that at the secondary school level curricula are indeed fragmented and too often have little relationship to problems students encounter out of school. Professional teacher associations tend to militate against integrated programs because many members in such associations see integration as a threat to their position and their professional identity. As a result, students in secondary schools study subject areas in narrow segments that seldom get put together in spite of the fact that most of us realize that almost all large-scale personal and social problems—from pollution of the environment to war—are interdisciplinary. There is no single field of inquiry that can—even in principle —provide adequate solutions.

The fragmentation at the secondary level, if incorporated at the elementary level, would, I believe, be educationally dysfunctional. Some methods must be developed whereby specialists can contribute their skills within a program that does have a unified organic quality to it. Why has fragmentation occurred in the schools? Why are schools organized as they are?

American schools have long been influenced by an efficiency motive taken from the concerns of industry. During the period of 1913 to 1925 the so-called efficiency movement became influential in education.[6] This movement was based on the desire to increase the efficiency and effectiveness of the schools by applying some of the tools of scientific industrial management to the problems of education. The devices in measurement, motivation, and control used to process pig iron were applied to the education of the young in the name of efficiency. One write describing this approach wrote:

This was done by dividing the work into its elements, and then timing each element with a stop watch. With the pig-iron handlers these elements were described as follows:
(a) picking up the pig from the ground or pile (time in hundredths of a minute); (b) walking with it on a level (time per foot walked); (c) walking with it up an incline to car (time per foot walked); (d) throwing the pig down (time in hundredths of a minute), or laying it on a pile (time in hundreds of a minute); (e) walking back empty to get a load (time per foot walked).
In case of important elements which were to enter into a number of rates, a large number of observations were taken when practicable on different first-class men, and at different times, and they were averaged.[7]

And:

His ideas [the founder of this movement] were adopted, interpreted, and applied chiefly by administrators; and while the greatest impact was upon administration, the administrator, and the professional training programs of administration, the influence extended to all of American education from the elementary schools to the universities.[8]

What also happened is that the way in which education was conceived altered; the language of education began to take on the characteristics of business. The head of the school or school system was called the superintendent, the school itself was viewed as a plant, the children were seen as raw materials to be processed in the plant by workers (teachers) according to quality control standards specified by consumers (the public). Cost effectiveness for various programs was calculated; one writer exclaimed:

What is to be done? What every other business does when it finds itself confronted with possible bankruptcy through preventable waste, losses, and inferiority of output. It calls in engineering and commercial experts to locate causes and to suggest reforms. We need "educational engineers" to study this huge business of

preparing youth for life, to find out where it is good, where it is wasteful, where it is out of touch with modern requirements, where and why its output fails; and to make report in such form and with such weight of evidence that the most conventional teacher and the most indifferent citizens must pay heed.

Such engineers would make a thorough study of (1) the pupils who constitute the raw material of the business of education; (2) the building and other facilities for teaching, which make up the plant; (3) the school boards and the teaching staff, who correspond to the directorate and the working force; (4) the means and methods of instruction and development; (5) the demands of society in general and of industry in particular upon boys and girls—this corresponding to the problem of markets; and (6) the question of the cost, which is almost purely a business problem.[9]

The conception of the school as a type of factory designed to produce citizens who could take their place in society *might* have been appropriate when the influx of immigrants was very high and the need for the English language and other communication skills was great. But this conception has not dramatically changed since that period. Schools, especially large ones, tend to have the character of factories. The need to process and control the movement of large numbers of students resulted in a mode of school organization and the development of attitudes that pay little attention to individual wants or needs. Even the toilets of many large schools do not have doors that can be closed. And it is not at all unusual to require students to ask permission to meet basic bodily needs. Indeed, in some schools students who are called hall guards sit at various intervals in the halls of the building to ask to see the hall pass that each student must possess to go through the building. These student hall guards are often checked by teachers on hall guard duty themselves. From time to time the vice-principal circulates through the building to determine if the teachers are checking the student hall guards who in turn are checking the students.[10]

Thus, a system of controls is established in schools that oftentimes contradicts the very values of independence, critical thinking ability and perceptivity that schools say they would like to develop in the young.

Schooling in the United States reflects the society in other ways as well. Large population densities have bred in America a feeling of powerlessness with respect to government. Many people believe that they can have little influence on the political course of events in the nation. Similar situations exist in secondary schools, although in some parts of the country this is beginning to change. For the most part, however, students have relatively little influence over the program, goals, or rewards of the schools they attend. Schoolmen, in general, have not developed the skills neces-

sary for providing such options to students; indeed, for years such options were not even considered legitimate. When one is in a large comprehensive high school, say, a school having from 2,000 to 4,000 students, the feeling of anonymity with respect to the faculty as a whole or to its principal is likely to be great. In such schools membership in student councils is often limited to a small elite group in the student population and might not represent the interests or values of the students as a whole. In any case, the decisions that such councils can make generally have little educational import. Indeed, such councils are frequently engineered away from questions of real significance.

The size of schools not only tends to develop a sense of powerlessness on the part of the students, such schools because of their size tend to treat students as pupils to be processed rather than as persons with particular likes and dislikes, aspirations and fears, strengths and weaknesses. High population density breeds needs for control, control breeds a disinterest or difficulty in developing the kind of relationship between student and teacher that makes for affection, affiliation, and a sense of community. Indeed, a sense of social cohesion and group identity is found more frequently on the football field for both players and spectators than in any other event sponsored by the school. The rapid movement every hour or so to a different class, time periods punctuated by a bell, the taking of classes in which one has little or no choice do not tend to nurture independence or strong interpersonal relations. The supermarket checkout counter is nothing more than a distant cousin to the type of brief visitations students make to some of their junior and senior high school classrooms.

The sense of isolation, the lack of community, the fragmented specialism that is felt and presented to students are also experienced by teachers. Teachers who work, for example, in large high schools might not during a course of several years even meet other teachers who also work in the same school—unless of course they happen to have the same lunch period. Specialization, physical distance, and complex scheduling militate against joint planning in large schools. Educational decisions are frequently determined not by a careful consideration of educational goals and the variety of means available for achieving them, but by the dictates of the schedule.

Earlier in the chapter I pointed out that the growth of urbanization has had the tendency to limit children's access to the world of work and to separate them from the older generations. Schooling has become a major social vehicle for such separation. Compared to the total number of

schools in the United States—almost 100,000—relatively few have programs that explicitly attempt to extend children's activities into the communities in which they live. On the contrary, "school" is a separate place to which children go. It is a place in which the talents in the community itself are seldom drawn upon as a source of instructional expertise. Indeed, even the physical characteristics of some schools, especially large junior and senior high schools, impede the development of a symbiotic relationship between the needs of the community and the goals of the school. Large fences are not unusual around schools. Between classes the doors leading to the outside are often locked, except the ones adjacent to the principal's office. In many ways some secondary schools provide more of the image of a fortress or a factory than a place where educational experience is being fostered. Thus, again we see the specialization and isolation of purpose and function so characteristic of society at large being reflected in the educational institutions that it has established.

What are then the parallels between American society and its school system? How does the school reflect the society? In what ways does it stand as a surrogate for the larger society in which children will participate?

Parallels Between School and Society

One obvious parallel exists in the realm of sheer size. As late as 1940 more than half of the schools (not school population) in the United States were one-room institutions. Today an extremely small percentage of such schools exists. The size of schools has grown in part as a result of the consolidation of school districts (in 1950 there were more than 30,000 school districts in the United States; today there are less than 20,000) and in part as a desire to provide the type of facilities and services that very small schools cannot afford. Although there are of course advantages to a school that has a wide array of facilities to offer students, where schools become quite large, more than two thousand students, the character of the institution changes from one in which one senses oneself as a part of a community to one which feels like a great society. Size begins to inflict itself not only because of sheer numbers, but because of the type of controls that schoolmen believe necessary for coping adequately with large numbers of students.

The development of increasingly large units in school buildings is of course parallel to the development of increasingly larger units in society

in general. The town, city, or suburb that can boast the largest shopping center in the area is, in at least American terms, making not only a descriptive claim but boasting a value. Size somehow has taken on a virtue—in automobiles (until recently), in cities, and in films. We have applied these values to the school and they have guided us in developing what we take to be an educationally efficient model for working with the young.

Another parallel between social developments and practices and the practices of schooling has already been attended to: the use of mechanistic controls for population management. The use of pre-punched cards, the reduction of face-to-face relationships with people who provide services, the growing distance between people and the source of services and goods is also found in the school. Computer teaching systems, automatic test grading, machine print-out report forms are becoming a larger part of school life. These devices can indeed respond rapidly and in this sense they are efficient; they get the job done quickly. But at the same time they replace contacts with humans that could provide a type of interpersonal relationship that goes well beyond the mechanical and instrumental. It has been argued that automation in school will free the teacher from the trivial chores that he had to execute under old systems of schooling; hence, more time would be available for the type of intimate relationship and concern that characterizes humane education. I doubt that this is occurring. Like so many of our technological innovations we seldom realize at the time they are implemented what their long-range consequences will be. Few people boasted of long hours away from home and traffic jams when highways were cut through the land. Rapid transit was the overriding conception. One cannot help but wonder if increasing the amount of automation in school will in fact contribute to greater humanization of the school's environment.

As society has moved towards increased specialization so too has the school. One finds that as people in schools become more and more specialized, the amount of expertise they can bring to bear on a specific problem increases. At the same time the scope of their concerns diminishes and unless there are mechanisms for integrating the perspectives, practices, and judgments of specialists, integration is hardly likely to occur. The ultimate consequence of extreme specialization in school as well as in society is a collection of individuals who share no common language and no common concerns. Their frame of reference becomes reduced, although precise and at times powerful, and the range of meaning they can secure from a situation becomes limited.

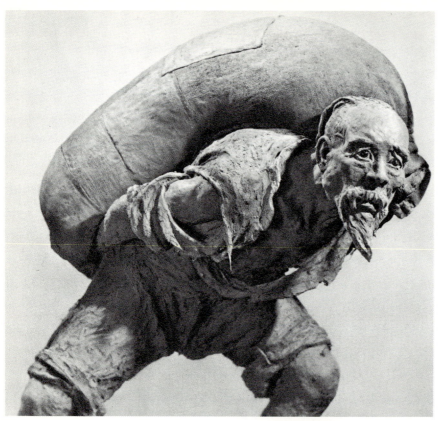

The crushing load of rent symbolizes the man-eating feudal system of exploitation.

After going through the "trick" winnower two full baskets of grain are reduced to one. With leaden hearts mother and daughter bring it to be measured.

These sculptures, produced in Communist China, provide a vivid illustration of the social uses of art. Note that the captions reinforce the social message that is conveyed visually. Such works demonstrate how art can be used to convey affect-loaded ideas about the social world.

Specialization not only reduces the frame of reference that is emphasized in dealing with phenomena; it also tends to shorten the duration of contact people have with specialists. When individuals in a society are responsible for a wide array of services, contact with them is likely to be more frequent and often more sustained. Such contact is more likely to develop feelings of affiliation and intimacy than brief institutional contacts. Passing through an assembly line of shops for services abbreviates contact with each; under such circumstances people tend to use one another instrumentally. When this occurs contacts tend to be superficial and are goal-oriented; little attention is devoted to the quality of the experience of the relationship in its own right. Large, specialized schools tend to replicate such social conditions, few teachers in large, departmentalized schools have either the time or inclination to establish other than instrumental relationships with the students. After all, how much depth of feeling can be nurtured when a teacher must work with two hundred students per day at intervals of forty to sixty minutes.

The instrumental attitude in human relationships so characteristic of society and its schools is a second cousin to a conception of schooling that sees it as preparation for the future. Where work in society is viewed as a means for earning rewards not indigenous with the work itself, it becomes labor. For example, one can conceive of three types of rewards that can come for one's efforts: intrinsic, extrinsic, and extraneous. Intrinsic rewards are those secured in the act of work itself; doing the job provides satisfactions that are valued for their own sake.

Extrinsic rewards are those that come not from the process of working but from the product of that work. A woman might not like the task of cleaning her house but she might very much enjoy a clean house. In such a case the reward is extrinsic to the process.

Extraneous rewards are those that are a part of neither the process nor the product of this process. Extrinsic rewards are the payoffs received for producing a product. A worker in a factory might like neither what he does nor what he produces as a result. But he might very much value the pay that he receives at the end of the week.

There is much in schooling that is modeled after the extrinsic and extraneous reward models. The extrinsic model is emphasized when little or no attention is devoted to helping the student savor the *experience* of inquiry. So much of schooling aims exclusively at the product of inquiry, at the outcome. Yet the kind and quality of experience a child has when he is engaged in work is of central importance regarding the likelihood that he will continue to inquire after he leaves the aegis of the school.

Still other aspects of schooling emphasize the propaedeutic aspects of school work. How often have parents and teachers said, "Someday you might need this"? In such situations the reward is in the form of an imaginative projection into a distant future. A child's faith must be strong indeed.

Competitiveness, postponement, separation of the generations so characteristic of American society are also prevalent characteristics of its school system. In many ways this is not surprising. Historically schools have reflected the characteristics of the societies in which they developed. Indeed, one can develop a strong argument to support the thesis that schools *should* reflect their societies. The society gives them life and they therefore owe their allegiance to that society.

Yet, no human society is perfect and American society is surely far from perfect. Merely to reflect the weaknesses of a social order as well as its strengths is no virtue. I believe schools ought to try to improve society and not just prepare people to fit into society as it is. Further, I believe education at large is a process of pursuing a quality of life that is itself life enhancing. To do this requires attention to those social factors that detract from life, which impede its development, which tend to stifle the development of human potential.

What Can Art Contribute?

What is it that the arts in general, and the visual arts in particular, can do to increase the quality of individual and social life? What are the contributions that art can make to the world in which men live?

Perhaps one of the most important contributions of the arts in a society in which work is fragmented and routine common is its ability to vitalize life by drawing attention to the quality of experience as such. If art is anything at all, it is a quality of life that is savored for itself. In a social order which tends to encourage people to treat both objects and other people as instruments, the arts call attention to the noninstrumental aspects of life. The work of visual art is a form to be visually explored, the rhythms of the work, its shape, its contour, its color, take one on a qualitative ride. Aesthetic experience is a process emerging out of the act itself. Unlike so many other types of human activities the experience that constitutes art does not begin when the inquiry is over—it is not something at the end of a journey, it is part of the journey itself. Thus, one major contribution of the arts in contemporary society is that of serving as both an experience and a reminder that life need not be viewed as a series

of means to a desirable end. Art reminds us that the act of looking intensely, of opening one's sensibilities to the environment yields a qualitative reward in the process of living.

> In short, art by its very nature creates tension. And tension occurs on any level of experience only when perceptions are forced out of their accustomed ruts, ideas beyond the range of routine implications, beliefs outside the contexts of habitual affirmation, and affection beyond the limits of conventional antipathy and sympathy. This is quite as true, moreover, of "classic" as of "romantic" art, of the sculpture of a Donatello as of a Michelangelo, or of the music of a Haydn as of a Berlioz. But if this is so then the real death of art does not lie simply in a loss of sensuous concreteness, but in the unfelt, inexpressive, routine gesture.[11]

In short, art teaches us how to be alive.

Experience in the arts also tends to encourage us to see the interrelationship of things. Experience in art, in either its production or its appreciation, demands attention to the relatedness of elements within a whole. In societies in which individuals have many opportunities to bring work to culmination the opportunity to develop such abilities through the visual arts might not be as important. But modern societies have a tendency to particularize work. Increasingly, fewer and fewer people are able to assume responsibility for the complete development of a product or activity. Specialization in both the factory and the office has fragmented work. The arts provide an opportunity to compensate for such fragmentation by giving men an opportunity to initiate, follow through, and conclude what they begin. In this sense the work reflects its maker and the maker in turn assumes a responsibility for and an identification with the work. In art man can once again become *homo faber*—man the maker.

Work in the arts develops the ability to care, to care not about the monumental but about the little things, the inner aspects of experience— the shimmer of a droplet on a golden leaf, the cool grayness of an early winter morning, a rusted, crumpled pile of wire laying near an old brick wall. When experienced, the arts contribute to the fund of our experiences, develop our perceptivity, and hence enable us to savor the previously insignificant. In this sense the arts develop the sensibility necessary for human concern. To be callused is to be hardened, to have a callus is to have a layer of hard skin between one's nerve endings and the world, hence not to be able to feel. Experience in the arts is a type of callus remover, a vehicle by means of which one's nerve endings become more acute and responsive. The arts thereby enable us *to make sense* of the world.

In an age when need for sensitive humans was never greater it is paradoxical that attention to their development in the schools is so neglected. Yet one might speculate that as long as men are calloused to one another and to the environment in which we all live, the likelihood of increasing the quality of life is small indeed. It would be an overstatement to say that education in the arts is sufficient; without it, however, the prospects look bleak.

How the arts develop human sensibility, what I have referred to as qualitative intelligence, can be understood best by appreciating the demands that work in the arts make. If we take seriously the fact that the types of experience men have affect how they function, then it should come as no surprise that those who spend a major part of their lives dealing with the perception, selection, and organization of qualities should develop a responsiveness to them. Similarly, those who by virtue of what schools emphasize do not, should not be expected to have developed refined sensibilities to phenomena they have seldom encountered. What I am arguing is that work in the arts makes special demands on the maker. It is these demands, what they elicit, that refine the imaginative and sensible aspects of human consciousness. The *work* of art remakes the maker. When society neglects or assigns a peripheral place to such work the abilities that give it life tend to wither or abort.

The import of such a notion is perhaps seen most clearly in the consequences of vocational choice. If the work men do develops or fails to develop certain qualities of mind, then the consequence of vocational choice is not merely that of choosing how one is to earn a living; it is to choose what sort of life one is to live. If the job of selling nurtures certain skills, it just as surely neglects others. When a social order differentially rewards various vocations, it implicitly if not explicitly assigns values to them. Schools that emphasize and hence give value to so-called cognitive fields to the exclusion of the arts are not likely to develop in the young capacities to develop a social order that can respond to the subtle dimensions of qualitative life. When our factories and our cities change their character from the mechanistic to the humane, when they become places in which qualitative experience is as prized as we now prize efficiency, the arts might not need the place in schools they do at present. When the culture itself honors the arts, their role in formal schooling can be neglected. Clearly this is not the case today.

notes

Chapter 1

1. Evidence concerning the peripheral role of the arts as seen by Americans may be found in a study by Lawrence Downey, titled *The Task of American Education: The Perceptions of People,* Midwest Administration Center, University of Chicago, 1960. The fact that most elementary school districts do not require competency in art as a requirement for teaching and the fact that only half of American secondary schools offer art as a part of their curriculum are further indications of the value placed upon the visual arts in American public elementary and secondary education.

2. Vincent Lanier, "The Teaching of Art as Social Revolution," *Phi Delta Kappa* (February 1969), p. 314.

3. During the period from 1957 to 1960 there were numerous articles in the public press concerning the need for tightening up the secondary school curriculum. This most often meant providing funds to support programs in mathematics and science. The titles of books published about public education are revealing: *Quackery in the Public Schools, Why Swiss Schools Are Better than Ours, Retreat from Learning,* are only a few.

4. "Needs assessment" is a concept that has been used most frequently in connection with the determination of goals of federally funded projects in education. Investigators are encouraged to study the community in order to identify needs.

5. Viktor Lowenfeld, *Creative and Mental Growth* (New York: The Macmillan Company, 1947), p. 1.

6. Irving Kaufman, *Report of the Commission on Art Education,* ed. by Jerome J. Hausman (Washington, D.C.: National Art Education Association, 1965), p. 25.

7. The importance of values in determining educational needs cannot be overemphasized. Recent interest in providing effective programs for the so-called "culturally disadvantaged" were not salient fifteen years ago, yet the problems of the "disadvantaged" were just as significant then. When a society begins to realize that a situation in its midst might prove potentially dangerous or uncomfortable, it frequently views the situation as needing to be remedied; hence, a need is formulated. Unfortunately, too often in educational literature needs are talked about as though they were "out there" to be discovered.

8. John Dewey, *Art As Experience* (New York: Minton, Balch and Company, 1934).

9. Susanne K. Langer, "Expressiveness," *Problems of Art* (New York: Charles Scribner's Sons, 1957), pp. 13–26.

10. Ibid., p. 25.

11. Leo Tolstoy, *What Is Art?* Translated by Aylmer Maude (London: Humphrey Milford, Oxford University Press, 1930), pp. 70–312.

12. The various ceremonial functions performed in both school and society should not be underestimated with respect to their power to help develop cohesiveness among people. The ceremonial function of the Saturday afternoon football game, the school assembly, and the pledge to the flag are instruments of art utilized not only for aesthetic satisfaction, but for creating a sense of unity among those who participate in such ceremonies. In this sense, art, as Tolstoy understood well, can be a potent binding agent in all societies.

13. Morris Weitz, "The Nature of Art," *Readings in Art Education,* ed. by Elliot

Eisner and David Ecker (Waltham, Mass.: Blaisdell Publishing Company, 1966), pp. 49–56.

14. John Dewey put it well when he said, "The moral function of art itself is to remove prejudice, do away with the scales that keep the eye from seeing, tear away the veils due to wont and custom, perfect the power to perceive." *Art As Experience,* p. 325.

Chapter 2

1. *Music and Art in the Public Schools,* Research Monograph, 1963, M3 (Washington, D.C.: National Education Association, 1963).

2. Edgar Z. Friedenberg, *Coming of Age in America* (New York: Random House, 1963), p. 75.

3. Paul Goodman, *Compulsory Miseducation* (New York: Horizon Press, 1964), p. 107.

4. Fred Newmann and Donald Oliver, "Education and Community," *Harvard Educational Review* (Winter 1967), Vol. 37, No. 1, p. 83.

5. For a report of this study in relation to the teaching of the humanities see Elliot W. Eisner, "Teaching the Humanities: Is a New Era Possible?" *Educational Leadership* (April 1969), Vol. 26, No. 7, pp. 561–564.

6. Lawrence Downey, *The Task of American Education: The Perceptions of People* (Midwest Administration Center, University of Chicago, 1960).

7. For a brilliant analysis of the child's educational socialization, see Philip W. Jackson, *Life in Classrooms* (New York: Holt, Rinehart & Winston, Inc., 1968).

8. For a discussion of the educational milieu, see Elliot W. Eisner, "Curriculum Theory and the Concept of Milieu," the *High School Journal* (December 1967), Vol. 51, No. 3, pp. 132–146.

9. For further discussion of the crisis of adolescence in American schools see Edgar Z. Friedenberg, op. cit.

10. Manuel Barkan, "Transition in Art Education," *Art Education* (October 1962), Vol. 15, No. 7, p. 16.

11. Curriculum development projects in the sciences especially have made imaginative use of instructional materials. See, for example, projects such as *Elementary School Science,* and *Science: A Process Approach.* Art education has much to learn from the use of materials developed to help children understand important scientific concepts.

Chapter 3

1. *Annual Statement of the Commissioner of Education to the Secretary of the Interior for the Fiscal Year Ended June 30, 1901.* (Washington, D.C.: Government Printing Office, 1901), p. 9.

2. Benjamin Franklin, "Proposals Relating to the Education of Youth," in Harry Beck Green, *The Introduction of Art As A General Education Subject in American Schools* (Stanford University, Doctoral dissertation, 1948), pp. 25–26.

3. Ibid.

4. Newton Edwards and Herman Richey, *The School in the American Social Order,* 2nd ed. (Boston: Houghton Mifflin Company, 1963), p. 57.

5. Harry Beck Green, op. cit., p. 23.

6. See Elwood P. Cubberley, *The History of Education* (Boston: Houghton Mifflin Company, 1920), pp. 624–627.

7. Harry Beck Green, op. cit., pp. 40–46.

8. "The Relation of Art to Education," *Circulars of Information of the Bureau of Education* (Washington: Government Printing Office, 1874), No. 2, pp. 86, 88.

9. Harry Beck Green, op. cit., pp. 84–85.

10. "Schmidt's Guide to Drawing," *Common School Journal* (1843), Vol. 5, No. 16, p. 241.

11. Horace Mann, *The Common School Journal* (1844), Vol. 6, No. 12, p. 198.

12. See, for example, Walter Smith, *Teacher's Manual of Free Hand Drawing and Designing* (Boston: Charles Osgood & Co., 1873).

13. Harry Beck Green, "Walter Smith, The Forgotten Man," *Art Education* (January 1966), Vol. 19, No. 1, pp. 3–9.

14. Lawrence Cremin, *The Transformation of the School* (New York: Alfred A. Knopf, 1961), p. 101.

15. For illustration of such practices see the journal *Progressive Education* as it was published during the decade of the 1930's.

16. Lawrence Cremin, op. cit., passim.

17. *The Applied Arts Book,* the Voice of the Applied Arts Guild of Worcester, Mass. (September 1901), Vol. 1, No. 1, p. 4.

18. Ibid.

19. Oscar Neale, *Picture Study in the Grades* (Milwaukee: O. W. Neale Publishing Co., 1927), from the Preface.

20. Geraldine Joncich, *The Sane Positivist: A Biography of Edward L. Thorndike* (Middletown, Conn.: Wesleyan University Press, 1968), p. 48.

21. Peppino Mangravite, "The Artist and the Child," *Progressive Education* (April, May, June 1926), Vol. 3, No. 2, p. 124.

22. Ibid.

23. Boyd H. Bode, "The Concept of Needs in Education," *Progressive Education* (January 1938), Vol. 15, No. 1, p. 9.

24. Melvin Haggarty, *The Owattona Art Education Project* (Minneapolis: The University of Minnesota Press, 1936), p. 5.

25. Edwin Ziegfield and Mary Elinore Smith, *Art For Daily Living* (Minneapolis: The University of Minnesota Press, 1944), p. 1.

26. Stella E. Wider, "The Art Teacher's Call to Arms," *School Arts* (September 1942), Vol. 42, No. 1, p. 7.

27. Erwin Edman, "No Blackout for the Arts," *School Arts* (December 1942), Vol. 42, No. 4, p. 112.

28. Natalie Robinson Cole, *The Arts in the Classroom* (New York: The John Day Company, 1940).

29. Victor D'Amico, *Creative Teaching in Art* (Scranton, Pa.: International Textbook Co., 1942).

30. Viktor Lowenfeld, *Creative and Mental Growth* (New York: The Macmillan Company, 1947).

31. Herbert Read, *Education Through Art* (New York: Pantheon Books, 1943).

32. Jean Piaget and Barbel Inhelder, *The Psychology of the Child* (New York: Basic Books, 1969).

Chapter 4

1. The conception of child development from the inside out as compared to the outside in was suggested lucidly by Jerome Bruner in his Harper lecture, "The Nature of Intellectual Growth," given at the University of Chicago, November 15, 1962. Bruner said: "I shall urge that in a major sense, growth is from the outside in and that a conception of unassisted maturation is scientifically untenable and, indeed, ethically irresponsible."

2. Rudolf Arnheim, *Art and Visual Perception: The Psychology of the Creative Eye* (Berkeley: University of California Press, 1954).

3. For research dealing with the developmental characteristics of culturally disadvantaged children see Benjamin Bloom, Allison Davis, and Robert Hess, *Compensatory Education for Cultural Deprivation* (New York: Holt, Rinehart and Winston, 1965).

4. Ernest Schachtel, *Metamorphosis: On the Development of Effect, Perception, Attention and Memory* (New York: Basic Books, 1959).

5. Philip Phenix, *Realms of Meaning: A Philosophy of the Curriculum for General Education* (New York: McGraw-Hill Book Company, 1964).

6. Piaget, op. cit.

7. Benjamin Bloom in conversation pointed out to me that an important difference between crutches and spectacles is that crutches are meant to be discarded after an individual becomes sufficiently strong to walk without them. Spectacles are, in almost all cases, used throughout one's life. There is no shame to my mind for individuals using crutches when they need them, as long as they use them so that eventually they can do without their support. I am indebted to Professor Bloom for this illuminating analogy.

8. Rudolf Arnheim, "Expression," *A Modern Book of Aesthetics,* 3rd ed., ed. by Melvin Rader (New York: Holt, Rinehart and Winston, 1966), pp. 258–270.

9. For an insightful discussion of nonverbal communication, see Andrew Halpin's article "The Muted Language," *The School Review* (Spring 1960), Vol. 68, No. 1, pp. 85–103.

10. Susanne K. Langer, "Expressiveness," *Problems of Art* (New York: Charles Scribner's Sons, 1957), p. 15.

11. This view is argued by Rudolph Arnheim in *Art and Visual Perception.*

12. Ibid.

13. Ibid, p. 128.

14. Ibid, pp. 130–131.

15. Rose Alschuler and LaBerta Hattwick, *Painting ond Personality: A Study of Young Children* (Chicago: University of Chicago Press, 1947), Vols. 1 and 2.

16. Rose Alschuler and LaBerta Hattwick, "Easel Painting as an Index of Personality in Preschool Children," *American Journal of Orthopsychiatry* (1943), Vol. 13, pp. 616–625.

17. Ibid.

18. Ibid.

19. Kenneth Beittel, *Selected Psychological Concepts as Applied to the Teaching of Drawing* Cooperative Research Project No. 3149 (University Park, Pa.: Pennsylvania State University, December 1966).

20. Margaret Naumberg, "Studies of the 'Free' Art Expression of Behavior

Problem Children in Adolescence as a Means of Diagnosis and Therapy," *Nervous Mental Disorders Monograph* No. 71 (New York: Coolidge Foundation, 1947).

21. Emmanuel Hammer, "Expressive Aspects of Projective Drawing," *The Clinical Application of Projective Drawings* ed. by E. F. Hammer (Springfield, Ill.: Charles C Thomas, 1958), pp. 59–79.

22. Ernst Kris, *Psychoanalytic Explorations in Art* (New York: International Universities Press, 1952).

23. Karen Machover, *Personality Projection in the Drawings of the Human Figure* (Springfield, Ill.: Charles C Thomas, 1950).

24. Florence Goodenough, *The Intellectual Factor in Children's Drawings,* Doctoral dissertation, Stanford University, 1924.

25. Dale Harris, *Children's Drawings as Measures of Intellectual Maturity* (New York: Harcourt, Brace and World, Inc., 1963).

26. Florence Goodenough, op. cit.

27. Dale Harris, op. cit.

28. Ibid.

29. Jean R. Medinnus, Diana Bobitt, and Jack Hullett, "Effects of Training on the 'Draw a Man' Test," *Journal of Experimental Education* (Winter 1966), Vol. 35, pp. 62–63.

30. Anastasi, Ann, *Psychological Testing, 3rd ed.* (New York: The Macmillan Company, 1968).

31. Dale Harris, op. cit.

32. Ibid.

33. Norman C. Meier, "Factors in Artistic Aptitude: Final Summary of a Ten-Year Study of a Special Ability," "Studies in the Psychology of Art," *Psychological Monographs* (1933), Vol. 45, No. 1, pp. 140–158.

34. Ibid.

35. Viktor Lowenfeld, *The Nature of Creative Activity* (New York: Harcourt, Brace and World, 1939).

36. Viktor Lowenfeld, *Creative and Mental Growth.*

37. Ibid.

38. Ibid.

39. Ibid., p. 40.

40. Viktor Lowenfeld, "Tests for Visual and Haptical Aptitudes," *American Journal of Psychology* (January 1945), Vol. 58, pp. 100–111.

41. Herbert Read, *Education Through Art* (New York: Pantheon Books, 1943).

42. Herbert Read, *Redemption of the Robot: My Encounter with Education Through Art* (New York: Trident Press, 1966), p. xxix.

43. Ibid.

44. Herbert Read, *Education Through Art,* 3rd rev. ed. (New York: Pantheon Books, 1956), p. 104.

45. June K. McFee, *Preparation for Art* (Belmont, Calif.: Wadsworth Publishing Co., Inc., 1961).

46. The distinctions between looking and seeing are directly related to the distinctions that Gilbert Ryle makes between the task verb and the achievement verb. For a discussion of this distinction see his book *The Concept Of Mind* (New York: Barnes & Noble, 1949).

47. This point is made lucidly by Rudolf Arnheim in *Art and Visual Perception*.

48. I believe that the creation of the appropriate environment for personal development is the sine qua non of the educator. At present, genetic endowment and other congenital conditions are beyond the control or influence of those working in educational settings.

49. Rudolf Arnheim, op. cit.

50. Ernest Gombrich, "Visual Discovery Through Art," *Psychology and the Visual Arts* ed. by James Hogg (Baltimore: Penguin Books, 1969), pp. 215–238.

51. Ibid.

Chapter 5

1. The conjunction "cognitive-perceptual" is used in this context to underscore the necessary operations of cognition in perception and vice-versa. Indeed, I wish there was one word that could be used to eliminate the distinction between the two. There are purposes for which the distinction is useful, but in educational circles, like many other distinctions, it has been reified.

2. John Dewey, *Philosophy in Civilization* (New York: Minton, Balch & Co., 1931).

3. Frances Villemain, "Democracy, Education, and Art," *Educational Theory* (January 1964), Vol. 14, No. 1, pp. 1–15.

4. Nathaniel Champlin, "Education and Aesthetic Method," *The Journal of Aesthetic Education* (April 1970), Vol. 4, No. 2, pp. 65–86.

5. David Ecker, "The Artistic Process as Qualitative Problem Solving," *The Journal of Aesthetic and Art Criticism* (Spring 1963), Vol. 21, No. 3.

6. John Dewey, *Art As Experience* (New York: Minton, Balch and Company, 1934).

7. For a lucid discussion of qualitative problem solving see David Ecker, op. cit.

8. For an attempt to relate contents of children's art to symbols emanating from the preconscious see Rhoda Kellogg, *What Children Scribble and Why* (San Francisco: N-P Publications, 1959).

9. Dale Harris, *Children's Drawings as Measures of Intellectual Maturity,* p. 19.

10. Herbert Read, *Education Through Art*.

11. Rhoda Kellogg, op. cit.

12. Hilda Lewis, "Spatial Representation in Drawing as a Correlate of Development and a Basis for Picture Preference," *Journal of Genetic Psychology* 102, (March 1963), pp. 95–107.

13. Rose Alschuler and LaBerta Hattwick, "Easel Painting as an Index of Personality in Preschool Children," *American Journal of Orthopsychiatry* (1943), Vol. 13, p. 617.

14. Ibid. pp. 620–625.

15. Dale Harris, op. cit.

16. Earl Barnes, "A Study of Children's Drawings" (Worcester, Mass.: *Pedagogical Seminary* II, 1892), pp. 455–463.

17. Florence Goodenough, op. cit.

18. Dale Harris, op. cit.

19. Viktor Lowenfeld, *Creative and Mental Growth*.

20. Earl Barnes, op. cit.

21. Hilda Lewis, op. cit.

22. Elliot W. Eisner, *The Development of Drawing Characteristics of Culturally Advantaged and Culturally Disadvantaged Children,* Project No. 3086 (U.S. Dept. of Health, Education, and Welfare, Office of Education, Bureau of Research, September 1967).

23. Elliot W. Eisner, "The Development of Information and Attitudes Towards Art at the Secondary and College Levels," *Studies in Art Education* (Autumn 1966), Vol. 8, No. 1.

24. Hilda Lewis, op. cit.

25. John I. Goodlad and Robert Anderson, *The Non-Graded Elementary School* (New York: Harcourt, Brace and Company, 1959).

26. Elliot W. Eisner, *Developmental Drawing Characteristics.*

27. Suzanne V. Lourenso, Judith W. Greenberg, and Helen H. Davidson, "Personality Characteristics Revealed in Drawings of Deprived Children Who Differ in School Achievement," *Journal of Educational Research* (October 1965), Vol. 59, pp. 63–67.

28. Max Kozloff, *Renderings: Critical Essays on a Century of Modern Art* (New York: A Clarion Book, Simon & Schuster, 1969), p. 56.

29. Ibid.

30. Brent Wilson, "An Experimental Study Designed to Alter Fifth and Sixth Grade Students' Perception of Paintings," *Studies in Art Education* (Autumn 1966), Vol. 8, No. 1.

31. Bernard Pyron, "Rejection of Avant-Garde Art and the Need for Simple Order," *Journal of Psychology* (1966) Vol. 63, pp. 159–78.

32. Frank Barron and George Welch, "Artistic Perception as a Possible Factor in Personality Style: Its Measurement by a Figure Preference Test," *Journal of Psychology* Vol. 33, pp. 199–203.

33. David Ecker, "Justifying Aesthetic Judgments," *Art Education* (May 1967), Vol. 20, No. 5, pp. 5–8.

34. For a variety of research studies on problems concerning aesthetic judgments, see the following by Irvin Child, "Esthetics," in *Handbook of Social Psychology,* ed. by Gardner Murphy and Eliot Aronson, 2nd ed. (Reading, Mass.: Addison-Wesley, 1968–69), Vol. 3, pp. 853–916.

35. Sumiko Iwao and Irvin L. Child, "Comparison of Esthetic Judgments by American Experts and by Japanese Potters," *Journal of Social Psychology* (1966), Vol. 68, pp. 27–33.

36. C. S. Ford, E. Terry Prothero, and Irvin L. Child, "Some Transcultural Comparisons of Esthetic Judgment," *Journal of Social Psychology* (1966), Vol. 68, pp. 19–26.

37. Irvin L. Child and Leon Siroto, "Bakwele and American Esthetic Evaluations Compared," *Ethnology* (October 1965), Vol. 4, No. 4, pp. 349–360.

38. Oscar K. Buros, *Tests in Print* (New Jersey: Gryphon Press, 1961).

39. Charles C. Horn, *The Horn Art Aptitude Inventory* (Chicago: C. H. Stoelting Co., 1939–53).

40. Alma Knauber, *Knauber Art Ability Test,* published by the author. 1932–35.

41. Ibid.

42. Norman C. Meier, *Meier Art Tests: I. Art Judgment* (Bureau of Educational Research and Service, State University of Iowa, Iowa City, Iowa). 1929–42.

43. Maitland Graves, *Graves Design Judgment Test* (New York: The Psychological Corporation, 1948).

44. Alfred S. Lewerenz, *Tests in Fundamental Abilities in the Visual Arts* (California: California Test Bureau, 1927).

45. William H. Varnum, *Selective Art Aptitude Test* (Scranton, Pa.: International Textbook Co., 1939–46).

46. Margaret McAdory, *McAdory Test* (Bureau of Publications, Teachers College, Columbia University). 1929.

47. *Cooperative General Culture Test* (Princeton, N.J.: Cooperative Test Division, Educational Testing Service), 1930–56.

48. *Cooperative Contemporary Affairs Test for College Students* (Princeton, N.J.: Cooperative Test Division, Educational Testing Service, 1938–51).

49. *National Teacher Examination* (Princeton, N.J.: Educational Testing Service, 1940–61).

50. H. H. Remmers et al., *Purdue Master Attitudes Scale,* University Book Store, 1934–60.

51. G. Frederic Kuder, *Kuder Preference Record—Personal* (Chicago: Science Research Associates, 1948–54).

52. Gordon W. Allport, Phillip E. Vernon, and Gardener Lindzay, *Allport-Vernon-Lindzay Study Values* (Boston: Houghton Mifflin Co, 1931–60).

53. Truman L. Kelley, Richard Madden, Eric F. Gardner, Lewis M. Terman, and Giles M. Ruch, *Stanford Achievement Test* (Tarrytown, N.Y.: Harcourt, Brace and World, 1953).

54. *Sequential Test of Educational Progress* (Princeton, N.J.: Cooperative Test Division, Educational Testing Service, 1957–59).

55. Louis P. Thorpe, D. Welty LeFauer, and Robert A. Naslund, *SRA Achievement Series* (Chicago: Science Research Associates, Inc., 1954–58).

56. *Every Pupil's Scholastic Test* (Emporia, Kan.: Bureau of Educational Measurements, Kansas State Teachers College). New forms issued annually.

57. *College Entrance Examination Board Admission Testing Programs* (Princeton, N.J.: Educational Testing Service, 1901–61).

58. *National Merit Scholarship Qualifying Test* (Chicago, Ill.: Science Research Associates). New forms issued annually.

59. *Knauber Art Vocabulary Test,* op. cit.

60. Ibid.

61. *Meier Art Tests.*

62. *Tests in Fundamental Abilities in the Visual Arts.*

63. *Graves Design Judgment Test.*

64. *The Fourth Mental Measurement Yearbook,* Oscar K. Buros (ed.) (New Jersey, The Gryphon Press, 1953).

65. Bruno Bettelheim, "What Students Think About Art," *General Education in the Humanities* ed. by Harold Dunkel (Washington, D.C.: American Council on Education, 1947).

66. Ibid., p. 226.

67. Ibid., p. 210.

68. Kenneth Beittel, "Experimental Studies of the Aesthetic Attitudes of College Students," *Research in Art Education, Seventh Yearbook* (Kutztown, Pa., 1956), pp. 47–61.

69. Ibid., p. 60.

70. Ibid., p. 60.

71. Coretta Mitchell, "A Study of Relationships Between Attitudes About Art Experience and Behavior in Art Activities," *Research in Art Education, Ninth Yearbook 1959* (Kutztown, Pa.), pp. 105–111.

72. Irving Kaufman, "Some Reflections on Research in Art Education," *Studies in Art Education* (Fall 1959), Vol. 1, No. 1, pp. 11–12.

73. Ray Faulkner, "Educational Research and Effective Art Teaching," *Journal of Experimental Education* (September 1940), Vol. 9, No. 1.

Chapter 6

1. Ralph W. Tyler, *Basic Principles of Curriculum and Instruction* (Chicago: University of Chicago Press, 1950).

2. There are at least two conditions which make it difficult, if not impossible, to verbally describe aspects of human experience with which art educators are concerned. First, the quality of life that works of art are designed to engender, the kind of appreciation and insight that can develop from them, is in most cases covert and not subject to direct observation. They must be inferred. Hence, any descriptions of such states are at least once removed from the phenomenon itself.

Secondly, discursive language is only one way in which human beings communicate. Not all phenomena are capable of being adequately or precisely described through discursive language. Hence, to expect statements to describe phenomena that do not lend themselves to verbal description is a mistake. Much of that which is art education is ineffable.

3. This state of affairs was achieved in the 1920's. For an example of an objectives approach to curricula planning see Franklin Bobbitt's *How to Make a Curriculum* (Boston: Houghton Mifflin Co., 1924).

4. The reader who wishes further explication on the nature of expressive objectives and their place in curriculum planning should see Elliot W. Eisner, "Instructional and Expressive Educational Objectives: Their Formulation and Use in Curriculum." *American Educational Research Monograph on Curriculum,* Evaluation No. III (Chicago: Rand McNally & Co., 1970), pp. 1–18.

5. This instance is used only as a suggestion of one of many possibilities. The major point is that the teacher and the program employed can provide for the gradual development of competencies by attending to the problems of sequence in curriculum planning.

6. For a brilliant description and analysis of the motivation for competency, see Robert White's paper, "Motivation Reconsidered: the Concept of Competence," *Psychological Review* (1959), Vol. 66, pp. 297–333.

7. I am not urging here that teachers encourage students to copy. I am simply attempting to help those who teach to question dogmatic notions that may be a gross disservice to children.

8. For a history of the Bauhaus see Hans Wingler, *The Bauhaus: Weimar, Dessau, Berlin, Chicago* (Cambridge: The M.I.T. Press, 1969).

9. The Institute of Design, now a part of the Illinois Institute of Technology, was started by Laszlo Moholy-Nagy and is the American counterpart of the Bauhaus. For a description of the work there when he was director see his volume, *Vision in Motion* (Chicago: Paul Theobald, Publisher, 1956).

10. For a complete report of the Kettering Project see Elliot W. Eisner, *Teaching Art to the Young: a Curriculum Development Project in Art Education* (School of Education, Stanford University, 1969).

Chapter 7

1. The distinction between curriculum and teaching becomes even more useful when one considers the fact that many of the new nationally developed curricula have been misunderstood by teachers. The fault is not simply to be placed on teachers' shoulders, but includes inadequate in-service education programs. In such cases the mode of teaching and the spirit of the curricula are at odds with each other.

2. For a discussion of the ways in which children cope with teachers' demands see Philip W. Jackson, *Life In Classrooms* (New York: Holt, Rinehart and Winston, Inc., 1968).

3. See, for example, Andrew W. Halpin, "Muted Language," *School Review* (Spring 1960), Vol. 68, No. 1, pp. 85–104.

4. Social learning theory is discussed in Albert Bandura and Richard H. Walters, *Social Learning and Personality Development* (New York: Holt, Rinehart and Winston, 1963).

5. The CEMREL Educational Laboratory in St. Louis has evaluated a project funded by the John D. Rockefeller III Fund, in which artists are taking up residence in elementary schools to provide students with an opportunity to see firsthand what artists do.

6. One educational program that utilizes problems of this kind is offered at the Institute of Design at the Illinois Institute of Technology.

7. Brent Wilson, "An Experimental Study Designed to Alter Fifth and Sixth Grade Students' Perception of Paintings," *Studies In Art Education* (Autumn 1966), Vol. 8, No. 1.

8. For empirical data of the state of college and secondary students' understanding of arts, see Elliot W. Eisner, "The Development of Information and Attitudes Towards Art at the Secondary and College Levels," *Studies In Art Education* (Autumn 1966), Vol. 8, No. 1.

9. Morris Weitz, "The Nature of Art," *Readings In Art Education,* ed. by Elliot W. Eisner and David W. Ecker (Waltham, Mass.: Blaisdell Publishing Co., 1966).

10. Eunice H. Waymack and Gordon Hendrickson, "Children's Reactions as a Basis of Teaching Picture Appreciation," *Elementary School Journal* (December 1932), Vol. 33, No. 4, pp. 268–276.

11. James Doerter, "Influences of College Art Instructors Upon Their Students' Paintings," *Studies In Art Education* (Spring 1966), Vol. 7, No. 2, pp. 46–53.

12. Bernard Pyron, "Rejection of Avant-Garde Art and the Need for Simple Order," *Journal of Psychology* (1966), Vol. 63, pp. 159–78.

13. Kenneth Beittel and Edward Mattil, et al., "The Effect of a 'Depth' Versus a

'Breadth' Method of Art Instruction at the Ninth Grade Level," *Studies In Art Education* (Fall 1961), Vol. 3, No. 1, pp. 75–87.

14. Ibid., p. 75.

15. Elizabeth Dubin, "The Effect of Training on the Tempo of Development of Graphic Representations in Preschool Children," *Journal of Experimental Education* (December 1946), Vol. 15, No. 2, pp. 166–173.

16. Ibid., p. 166.

17. R. H. Salome, "The Effects of Perceptual Training upon the Two Dimensional Drawings of Children," *Studies In Art Education* (Autumn 1965), Vol. 7, No. 1, pp. 18–33.

18. Ibid., pp. 31–32.

19. R. Murray Thomas, "Effects of Frustration on Children's Paintings," *Child Development* (June 1951), Vol. 22, No. 2, pp. 123–132.

20. Rose Alschuler and LaBerta Hattwick, *Painting and Personality* (Chicago: University of Chicago Press, 1947), Vols. 1 and 2.

21. David Manzella, "The Effect of Hypnotically Induced Change in the Self-Image on Drawing Ability," *Studies In Art Education* (Spring 1963), Vol. 4, No. 2, pp. 59–67.

22. Ibid., p. 64, 67.

23. See Dale Harris, *Children's Drawings As Measures of Intellectual Maturity* (New York: Harcourt, Brace and World, 1963).

24. Jean R. Medinnus, Diana Bobitt, and Jack Hullett, "Effects of Training on the 'Draw a Man Test,'" *Journal of Experimental Education* (Winter 1966), Vol. 35, pp. 62–63.

Chapter 8

1. Daniel Stuffelbeam, "The Use and Abuse of Evaluation in Title III," *Theory Into Practice* (June 1967), Vol. 6, No. 3, pp. 126–133.

2. Michael Scriven has called this process formative evaluation. See, for example, his article, "The Methodology of Evaluation," *AERA Monograph Series on Curriculum Evaluation* No. 1 (Chicago: Rand McNally and Co., 1967), pp. 39–83.

3. The concept of terminal behavior is used by educational writers such as Robert Mager and James Popham and refers to the way in which the student is expected to be able to act at the completion of an instructional unit.

4. For a discussion of unobtrusive measures see Eugene J. Webb, Donald T. Campbell, Richard D. Schwart, and Lee Sechrest, *Unobtrusive Measures: Non-Reactive Research in the Social Sciences* (Chicago: Rand McNally, 1966).

5. The concept of predictive validity is explicated in Lee Cronbach, *Essentials of Psychological Testing,* 2nd. ed. (New York: Harper & Row, 1960).

6. Oscar K. Buros, *Tests in Print* (New Jersey: Gryphon Press, 1961).

7. See, for example, Banesh Hoffman, *The Tyranny of Testing* (New York: Crowell-Collier Press, 1962).

8. This point needs emphasis. Because I believe education is a moral undertaking, not to evaluate the consequences of the situations teachers create for children is to be morally irresponsible.

9. Benjamin Bloom, *Learning for Mastery, UCLA Evaluation Comment* (May 1968), Vol. 1, No. 2, p. 1.

10. Arthur Koestler, *Insight and Outlook* (New York: The Macmillan Company, 1949), pp. 254–255.

11. Ibid., p. 262.

12. J. M. Stephens, *Educational Psychology,* Rev'd. ed. (New York: Holt Rinehart & Winston, 1951).

13. Frank Barron, "The Psychology of Imagination," *Scientific American* (September 1958), Vol. 199, pp. 150–166.

14. See Elliot W. Eisner, "Children's Creativity in Art: A Study of Types," *American Educational Research Journal* (May 1965), Vol. 2, No. 3.

15. Thomas Kuhn, *The Structure of Scientific Revolutions* (Chicago: Phoenix Books, 1962).

16. David W. Ecker, "Justifying Aesthetic Judgments," *Art Education* (May 1967), Vol. 20, No. 5, pp. 5–8.

17. Ibid., p. 7.

18. Max Kozloff, *Renderings: Critical Essays on a Century of Modern Art* (New York: A Clarion Book, Simon & Schuster, 1969).

19. Ibid., p. 56.

20. H. W. Janson, *History of Art* (Englewood Cliffs, N.J.: Prentice-Hall; New York: Harry N. Abrams, 1962), p. 524.

Chapter 9

1. See, for example, Alfred Jules Ayer, *Language, Truth and Logic* (New York: Dover Publications).

2. A good example of methodological canons of experimental inquiry can be found in D. T. Campbell and J. C. Stanley, *Experimental and Quasi-Experimental Designs for Research* (Chicago: Rand McNally, 1966).

3. John Dewey, *Democracy and Education: An Introduction to the Philosophy of Education* (New York: The Macmillan Company, 1916).

4. Herbert Read, *Education Through Art* 2nd ed. (New York: Pantheon Books, 1945).

5. Harry Broudy, "The Case for Art Education," *Art Education* (January 1960), pp. 7–8, 19.

6. Francis Villemain, "Democracy, Education and Art," *Education Theory* (January 1964), Vol. 14, No. 1, pp. 1–15.

7. Nathaniel Champlin, "Education and Aesthetic Method," *The Journal of Aesthetic Education* (April 1970), Vol. 4, No. 2, pp. 65–86.

8. David Ecker, "How To Think in Other Categories: The Problem of Alternative Conceptions of Aesthetic Education," *The Journal of Aesthetic Education* (April 1970), Vol. 4, No. 2, pp. 21–36.

9. Ralph Smith, "The Liberal Tradition of Art Education," *Studies in Art Education* (Spring 1963), Vol. 4, No. 2, pp. 35–44.

10. Harry Beck Green, *The Introduction of Art as a General Education Subject in American Schools* (Doctoral dissertation, Stanford University, 1948).

11. Robert Saunders, "The Search for Mrs. Minot: An Essay on the Caprices of Historical Research," *Studies in Art Education* (Autumn 1964), Vol. 6, No. 1, pp. 1–7.

12. John Keel, "Research Review: The History of Art Education," *Studies in Art Education* (Spring 1963), Vol. 4, No. 2, pp. 45–51.

13. Fred Logan, *The Growth of Art in American Schools* (New York: Harper & Row, 1955).

14. Lee J. Cronbach and Patrick Suppes, ed., *Research for Tomorrow's Schools: Disciplined Inquiry for Education* (New York: The Macmillan Company, 1969), pp. 20–21.

15. Lee Shulman, "Reconstruction of Educational Research," *Review of Educational Research* (June 1970), Vol. 40, No. 3, pp. 374–375.

16. Ibid., p. 375.

17. Ibid., p. 375.

18. Thomas Kuhn, *The Structure of Scientific Revolutions* (Chicago: Phoenix Books, 1962), p. 5.

19. Ibid., p. 6.

20. Arthur W. Staats, "Categories and Underlying Mentral Processes, or Representative Behavior Samples and S-R Analyses: Opposing Heuristic Strategies," *Ontario Journal of Educational Research* (Special Issue, Spring 1968), Vol. 10, No. 3, p. 195.

21. Margaret Naumberg, *Dynamically Oriented Art Therapy: Its Principles and Practice* (New York: Grune and Stratton, 1966), p. 18.

Chapter 10

1. Philip Hauser and Leo Schnore, *Study of Urbanization* (New York: John Wiley & Sons, 1965), pp. 7–8.

2. For a general discussion of the effect of technology on human behavior see Jacques Ellul, *The Technological Society* (New York: Alfred A. Knopf, 1967).

3. Sloan Wilson, *The Man in the Gray Flannel Suit* (New York: Simon & Schuster, 1955).

4. William H. Whyte, Jr., *The Organization Man* (New York: Simon & Schuster, 1956).

5. Theodore Roszak, *The Making of a Counter Culture* (Garden City, N.Y.: Doubleday, 1969).

6. For a lucid discussion of this period in American education see Raymond Callahan, *Education and the Cult of Efficiency* (Chicago: University of Chicago Press, 1962).

7. Ibid., p. 35.

8. Ibid., p. 41.

9. James Phinney Munroe, *New Demands in Education* (New York: 1912, preface p. v, as quoted in Callahan, op. cit., p. 62.

10. For a discussion of the milieu of secondary schools see Elliot W. Eisner, "Curriculum Theory and the Concept of Educational Milieu," *High School Journal,* (December 1967), Vol. 51, No. 3, pp. 132–146.

11. Henry David Aiken, "American Pragmatism Reconsidered, III. John Dewey," *Commentary* (October 1962), Vol. 34, No. 4, p. 338.

index